DOMESTIC INSTITUTIONAL INTERIORS IN EARLY MODERN EUROPE

VISUAL CULTURE IN EARLY MODERNITY

Series Editor: Allison Levy

A forum for the critical inquiry of the visual arts in the early modern world, *Visual Culture in Early Modernity* promotes new models of inquiry and new narratives of early modern art and its history. We welcome proposals for both monographs and essay collections which consider the cultural production and reception of images and objects. The range of topics covered in this series includes, but is not limited to, painting, sculpture and architecture as well as material objects, such as domestic furnishings, religious and/or ritual accessories, costume, scientific/medical apparata, erotica, ephemera and printed matter. We seek innovative investigations of western and non-western visual culture produced between 1400 and 1800.

Domestic Institutional Interiors in Early Modern Europe

Edited by Sandra Cavallo and Silvia Evangelisti

ASHGATE

Published by
Ashgate Publishing Limited
Wey Court East
Union Road
Farnham
Surrey, GU9 7PT
England

Ashgate Publishing Company
Suite 420
101 Cherry Street
Burlington, VT 05401-4405
USA

www.ashgate.com

British Library Cataloguing in Publication Data
Domestic institutional interiors in early modern Europe.
 -- (Visual culture in early modernity)
 1. Interior architecture--Europe--History--16th century.
 2. Interior architecture--Europe--History--17th century.
 I. Series II. Cavallo, Sandra. III. Evangelisti, Silvia.
 392.3-dc22

Library of Congress Cataloging-in-Publication Data
Cavallo, Sandra.
 Domestic institutional interiors in early modern Europe / Sandra Cavallo
 and Silvia Evangelisti
 p. cm. -- (Visual culture in early modernity)
 Includes bibliographical references.
 ISBN 978-0-7546-5647-0 (hardcover : alk. paper)
 1. Interior architecture--Europe--History. 2. Architecture and society--Europe--
 History.

 NA2850.E93 2009
 392.3--dc22

 2009011299

Publication of this book have been generously aided by a Lila Acheson Wallace–Reader's Digest Publication Subsidy from Villa "I Tatti", the Harvard University Center for Italian Renaissance Studies.

ISBN 978 0 7546 5647 0

Mixed Sources
Product group from well-managed forests and other controlled sources
www.fsc.org Cert no. SA-COC-1565
© 1996 Forest Stewardship Council

Printed and bound in Great Britain by
MPG Books Group, UK

Contents

Part II The meaning and use of objects

Illustrations

Contributors

MOLLY BOURNE teaches art history at Syracuse University in Florence. A specialist in the cultural history of Renaissance Mantua, her recent publications include a book, *Francesco II Gonzaga: The Soldier-Prince As Patron* (Rome, 2008), a chapter on Mantegna's *Madonna della Vittoria* altarpiece and the economics of information, and an essay on Medici women at the Gonzaga court. She contributed an essay on Francesco II Gonzaga to the exhibition catalogue *Mantegna a Mantova, 1460–1506*, served as guest editor for a *Renaissance Studies* issue dedicated to the art and culture of Mantua, and has published articles on cultural exchange between Italy and Spain, as well as on villas and cartography at the Gonzaga court. Forthcoming publications include essays on sexual innuendo in the correspondence of Francesco II Gonzaga, on Mantua and the Gonzaga 1328–1630.

SANDRA CAVALLO is Professor of Early Modern History at Royal Holloway University of London. She has researched and written extensively on the history of charitable and medical institutions, the medical profession and the body, and gender and family history. Her publications include *Charity and Power in Early Modern Italy* (Cambridge University Press, 1995), *Widowhood in Medieval and Early Modern Europe*, co-edited with Lyndan Warner (Longman, 1999), *Artisans of the Body in Early Modern Italy. Identities, Families, Masculinities* (Manchester University Press, 2007), *Spaces, Objects and Identities in Early Modern Italian Medicine*, co-edited with David Gentilcore (Blackwell, 2008), and *A Cultural History of Childhood and the Family: The Early Modern Age (1400–1650)*, co-edited with Silvia Evangelisti (forthcoming, Berg, 2010). Recently, she has become interested in the study of the home and its material culture. Her current research project looks at the construction of the 'healthy domestic environment' in Renaissance and early modern Italy.

HENRY DIETRICH FERNÁNDEZ, Senior Lecturer, taught courses in architecture and architectural history at the Rhode Island School of Design. He received his BA at the University of California, Berkeley, and an MA at Harvard University. His PhD was from the University of Cambridge (UK),

his thesis being entitled 'Bramante's Architectural Legacy in the Vatican Palace: A Study in Papal Routes'. His honours included the Hawksmoor Medal from the Society of Architectural Historians of Great Britain. His most recent project, 'Reconstructing Renaissance Rome,' was a digital reconstruction of the sixteenth-century Vatican Borgo and the Via Giulia, and it was sponsored by the Scott Opler Foundation. During the 2006/07 academic year he was the Kress Visiting Fellow at the Warburg Institute in London. His publications include the following: 'Avignon to Rome. The Making of Cardinal Giuliano della Rovere as Patron of Architecture', in Ian Verstegen (ed.), *Patronage and Dynasty. The Rise of the della Rovere in Renaissance Italy, Sixteenth-Century Essays and Studies 77* (Truman State University Press, 2007); 'Raphael's Bibbiena Chapel in the Vatican Palace', in Tristan Weddigen, Sible de Blaauw and Bram Kempers (eds), *Functions and Decorations: Art and Ritual at the Vatican Palace in the Middle Ages and the Renaissance* (Biblioteca Apostolica Vaticana, 2003); 'The Patrimony of St Peter, the Papal Court at Rome', in John S.A. Adamson (ed.), *The Princely Courts of Europe: Ritual, Politics and Culture under the Ancien Régime 1500–1750* (Weidenfeld & Nicolson, 1999).

LOUISE DURNING is Senior Tutor at Lincoln College, Oxford. Her publications include the edited volumes *Gender and Architecture: History, Interpretation and Practice* (John Wiley & Sons, 2000) (ed. with Richard Wrigley) and *Queen Elizabeth's Book of Oxford: Ms Bodley 13a Facsimile* (The Bodleian Library, 2006). She is involved in the AHRC-funded project 'The early modern parish church and the religious landscape'.

SILVIA EVANGELISTI is Lecturer in European History at the University of East Anglia, Norwich. Her main research interests have focussed on female monastic institutions, religious writing and artistic tradition, and the material culture and circulation of material objects in convents and households. Her publications include *Nuns: A History of Convent Life 1400–1750* (Oxford University Press, 2007), *Unmarried Men and Women in Early Modern Italy and Europe*, co-edited with Margareth Lanzinger and Raffaella Sarti (Sage, 2008), *A Cultural History of Childhood and the Family: The Early Modern Age (1400–1650)*, co-edited with Sandra Cavallo (forthcoming Berg, 2010), and a number of journal articles. Recently she has developed an interest in the devotional and educational aspects of domestic culture and environments, and in the missionary enterprise.

ISABEL DOS GUIMARÃES SÁ is Associate Professor at the Instituto de Ciências Sociais at the Universidade do Minho and associate researcher at the Instituto de Ciências Sociais (Lisbon). She is the author of the books *A circulação de crianças na Europa do Sul: o exemplo da Casa da Roda do Porto no século XVIII* (1995), *Quando o Rico se faz Pobre: Misericórdias, Caridade, e Poder no Império Português, 1500–1800* (1997), and *As Misericórdias Portuguesas de*

D. Manuel I a Pombal (2001). Her current research interests focus on material culture, in addition to the study of charity in early modern Portugal and its empire.

HELEN HILLS is Professor of Art History in the Department of History of Art at the University of York. Her principal research interests embrace the interrelationships between architecture, religious devotion, social class and gender, and the remobilization of the idea of 'baroque' in recent theory. Publications include: *Invisible City: The Architecture of Devotion in Seventeenth-Century Neapolitan Convents* (Oxford University Press, 2005) (Winner of the Best Book Prize, 2004, awarded by the Society for the Study of Early Modern Women, USA); *Marmi Mischi Siciliani: Invenzione e Identità*, translated by Anna Vio (Società Messinese di Storia Patria, Scholarly Monograph Series, Messina, 1999); she is editor of *Architecture and the Politics of Gender in Early Modern Europe* (Ashgate, 2003) and co-editor with Penelope Gouk of *Representing Emotions: New Connections in the Histories of Art, Music and Medicine* (Ashgate, 2005). She is currently writing a book on forms of holiness in baroque Naples.

JANE KROMM is the Kempner Distinguished Professor of Art History at Purchase College, State University of New York. Her principal research interests are in the representation of psychological states and in the architecture of charitable institutions in the early modern period. She is the author of *The Art of Frenzy: Public Madness in the Visual Culture of Europe 1500–1850* (Continuum, 2002) and is currently editing with Susan Bakewell *A History of Visual Culture* (Berg, 2009). Recent essays include 'Site and Vantage: Sculptural Decoration and Spatial Experience in Early Modern Dutch Asylums', in Leslie Topp, James E. Moran and Jonathan Andrews (eds), *Madness, Architecture, and the Built Environment* (Routledge, 2007), and 'The Bellona Factor: Political Allegories and the Conflicting Claims of Martial Imagery', in Cristelle Baskins and Lisa Rosenthal (eds), *Early Modern Visual Allegory: Embodying Meaning* (Ashgate, 2007).

ANNE E.C. MCCANTS is Professor and Head of History, Massachusetts Institute of Technology. She is an economic and social historian of the late Middle Ages and early modern Europe. Her research has addressed such questions as the distribution of resources within and between households, the emergence of different types of family systems, the organization of work by gender and age, the provision of social welfare from institutions outside of the family, and the connection between economic growth and changes in material culture and consumer practices. She is the author of *Civic Charity in a Golden Age: Orphan Care in Early Modern Amsterdam* (University of Illinois Press, 1997); and of recent articles in the *Economic History Review*, *Explorations in Economic History*, the *Journal of World History*, and *Historical Methods*.

SUSAN MERRIAM is Assistant Professor of Art History at Bard College. Her research interests include still life and *trompe l'oeil* painting. This chapter is part of a larger project about the Flemish garland pictures.

RAFFAELLA SARTI teaches Early Modern History and Demography and Social History at the University of Urbino (Italy) as well as Women's and Gender History at the University of Bologna (Italy). She is associate member of the Centre de Recherches Historiques of the Ecole des Hautes Etudes en Sciences Sociales/CNRS in Paris. She has recently begun to work on graffiti and wall writings. She has published on the history of domestic service in early modern and contemporary times, slavery in the Mediterranean, celibacy and marriage, gender and the nation, the family and material culture. She is the author of *Europe at Home. Family and Material Culture 1500–1800* (Yale University Press, 2002), which has been translated into several languages.

Abbreviations

ASDN	Archivio Storico Diocesano, Naples
ASF	Archivio di Stato, Florence
ASMn	Archivio di Stato, Mantua
ASMR	Archivio di S. Maria del Rosario, Rome
ASN	Archivio di Stato, Naples
ASV	Archivio Segreto Vaticano
b. (bb.)	*buste* (*buste*) [packet or case]
c. (cc.)	*carta* (*carte*) [paper or document]
Corp. relig. sop.	Corporazioni religiose soppresse
MdP	Mediceo del Principato
n.n.	not numbered

Acknowledgements

This volume arises from the Conference 'Domestic and Institutional Interiors in Early Modern Europe' that was held at the Victoria and Albert Museum in November 2004 as part of the activities of the AHRC Centre for the Study of the Domestic Interior. The editors are greatly indebted to the Director and staff of the Centre for their intellectual and organizational support, to all the participants in the conference who made it a highly stimulating event and to the British Academy for contributing to its funding. Very special thanks go to Villa 'I Tatti', the Harvard University Center for Italian Renaissance Studies, and particularly to its director, Joe Connors, who warmly supported this project from the very beginning, and to the Lila Acheson Wallace Publications Grant scheme. This grant provided a generous and invaluable contribution for the illustrations included in the book, without which the book would not be the same.

A deep thank you also goes to Clare Coope and Liz Heron for translating and revising some of the chapters.

Finally we would like to thank all our contributors for their patience during the long process that has led to the completion of the volume.

While this book was in the final stages of production we received the sad and unexpected news of the death of Henry Dietrich Fernández, who contributed a chapter. Henry was a valued colleague for all of us, and a dear friend for many. He will be deeply missed.

Introduction

Sandra Cavallo and Silvia Evangelisti

Early modern people did not only live in houses. A significant proportion of men and women, from a variety of social backgrounds, made their homes in monastic institutions, houses for the poor, hospitals, orphanages and colleges, some for brief periods but others for all their lives. Indeed, early modern Europe saw an increasing number of people dwelling in institutional environments. This trend was a reflection, amongst other things, of the proliferation of charitable and religious institutions, and to a certain extent of the expansion of specific educational institutes, such as universities, all of which became more visible components of the urban landscape. Furthermore, the growth of the urban population, observed in all major European centres from the sixteenth century onwards, contributed to increasing the number of people in need of charity and residential support, challenging the strength of family cohesion and public welfare, and placing these institutions under enormous pressure. Besides, we also need to consider the growth of public buildings in this period and their ambiguous status, for these were at the same time the sites of political and religious power and the domestic residences (permanent or temporary) of a range of people, from elite rank to attendants and servants.

Historians of early modern Europe have extensively researched the multiple social roles played by institutions in caring for the poor, the elderly and orphans, providing education and training or simply shelter, and offering opportunities for spiritual fulfilment and intercession with the divine, as in the case of Catholic convents.[1] Moreover, princely households, especially their ceremonial life, have received considerable attention. However, we still know relatively little of the domestic experience of those who lived in non-family arrangements and of the way in which they understood and used their living environments. One of the primary aims of this book is to begin filling this gap. The articles in the volume seek to employ a new perspective on early modern institutions and living interiors by looking at domestic and institutional spaces and the fluid boundaries

between them. Focusing on the organization and representation of a variety of living spaces, the authors examine the extent to which institutions and homes shared common spatial arrangements and patterns of decoration and furnishing, thus re-assessing the validity of the widely used categories of the 'domestic' and 'institutional' and of the related distinctions between public and private, and between religious and profane spaces and objects. Our contributors explore this relationship from two perspectives. On the one hand, they examine the domestic dimension of life in a range of charitable and religious institutions. On the other hand, they discuss the relationship between the institutional and the domestic environments with reference to specific residential contexts: princely and papal palaces and the homes of the urban wealthy elites. In doing so, the collection offers a contribution to the study of both early modern institutions and domestic interiors. It highlights the strategies underpinning the organization of institutional space and its decoration, but also the creative ways in which the residents participated in the formation of their living settings.

The basic assumption from which most of the articles move is that living interiors and the objects that inhabited them both reflected and contributed to shape individual and collective identities, according to class, status, gender and other variables.[2] But these elements were far from static. Hence the volume highlights the dynamic elements in the domestic dimension of institutional life. The early modern period was witness to some major reforms in the history of welfare and religious institutions. The growing efforts of the state and the church to pursue social discipline and regulate many aspects of family life paralleled the creation of new institutions and the reorganization of old ones. In Catholic Europe, the institution most affected by the regulatory trend was probably the convent, but growing control and seclusion were not an exclusive prerogative of female religious houses. They also affected those living in charitable institutions, as some of the articles in this collection demonstrate. Inevitably, this process left a mark not simply on the public role played by such institutions, but also on their internal functioning, altering their material culture and spatial arrangements and hence the experience of those who inhabited these spaces. At the same time, growing social and gender differentiation had a visible impact upon the physical structure and organization of early modern institutions, which increasingly mirrored rank and dynastic interests, and expressed gender divisions more clearly.

This book examines these trends in a variety of countries in both Catholic and Protestant Europe (Italy, the Netherlands, Flanders, Britain and Portugal), thus providing material for comparative study. It explores the relationship between the domestic and the institutional interior from the multiple perspectives of material culture, art and architectural history, and gender and social history, thus adopting an interdisciplinary approach. Moreover, the authors analyse not only the visual culture of the living interiors considered, but also the display strategies employed within them;

they pay attention to the characteristics of the interior as well as the ways in which it was collectively represented.[3]

Domesticity outside the home

The occurrence of the institutional experience in the lives of people becomes more frequent in early modern times. For instance, Durning underlines that, in this period, students were more and more attracted to universities which increasingly offered boarding facilities to those who had until then been used to hostels or rented accommodation. But although universities acquired a stronger residential character, and recruited students from a wider social background, they remained a prerogative of a specific social group: young males in their pre-professional life. Indeed, the institutional experience was often associated with specific age-groups and particular phases of life. Orphans might enter charitable institutions only for a few years upon the death of their parents; the poor might do the same in the most vulnerable periods of their life-cycles. The institutional experience, therefore, became more common in this period also because, with the exception of nuns, it was not a definite fate. Some people might repeatedly spend periods of their life in one institution, so that an emotional bond was often established with it, and ageing former residents could find refuge there.[4] Even the convent was not always a definitive choice for all its residents, but rather a temporary alternative to family and secular life: young girls from the wealthiest classes would spend their childhood and adolescence there in education, but would then leave to marry, as shown by the case of the Gonzaga princesses studied by Bourne. Furthermore, some adult women would take refuge in convents for certain periods of their life: widows, particularly those without charges, would often choose the convent as their residence, which would almost become an extension of their home. Despite being theoretically repealed by the Council of Trent, the custom of allowing lay women to live in a convent without taking vows, and to come and go as they pleased, was tacitly accepted for a long time, at least when it concerned the highest classes, as demonstrated by the Neapolitan case studied by Hills. Even more striking are the examples of Margherita Gonzaga and Caterina de' Medici (discussed by Bourne) who, in clear breach of the rules of strict enclosure, received visits not only from members of their close families, but also from diplomats and politicians.

Institutional and domestic life, then, often alternated in people's lives. Such a reality helps to explain the reproduction of patterns of domestic living and furnishing within the institution, which is documented by many of the articles in this volume. People not only entered institutions bringing with them objects, habits and consumer aspirations, but they left them deeply marked by the experience of institutional life. As McCants suggests, this culturally and materially depriving experience triggered in the former

residents of the Amsterdam orphanage a thirst for consumption which is testified by the range and amount of personal and domestic possessions found in their houses at the end of their adult life. Thus the material deprivation of the years spent in the orphanage left deep traces upon the orphans and on their behaviour as adult consumers.

Furthermore, artefacts which we might normally associate with either the home or an institution moved from one space to the other, and vice versa. Many benefactors bequeathed to churches and convents objects and paintings they had kept in their homes, particularly those of a devotional nature (a practice that, as will be shown, had specific gender connotations).[5] But objects crossed over the threshold of institutions in the opposite direction, too: lay residents leaving the institution took their possessions with them; nuns donated their personal belongings to lay relatives or acquaintances, or even sold them, as the case of Correggio's painting discussed by Bourne illustrates.[6]

In order to understand this intense communication between domestic and institutional environments it is necessary to consider the particular nature of religious and charitable institutions in the early modern age: the image that we have of them is still dominated by nineteenth-century patterns and is, therefore, associated with a high degree of isolation and separation from the world. But in the previous centuries institutions were not so off-limits and they seem to have been more accessible to temporary inmates as well as to visitors than they would become later on. For example, visual representations of the interiors of hospitals and other charitable institutions underline this openness. They systematically show the presence of 'outsiders', who keep watch on their own relatives or the orderly working of the institution (Fig. I.1, Pl. 14 and Pl. 15).

Even convents, allegedly the most secluded institutions of all, do not escape this pattern. Perhaps as a result of their cloistered nature, which was reinforced by the Tridentine directives, contemporary visual representations of convents do not reveal a great deal about their interiors. For example, portraits of nuns and their powerful patrons include only few particulars about specific monastic spatial settings. This scarcity of a recognizable placement may be seen as a powerful allusion to the absence of material goods and luxury which ideally characterized monastic life. However, visual representations of convent life stress contact between the institution and the outside world. In some eighteenth-century Venetian images, the convent parlour is presented as a salon-like space: the nuns are engaged in conversations with their visitors, through grilled windows, while children play and watch a puppet show in a corner, and workers bring goods in at the convent gate.

Images of institutional life therefore cannot help but acknowledge the links between the interior spaces of hospitals, orphanages, and even convents, and the outside world. Neither must it be forgotten that poor-relief and religious institutions relied on charity and this necessarily left them open to scrutiny. The need to attract donors and patrons also moulded

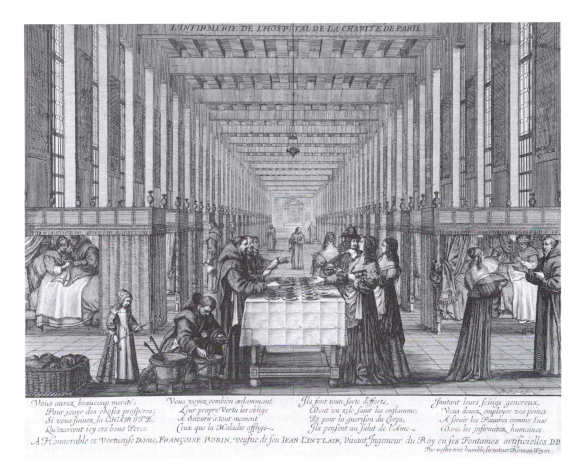

I.1 Abraham Bosse (1604–76), *The Infirmary of the Hospital of Charity in Paris*, etching and engraving on white laid paper (Museum of Fine Arts, Boston)

the institutions' strategies of self-representation, analysed in this volume in Kromm's contribution on the almshouses and asylums of Leiden and Amsterdam. These systematically insisted on the transparency of institutional life through images which offered an overview of the institution's internal structure, of the quality of the services it offered and of the differing types of patient that it welcomed (Fig. 4.2). The visual strategy adopted in the images appearing on the tablets placed above the entrance to institutions, and on the lottery cards sold to raise funds, therefore set out to reassure: it alluded implicitly to the fact that the institution worked for the benefit of the community, rescuing from neglect and isolation many worthy poor people who were offered care and a welcome, and removing the few made violent and dangerous by mental illness (Figs 4.2 and 4.3). These images, focusing on ordinary daily activities, highlighted the domesticity of the institution, implicitly drawing a parallel between home and institution as places where one cooked, ate meals, slept, received visits, did the washing, bathed, was taken care of (Pl. 1).

The marked domesticity of institutional interiors also seems to have been underlined in contemporary depictions of convents. Indeed, images that

stress the continuity between domestic occupations and monastic chores are common, such as, for instance, nuns at work, busy with their daily activities: preparing food, or weaving, or tending the animals (Pl. 2).

In these representations, the convent is the locus of domestic activities. There is almost no evidence of a clear distinction between 'domestic' and 'institutional', according to which domesticity would be associated with ideas of private life, personal choice and the secular sphere, while the institutional would refer to notions of communal life, standardization, de-personalization and religious life. These images suggest that the domestic could be institutionalized, and the institution domesticized.

An even greater challenge to the domestic/institutional distinction comes from the examination of the princely palace carried out by Sarti. She looks from a new perspective at the widely studied ducal palace of Urbino, focusing on the graffiti and the more official inscriptions carved on the internal and external walls of this building, including the most hidden corners. This unusual viewpoint fully exposes the difficulty of distinguishing domestic areas from those with public and political functions. Not only those who dwelled and worked in the palace moved between different areas but – Sarti argues – the spaces one would tend to associate with domestic activities, like the kitchen, appear in reality charged with public and political value. Indeed, it was precisely in the kitchen that the banquets and the official meals for important public occasions were prepared. The public function performed by these domestic spaces was openly acknowledged by the presence in these rooms of official inscriptions which reproduced, on the kitchen's or *tinello's* fireplace, the initials or name of duke Federigo da Montefeltro, in this way reminding the kitchen's staff of the importance of their tasks and making them part in the celebration of the duke's power.

Circulation and transformation of models

Scholars who have recently devoted attention to the nature, forms and functions of sacred spaces have underlined the appropriation of institutional models in domestic life.[7] In the Renaissance and early modern period, the domestic space was adapted for religious purposes, and turned into an area in which contact with the divine was made possible.[8] The boundaries between the secular, domestic environment and the religious space – above all, the space of the church designed for public worship and prayer – therefore appear to have been rather fluid. A major factor explaining this trend is the strong drive towards lay and often home-based piety, which was inherited from the religious movements of the late Middle Ages.[9] Moreover, the development, from the fifteenth century onward, of a mass production of religious images and objects which were specifically designed for domestic worshipping facilitated the growth of this home-based religiosity.[10] On certain days and at certain hours, parts of the house were turned into places of devotion and even

of liturgy: in the home people prayed, contemplated sacred images, celebrated Mass and even marriages. Fifteenth and sixteenth century houses, including those of middle ranked people, often contained pieces of sacred furniture such as domestic altars, either fitted or portable, whilst many prestigious dwellings boasted private chapels as part of the domestic space. These features played a fundamental part in the sacred rites that were performed within the domestic setting. Ignored for a good part of the day or hidden in a cupboard or behind a curtain, the domestic altar could become the focus of devotion at certain moments, transforming the home into a church with the help of a variety of objects, words and gestures (such as genuflection or the singing of psalms) which were usually associated with consecrated spaces. In Italy, for instance, by the sixteenth century the home contained not only sacred images but also accommodated a whole apparatus of devotional objects (candles, altar vestments, bells, holy water sprinklers and incense burners, rosaries and paternosters, Agnus Dei, relics, books of hours) which at the desired moment re-created in the domestic space the setting and sensory experiences (sounds, smells, sights) of the ecclesiastical rite.[11] The home might even reproduce the model of monastic life, as is shown by the experiences of those pious and holy women who chose to withdraw to a life of voluntary poverty and prayer, and segregated themselves to their house, or even their bedroom, which was turned into a monastic 'cell', both in appearance and name. The presence of these lay religious women living at home seems to have been particularly significant in the late Middle Ages, and to have declined in the early modern period – also parallel to the expansion of female monastic orders which were strongly sponsored by the Roman Church. However, forms of home-based female piety, which saw devout women – married women and, above all, widows – engaged in charitable and devotional activities within the local community, remained, in some European countries, a recognized component of lay religiosity in the sixteenth and seventeenth centuries.[12]

Surely, in an age of confessional redefinitions like the one we are considering, any discussion on the circulation of devotional images and objects, and on the meaning attributed to domestic and sacred spaces, cannot but acknowledge the different discourses proposed by Protestants and Catholics on this matter. Indeed, the question of religious art became an issue of disagreement amongst the first Protestant reformers, who rejected and condemned the use of sacred images and objects made by Catholics. However, in Protestant countries, religious imagery did not completely disappear from public and private contexts; rather it was transformed and adapted to the new demands of the reformed society.[13] According to recent research in this field, despite the advent of the Lutheran reform, a degree of continuity with the Catholic past was maintained, which also affected the shape of religious spaces. The binary opposition which often contrasts hyper-furnished and lavishly decorated Catholic baroque churches with whitewashed and purified, image-free Lutheran churches, needs to be re-addressed. There was a range of attitudes towards sacred images and

spaces in the various reformed churches (Lutheran, Calvinist, Zwinglian) and an array of pre-existing differences in various localities of Northern, Central and Eastern Europe, which have all been under-estimated.[14] For instance, in the sixteenth and seventeenth centuries, several Lutheran parish churches in Denmark maintained a partial decorative and structural link with the shape and furnishing of the previous building. Hence, the newly reformed Mass and religious rites were performed within churches which were heavily marked by the presence of 'old' altarpieces and sacred images pre-dating the Reformation. The visual apparatus of the churches might still display late medieval images of the Virgin Mary and episodes of the lives of saints, which – in some cases – were painted white and eliminated much later, in the centuries which followed the Reformation.[15] But what is even more important, for the purpose of our discussion, is that amongst Protestants, as well as Catholics, the space of the house continued to provide specific devotional areas where prayers could be properly carried out. In seventeenth-century England, for example, aristocratic houses included chapels for domestic reformed worshipping.[16] Similarly, throughout Catholic Europe, private domestic chapels and altars were a common feature in wealthy houses – together with devotional images of various sorts and dimensions – although the Roman Church, in particular in the period following the Council of Trent, limited the rights to celebrate Mass in a private residence without formal permission.[17] All this is hardly surprising if we consider that, in spite of all the theological differences between the two parties, the family and household held a crucial relevance in the process of social discipline and confessionalization which accompanied the religious transformations of the sixteenth century. Protestants saw the household as a place for worship and prayers, as well as a social institution, parents being called to instruct all family members to pray at home every day and attend services in the community.[18] Catholic reformers considered fathers and heads of the household as an indispensable support to the clergy, charging them with the responsibility to pass on to their wives, children and servants those spiritual and moral values which would make them good Christians.[19]

Building on these premises, the essays included in this volume discuss the influence of institutional models upon the domestic realm, stressing the importance of both their structural and visual impact. Indeed, visual representations of interiors speak of this circulation of models. In her analysis of the depictions of Dutch charities, for instance, Kromm argues that these images became the canon by the onset of the seventeenth century, and had a profound influence on the representation of domestic interiors which then characterized the Golden Age of Dutch painting. In particular, the frequent focus on the entrance to the home found in this genre (that is, the assumption of a viewpoint which allows a glimpse of the rest of the house and the activities carried out there while stressing the links between the street and outside world and the inner living space) seems to reproduce

a paradigm encountered in the depictions of institutional interiors placed above the doors of almshouses or displayed on the lottery cards through which these raised funds.

It would be simplistic, however, to speak of a simple reproduction of models. The transfer of particular objects from the institutional to the domestic environment, for example, could also involve a transformation of their purpose and use. The meaning and formal qualities of an object are multi-purpose, they lend themselves to multiple interpretations in accordance with the space where the object is found and with the functions it carries out. In her study of garland pictures, objects which have their origin in a clerical context, Merriam shows how the context in which they were displayed and their position in relation to other objects determined the prevalence of one meaning over another. In the Flemish bourgeois house, therefore, the devotional and miraculous nature of the garland picture, originally a sacred image surrounded by a garland decoration, was put aside and the ornamental element of the composition, the garland, came to the fore as an example of *trompe l'oeil*, or as a curiosity object which engaged the viewer in a reflection on the relationship between art and nature, which was typical of the culture of the age.

We can also detect a profound impact of patterns of domestic organization upon institutional life. Institutions looked to the home. It is interesting that Renaissance architectural plans and treatises, such as those by Cesariani, Alberti and Filarete, establish a parallel between hospital and residential architecture, arguing that hospitals must draw their inspiration from the family house. Indeed, the architecture of both the home and the institution played a fundamental role in mediating family ideology as well as civic and religious values, with the primary aim of forging the citizen.[20] Furthermore, the appropriation of domestic models in institutional spaces can be found in unique contexts, as shown by Fernández in his reconstruction of Bramante's project for the Conclave hall. From his analysis we learn that in the event of papal elections the Vatican Palace was temporarily transformed into an almost domestic setting. Its rooms functioned as an improvised dormitory for the cardinals who were literally locked in for days; their bedsteads, furnishings and personal objects were dismantled and put away only after the selection of the new pontiff.

The family experience did not just provide spatial and organisational models, but was re-created in the relationships within the institution. The custom for women who were related to each other to enter the same convent, not only as nuns but for educational purposes, or in retreat as in the case of widows, is documented in this volume by Bourne and Hills. As the latter argues, the fact that mothers and daughters, aunts and nieces, and other women from the same kinship group often lived in a convent at the same time, created a family atmosphere that made them feel 'at home' and probably softened the psychological weight of institutionalization.[21]

Convents reproduced aspects of domesticity in their material culture as well as in their emotional climate. The cells of wealthy nuns might be rather large apartments consisting of several rooms including private kitchens, toilets, and separate living and sleeping areas. They resembled the rooms and dwellings such nuns had been used to before entering the religious life, and reflected their family status, background and taste more than the religious ideal of deprivation they had embraced on becoming brides of Christ. Hills provides many examples of splendidly personalized cells and living quarters with furnishings and ornaments of every type. This practice is well documented by many studies;[22] but her examples are interesting in particular as they show that these phenomena continued well after the restrictions imposed by the Council of Trent.[23] It was not only nuns who actively contributed to importing material elements of the home into the monastic environment; patrons did it too. Wealthy matrons and women from royal families were prominent supporters of convents, which they endowed with lands, houses and all sorts of gifts, including furniture, silver artefacts, clocks, utensils, books, devotional images and liturgical objects, as we see in the case of the three Portuguese queens studied by Guimarães Sá. They also commissioned decorations, frescoes and other works of art, engaging artists, architects and craftsmen. It was surely the case that, through their frequent gifts, patrons influenced the monastic interiors which they contributed to creating with their secular taste and personal choices.[24]

These practices make the distinction we tend to draw between 'domestic' and 'institutional' highly ambiguous. Sometimes, private domestic spaces and institutional spaces even appear physically connected and hardly distinguishable. Instances of the appropriation of institutional spaces by domestic ones intensified at the beginning of the early modern period among royal and aristocratic families. The case of the palace-monastery of the Escorial perfectly exemplifies the fusion of domestic, religious and public motives in one space. Built as a 'temple of peace' for Philip II and Spanish monarchs to rest in eternity, it featured specific architectural devices which allowed the king to follow the Mass performed in the church directly from the oratory which was joined to his bedchamber.[25] Similarly, by way of a less exclusive example, the private oratories built by noble patrons – rather common among the late medieval and early modern European elites – amounted to an extension of their house into the church. Indeed, a private passageway often connected the house or the palace to a private oratory which possibly had sight of the altar, allowing the patron undisclosed use of the church.[26] Convents, too, were built in proximity to their royal palaces and could be reached in a few minutes.[27] Guimarães Sá and Bourne attest to similar practices in Portugal and Italy. In Lisbon, D. Leonor's palace was connected to the church of the monastery of St John the Evangelist. Similarly, the palace built by Margherita Gonzaga in Mantua was adjacent to the convent she founded, and gave her direct access to the cloistered area of the building, which in theory should have been locked and off-limits to outsiders; even her rooms were part of the cloistered space,

as the nuns had access to them. The language used by contemporaries fully conveyed the confusion between domestic residence and institution: the rooms Margherita occupied were referred to both as 'palace' and as 'convent'.

Such practices make the boundary between the outside and the inside of the convent much more problematic than the idea of strict enclosure would lead us to believe. Paradoxically, precisely at the time when convent reformers prescribed specific architectural devices to close the convents – building walls, barring windows, and moving all internal communal areas further away from the street – the presence of private rooms for patrons and benefactors made convents open to the outside, and increased the entrance of visitors. This practice spread upon patrons' requests but with the approval of the ecclesiastical hierarchies, thus showing the ambiguity of their politics and the compromises the church was prepared to accept in its dealings with donors. It is an aspect of the expansion of lay spirituality which was not restricted to women religious and convents, but was found in Spanish monasteries, for instance. Here, the growth of military orders during the reign of Charles V led to the construction of private rooms within the monastery, to encourage the knights' devotional practices and sexual abstinence.[28] In the case of these members of military orders this practice became somewhat prescriptive.

In the case of convents, it seems therefore more appropriate to speak of spaces with different degrees of enclosure, rather than of enclosed or non-enclosed spaces. On the other hand, as already mentioned, convents offer examples of liminal spaces, not entirely separated from the outside: in addition to the parlour and the choir, the infirmary (the large room the cells for sick nuns opened onto) allowed them to see the doctor through the grates. A simple juxtaposition of inside/outside spaces does not reflect the organization of the convent for another reason: the architectural barriers which impeded the access of bodies to the convent were permeable to vision and sound. As observed by Hills, the public space of the convent church was physically inaccessible to the nuns but filled with the sound of their chanting and penetrated by their gaze.[29]

Blurred boundaries: private and public spaces

Forms of privatization of the institutional space such as the ones examined so far were not limited to religious institutions. They were also found in the university colleges studied by Durning, which were rebuilt early in the seventeenth century with substantial private contributions.[30] Moreover, we know very well that the appropriation made by patrons of parts of the institution also extended to the tombs, chapels and altars they built in churches and monasteries. Sometimes the entire building was regarded as privately 'owned' by those who had financially contributed to its construction. It is striking, for example, that the Gonzaga family celebrated their weddings not in the public church of the convent that was the object of their patronage

but in the more internal and semi-public space of the parlour. This choice attested to the divine protection that the sacred space of the convent and the nuns' intercessory prayers were supposed to ensure, as well as to the sense of ownership the Gonzaga maintained towards this religious institution. Such practices underline the hybrid nature of institutions, so deeply characterized by a tension between the public and the private, and largely subject to dynastic logics and concerns for family power.

The penetration of institutional spaces by secular logics of prestige was also attained through the circulation of objects. This is particularly obvious in the kind of images found in convents. Portraits of illustrious women – founders, abbesses and novices – were displayed in chapter rooms, parlours and cells.[31] Bourne shows that the Poor Clares convent of Mantua was no exception to this practice. Alongside artworks of religious subjects, numerous portraits of Gonzaga princesses were found here even in the most secluded parts; altogether there were as many as 34 portraits in the cloistered areas of the convent. The Gonzaga patronage left therefore a deep mark even on the most intimate visual decoration of the convent. However, the presence of images to which a modern viewer would attribute a dynastic value in the most intimate areas of the convent might have carried a different meaning in the early modern period. If we take into account the difficulties, stressed by Merriam, of drawing a clear distinction between 'secular' and 'religious' subjects in early modern paintings, we should perhaps consider the spiritual effect of these founders' portraits on the nuns contemplating them. Many studies have indeed insisted on the edifying function that images fulfilled in the early modern period.[32] Merriam reminds us that Cardinal Borromeo considered even the mere contemplation of still life or landscape paintings as a spiritual experience: for him their perfect imitation of nature made it possible to admire the effects of creation and divine action from the comfort of one's own room. Surely, contemplating the portraits of the convent's illustrious patrons generated reverence for, and identification with, the devout women of the ruling dynasty, strengthening the nuns' self-perception as a group which was almost part of the ruling family. But contemplating these images also allowed the nuns to simply admire and identify with models of perfection and of great charity and piety.

Studies of institutions have given much space to dynastic patronage, which obsessively marked gates, altars, chapels, tombs, silver cups and plates with coats of arms, reaffirming the power of the family over the institution in every corner of the building and at every moment of the day. It could almost be said that institutions were shaped by the interests of the laity and controlled by them. But as well as recognizing the importance of these expressions of influence, the articles in this volume highlight the institutions' and even the givers' capacity to act independently of dynastic logics. There were forms of patronage less redolent of the family identity, and less concerned with external recognition, which are still to be researched. In Neapolitan convents, Hills sees the nuns themselves as active givers, identifying forms of internal patronage which have received too little attention.[33] The nuns' patronage operated

through donations which – in a way not dissimilar from those made by some lay female benefactors – aimed to enrich and embellish the institution, but disseminated their benefaction in a less visible way, avoiding concentrating it upon any specific object. Nuns contributed to the building and shaping of the institution but they did so in a way which was more anonymous and impersonal than that of external patrons. Their contribution simply remained part of the memory of the convent, recorded for example in the documents to which only successive generations of nuns would have access. The existence of internal patronage, and of a written collective memory of the convent, highlights the working of powerful mechanisms through which the residents identified with the institution where they lived, which we must not overlook. To a certain extent, nuns developed a convent identity which replaced their family identity. A sort of convent 'genealogy' was established and ties of spiritual kinship were created in the convent through the nuns' religious names for instance; often these were either those of the institution's patron saint or those of nuns who had preceded them.

Despite the pressure exercised by external patrons, therefore, institutions managed to express a measure of autonomy through their decorative choices, thus demonstrating a sense of collective agency. As Durning suggests in her analysis of the management of donations, university colleges were not passive subjects but independent entities able to transform the intentions of patrons, and to adapt them to their own needs. Hence the gifts received were donated or sold by the colleges themselves in order to solicit further donations. Nor were patrons always allowed to interfere with the institution's building plans; rather, the 'ideal' benefactor was defined as the one who simply subsidized them.

To a certain extent, in the early modern period, institutional and domestic interiors evolved along analogous lines; for example, it was surely the case that the search for a higher degree of intimacy and individualization marked institutional as well as domestic spaces. While in the elitist convent rooms and cells were reserved for certain families, the collective space of the institutions for the poor also witnessed an increase in the value attributed to privacy: this is attested, for example, by the introduction of curtained beds and individual rooms for the residents in the Dutch charitable houses studied by Kromm. At the same time, fundamental transformations increased the separation of private and public functions within the home, and the degree of domestic privacy. For example, the cabinets of curiosities discussed by Merriam were almost private museums within the homes of wealthy Flemish bourgeois families. In the seventeenth century they occupied the reception rooms, that is the liminal space of the house where the private meets the public, and were accessible to external visitors. These collections of curiosities were progressively removed from the domestic environment to become part of the eminently institutionalized domain of the public museum.[34] Domestic collections took different forms and included different items: like book collections, for instance, which moved to public libraries only well into the eighteenth century.

Furthermore, the household long retained its function as a laboratory and a site for medical and scientific observation and experimentation,[35] where, for example, anatomical dissections and demonstrations were performed.[36] As Cooper suggests, it is necessary therefore 'to contemplate the household itself as an institution'.[37]

Specificity of institutional models

Notwithstanding the analogies between home and institution discussed above, there were also ways of organizing space which were specific to the latter. On the one hand, another influential prototype for the institutional organization of space was the monastic one.[38] As Kromm explains, the monastic model often structured early modern charitable institutions, simply because, among other things, these institutions frequently re-utilized medieval monastic buildings fallen into disuse or confiscated after the Protestant Reformation. On the other hand, there was no unique model for institutional space, nor was one always moulded onto the monastic one.[39] Durning points out, for instance, the peculiarity of the sleeping arrangements in English university colleges in relation to the monastic dormitory or cell. Nor was the domestic residential prototype the dominant one: in the colleges studied by this author, the order of seating in the dining hall followed a logic which was different from the one found in the houses of the gentry, as the former did not distinguish between low and high ends, but between high table and ordinary tables. The diners were grouped not so much according to their family rank but according to their academic rank, which was revealed by their clothes. Furthermore, the dining hall lost its importance, in the early modern period, in the mansions of the gentry; meals were increasingly taken in more contained spaces without involving anymore the entire household. In the colleges, by contrast, the dining hall maintained its value as the principal common space, where meals continued to be a collective ritual throughout the early modern period.

The difference between institutional and domestic interiors is developed by McCants in terms of material culture: the orphanages of Amsterdam appear totally bare and mark an impoverishment of the orphans' material experience compared with their life in the family environment. The institutional experience had very different characteristics for the rich and for the poor. In the institutions aimed at the more prosperous classes, like convents or colleges, the features of living space had to be appropriate to the rank of its inhabitants and include symbols of wealth and status. In contrast, the institutional environment of the children of poor artisan families was simply functional and devoid of personalizing elements. The orphans' families were certainly less capable of exercising significant pressure upon the treatment of the parentless children. Only the parts frequented by governors were sumptuous and expensively adorned. McCants' contribution also stresses other important elements which distinguished the family organization from the institutional one: in the latter

case the consumer was totally separated from those who made the decisions on consumption related to food, furnishings and clothing. Moreover, the institution performed a series of functions which in family life were devolved to a variety of external agents: education, work training, religious instruction. The orphanages such as those studied by McCants maintained a much more totalizing character than the family; so much so that Goffman's famous definition – 'total institution' – appears still valid. On the other hand, as Hills reminds us, the opposition between institution and family appears in other instances conceptually false. If the notion of 'institution' is associated with the transmission of models of behaviour the family is undoubtedly the first and main institution.

The rigid division of the sexes implemented by early modern institutions is another characteristic that marks them out.[40] In her study of the Ospedale Maggiore in Milan, for example, Howe has shown how, behind the apparent symmetry of male and female areas, hospitals applied gender distinctions in the management of space, using grates or chains to delimit the female area and barring external access to the female ward.[41] Gender segregation was pursued to some extent in the aristocratic household but was never so fully achieved in the domestic environment.[42] In the institutional context, in contrast, segregation was realized not only through the separation of sleeping quarters for males and females, but in the duplication of all other services and communal spaces: kitchens, dining halls, laundry areas, work rooms, schools and hospital wards (McCants). Once again, this gender separation and, at the same time, duplication of collective life recall the medieval double monasteries, where two monastic houses, one male and one female, formed part of the same institution and of the same architectural complex, though they were completely separated in every daily function. The only connection was the church, shared by the male and female religious communities but partitioned by a wall.

Gender, rank, subjectivity

The focus on institutions makes it possible to explore the extent to which the relationship with particular categories of objects was gendered.[43] In particular, the special ties that women often established with devotional objects, already highlighted in a number of studies, emerges with strength in the contributions by Bourne and Guimarães Sá on the links between court and convent in Mantua, and in Lisbon.[44] Guimarães Sá shows how the consumption of luxury goods at the court of Lisbon, in the early sixteenth century, had a marked devotional character in the case of women. The acquisition of relics, the author maintains, was a distinctive feature of female collecting habits and served to furnish an intimate and domestic devotional space (the bedroom or the private oratory). Furthermore, among the members of the Portuguese royal family it was a woman who first organized private worship at home. Significantly,

only one of the women of the Portuguese royal family, Catarina of Habsburg, created a domestic collection which was clearly detached from traditional liturgical objects. Indeed, Catarina's collection, rather than being constituted by religious objects such as relics, was largely made of precious artefacts from the Portuguese empire in Asia. Catarina was surely anomalous for other reasons, too: not only was she a regent for several years, but she stood out, even during her husband's lifetime, for her considerable political influence. This Portuguese case is intriguing as it suggests that collecting practices amounted to a powerful means of enhancing royal women's participation in political discourses, as well as their devotion and visibility in public religious life.[45] On the contrary, in the case of men, we do not find, in Portugal, the same direct use of religious objects: their acquisitions aimed at feeding the royal politics of patronage and donations in favour of churches, monasteries and brotherhoods in the kingdom and empire. As has been shown for the collections of Philip II, relics expressed devotion and respect for the Catholic Church, as well as specific royal needs which were associated with the construction of a monarchical and national identity through the celebration of Christian values and the Christian past.[46]

The same gender differentiation is to be found in the patterns of pious donation pursued by the members of the Portuguese royal family.[47] Although common to men and women, the practice of donating objects which came from the personal, domestic sphere, or from one's own collection, to religious and charitable institutions, seems to indicate, in the female case, an individual and spiritual relationship with the recipient: women's donations addressed in fact a very limited, and often local, range of institutions, with which they had established direct ties. Male donations were on the other hand territorially more widespread, and more directly aimed to legitimize and reinforce the donor's image and political power. Too often patronage is discussed in an undifferentiated way, whereas, as Guimarães Sá suggests, male and female patronage displayed traits which were partly distinctive.

Studies in this volume also pay considerable attention to the question of how class played a role in the articulation of space, and in the material culture of the institution, a theme so far relatively under-researched. At first sight, it would appear that the relationship between institution and social distinctions is configured in the early modern period inversely to that between institution and gender: whereas gender differences are emphasized, there is an attempt to eliminate those, often expressed by material signs, of rank and class. Indeed, a number of the studies in this volume document the intent to standardize and abolish all signs of distinction, which seems to involve, at the beginning of the early modern period, all types of institutions, male and female, secular and religious. Fernandez's study of the Conclave illustrates the attempt to standardize even the living spaces, furnishings, clothes and living habits of the cardinals gathered to decide who would be the next pope. Bramante's architectural plan of a hall for the Conclave actually expressed similar intents to those pursued in the same period in institutions such as the convent: on

the one hand it aimed to make the total structure more worthy, grandiose and splendid, as a tribute to the ecclesiastical power it represented; on the other, it aimed to de-personalize it and repress any individuality within it, suppressing all signs of belonging to a dynasty or a rank, and encouraging instead a sense of collective endeavour. For example, there was an attempt at flattening the economic and power differences which used to be expressed in the very different quality of the residences in which the cardinals could afford to live during the Conclave.

At the same time, the articles in this volume show how contrasted these projects of standardization were and how partial was their success. As far as the Conclave is concerned, even when the Cardinals' residence moved to the Vatican, this continued to offer a range of accommodations and, although in theory their allocation was left to chance, in practice it reflected political logics and the influence of individual cardinals. Furthermore, despite the austerity of rules and the uniformity imposed by bedsteads, marks of distinction remained, signalled for example by the coats of arms and textiles which adorned the bedstead itself, and by the linen and food received from outside, which breached the standardization of common meals. Even in the orphanages studied by McCants there were manifestations of reaction and resistance against being deprived of the faculty to exercise consumption choices. Above all, there was opposition to the standardization of clothing – the measure which probably created the biggest and most visible difference between the children of the orphanage and those with families. This is suggested by the way in which the orphans used their savings for the embellishment and personalization of their appearance, and in the purchase of accessories such as buttons, ties and buckles which could perhaps be worn upon their uniforms. As adults living outside the orphanage, clothing remained the most substantial item of expenditure in the budgets of the former orphans.

These attempts at personalization were not limited to the mere physical appearance, nor, as we have already seen in the case of convent cells, to the institutional space by definition more 'private' (and perhaps for this reason more subject to checking and repressive intervention). They also concerned communal spaces. Focusing on the areas of collective use in the convent (corridors, staircases, dormitories and the garden), up until now scarcely analysed, Hills finds evidence of the tendency to create areas for private worship, that is, chapels associated with individual nuns. These altars were the object of their economic patronage but also of an emotional investment, for, they became the focus of their special care and attention. Acknowledged by the internal community as 'belonging' to a particular nun, these personalized collective spaces contributed to establishing the position of their patron within the internal ranking system, providing at the same time an outlet for the expression of subjectivity.

The institutional environment, therefore, was not incompatible with the expression of individualized identities. The graffiti that Sarti finds scattered on the walls of the Urbino ducal palace and the fact that they were preferably

located in the official areas of the building rather than in the more secluded corners suggests that, exactly because of its public nature and exposure to an audience, the institution provided the ideal setting for the communication of hidden individual feelings. Moreover, the permanent character of these signs gave the anonymous inhabitants of the palace (servants, attendants, visitors) the opportunity to leave an enduring mark of their existence.

In the early modern period, new ways of expressing rank emerged also in the colleges. The system, in fact, allowed those who came from rich and powerful families to occupy spatial positions they were not entitled to and to be designated with titles they had not achieved, creating therefore alternative hierarchies to that simply defined by academic status. As Durning points out, initially these privileges were granted in response to pressure from below, but they were soon transformed into a codified system of dispensations re-paid with gifts in cash or precious objects. A degree of collusion was therefore established between the strategies for social differentiation stemming from the students and their families, and the institution's financial interests. The architectural form of the colleges was, on the other hand, also increasingly a vehicle of social distinction, as it broke free of the quadrangular scheme introduced in the fourteenth century which projected the image of a community of social equals, only structured by internal criteria of seniority defined by academic rank.

In conclusion, the studies included in this collection redefine the relationship between the institutional and the domestic in many original ways, bringing to the fore previously unexplored examples of this relationship, and revealing fundamental aspects of people's experience of their living spaces. On the one hand, the chapters highlight instances of the reciprocal influence between domestic and institutional models; on the other, they identify specific features of the institutional experience and the distinctive characters that mark out early modern institutions, distancing them from their predecessors. Indeed, institutional interiors increasingly carried clear signs of the original social status of those who inhabited them but were also shaped by the institutional identity acquired by the long-term residents. More generally, the exploration of a range of institutional interiors in early modern Europe provides scope for thinking of another domesticity or, more appropriately, of other domesticities. As we shall see, these alternative domesticities were to be found not exclusively within the walls of the house – the residential environment *par excellence* – but also outside it, in those religious, charitable and educational institutions which offered a multiplicity of living options to early modern men and women.

Notes

1 The literature on early modern charitable institutions and convents in Europe is huge. Among the most recent works, see Anne E.C. McCants, *Civic Charity in*

a Golden Age: Orphan Care in Early Modern Amsterdam (Urbana IL: University of Illinois Press, 1997); Thomas M. Safley, *Charity and Economy in the Orphanages of Early Modern Augsburg* (Boston MA: Humanities Press, 1997) and Thomas M. Safley, *Children of the Labouring Poor: Expectation and Experience Among the Orphans of Early Modern Augsburg* (Leiden and Boston MA: Brill, 2005); P. Renée Baernstein, *A Convent Tale: A Century of Sisterhood in Spanish Milan* (New York and London: Routledge, 2002); Mary Laven, *Virgins of Venice: Enclosed Lives and Broken Vows in the Renaissance Convent* (London: Penguin, 2002); Claire Walker, *Gender and Politics in Early Modern Europe: English Convents in France and the Low Countries* (London: Palgrave Macmillan, 2003); Ulrike Strasser, *State of Virginity: Gender, Religion and Politics in an Early Modern Catholic State* (Ann Arbor MI: University of Michigan Press, 2004); Elizabeth A. Lehfeldt, *Religious Women in Golden Age Spain: The Permeable Cloister* (Aldershot and Burlington VT: Ashgate, 2005); Amy Leonard, *Nails in the Wall: Catholic Nuns in Reformation Germany* (Chicago IL: University of Chicago Press, 2005); Laurence Lux Sterrit, *Redefining Female Religious Life: French Ursulines and English Ladies in Seventeenth-Century Catholicism* (Aldershot and Burlington VT: Ashgate, 2005); Nicholas Terpstra, *Abandoned Children of the Italian Renaissance: Orphan Care in Florence and Bologna* (Baltimore MD: Johns Hopkins University Press, 2005); Susan E. Dinan, *Women and Poor Relief in Seventeenth-Century France: The Early History of the Daughters of Charity* (Aldershot and Burlington VT: Ashgate, 2006).

2 Arjun Appadurai (ed.), *The Social Life of Things: Commodities in Cultural Perspective* (Cambridge: Cambridge University Press, 1986); Pierre Bourdieu, *Distinction: A Social Critique of the Judgment of Taste* (Cambridge MA: Harvard University Press, 1984).

3 On domestic interiors and their representations, see Jeremy Aynsley, Charlotte Grant and Harriet McKay (eds), *Imagined Interiors: Representing the Domestic Interior Since the Renaissance* (London: V&A Publications, 2006) and the database of the Centre for the Study of the Domestic Interior (<www.rca.ac.uk/csdi/didb>). Also see Marta Ajmar-Wollheim and Flora Dennis (eds), *At Home in Renaissance Italy* (London: V&A Publications, 2006).

4 For evidence of the intermittent character of residence in charitable institutions, see Sandra Cavallo, 'Family Obligations and Inequalities in Access to Care (Northern Italy, 17th–18th Centuries)', in *The Locus of Care: Families, Communities, Institutions,* ed. Peregrine Horden and Richard M. Smith (London: Routledge, 1998).

5 See chapters by Bourne and Guimarães Sá in this volume. See also Lisa A. Banner, 'Private Rooms in the Monastic Architecture of Habsburg Spain', in *Defining the Holy: Sacred Space in Medieval and Early Modern Europe*, ed. Andrew Spicer and Sarah Hamilton (Aldershot and Burlington VT: Ashgate, 2006), 89.

6 On the circulation of domestic and devotional objects between convents and outside circles of relatives and friends, see Silvia Evangelisti, 'Monastic Poverty and Material Culture in Early Modern Italian Convents', *The Historical Journal*, 47/1 (2004), 1–20.

7 Spicer and Hamilton; William Coster and Andrew Spicer (eds), *Sacred Space in Early Modern Europe* (Cambridge: Cambridge University Press, 2005).

8 Margaret A. Morse, 'Creating Sacred Space: The Religious Visual Culture of the Renaissance Venetian *Casa*', *Renaissance Studies*, 21/2 (2007), 151–84, at 184.

9 Herbert Grundmann, *Religious Movements in the Middle Ages: The Historical Links between Heresy, the Mendicant Orders, and the Women's Religious Movement in the*

Twelfth and Thirteenth Century, with the Historical Foundations of German Mysticism (Notre Dame IN: University of Notre Dame Press, 1995). André Vauchez, *The Laity in the Middle Ages: Religious Beliefs and Devotional Practices* (Notre Dame IN: Notre Dame University Press, 1993).

10 Morse, 'Creating Sacred Space', 159. Jeanne Nuechterlein, 'The Domesticity of Sacred Space in the Fifteenth-Century Netherlands', in Spicer and Hamilton, 49–79. See also Richard A. Goldthwaite, *Wealth and the Demand for Art in Italy, 1300–1600* (Baltimore MD: Johns Hopkins University Press, 1995); Lisa Jardine, *Worldly Goods: A New History of the Renaissance* (London: Papermac, 1997); Arnold Esch, *Economia, cultura materiale ed arte nella Roma del Rinascimento: studi sui registri doganali romani, 1445–1485* (Rome: Roma nel Rinascimento, 2007).

11 Morse, 'Creating Sacred Space', 163–70; Philip Mattox, 'Domestic Sacral Space in the Florentine Renaissance Palace', *Renaissance Studies*, 20/5 (2006), 658–73.

12 Diane Webb, 'Domestic Space and Devotion in the Middle Ages', in Spicer and Hamilton, 27–47; and Diane Webb, *Privacy and Solitude in the Middle Ages* (London and New York: Hambledon Continuum, 2006), 119–33. On early modern devout women living at home much has been done on France, see Barbara B. Diefendorf, *From Penitence to Charity: Pious Women and the Catholic Reformation in Paris* (Oxford: Oxford University Press, 2004); Elizabeth Rapley, *The Dévotes: Women and Church in Seventeenth-Century France* (Montreal: McGill-Queen's University Press, 1990).

13 Joseph L. Koerner, *The Reformation of the Image* (Chicago IL: University of Chicago Press, 2004); *Art Re-Formed: Re-Assessing the Impact of the Reformation on the Visual Arts*, ed. Tara Hamling and Richard L. Williams (Newcastle: Cambridge Scholars, 2007); Carl C. Christensen, 'Art', in *The Oxford Encyclopaedia of the Reformation*, ed. Hans J. Hillerbrand, vol. 1 (Oxford: Oxford University Press, 1996), 74–80.

14 Margit Thofner, '"Spirito, acqua e sangue". Gli arredi delle chiese luterane (XVI–XVII secolo)', *Quaderni storici*, 123/3 (2006), 519–48.

15 Thofner, '"Spirito, acqua e sangue"', 536–42.

16 On religious and domestic spaces and images in Protestant environments, see Annabel Ricketts with Claire Gapper and Caroline Knight, 'Designing for Protestant Worship: The Private Chapels of the Cecil Family', in Spicer and Hamilton, 115–36; Tara Hamling, 'The Appreciation of Religious Images in Plasterwork in the Protestant Domestic Interior', in Hamling and Williams, 147–63.

17 On sacred images in Catholic domestic environments, see Mattox, 'Domestic Sacral Space', 659–63 and 671–3; Isabella Palumbo Fossati, 'L'interno della casa dell'artigiano e dell'artista nella Venezia del Cinquecento', *Studi Veneziani*, 8 (1982), 109–53, and 'La casa veneziana', in *Da Bellini a Veronese: temi di arte veneta*, ed. Gennaro Toscano and Francesco Valcanover (Venice: Istituto Veneto di scienze lettere ed arti, 2004), 443–92.

18 Christopher Hill, 'The Spiritualization of the Household', in his *Society and Puritanism in Pre-Revolutionary England* (London: Secker & Warburg, 1966), 443–81; Ronald Po-Chia Hsia, *Social Discipline in the Reformation: Central Europe, 1550–1750* (London: Routledge, 1989).

19 See Paolo Prodi (ed.), *Disciplina dell'anima, disciplina del corpo e disciplina della società tra Medioevo ed età moderna* (Bologna: Il Mulino, 1994); Oliver Logan, 'Counter-Reformatory Theories of Upbringing in Italy', in *The Church and*

Childhood, ed. Diana Wood, 31 (1994), 275–84; Gabriella Zarri (ed.), *Donna, disciplina, creanza cristiana dal XV al XVII secolo: studi e testi a stampa* (Rome: Edizioni di Storia e Letteratura, 1996), 6–9.

20 Eunice D. Howe, 'The Architecture of Institutionalism: Women's Space in Renaissance Hospitals', in *Architecture and the Politics of Gender in Early Modern Europe*, ed. Helen Hills (Aldershot and Burlington VT: Ashgate, 2003), 63–80.

21 On convent kinship ties see, for example, Francesca Medioli, 'Reti famigliari. La matrilinearità nei monasteri femminili fiorentini del Seicento: il caso di Santa Verdiana', in *Nubili e celibi tra scelta e costrizione (secoli XVI–XX)*, ed. Margareth Lanzinger and Raffaella Sarti (Udine: Forum, 2006), 11–36.

22 Silvia Evangelisti, 'Rooms to Share: Convent Cells and Social Relations in Early Modern Italy', in *The Art of Surviving: Gender and History in Europe, 1450–2000. Supplement of Past and Present*, ed. Ruth Harris and Lyndal Roper (Oxford: Oxford University Press, 2006), 55–71; Elizabeth A. Lehfeldt, 'Spatial Discipline and its Limits: Nuns and the Built Environment in Early Modern Spain', in Hills, 2003, 140.

23 On Italian convent architecture see also Helen Hills, *Invisible City: The Architecture of Devotion in Seventeenth-Century Neapolitan Convents* (Oxford: Oxford University Press, 2004).

24 On female patrons of convents see also Kate J.P. Lowe, 'Raina D. Lenor of Portugal's Patronage in Renaissance Florence and Cultural Exchange', in *Cultural Links between Portugal and Italy in the Renaissance*, ed. Kate J.P. Lowe (Oxford: Oxford University Press, 2000), 225–48; Marilyn R. Dunn, 'Spiritual Philanthropists: Women as Convent Patrons in Seicento Rome', in *Women and Art in Early Modern Europe: Patrons, Collectors, and Connoisseurs*, ed. Cynthia Lawrence (University Park PA: Pennsylvania State University Press, 1997), 157–84, and Marilyn R. Dunn, 'Spaces Shaped for Spiritual Perfection: Convent Architecture and Nuns in Early Modern Rome', in Hills, 2003, 151–76; on Spain see Magdalena S. Sánchez, *The Empress, the Queen, and the Nun: Women and Power at the Court of Philip III of Spain* (Baltimore MD: Johns Hopkins University Press, 1998).

25 Guy Lazure, 'Possessing the Sacred: Monarchy and Identity in Philip II's Relic Collection at the Escorial', *Renaissance Quarterly*, 60 (2007), 58–93. On the form and plan of the Escorial see George Kubler, *Building the Escorial* (Princeton NJ: Princeton University Press, 1982); see also Catherine Wilkinson-Zerner, *Juan de Herrera, Architect to Philip II of Spain* (New Haven CT and London: Yale University Press, 1993).

26 Banner, 'Private Rooms', 82–4; Nuechterlein, 'The Domesticity of Sacred Space', 68–70.

27 Yves Rocher (ed.), *L'art du XVIIme siècle dans les Carmels de France* (exh. cat.) (Paris: Musée du Petit Palais, 1982).

28 Banner, 'Private Rooms', 9, 82, 88, 92.

29 The issue of 'visual privacy' in the convent is discussed in Saundra Weddle, 'Woman's Place in the Family and the Convent', *Journal of Architectural Education*, 55/2 (2001), 64–72.

30 On this practice see also Louise Durning, 'Woman on Top: Lady Margaret Beaufort's Buildings at Christ's College Cambridge', in *Gender and Architecture*, ed. Louise Durning and Richard Wrigley (Chichester: Wiley, 2000), 47.

31 Ana Garcia Sanz and Leticia Sánchez Hernandez, 'Iconografia de monjas, santas y beatas en los monasterios reales espanoles', in Centro de Estudios Historicos, *La mujer en el arte espanol: VIII jornadas de arte* (Madrid: Alpuerto 1997), 131–42.

32 Ronda Kasl, 'Holy Households: Art and Devotion in Renaissance Venice', in *Giovanni Bellini and the Art of Devotion*, ed. Ronda Kasl (Indianapolis IN: Indianapolis Museum of Art, 2004), 75; Webb, 'Domestic Space and Devotion', 35; Dunn, 'Spaces Shaped for Spiritual Perfection', 155.

33 For exceptions to this, see Marilyn R. Dunn, 'Nuns as Patrons: The Decorations of S. Marta at the Collegio Romano', *Art Bulletin*, 70/3 (1988), 451–77; and Andrea Pearson, *Envisioning Gender in Burgundian Devotional Art, 1350–1530* (Aldershot and Burlington VT: Ashgate, 2005).

34 See amongst others *The Origins of Museums: The Cabinet of Curiosities in Sixteenth- and Seventeenth-Century Europe*, ed. Oliver Impey and Arthur MacGregor (Oxford: Oxford University Press, 1985); Paula Findlen, *Possessing Nature. Museums, Collecting, and Scientific Culture in Early Modern Italy* (Berkeley CA: University of California Press, 1994).

35 Alix Cooper, 'Homes and Households', in *The Cambridge History of Science, Vol. 3: Early Modern Science*, ed. Katherine Park and Lorraine Daston (Cambridge: Cambridge University Press, 2006), 224–37.

36 For an eighteenth-century example of domestic anatomical dissections, see Lucia Dacome, 'Women, Wax and Anatomy in the "Century of Things"', in *Spaces, Objects and Identities in Early Modern Italian Medicine*, ed. Sandra Cavallo and David Gentilcore, *Renaissance Studies*, 21/4 (2007), 522–50.

37 Cooper, 'Homes and Households', 229.

38 *The Hospital: A Social and Architectural History*, ed. John D. Thompson and Grace Goldin (New Haven CT: Yale University Press,1975) and, in relation to Florentine hospitals, John Henderson, *The Renaissance Hospital: Healing the Body and Healing the Soul* (New Haven CT: Yale University Press, 2006), ch. 5, esp. 157, 161–8.

39 On the hospital's emancipation from the palatial and monastic legacy, see Christine Stevenson, *Medicine and Magnificence: British Hospital and Asylum Architecture, 1660–1815* (New Haven CT: Yale University Press, 2000), ch. 2.

40 Scholars from different disciplines have increasingly been paying attention to the relationship between gender and space; see, for instance, Durning and Wrigley, *Gender and Architecture*; Hills, *Architecture and the Politics of Gender*; Roberta Gilchrist, *Gender and Archaeology: Contesting the Past* (London: Routledge, 1999) and Roberta Gilchrist, *Gender and Material Culture: The Archaeology of Religious Women* (London and New York: Routledge, 1994).

41 Howe, 'The Architecture of Institutionalism', 69–72.

42 Separate female spaces, both for sleeping and eating, can be found in Italian noble palaces. See Katherine A. McIver, *Women, Art and Architecture in Northern Italy 1520–80* (Aldershot and Burlington VT: Ashgate, 2005), 116–19.

43 The issue has been widely debated. For an overview see Sandra Cavallo and Isabelle Chabot, 'Introduzione' to *Oggetti, Genesis*, V/1 (2006), 7–22, and, in relation to the English context, John Styles and Amanda Vickery, 'Introduction', in *Gender, Taste and Material Culture in Britain and North America 1700–1830*, ed. John Styles and Amanda Vickery (New Haven CT: Yale University Press, 2006).

For a German example, see Karin Gottschalk, 'Does Property have a Gender? Household Goods and Conceptions of Law and Justice in Late Medieval and Early Modern Saxony', *The Medieval History Journal*, 8 (2005), 7–24.

44 Nuechterlein, 'The Domesticity of Sacred Space', 76. For a thought-provoking discussion on the use and meaning of devotional objects in Northern European convents in the medieval and early modern periods, see *Crown and Veil: Female Monasticism from the Fifth to the Fifteenth Centuries*, ed. Jeffrey F. Hamburgher and Susan Marti (New York: Columbia University Press, 2008) and Jeffrey F. Hamburgher, *The Visual and the Visionary: Art and Female Spirituality in Late Medieval Germany* (New York: Zone Books, 1998).

45 See the case of the Habsburg Margaret of Austria discussed in Deanna MacDonald, 'Collecting a New World: The Ethnographic Collections of Margaret of Austria', *Sixteenth Century Journal*, 33/3 (2002), 649–63.

46 Lazure, 'Possessing the Sacred', 60.

47 On the circulation of relics in the Iberian context, see William A. Christian, Jr, *Local Religion in Sixteenth-Century Spain* (Princeton NJ: Princeton University Press, 1981), 126–41.

Part I
Organizing and representing spaces

A temporary home: Bramante's Conclave Hall for Julius II

*Henry Dietrich Fernández**
For James S. Ackerman

This investigation will consider the motives behind the design of a colossal never-realized Conclave Hall for Pope Julius II by the architect Donato Bramante (c. 1444–1514), and how the interior space of the conclave hall functioned within the institutional life of the papacy. Julius, as Cardinal Giuliano della Rovere, had participated in four conclaves, including his own, and the election of his nemesis, Pope Alexander VI, in 1492.[1] Along with his fellow princes of the Church, he had endured enclosure, had literally been 'locked in a room' with them to elect a new pope. Cardinal Giuliano had experienced at first hand all the tensions, squabbling and political bargaining between cardinals to see their favourite elected, as well as the physical discomfort of sharing the same, confined physical space. As such, part of his vision of the legacy that he planned to leave at the Vatican Palace complex, in addition to the Vatican Logge, the Cortile del Belvedere, not to mention the new Saint Peter's Basilica, was a new conclave hall. Here, he envisioned, cardinals could elect the new pontiff, the Vicar of Christ on Earth, interred in a more splendid and commodious fashion, adding a further dignity and security to the momentous proceedings.

The speculative reconstruction of Bramante's Conclave Hall presented in this essay allows one to consider the scope of the Julian vision of the papal palace, which functioned both as domestic and residential space and as bureaucratic headquarters for the Catholic Church. More specifically, a particular kind of paradox emerges from the study of the conclave hall and the living conditions its interior space generated. The very idea of institutional living can bring to mind a communal setting, of rows of beds within a shared space, occupied by the dispossessed or those of limited means. Such was the physical nature of the conclave hall, only now the beds were occupied by wealthy, political powerful 'inmates'.

For every cardinal, the contrast between the conditions of his daily life and those he experienced during conclave were immense. In Paolo

Cortesi's *De cardinalatu*, cardinals were portrayed as princes of Renaissance Rome, who lived in a fashion more sumptuous than the old baronial families of Rome.[2] According to Cortesi, it was the cardinal's duty to live so magnificently and palatially.[3] Cortesi even provided prescriptions for the ideal palace for the cardinal, designed with his 'health and well-being' in mind.[4] For example, the palace should face east, to avoid the sun's glare. In addition to rooms to accommodate the cardinal, his household, and guests perhaps numbering two hundred or more, the palace should be appointed with stables, an armoury, a library, a music room, a large meeting hall, a private audience chamber and a room for night-time study. A small room should display the cardinal's collection of silverware, and another his collection of gems. Rooms should be set aside for artists-in-residence, and the main dining room should overlook 'a covered walkway and a garden, so that their cheerful aspect will make dining more pleasant'.[5] And indeed, the great scale of the Palazzo Venezia, begun by Cardinal Pietro Barbo in 1455 and enlarged in 1465 after he became Pope Paul II in 1464, or the Palazzo della Cancelleria, begun by Cardinal Riario in 1489, which later accommodated Michelangelo with a temporary home, are testaments to the magnificence of the fabric housing the richest of Rome's cardinals.[6]

Conclave would momentarily curtail this opulent lifestyle. Historically, the living environment for conclave had always been less than commodious for the voting cardinals. The first conclave, or first election of a pope in enforced privacy and secrecy *cum clave* (under lock and key), took place in Rome during the election of Celestine IV on 25 October 1241.[7] After two months of indecision, in order to compel the ten deeply divided cardinals to reach a decision on the election of the next pope, the Roman senator Matteo Rosso Orsini, the *de facto* dictator of Rome, had them locked up in the unsanitary environment of the ancient ruins of the Septizodium (203 A.D.), located at the base of the Palatine Hill.[8] During the fierce argument that ensued among the ten cardinals that comprised the voting body, one died, it is said, due in part to the unspeakably bad conditions of their temporary housing. Eventually, out of this domestic squalor, Goffredo da Castiglione from Milan was elected without the prescribed two-thirds majority outlined in a decree, *Licet de vitanda*, formulated 62 years earlier during the Third Lateran Council of 1179.[9] But the triumphant feeling of having finally elected a pope dissipated 16 days later when the newly elected Pope Celestine IV died on 10 November. The cause of Celestine's death was never determined, but everyone suspected that the horrid conditions of his house arrest weakened his constitution and contributed to the Milanese nobleman's untimely demise.

In 1270, the papal election took place in Clement IV's papal palace in Viterbo, north of Rome, when the Viterbese 'locked the cardinals into Clement's palace', probably in a chapel on the top floor of the Wardrobe Tower.[10] This enclosure in the tower had been preceded by almost three years of frustrating schismatic deliberation without the election of a new

pope.[11] The civic authorities, in order to hasten a decision, locked them in this uppermost part of the palace; they then removed its roof, exposing the cardinals to the elements, and threatened them with a starvation diet to spur on the election of a new pontiff.[12]

During the fourteenth century, conclave living conditions largely improved. At the Vatican Palace, the cardinals sometimes met for conclave in the Cappella Parva Sancti Nicolai, located next to the Sala Regia, before the chapel's subsequent removal by Paul III in the 1530s.[13] During conclave the College of Cardinals were housed within and outside the Vatican Palace. However, this uneven distribution of the cardinals' housing presented serious security problems in terms of their physical safety, and it could not guarantee a clean election. Moreover, it signalled for all to witness the discrepancy of means between the electors of the next pope; some were hosted in splendour by their families or through their local affiliations with noble families such as the Orsini and Colonna. Some of the cardinals lived in their own richly appointed palaces in Rome, while others, by contrast, who did not have the means or political connections endured more modest lodgings during the conclave. Such a situation was a breach of ecclesiastical decorum in the eyes of a Cortesi, and also publicly highlighted the imbalance of power within the College of Cardinals.

Greater security and a more egalitarian comfort level were established when conclave took place within the walls of the Vatican complex. Cardinals' bedstead enclosures, *camerette*, came to be grouped in a series of rooms including the Sala Regia, the two Sale Ducali, the Sistine Chapel and adjacent rooms in the palace. While the election for the future pope usually took place in the Cappella Parva, sometimes voting took place in the Sistine Chapel where some of the cardinals had previously spent the night (Fig. 1.1).

Nonetheless, the situation in the palace still posed an unbalanced housing distribution, which meant that some cardinals might have better lit or airier accommodation, hotter or cooler chambers. However, camping out in the Sistine Chapel could cast some favour on some hopeful candidates, due, many believed, to the fresco cycle Pope Sixtus IV had commissioned for the Sistine Chapel's walls, executed between 1481 and 1483, from the team of painters that included Ghirlandaio, Botticelli and Perugino, which portrayed scenes from the life of Moses and Christ.[14] The intent behind the fresco cycle was in fact designed in part to speak to and inspire the nominations of cardinals at conclave, and Perugino's image of *Christ Consigning the 'Chiave' to Saint Peter* spoke most coherently to this aspect of the Sistine Chapel's sometime function. A cardinal's spot on the Sistine Chapel floor could be determined through a lottery. Furthermore, as David S. Chambers points out, to win the lot to have one's *cameretta* next to that particular Petrine fresco was considered especially fortuitous.[15] It so happens that in the conclave which took place in 1503 it was the site of the *cameretta* of Giuliano della Rovere, who was elected Pope Julius II at its conclusion. Twenty years later, that same campsite was to be providentially allocated to Cardinal Giulio de' Medici, who, in 1523, was to be

1.1 Conclave plan for the election of Paul IV, 15–23 May 1555. Photo: Henry Dietrich Fernández

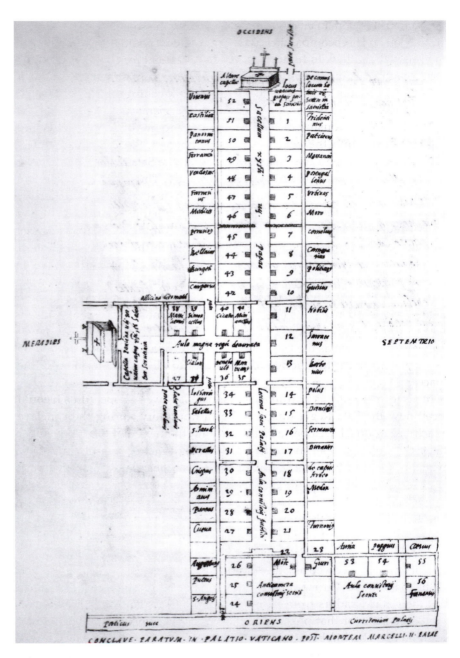

elected Clement VII.[16] The degree to which divine providence endowed this prime piece of 'palatine real estate' on the della Rovere and Medici cardinals is questionable; the chances of landing on this lucky spot was certainly helped along by their strategic power-brokering, an exchange that reached beyond the parameters of the lottery and the walls of the Vatican Palace.

But despite his own fortuitous positioning in the Sistine Chapel, Pope Julius II still wanted to see elections proceed in a more socially and spatially

harmonious fashion, in an environment befitting the so-called princes of the Church, on an all-encompassing terrain that at least could be perceived to be an even playing field. In Julius II's ideal environment for conclave, even the least wealthy cardinal was supposed to be able to maintain some measure of his dignity, with the knowledge that there was a levelling strategy organized by the pope's Master of Ceremonies and the *Maggiordomo*.

The practice of housing *camerette* in the large rooms of the Vatican Palace continued well into the next century and beyond. Since its inception in the late thirteenth century, under Nicholas III, the Sala Regia had been the epicentre of ceremonial life in the Vatican Palace. Thus, the Sala Regia was the ritual centre of the pope's life as monarch, just as the Sistine Chapel and Saint Peter's Basilica defined the two principle foci of the Julian court's religious liturgies within the Vatican complex.[17] Here stood the grandest of the chairs of state to be found within the interior domain of the palace, elevated on a podium, approached by a short flight of three steps, and surmounted by a curtained canopy, the traditional emblem of sacred sovereignty, hung with cloth of gold. Positioned between the Sistine Chapel, two audience halls (the Sala Ducale Secunda and the Sala Ducale Tertia) and a minor chapel (the aforementioned Cappella Parva Sancti Nicolai, also known as the Cappella Parva), the pivotal position of the Sala Regia meant that it functioned as an atrium to all these interior palatine spaces.

In his former rank, as Cardinal Giuliano della Rovere, Pope Julius II could recall how the Sala Regia functioned as a dormitory during the conclave which began on 31 October and elected him the next day on 1 November 1503, the quickest conclave on record.[18] This practice of utilizing every available space in the Vatican Palace, including the Sala Regia, dated back to at least the mid-fifteenth century, to the election of Calixtus III on 20 August 1455. As described by Ehrle and Egger in their 1933 publication, the conclaves that elected Eugene IV (1431–47) and Nicholas V (1447–55) were housed at the convent of Santa Maria sopra Minerva; thereafter conclaves were held in the Vatican Palace.[19] Nonetheless, while the Sala Regia interior may have at times served as a dormitory during conclaves, it above all served as the major papal throne room, where the pontiff received royal personae and their ambassadors from all corners of the Christian world.[20] Ideally, it should be kept for that purpose, its stateliness left uncompromised by the addition of makeshift bedsteads. Thus, Julius II, advised by Paris de Grassis, his Master of Ceremonies, went in search of a more decorous solution to the question of a space for conclave.[21]

The solution was provided by his architect Donato Bramante who devised a scheme that would have created a decorous interior space that could accommodate every cardinal within one gigantic hall, a hall intended to surpass the splendour and size of the Sistine Chapel.

Papal plans for a new conclave hall within the confines of the Vatican Palace can be dated back to the mid-fifteenth century during Nicholas V's

papacy (1447–55). According to Gianozzo Manetti, the pope's biographer, the earliest part of Nicholas's building programme included a conclave hall to be contained within his Torrione, a great round defensive tower with a diameter of 41 metres with walls 9.5 metres thick at its base, and a height of 55.85 metres, of which only 16.7 metres were actually completed.[22] While Nicholas V's vision for a new conclave hall was never realized, the 100-metre-long defensive wall that bridged the gap between the Torrione and the residential block to the southwest that defined the Vatican Palace, would serve as a starting point for Bramante's scheme for Julius II's new Conclave Hall.

As could be witnessed by the many massive building projects launched by Julius II and his architect Bramante, the scale, scope and splendour of these pre-1503 projects would suggest that Julius had known about them and may have long been considering such a huge building enterprise well before his own ascendancy to the papal throne.[23] He had always been attracted to monumental spaces. As Cardinal Archbishop Giuliano della Rovere of Avignon, the future pope directed the renovation of the Archbishop's palace, known as the Petit Palais, between 1481 and 1486, within the grounds of the papal palace at Avignon.[24] In his hometown, the seaport of Savona, between 1495 and 1496, he built the largest palace in the city on property originally owned by his uncle, Sixtus IV.[25]

Upon his ascendancy to the papacy Julius certainly had the construction and administrative experience to envision such a grand scheme for a new Conclave Hall. Since Giuliano had been a favoured *cardinale nipote* of Pope Sixtus IV, his deep knowledge of architecture and the means by which to realize such projects was complemented by his intimate knowledge of the Vatican Palace complex. He knew first-hand its many splendours, as well as the areas of the palace that were sorely in need of improvement. Together with his architect, Julius initiated improvements that would eventually transform a medieval building fabric into a model of grace and grandeur, not just for every princely palace in Rome, but throughout every court in Europe.[26] Had the new Conclave Hall been completed, its magnificence and size would have rivalled the dimensions of all major ancient Roman edifices, the very buildings that inspired Bramante's architectural vision, whose remains allow us a visual sense of the projected size of the interior space of the Conclave Hall.

Had it been completed, the size of Bramante's design for Julius II would have surpassed the Sistine Chapel by more than 3½ times. The gigantism of this great hall certainly would have reminded everyone attending this solemn conclave event of the *gravitas*, glory and especially the sheer magnitude of a number of ancient Roman building interiors such as the Baths of Caracalla and Basilica of Maxentius. These were some of Bramante's models, the same ones which he used to evoke the spirit of the ancient past in equal measure in his design for a gargantuan new Saint Peter's Basilica, founded a few years earlier on 18 April 1506, or at a smaller scale, the monumental coffering of the choir interior at the church of Santa Maria del Popolo, another della Rovere foundation.[27]

An examination of the surviving drawings related to Bramante's design for the new conclave hall allows one to consider and understand the place of the hall within the fabric of the Vatican Palace, as well as to begin a reconstruction of the appearance of its interior. The Conclave Hall is included within the vast renovation scheme of the Vatican Palace for Julius II, in a drawing identified by Vasari as the 'disegno grandissimo', also known as UA287 (Fig. 1.2).[28] From Bramante's own workshop, this drawing, dated c. 1506, shows the plan of the Conclave Hall positioned between Nicholas V's Torrione and Bramante's design for the east façade of the Vatican Palace that was defined by four levels, the top three occupied by his new Logge.[29] The Conclave Hall site would have been reachable from the second level of this façade that corresponded to the first of Bramante's Logge.[30] In 1510, Francesco Albertini describes how Bramante's covered road (his first *loggia*) will be used on horseback, to reach the new Conclave Hall or the Cortile del Belvedere beyond.[31]

Bramante's first Loggia comprised an intermediate portion of a route that began at the narthex of Old Saint Peter's Basilica.[32] From the narthex the pope and others could proceed up the Via Giulia Nova, a *cordonata* or stair-ramp that could accommodate riders on horseback, to the Sala Regia (Fig. 1.2). From the Sala Regia the route continued eastward through the two Sala Ducale. From the easternmost Sala Ducale one could then enter the first level of the Logge that in turn led northward to Nicholas III's late-thirteenth-century North Tower, that marked the northernmost edge of Bramante's Logge.[33] At this juncture one could choose to continue north along the major route to Innocent VIII's Villa Belvedere or take a short passage within the North Tower that led down into another *cordonata*. At the bottom of this stair-ramp one arrived at the portico of the lower level of the Cortile del Belvedere, which would have given the pope, his cardinals and his *famiglia* access to the site of the proposed Conclave Hall. From this portico area Bramante planned to incorporate Nicholas V's massive 100-metre-long defensive wall, that at its easternmost end connected to Nicholas V's Torrione (Figs 1.2 and 1.3).[34] As indicated on Bramante's drawing UA287, the width of Nicholas V's wall, approximately six metres thick at ground level, was to have been replicated by a parallel wall of equal dimension. The magnitude of this perimeter enclosure would suggest that Bramante's Conclave Hall design would have functioned as a significant part of the palace's fortifications on the eastern edge of the Vatican complex. Incorporating Nicholas V's defensive wall and Torrione into his new Conclave Hall design was part of Bramante's economical scheme to build the Conclave Hall as quickly as possible, but even this expeditious strategy did not ensure that it would ever be completed. What little was built was begun in the summer of 1511 and is documented as being under construction in the early autumn of 1512.[35]

Complementing Bramante's drawing of the Vatican Palace, UA287 (Fig. 1.2), is a second drawing related to the Conclave Hall, UA1385, by one of Bramante's assistants, Gianfrancesco da Sangallo (Fig. 1.4).

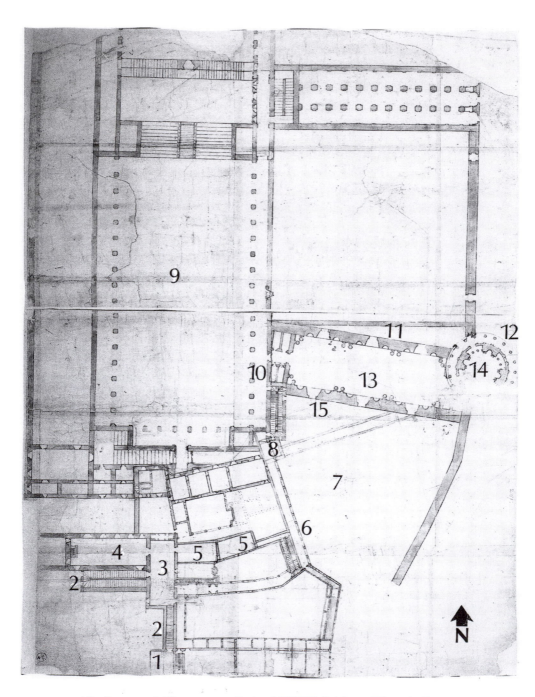

1.2 Bramante's 'disegno grandissimo', UA287, Gabinetto Disegni e Stampe, Galleria degli Uffizi, Florence. Photo: Henry Dietrich Fernández

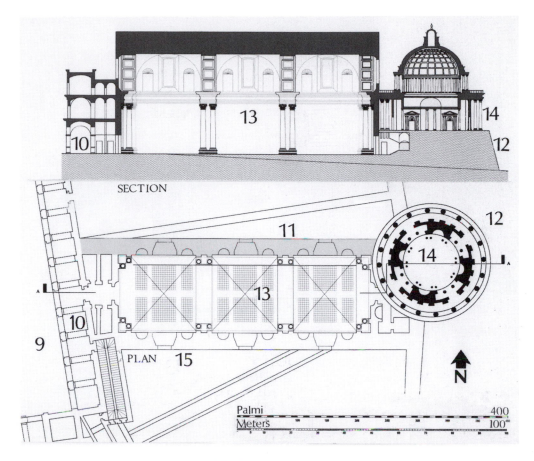

1.3 Conclave Hall plan and longitudinal section, after
Frommel. Drawing by Henry Dietrich Fernández

Key for Figs 1.2 and 1.3

1 Narthex of Old St Peter's
2 Via Giulia Nova
3 Sala Regia
4 Sistine Chapel
5 Sale Ducale
6 First Bramante Loggia, second level
7 Cortile di San Damaso
8 Nicholas III's North Tower
9 Lower court of Cortile del Belvedere
10 East portico of Lower Court of Cortile del Belvedere
11 Nicholas V's defensive wall
12 Nicholas V's Torrione, base for Conclave Chapel
13 Conclave Hall
14 Conclave Chapel, atop Nicholas V's Torrione
15 Bramante's proposed new wall

1.4 Gian-
francesco da
Sangallo, detail
of a drawing
for the interior
of the Conclave
Hall, UA1385,
Gabinetto Disegni
e Stampe,
Galleria degli
Uffizi, Florence.
Photo: Henry
Dietrich
Fernández

An inscription, 'chonchiave' [conclave], on this drawing identifies it as being
for the Conclave Hall, though the relationship of the 'columns to wall' differs
from the scheme represented on UA287. Significantly, Sangallo's drawing
UA1385 describes a portion of the coffered vaulting for the new Conclave
Hall and the interior relationship between the huge freestanding Corinthian
columns and the adjacent walls (Fig. 1.4), a compositional motif also used in
Bramante's schemes for the new Saint Peter's Basilica.[36] For both his Conclave
Hall and new Basilica design, Bramante drew inspiration for this interior
columnar detail from the ancient Forum of Nerva, a detail that illustrates this
idea has been recorded at the far right side of a print by Du Pérac in 1575 (Fig.
1.5).[37]

Other precedents for this motif appropriated by Bramante can be seen at
the Baths of Diocletian, as cited in drawings by Giovanni Antonio Dosio and
other draughtsmen from the sixteenth century.[38] Had it been built according
to Bramante's design, the Conclave Hall would have had an interior width of
29 metres, a length of 85 metres and a height of 35 metres from the floor to the
vaulted ceiling (Fig. 1.3).

As noted on drawing UA287, at the eastern end of the new Conclave Hall,
at the top of Nicholas V's Torrione, Bramante also designed a very large
Tempietto-like structure, about 40 metres in diameter, that very likely would
have functioned as a chapel for the captive cardinals and, more importantly, a
convenient place to meet and eventually cast their ballots for the next pope.[39]
With the exception of the ongoing construction of the new Saint Peter's, the
new Conclave Hall would have surpassed in size any other edifice within
the Vatican Palace complex or anything Julius II would have known from the
Palais des Papes at Avignon. When not in use during a conclave, this gigantic
interior space could have served as a hall for papal audiences and other
Vatican-related assemblies. It can be speculated that its immense size and
strategic location would have challenged the primacy of the Sala Regia.

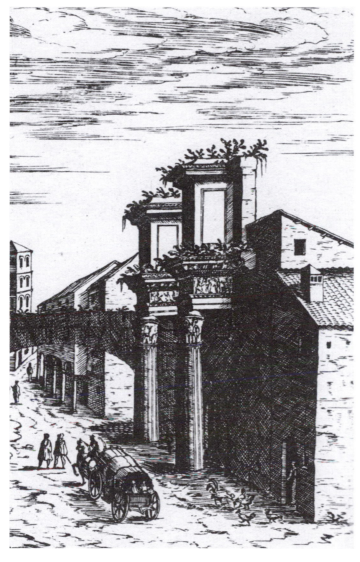

1.5 View of Forum of Nerva, in S. du Pérac, *I vestigi dell'antichità di Roma* (Rome: 1575), fol. 6

Not only would Bramante's Conclave Hall have played an important role in Julius II's renovation and amplification of the Vatican Palace complex, it would have, in theory, secured the privacy and secrecy for an ever-increasing College of Cardinals in one vast interior space, a locus which was both domestic and institutional.[40] Julius II was elected with a conclave composed of 38 cardinals.[41] At his death in 1513 there would have been 35 cardinals available for the future Leo X's election, but four were excommunicated, which left 31 when Leo ascended the papal throne. Nonetheless, the trend for an increased number of cardinals who were active in future conclaves would have justified further Julius II's vision for his new Conclave Hall.[42] The dimensions of the Conclave Hall, as indicated in the plan, combined with the established size of the *camerette*, discussed

below, would suggest that the maximum number of cardinals who could have been comfortably accommodated in Bramante's Conclave Hall would have been 70.[43]

Julius II had his own models to drawn upon as well. Having been Archbishop of Avignon, he had come to appreciate the spaciousness of the fourteenth-century Grand Tinelle and the Great Consistory Hall at the Palais des Papes, and his visions might have also have been conditioned by a visit to the large Salle de Justice in Paris.[44] As such, one can also surmise that northern courtly splendour, still, in Renaissance Italy, the benchmark for opulent living, played a conspicuous role in Julius II's ambitions for his palatine interiors.[45]

While Bramante had his ancient architectural sources as inspiration and Julius II memories of the palatial splendour of Avignon, certain cardinals had their own models for and expectations of their conclave experience. Arriving at the conclave, many cardinals would have fresh memories of their own princely residences, while others would be arriving from more humble domiciles. Nonetheless, once they were under lock and key, all would be obliged to accept compromises, not only on the size and comfort of their physical surroundings but also on their privacy and political networking that would be curtailed or at least reshaped for the duration of their encampment at the conclave. Moreover, however powerful some cardinals believed themselves to be, when it came to the election of a new pope, each cardinal could only cast one vote. In accordance with this 'one cardinal, one vote' understanding, each cardinal's single *cameretta* was in theory to be equivalent to all the others.

Nonetheless, as mentioned above, the location of a cardinal's *cameretta* could and many times did signal their privileged status among their fellow cardinals. In order to maintain some semblance of equality, all the conclave *camerette* were defined by the same wooden frame, which measured about 3.5 metres in width, 5.4 metres in length and about 3 metres in height (Fig. 1.6).[46] The wooden framework would then be covered in fabrics that varied in quality depending on the cardinal's purse. On some occasions, in honour of the recently deceased pope, the colour purple was reserved for those who had become cardinals during his papacy (Pl. 3).[47] All the other cardinals then used the colour green. At a glance, one could survey the domestic landscape and perhaps even discern the relative adjacencies of the political encampments.

Within the camp structures, the cardinals and a few of their servants, who sometimes slept in the mezzanine compartment of the wooden structure, shaped the décor of their temporary housing according to their taste. All the accoutrements needed to sustain the cardinals' daily life, as they negotiated the election of the next pontiff, were located in their individual campsites. What items they could not accommodate in their campsites, such as food supplies and clean linen, were delivered to them by other members of the papal household.

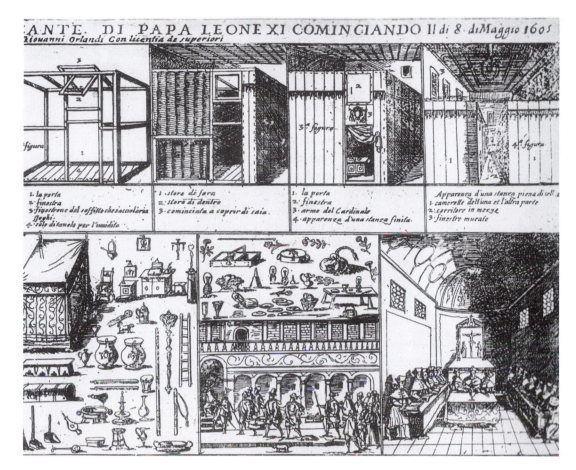

ANTE. DI PAPA LEONE XI COMINCIANDO Il di 8 di Maggio 1605
Giouanni Orlandi Con licentia de superiori

Through an inspection of a variety of sixteenth- and early seventeenth-century conclave plans, one can gain a very intimate sense of what each *cameretta* contained in the daily support of a cardinal in conclave (Figs 1.1 and 1.6). This convention can be seen in an illustrated and annotated description of Paul V's election, 8–16 May 1605, where a typical campsite embodied the cardinal's opulent daily life in minutiae.[48] Listed under 'La fabrica del conclave', the camp structures are described as *camerette*, and 'the things that the Illustrious Cardinals bring with them into conclave' are more plentiful than any number of the elite would have assembled over the course of a lifetime.[49] The cardinal's *cameretta* was furnished with holy pictures, including an image of the Madonna and Child, and a Crucifixion scene, as well as a prie-dieu. The cardinal's bed was curtained, ensuring his privacy at night. He had a little bell to ring for assistance, a chair, table, credenza, chest, a pen and ink stand. There was a lantern, a candlestick, a strongbox, a long bench, a stool with a high back, and two vessels containing 'water from the Tiber' and a silver jug and basin in which the cardinal could wash his hands. A dustpan and brush were presumably for use by the cardinal's servant, and not by the ecclesiastic himself. The cardinal also brought with him other

1.6 Wooden framework of *camerette* (bed enclosures), a detail from conclave plan for Paul V's election, 8–16 May 1605. Photo: Henry Dietrich Fernández

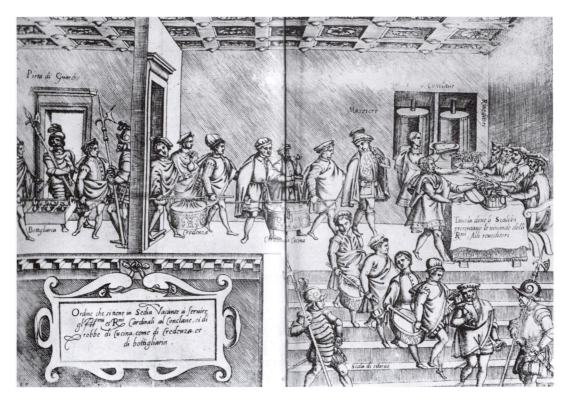

1.7 'Serving Dinner to Cardinals in Conclave', in Bartolomeo Scappi, *Opera di M. Bartolomeo Scappi, cuoco secreto di Papa Pio Qvinto …; con il discorso funerale, che fu fatta nelle essequie di Papa Paolo III; Con le figure che fanno bisogno nella cucina & alli reverendissimi nel conclaue* (Venice, 1598), Tav. XX–XXI

things according to his own personal taste. The print indicates one such item that had become highly fashionable in the sixteenth century with the secular elite. Cardinals were even clearly permitted to take with them to conclave their *cagnolini*, lap dogs. And despite its status as fashionable accessory, *il cagnolino* may have offered a cardinal the only truly faithful companionship during his residence at the conclave.

The cardinals in conclave now certainly ate better than they had done in the previous centuries when they were sometimes threatened with starvation. 'La fabrica del conclave' explains that each cardinal could feast on a meal accompanied by fruit and sweets, and had a variety of wines from which to choose. He had an extensive dinner service, cups, glasses, plates, knives, forks, spoons and napkins.

By the time of the conclave that elected Paul V, traditions for the embellishment of the *camerette* were firmly embedded. Confirmation of these domestic conventions is confirmed by Bartolomeo Scappi's *Opera*, first published in 1570 and reprinted in another edition in 1598 (Fig. 1.7).[50]

Scappi, Pius V's 'secret cook', produced a cookbook that included at the back a description of the February 1549 conclave, which elected Pope Julius III, as well as illustrations of some of the objects the cardinal brought with them into conclave.[51] The book's 217 recipes, which begin with *acqua cotta* and end with *minestra di pignoli e pistachio*, literally run from soup to nuts, giving some idea of the kinds of dishes the cardinals might be served at conclave.

These dishes included minced chicken livers, roast veal, pheasant pie, almond cream and candied fruit. This conclave reserved purple as the colour for the cardinals created by the recently deceased Paul III, which meant that 'the bed and its hangings were purple, with purple silk fringe, valences, covers, curtains and cushions, and for each chamber there was a table covered in the same cloth'.[52] Scappi also mentions the water vessels to be found in the description of the Paul V conclave, though with the interesting addition that the vessels were capped *cum clave*, 'with a cover with a copper lock, with its own key', which he also illustrates – clearly to reduce the threat of poisoning.[53] There were also 'many other necessary things for use in the room. Every thing, however, was purple, with the arms of the cardinal residing there.'[54] The other 'illustrissimi cardinali' not appointed by Paul V had exactly the same furnishings, except theirs were decorated in the colour green. And every cardinal had a microcosmic *famiglia*, a secretary, a man-servant and a gentleman of the bedchamber 'e non altri'.[55]

While these descriptions date from papacies later than that of Julius II, one can use their elements to picture how the interior space of Bramante's Conclave Hall would have been activated. However opulent the space, each cardinal would undoubtedly have still felt the necessity of imprinting his own personal stamp upon the environment, just as, in the world of Rome, each cardinal expressed his individuality, according to his family and his means and by the palace which he occupied.[56]

As mentioned, reasons for the suspension of the construction of Bramante's Conclave Hall are not entirely clear. Julius died on 21 February 1513 and Bramante followed him about 13 months later on 11 April 1514. While the new Conclave Hall was of great importance for Julius II's successor, Leo X's progress on other Vatican projects were even more pressing. The reason for the necessity of reconstructing Bramante's vision for a new Conclave Hall is that it was only one part of Julius II's grand scheme to be launched during his ten-year papacy. While none of his grand architectural plans, such as the new Saint Peter's Basilica, the Vatican Logge or the Cortile del Belvedere, were completed in his lifetime, they were sufficiently advanced to be taken over by Leo X and subsequent popes. For a future pope to oversee the construction of the Conclave Hall would have been by definition, a gesture of altruism, of taking care of a future which the incumbent pope would not live to see. Most of Julius II's successors preferred to sponsor works that they themselves had launched and could ideally enjoy in their own time. Conclave continued to be held in those previously designated rooms of the Vatican Palace.[57]

Nonetheless, imagining the visual possibilities this Conclave Hall would have offered is intriguing; what kind of decorative scheme and pictorial cycle might have been produced for walls 3½ times the size of those of the Sistine Chapel? Would Raphael and Michelangelo have been asked to participate in the decoration of a colossal space that would have rivalled anything built by the ancients? And, standing at the threshold of the Conclave Hall, under one massive vaulted ceiling, a sea of *camerette* would have had a humbling effect

(Pl. 4).[58] Here, across this expansive interior terrain, the individual cardinal's sense of importance may have been replaced by the feeling of a collective duty in play as they worked to elect the next Pontifex Maximus.

While there is no evidence that smoke was used to signal the election of a pope before 1903, there is sufficient documentation, beginning in 1500, for the burning of ballots in order to preserve the secrecy of each cardinal's vote.[59] At the end of the conclave, with the smell of smoke still fresh in their memory, the cardinals and the new pope were unlocked, and set free to plan the final stage of the election process. The newly elected pope could now look forward to his *possesso*, which would move with great pomp and majesty from the Basilica of Saint Peter's down the Via Alessandrina towards the Castel Sant'Angelo, and onto their ultimate destination, San Giovanni in Laterano, where he would officially take possession of his papacy.[60] The cardinals would also travel in the papal cavalcade honouring the election of their pope. But they also were probably thinking about the splendid comfort that, at least for those who resided in Rome, they would be enjoying in their princely beds in their 'own' palaces that night, and that they could avoid any further prospects of camping out in the Vatican, at least until the election of the next pope.

Appendix I: List of papal conclaves[61]

Conclave	Beginning	Closed	Cardinals	Conclave space
Eugene IV	25 Feb.	3 Mar. 1431	14	Convent of S. Maria sopra Minerva
Nicholas V	4 Mar.	6 Mar. 1447	18	
Calixtus III	4 Apr.	8 Apr. 1455	15	
Pius II	16 Aug.	19 Aug. 1458	18	Vatican 'Cap. Maior palatii'
Paul II	28 Aug.	30 Aug. 1464	19	
Sixtus IV	6 Aug.	9 Aug. 1471	18	
Innocent VIII	26 Aug.	29 Aug. 1484	25	
Alexander VI	6 Aug.	11 Aug. 1492	23	
Pius III	16 Sept.	22 Sept. 1503	37	'Cap. Maior Palatii' (Cap. Sixti IV)
Julius II	31 Oct.	1 Nov. 1503	38	

Leo X	4 Mar.	11 Mar. 1513	**25**	
Hadrian VI	27 Dec. 1521	1 Jan. 1522	**39**	
Clement VII	1 Oct.	19 Nov. 1523	**35**	
Paul III	11 Oct.	13 Oct. 1534	**35**	
Julius III	29 Nov. 1549	8 Feb. 1550	**54**	Cap. Sistina, Sala Regia, Sala Ducale, 'Anti-Camera et Locus Concistorii segreti'
Marcellus II	5 Apr.	10 Apr. 1555	**57**	
Paul IV	15 May	23 May 1555	**56**	
Pius IV	5 Sept.	26 Dec. 1559	**54**	Sala Regia, Borgia Tower
Pius V	20 Dec. 1565	7 Jan. 1566	**70**	

Notes

* This research would not have been possible without the generous help of the following: Christoph Luitpold Frommel, Deborah Howard, David S. Chambers, Charles Hope and Caroline P. Murphy. The realization of the digital reconstructions of the Conclave Hall were made possible by the technical advice of Jason John Roan, John Kim and Giovanni Castillo.

1 For Alexander VI, see Michael E. Mallett, *The Borgias. The Rise and Fall of a Renaissance Dynasty* (Chicago IL: Academy Chicago Publishers, 1987); for Julius II, see Christine Shaw, *Julius II, the Warrior Pope* (Oxford and Cambridge MA: Blackwell, 1993).

2 For Paolo Cortesi's *De Cardinalatu*, see Kathleen Weil-Garris and John D'Amico, 'The Renaissance Cardinal's Ideal Palace: A Chapter from Cortesi's *De Cardinalatu*', in *Studies in Italian Art and Architecture, 15th through 18th Centuries*, ed. Henry A. Millon (Cambridge MA and London: MIT Press, 1980), 45–123; a separate augmented version by the same title, with corrections, amplifications and 15 added illustrations by Weil-Garris and D'Amico was published by the American Academy in Rome in 1980. For descriptions of domestic life in early sixteenth-century palaces in Rome, see Christoph Luitpold Frommel, 'I palazzi di Raffaello: come si abitava e viveva nella Roma del primo Cinquecento', in Christoph Luitpold Frommel, *Architettura alla corte papale nel rinascimento* (Milan: Mondadori Electa, 2003), 240–55.

3 David S. Chambers, 'The Economic Predicament of Renaissance Cardinals', in *Studies in Medieval and Renaissance History*, 3 (1966), 291.

4 Weil-Garris and D'Amico, 'The Renaissance Cardinal's Ideal Palace', 73.

5 *Ibid.*, 83.

6 For the Palazzo Venezia, see Christoph Luitpold Frommel, *Der Palazzo Venezia in Rom* (Opladen: Westdeutscher Verlag, 1982); for the Palazzo della Cancelleria, see Christoph Luitpold Frommel, 'Il Palazzo della Cancelleria', in *Il Palazzo dal Rinascimento a Oggi, in Italia nel regno di Napoli in Calabria storia e attualità*, ed. Simonetta Valtieri (Rome: Gangemi, 1989), 29–54.

7 See Frederic J. Baumgartner, 'Election of the College of Cardinals, 1059–1274', in *Behind Locked Doors, A History of the Papal Elections*, ed. Frederic J. Baumgartner (New York: Palgrave Macmillan, 2003), 19–38.

8 See John Norman Kelly Davidson, *The Oxford Dictionary of Popes* (Oxford and New York: Oxford University Press, 1986), 191–2.

9 As outlined in this conciliar decree, *Licet de vitanda*, all cardinals of whatever rank were to be equal electors: excluding the emperor and the Roman clergy from the electoral procedure, it became the rule for all subsequent papal elections to the present day. See Walter Ullman, *A Short History of the Papacy in the Middle Ages* (London: Methuen, 1972), 229.

10 Gary M. Radke, *Viterbo. Profile of a Thirteenth-Century Papal Palace* (Cambridge: Cambridge University Press, 1996), 81–2.

11 Ludovico Gatto, 'Il conclave di Viterbo nella storia delle elezioni pontificie del "200"', in *Atti del convegno di studio, VII centenario del 1 conclave (1268–1271)* (Viterbo: Azienda autonoma di cura, soggiorno e turismo di Viterbo, 1975), 37–62.

12 Gregory X was pope from 1 September 1271 to 10 January 1276; see Kelly, *The Oxford Dictionary of Popes*, 197–8.

13 The Cappella Parva Sancti Nicolai is recorded in a drawing, UA1333 by Antonio da Sangallo the Younger, in the 1530s before its demolition; see Hermann Egger, *Carlo Madernas Projekt für den Vorplatz von San Pietro in Vaticano* (Leipzig: Poeschel & Trepte, 1928), pl. III. For a description of its demolition and the new Pauline Chapel, see Christoph Luitpold Frommel, 'Antonio da Sangallos Cappella Paolina. Ein Beitrag zur Baugeschichte des Vatikanischen Palastes', *Zeitschrift für Kunstgeschichte*, 27 (1964), 1–42; and in an updated version, 'La cappella Paolina di Antonio da Sangallo. Un contributo alla storia edilizia del palazzo Vaticano', in Frommel, *Architettura alla corte papale*, 359–91.

14 John Shearman, 'The Fresco Decoration of Sixtus IV', in *The Sistine Chapel, the Art, the History, and the Restoration*, ed. Carlo Pietrangeli (New York: Harmony Books, 1986), 38–87.

15 Other lucky spots on the Sistine Chapel's floor cited by Chambers included the area under Signorelli's *Last Acts of Moses*, showing Moses handing on the golden rod to Joshua, and on the raised area, above the floor where the other cardinals were camped, where the papal throne normally stood; see David S. Chambers, 'Papal Conclaves and the Prophetic Mystery in the Sistine Chapel', in *Journal of the Warburg and Courtauld Institutes*, 41 (1978), 323, and Baumgartner, *Behind Locked Doors*, 82.

16 Baumgartner, *Behind Locked Doors*, 98–100. For Master of Ceremonies Johann Burchard's account of the election of Julius II, see Johann Burchard, *Johannis Burckardi Liber notarum: ab anno MCCCCLXXXIII usque ad annum MDVI*, in *Rerum Italicarum Scriptores, XXXII*, ed. Enrico Celani (Città di Castello: Tipi della Casa editrice S. Lipi, 1907–42), 370.

17 Henry Dietrich Fernández, 'Bramante's Architectural Legacy in the Vatican
 Palace: A Study in Papal Routes' (PhD diss., University of Cambridge, 2003),
 136–8.

18 Franz Ehrle and Hermann Egger, *Die Conclavepläne beiträge zu ihre
 Entwicklungsgeschichte* (Vatican City: Biblioteca Apostolica Vaticana, 1933); and
 Shaw, *Julius II*, 117–26.

19 See Ehrle and Egger, *Die Conclavepläne*; and Chambers, 'Papal Conclaves', 322.

20 Ehrle and Egger, *Die Conclavepläne*.

21 John Shearman, 'The Vatican Stanze: Functions and Decorations', in *Proceedings
 of the British Academy*, 57 (1971), 370, 390–91.

22 In his *Biography of Pope Nicholas V*, Giannozzo Manetti cites the pope's grand
 schemes for a similar expansion and embellishment of the Vatican Palace
 complex. While most of Nicholas V's visions never came to fruition, it is likely
 that Julius II not only knew these earlier plans projected by his Ligurian
 compatriot, but may have been inspired by them. See Torgil Magnuson, *Studies
 in Roman Quattrocento Architecture* (Stockholm: Almqvist & Wiksell, 1958),
 55–84, 126–7, 351–62; Giannozzo Manetti, *Vita di Nicolò V*, edited translation
 in Italian by Anna Modigliani and preface by Massimo Miglio (Rome: Roma
 nel Rinascimento, 1999); Christine Smith and Joseph O'Connor, *Building the
 Kingdom: Giannozzo Manetti on the Material and Spiritual Edifice* (Tempe AZ and
 Turnhout, Belgium: Arizona Center for Medieval and Renaissance Studies and
 Brepols, 2006). For Nicholas V's Torrione, see Amato Pietro Frutaz, *Il Torrione di
 Niccolò V in Vaticano* (Vatican City: Tipografia Poliglotta Vaticana, 1956).

23 He acquired an intimate knowledge of the Vatican Palace and the Villa
 Belvedere as a cardinal during the reign of Pope Innocent VIII. Described as
 'more than pope' during that period, the future Julius II came to know and
 understand what renovations and embellishments the Vatican Palace required.
 For example, while still Cardinal Giuliano della Rovere he oversaw the building
 of Innocent's Villa Belvedere. See Ludwig Pastor, *The History of the Popes from
 the Close of the Middle Ages: Drawn from the Secret Archives of the Vatican and Other
 Original Sources* (St Louis MO: B. Herder, 1898), vol. V, 242; and Caroline P.
 Murphy, *The Pope's Daughter* (London: Faber & Faber, 2004), 25.

24 For Cardinal Archbishop Giuliano delle Rovere as patron of architecture at
 Avignon, see Joseph Girard, *Evocation du vieille Avignon* (Paris: Les Editions
 de Minuit, 1958), 70–72; Léon-Honoré Labande, 'Le début du Cardinal
 Julien de la Rovère', in *Annuaire de la Société de Amis du Palais des Papes et des
 Monuments d'Avignon* (1926); Deborah Taynter Brown, 'Cardinal Giuliano
 Della Rovere, Patron of Architecture, 1471–1503' (MPhil. diss., University of
 London, Courtauld Institute of Art, 1988); and Henry Dietrich Fernández,
 'Avignon to Rome, The Making of Cardinal Giuliano della Rovere as Patron of
 Architecture', in *Patronage and Dynasty. The Rise of the della Rovere in Renaissance
 Italy*, ed. Ian Verstegen, *Sixteenth-Century Essays and Studies 77* (Kirksville
 MO: Truman State University Press, 2007), 63–88. Archbishop Giuliano also
 sponsored the renovation of a chapel dedicated to the Virgin Mary in Notre-
 Dame-de-Doms at Avignon; see Leopold Duhamel, *Une Visite à Notre Dame de
 Doms d'Avignon. Guide de l'etranger dans ce monument, avec un plan inédit et trois
 gravures* (Avignon: J. Roumanille, 1890), 49.

25 For Cardinal Giuliano's palace in Savona, see Francesco Paolo Fiore, 'La fabbrica
 quattrocentesca del Palazzo della Rovere in Savona', in *Sisto IV e Giulio II,
 mecenati e promotori di cultura: atti del convegno internazionale di studi, Savona, 1985,*

ed. Silvia Bottaro, Anna Dagnino and Giovanna Rotondi Terminiello (Savona: Coop Tipografi, 1989), 261–76; and Fernández, 'Avignon to Rome', 63–88.

26 For a description of the papal court within a broader European context, see Christoph Luitpold Frommel, 'Il Palazzo Vaticano sotto Giulio II e Leone X. Strutture e funzioni', in *Raffaello in Vaticano*, ed. Carlo Pietrangeli and Fabrizio Mancinelli (Milan: Gruppo Editoriale Electa, 1984), 118–34; and Henry Dietrich Fernández, 'The Patrimony of St Peter: The Papal Court at Rome', in *The Princely Courts of Europe: Ritual, Politics and Culture under the Ancien Régime 1500–1750*, ed. John S.A. Adamson, 2nd edn (London: Cassell, 2000), 140–63.

27 The coffering of Bramante's design for the Choir at Santa Maria del Popolo may have been inspired by the coffering above the entrance portal arch at Hadrian's Pantheon. For this detail see an anonymous drawing of the portal in the *Codex Escurialensis*, fol. 29, in Kjeld De Fine Licht, *The Rotunda in Rome, a Study of Hadrian's Pantheon* (Copenhagen: Gyldendal, 1968), fig. 136, p. 128.

28 This drawing, a plan described by Vasari that records the *restaurare e dirizzare*, renovation and straightening, of the Vatican Palace, has been attributed to Bramante's workshop and may have been drawn by one of his assistants, Antonio di Pellegrino from Fiesole. This composite sheet, made from 15 smaller sheets glued together, was drawn with ink and *sanguine* on white paper. The dimensions of this drawing are 1.340 × 1.030 metres and it has been cut on the side, which runs along the west side of the partially drawn Cortile del Belvedere; it is kept at the Gabinetto Disegni e Stampe, in the Galleria degli Uffizi in Florence. For the citation of this drawing as *disegno grandissimo* in Vasari's 1550 and 1568 editions of his 'Vita di Bramante da Urbino', see Rossana Bettarini (ed.), Giorgio Vasari, *Le vite de piu eccellenti scultori e architettori nelle redazioni del 1550 e 1568* (Florence: Sansoni, 1976), vol. IV, 81. Drawing UA287 is reproduced in James S. Ackerman, *The Cortile del Belvedere* (Città del Vaticano: Biblioteca Apostolica Vaticana, 1954), 263, fig. 3; Arnaldo Bruschi, *Bramante architetto* (Bari: Editori Laterza, 1969), 332, fig. 216; Arnaldo Bruschi, *Bramante* (London: Thames & Hudson, 1973), 90, fig. 93; Christoph Luitpold Frommel, Stefano Ray and Manfredo Tafuri (eds), *Raffaello Architetto* (Milan: Electa Editrice, 1984), 337; and Franco Borsi, *Bramante* (Milan: Electa Editrice, 1989), 293; Christoph Luitpold Frommel, 'I tre progetti bramanteschi per il Cortile del Belvedere', in *Il Cortile delle statue der Statuenhof des Belvedere im Vatikan*, ed. Matthias Winner, Bernard Andreae and Carlo Pietrangeli (Mainz am Rhein: Verlag Philipp von Zabern, 1998), 20, fig. 5.

29 Bramante's drawing, UA287, records the second-level plan of the First Loggia facing east onto the Cortile di San Damaso.

30 'Omitto locum pro conclavi designatum a tua beatitudine …'; see Francesco Albertini, *Opusculum de mirabilibus novae et veteris urbis Romae* (Rome: 1510), fols 91v and 92r; Ackerman, *The Cortile del Belvedere*, 143; Frommel, 'I tre progetti bramanteschi', 17–66.

31 While Bramante's Logge would be completed by Raphael about 1518, much of the First Loggia level would have been completed by 1512, giving Julius II direct access from the Vatican Palace to Innocent VIII's Belvedere. In anticipation of this eventuality, Albertini wrote, '… ut ad summitatem usque tecti facile posit equitari …'; see Albertini, *Opusculum*, fol. 85v.

32 Fernández, 'Bramante's Architectural Legacy', 103–85.

33 For a measured survey of the First Loggia plan, see two drawings by Henry Dietrich Fernández, in Frommel, 'Il Palazzo Vaticano', 133; and Henry Dietrich

Fernández and Barbara Shapiro, 'Il Palazzo Vaticano al tempo di Raffaello. La Scala di Bramante e Raffaello nei Palazzi Vaticani, stato attuale', in Pietrangeli and Mancinelli, 140, fig. 64c.

34 As indicated on drawing UA287, Bramante faced a problem posed by the uneven, off-centred connection between the Nicholine period wall and the Torrione. Bramante's resolution included squaring the design of his plan, relative to the Nicholine wall, at the east end, thus creating, from an interior point of view, the perception of a hall that was evenly balanced, a symmetry underscored by a large portal positioned in the centre of his new east wall. He employed the same architectural device at the west end of his Conclave Hall design, this time resolving the divergent geometry between his design for the area behind the portico at the southeast corner of the lower level of the Cortile del Belvedere and the interior west wall of his Conclave Hall design, providing for the perception of an evenly balanced threshold entrance into the interior of the Conclave Hall. In the process of resolving the geometry of the east and west elevations of his Conclave Hall design, he would have remembered a precedent from his early days as an architect in Milan, one that involved the resolution of a circular plan and its connection to a rectangular one, at the church of Santa Maria presso San Satiro. For a view of the plan of this Milanese church, see Bruschi, *Bramante*, 123, fig. 67, and 130, fig. 73; and Richard Schofield and Grazioso Sironi, 'Bramante and the Problem of Santa Maria presso San Satiro', in *Annali di Architettura*, 12 (2000), 22, figs 10 and 11.

35 See Frommel, *Architettura alla corte papale*, 136–47.

36 See Christoph Luitpold Frommel, 'Lavori architettonici di Raffaello in Vaticano', in Frommel, Ray and Tafuri, 361; and Frommel, 'I tre progetti bramanteschi', 60, fig. 67. A similar relationship between huge freestanding columns, perhaps Corinthian, and pilasters on a wall, can be observed in Bramante's early scheme for the new Saint Peter's Basilica: see his autograph drawing, UA1, also known as the 'Parchment Plan', in Franz Graf Wolff Metternich, *Die Erbauung der Peterskirche zu Rom im 16. Jahrhundert* (Vienna and Munich: Verlag Anton Schroll & Co., 1972), 35, fig. 1, 75, pl. 1. Also, it is possible that Bramante knew drawings by Giuliano da Sangallo, such as a presentation design for a *Palace for Ferdinand I, King of Naples*, c. December 1488. Within this plan, in the Salle Grande marked 'S', the relationship between twin columns against a wall flanked by niches may have inspired Bramante's interpretation of the columnar-mural composition of his Conclave Hall design. For a reproduction of Sangallo's plan and a detail of the Salle Grande, see Stefano Borsi, *Giuliano da Sangallo. I disegni di architettura e dell'antico* (Rome: Officina Edizioni, 1985), 'Barb. F. 39 verso', 395–9; and Christian Huelsen, *Il Libro di Giuliano da Sangallo, Codice Vaticano Barberiniano Latino 4424 riprodotto in fototipia*, 2 vols (Leipzig: O. Harrassowitz, 1910); reissued with 17 additional plates in text vol. (Modena: Biblioteca Apostolica Vaticana, 1984), fol. 39v. Furthermore, Bramante may have known other drawings with similar mural features, such as plans in Giuliano da Sangallo's Sienese sketchbook; see *Il Taccuino Senese di Giuliano da San Gallo: 50 facsimili di disegni d'architettura, scultura ed arte applicata, pubblicati da Rodolfo Falb* (Siena: Stab. Fotolit. Del Cav. L. Marzocchi, 1899), pls XIII, XVIII, XXXI, XXXIV.

37 For 'View of Forum of Nerva', see *I vestigi dell'antichità di Roma raccolti et ritratti in perspettiva con ogni diligentia da Stefano Dv Perac Parisino* (Rome: Lorenzo della Vaccheria, 1575 and 1600), fol. 6.

38 See Franco Borsi, *Giovanni Antonio Dosio. Roma Antica e i disegni di architettura agli Uffizi* (Rome: Officina Edizioni, 1976), 80–81.

39 See Frommel, 'I tre progetti bramanteschi', 136–47.

40 For the rising number of cardinals, see Chambers, 'Papal Conclaves', 322.

41 Christine Shaw, 'The Election', in Shaw, 117–26. See the list of papal conclaves in Ehrle and Egger, *Die Conclavepläne*, 16. This is a comparative list of conclaves from Eugene IV in 1431 to Pius V in 1565. This chronological list cites the elected pope's name, the beginning and end date of their respective conclave, how many cardinals participated in their election and the locus of their conclave space. See Appendix I above.

42 See Chambers, 'Papal Conclaves', 322; and Frederic J. Baumgartner, 'Conclaves During the Renaissance', 76–100.

43 The number 70 is of significance. In 1586 Pope Sixtus V mandated that the maximum number of cardinals should be 70 to reflect the number of Moses' elders, a limit not extended until 1958 by John XXIII; see Francis E. Peters, *The Monotheists, Jews, Christians and Muslims in Conflict and Competition* (Princeton NJ: Princeton University Press, 2003), 214.

44 For plans, sections and interior views of the Palais des Papes in Avignon, see Léon-Honoré Labande, *Le Palais des Papes et les monuments d'Avignon au XIVe siècle*, 2 vols (Aix/Marseilles: F. Detaille, Editeur, 1925).

45 For example, one can observe the way the Medici sought to emulate the courtly habits of Northern princes at the Palazzo Medici in Florence or at Poggio a Caiano; see Dale Kent, *Cosimo de' Medici and the Florentine Renaissance, the Patron's Oeuvre* (New Haven CT and London: Yale University Press, 2000), 215–328.

46 Ehrle and Egger, *Die Conclavepläne*, Tav. XIII.

47 See Burchard in 1484, *Liber Notarum*, I, p. 23, as cited by Chambers, 'Papal Conclaves', 323, note 21; and Baumgartner, *Behind Locked Doors*, 82.

48 Ehrle and Egger, *Die Conclavepläne*, Tav. XIII.

49 Ehrle and Egger, *Die Conclavepläne*, Tav. XIII.

50 My thanks to Angelica Pediconi for bringing my attention to the illustrations in *Opera di M. Bartolomeo Scappi, cuoco secreto di Papa Pio Qvinto ...; con il discorso funerale, che fu fatta nelle essequie di Papa Paolo III; Con le figure che fanno bisogno nella cucina & alli reverendissimi nel conclaue* (Venice: 1598), Tav. XX–XXI.

51 *Opera di M. Bartolomeo Scappi*, Tav. XX–XXI.

52 'Le camere delli cardinali create dal passato Pontefice erano ornate di paonazzo, con le lettiere e fornimenti paonazzi con frange di seta, tornoletti, coperti, coltrine e cussini paonazzi, e per ciaschuna d'una camera era anchora una tavola coperta dal medesimo panno.' *Opera di M. Bartolomeo Scappi*, 310r.

53 'Una vettina di tre some in circa, col coperchio di rame serrata, con sua chiave.' *Opera di M. Bartolomeo Scappi*, 310r.

54 '... molte altre cose necessarie per l'use della camera. Ogni cosa pero di paonazzo con l'arme del card. che ivi stava.' *Opera di M. Bartolomeo Scappi*, 310r.

55 'Ogni cardinale haveva un secretario, un gentilhuomo, un cameriere, e non altri', *Opera di M. Bartolomeo Scappi*, 310v.

56 Chambers, 'Papal Conclaves', 323.

57 See the list of papal conclaves in Ehrle and Egger, *Die Conclavepläne*.

58 Chambers, citing Cristoforo Marcello's letter of 7 March 1513, describes how the Sistine Chapel, during conclave, resembled a hospital ward; see Chambers, 'Papal Conclaves', 323.

59 See Frederic J. Baumgartner, 'Sfumata!', in Baumgartner, 241–5.

60 For descriptions of *possesso* routes, see Francesco Cancellieri, *Storia de' solenni possessi de' sommi pontefici detti anticamente processi o processioni dopo la loro coronazione dalla Basilica Vaticana alla Lateranense*, dedicata alla santita' di n.s. Pio VII. P.O.M. (Rome: Presso Lvigi Lazzarini Stampatore della R.C.A., 1802).

61 Transcribed from Ehrle and Egger, *Die Conclavepläne*, 16.

Renaissance graffiti: the case of the Ducal Palace of Urbino*

Raffaella Sarti

A palace to read: inscriptions and graffiti

As everye man knoweth the lytle Citye of Urbin is sytuated upon the side of the Appenine (in a maner) in the middes of Italy towardes the Golf of Venice. The which for all it is placed emonge hylles, and those not so pleasaunt as perhappes some other that we behoulde in many places, yet in this point the element hathe been favourable unto it, that all aboute, the countrye is very plentyfull and full of fruites: so that beside the holsomenesse of aer, it is very aboundant and stored wyth all thinges necessarye for the lief of man. But amonge the greatest felycityes that men can recken it to have, I counte thys the chief, that now a longe tyme it hath alwayes bene governed with very good Princes, although in the commune calmyties of the warres of Italy it remayned also a season with out anye at all. But without searching further of this we maye make a good proofe wyth the famous memorye of Duke Fridericke, who in his dayes was the light of Italy. Neyther do we want true and very large testimonies yet remayninge of his wisdome, courtesye, justice, liberalitye, of his invincible courage and pollycy of warr. And of this do his so many vyctoryes make proofe, chyeflye his conquerynge of places impregnable, his sodyne redynesse in settynge forwarde to geve battaile, his putting to flyght sundrye tymes wyth a small numbre, verie greate and puissaunte armyes, and never suteined losse in any conflict: so that we may, not without cause, compare hym to manye famous men of olde time. This man emong his other deedes praiseworthy, in the hard and sharpe situation of Urbin buylt a Palaice, to the opinion of many men, the fayrest that was to be founde in all Italy, and so fornished it with everye necessary implement belonging therto, that it appeared not a palaice, but a Citye in fourme of a palaice.[1]

With these words Baldassar Castiglione described Urbino in Italy, and its palace, the setting for his book *The Courtier*, published in 1528 but in preparation from 1513–14:[2] more precisely, the dialogue is supposed to take place at the court of Duke Guidubaldo of Montefeltro (1472–1508) and his wife Elisabetta Gonzaga (1471–1526). The palace had been built by Federico (1422–82), father of Guidubaldo.[3]

That this was the case is apparent to anyone who enters the main courtyard of the palace and reads the Latin inscription which runs all along the courtyard's perimter, etched onto the strip of the architraves:

FEDERICVS VRBINI DVX MONTISFERETRI AC DVRANTIS COMES SANCTAE
RO ECCLESIAE GONFALONERIVS ATQVE ITALICAE CONFOEDERATIONIS
IMPEATOR HANC DOMVM A FVNDAMENTIS ERECTAM GLORIAE ET
POSTERITATI SVAE EXAEDIFICAVIT QVI BELLO PLVRIES DEPVGNAVIT SEXIES
SIGNA CONTVLIT OCTIES HOSTEM PROFLIGAVIT OMNIVMQUE PRAELIORVM
VICTOR DITIONEM AVXIT EIVSDEM IVSTITIA CLEMENTIA LIBERALITAS ET
RELIGIO PACE VICTORIAS AEQUARVNT ORNARVNTQVE.

Impressive words, which in English read thus:

Federico, Duke of Urbino, Count of Montefeltro, Gonfalonier of the Holy Roman
Church and Commander of the Italic League, erected this residence from its
foundations for his glory and posterity, he who many times waged war, six times
fought in order of battle, eight times defeated the enemy and, the conqueror in every
encounter, increased his dominion. In peace his justice, clemency, liberality and
religion equalled and honoured his victories.

This, then, is an inscription that celebrates Federico da Montefeltro and
presents the palace as the seat of a lord victorious in battle, who is just,
merciful, liberal and religious; a personal glorification that is simultaneously
a legitimation of his power.

But the palace offers surprises that complicate this view of the building as a
celebration of an individual. And it is also (though perhaps it would be better
to say: particularly) on the walls that we find solid traces of a more mundane
character. The hypothetical visitor to the palace, if blessed with the slightest
gift for observation, will notice that its walls are home to hundreds (or even
thousands) of graffiti: drawings and writings in Italian, Latin, French, German
etc. Some are very recent: among those I have so far identified the most recent is
'Mirco 2000'.[4] Mirco etched his name on the wall, as so many others did before
him. In fact the palace graffiti are mostly etched: in short they are graffiti in the
original sense of the word. But there are also writings and designs in charcoal,
in red and black pencil, in biro etc. The most ancient dates discovered go back
to the years around 1450, to an age when the construction of the palace as we
know it today still had to start or was at its very beginning.[5] In short, five and
a half centuries of graffiti crowd the palace walls.

In the introduction to their most valuable bibliography of studies on
graffiti datable from 500 up to 1900, Detlev Kraack and Peter Lingens make a
distinction between graffiti and inscriptions, as do other authors working on
the same topic. Kraack and Lingens define graffiti as spontaneous writings
or drawings which are never done to order or with the authorization of the
builder or owner of the palace, church, house, etc., on whose walls they are
traced, or with the approval of the authorities; on the contrary, they are done
without their approval and even against their wishes. Inscriptions, on the
other hand, have an official character.[6]

Within this perspective one could therefore conclude that inscriptions
are public and institutional, while graffiti are more private, or at any rate
less institutional. In this sense inscriptions and graffiti may perhaps help

us to probe the subject of this book: the relationship between domestic and institutional spaces. If we take this summary reasoning a bit further, we could in fact assume that in a palace such as the one at Urbino, which had simultaneously a domestic character (inasmuch as it was a family residence) and an institutional character (inasmuch as it was a seat of political power), inscriptions would be present above all in the more public areas. If only for the sake of symmetry, we could assume that graffiti would be present above all in the more private areas. In short, we could imagine three oppositions that at least partially coincide or are overlaid:

Inscriptions ↔ Graffiti
Institutional ↔ Domestic
Public ↔ Private

In this essay, focusing especially on the first opposition, I shall, however, show that these binary oppositions do not obviously apply to the palace of Urbino and that there is no coincidence or overlapping among them. The reality seems much more complex and the boundaries turn out to be much more fluid than one might imagine. Nonetheless, taking our starting point in these clear and simple oppositions and questioning how far they can go will allow us to understand how things were in reality. Let us first of all analyse the function of the palace.

The palace: a domestic and/or institutional space?

As we have seen, the palace was built at the instigation of Federico da Montefeltro (see Table 2.1). One of the most successful *condottieri* of the time, Federico became the lord of Urbino in 1444 and obtained, in 1474, the title of duke from Pope Sixtus IV (Francesco della Rovere). Federico, who was not only a soldier but also a patron of art and literature, transformed Urbino into one of the liveliest cultural centres of the Renaissance. The Montefeltro family's rule over Urbino, however, was not to last long after Federico's death in 1482, if one looks at the succession from a patrilineal vantage point. Federico's son and successor, Guidubaldo, had no offspring. When he died in 1508, the duchy went to Francesco Maria della Rovere, the son of a sister of Guidubaldo, Giovanna, who had married Giovanni della Rovere, nephew of Pope Sixtus IV and brother of Pope Giulio II (Giuliano della Rovere). By 1523 Francesco Maria I had transferred his main court to Pesaro: when Baldassar Castiglione published his enthusiastic description of Urbino, the decline of the city had already started.[7] Until then the palace was both the residence of the ducal family and the seat of the court. Even later, however, it remained one of the dwellings of the ducal family; in other words, it was both a domestic and an institutional space, to use a distinction that Renaissance Italian people certainly did not conceive as we conceive it (not only because they used a

different language,[8] but also because at that time the palaces of ruling families were normally domestic dwellings and institutional buildings at the same time).

The real change came about in 1631, when the della Rovere dynasty died out for want of male heirs. The dukedom then devolved by right to the Pope. The palace was almost completely emptied of its rich furnishings: some were sold in a kind of auction held in Urbino while the most precious were taken to Tuscany; the son of the last duke, Federico Ubaldo, who had predeceased his father Francesco Maria II, had married Claudia de' Medici, and their little daughter Vittoria, her grandfather's overall heir, had, on her father's death, become betrothed to her cousin, and the future Grand Duke of Tuscany, Ferdinando de' Medici. The wedding was to take place in 1634.[9]

After the devolution, the palace became the seat of the representatives of papal rule, the legate (who divided his residence between Pesaro and Urbino) and the vice-legate.[10] At that time the word *famiglia*, 'family', was also used in relation to the entourage of the Pope (an Italian usage that persists even today) as well as in relation to the entourage of cardinals, bishops, legates and vice-legates; one of the meanings of the word *famiglia* was in fact that of a group of people living under the direction of a *capo*, a head or leader.[11] The concept of family did not therefore necessarily presuppose relationships either by marriage, filiation or kinship, nor any implication of affection or domesticity.[12] It was applied equally to the family of the Duke and the Duchess, and to the family of the legate or vice-legate (just as it was to monastic 'families' or the 'family' of the *bargello*[13]). Nevertheless, like us, men and women of the 1600s could grasp the difference, albeit with a different degree of nuance and implication, between the presence of a ducal family that reproduced itself through a genealogical line (involving marriages, sexual relationships, the birth and upbringing of children),[14] and the presence in the palace of a legate's family that reproduced itself by means of papal bureaucracy and the mechanisms governing curial careers. To employ the interpretative categories of this book, in the wake of the reassignment to the Pope, the palace in fact lost a significant part of its domestic character. Certainly it continued to be a locus of residence for the vice-legate and (part of) his entourage and, in certain periods, for the legate and (part of) his staff, as well as of activity in such domestic terms as the preparation of food for (some of) them. Yet all in all it largely ceased to be a space that was simultaneously domestic and institutional, and remained a more distinctly institutional space, even though (quite paradoxically) with less representative functions than in the time when it was the seat of the ruling family of an independent state.[15]

This essay focuses on the Renaissance, as shown by its title, and then gives some attention to the first phase of the papal rule (1631–1797). Nonetheless it is worth noting that the history of change in the usage of the palace did not stop with the devolution to the Pope. When the French conquered Urbino, the seat of city government (*municipalità*) was transferred to the palace (1798).[16] Under the French rule some rooms were converted into a prison. Indeed, part of the

Table 2.1 Rulers in Urbino, 1444–1860

Montefeltro	
Federico (1422–82), Count 1444, Duke 1474	1440 married Gentile Brancaleoni (d. 1459) 1460 married Battista Sforza (1446–72)
Guidubaldo (or Guidobaldo) (1472–1508), Duke 1482	1488 married Elisabetta Gonzaga (1471–1526)
[1502–1503: Urbino under the rule of Cesare Borgia]	
Della Rovere	
Francesco Maria (1490–1538), Duke 1508	1509 married Eleonora Gonzaga (1493–1550)
[1516–21: Urbino under the rule of Lorenzino de' Medici and Pope Leo X (Giovanni de' Medici)]	
Guidubaldo II (or Guidobaldo II) (1514–74), Duke 1538	1535 married Giulia da Varano (1524–47) 1548 married Vittoria Farnese (1521–1602)
Francesco Maria II (1549–1631), Duke 1574, abdicated in 1621, returned to power after the death of his son Federico Ubaldo in 1623	1571 married Lucrezia d'Este (1535–98), marriage separation 1578 1599 married Livia della Rovere (1585–1641)
Federico Ubaldo (1605–23), Duke 1621	1621 married Claudia de' Medici (1604–48)
Papal rule	
1631–1860, with interruptions due to French occupation in 1797–99, 1808–14 and 1815	

palace remained a prison even after the restoration of papal rule (1814) and even after the inclusion of Urbino in the Italian State in 1860. In the nineteenth century the palace also hosted a tribunal, the police and other offices, as well as the apartment of the vice-legate, barracks for the Swiss guards, a theatre, a

pawnshop (*Monte di Pietà*), archives, school rooms, private flats, storerooms, etc.[17] In 1883 67 paintings were on show in the palace and in 1913 the Galleria Nazionale delle Marche was eventually opened.[18] In other words, in the course of the nineteenth and twentieth centuries the tendency towards the 'institutionalization' of the palace made further advances, with the ultimate outcome of completely nullifying its domestic dimension.[19]

Now that we have established that in the course of time the balance between the domestic and institutional components of the palace underwent radical change, let us concentrate our attention on those phases when they were contemporaneous. Studies carried out, through a variety of sources (inventories, descriptions of the palace, etc.), by Luisa Fontebuoni in particular, on the use and functions of the rooms have made it possible to identify (albeit sometimes with a degree of uncertainty) which areas were the Duke's family residence and which were lived in by the members of the court in the ducal period, and those lived in by the legate and his staff after the devolution to the Pope. Fontebuoni also identified the private walkways and the private gardens, as well as the public walkways, the rooms allocated for official meetings and those for administrative business and services. This scholar's detailed work has been translated into a series of plans of the palace, the first of which, relating to the Montefeltro period, I partially reproduce here, along with the third, relating to the first period of the legates (Pls 5 and 6).

Thus, although during the ducal period and in part also in that of the legates the palace was contemporaneously a place of institutional and domestic functions, it was in no way an undifferentiated space: inside, it was possible to distinguish areas allocated (especially) to institutional functions and spaces connected with (more) domestic functions, spaces that were (more) public and spaces that were (more) private. Actually, one of the most striking features of the palace is the programmatic distinction of the rooms according to their functions,[20] and interestingly some areas were explicitly defined as 'public' in Renaissance sources, too. In particular, an anonymous late fifteenth- or early sixteenth-century manuscript on the running of the ducal *casa* (*Ordine et officij de casa de lo Illustrissimo Signor Duca de Urbino*) explained that the public areas of the palace ('lochi publici de casa') should be swept every day, and especially the entrance, the stairs, the walkways, the galleries and all the rooms that had to be passed through to get to the chamber of the Duke.[21] These areas, the access to which should be closed when the Duke was taking his meals, should be well lit with lanterns. Though the palace was in itself splendid and did not necessarily need any further decoration, embellishing the public areas with tapestries and other things was a great honour for the Duke. In any case the public areas should be provided with benches both for the *famiglia* and the foreigners; to heat up both of them, in the public *sala* ('sala publica'), the fires should be regularly fired when it was cold.[22]

At the same time there were ambiguities and overlaps, at least according to our 'modern' sensibilities. For instance, according to the *Ordine et officij* the 'general kitchen' should be 'public'.[23] Certainly the meals and particularly the

banquets prepared in the palace kitchens had public, political and institutional importance.[24] Yet the kitchens were located in a basement out of public walkways according to Fontebuoni's careful reconstruction.[25] Furthermore, to quote another example, according to the *Ordine et officij* a chancellor should sleep in the *guardacamera* (the antechamber) of the lord's chamber to reply immediately to letters which arrived during the night or to make a record of any important thoughts of the Duke.[26] Actually, during the ducal period administrators managed what we would now regard as family affairs as well as those relating to the 'state'. 'In that form of rule an inextricable confusion … tends to merge the organisation of the domestic life of the prince and the wider affairs of the state.'[27]

This being the case, we can ask ourselves whether the writings on the walls – inscriptions and graffiti – tell us something about these boundaries, blurred as they are, and in part different from those of today, but nonetheless present. As already mentioned, on the basis of widely accepted definitions, according to which inscriptions would have an official character not pertaining to graffiti, we might well ask whether the inscriptions were not to be found most of all in the public and reception areas, and the graffiti in the more domestic and private ones.

Inscriptions are indeed present above all in those areas that Luisa Fontebuoni, Paolo Peruzzi[28] and other scholars have identified as public and reception areas. In certain respects inscriptions do indeed contribute to defining the public and institutional nature of these spaces. This is especially the case for the long inscription in the main court quoted above. Even the less high-sounding inscriptions give us some indication: Federico had inscriptions made with his initials ('F.C.', 'Federicus comes', in other words 'Federico Count', or else, after 1474, 'FE. DVX', in other words 'Federico Duke') on the external walls of the towers (*torricini*), on the external architraves of the windows, and, inside the palace, on the architraves of many doors and, though less obsessively, on the doors themselves, on the mantelpieces of fireplaces and on some ceilings. Along with these inscriptions, or alternating with them, we find symbols of the power of the dukes, particularly – as is obvious – those of Federico: arms as well as *imprese*; that is, 'allegorical emblems used by personages of high station or celebrity' made by an allegorical figure with a motto.[29]

Significantly, however, inscriptions and symbols are absent, as far as I can judge,[30] from the doors of the service areas at basement level (the room which was probably a laundry and the smaller rooms near to it; the snow-house [*neviera*]; the rooms where allegedly victuals, food and forage were stored; the latrines; the stables[31] as well as the servants' hall [*tinello*],[32] the kitchen and the bathroom). Similarly, they were absent from almost[33] all the doors to the spiral staircases of the towers (these staircases are listed by Fontebuoni among the private walkways; see Pl. 5, nos. 1 and 3 both on the ground and first floors). Can we therefore conclude that the presence of inscriptions in some unequivocal way marks out the public and institutional areas? The answer is negative.

For instance, besides a long series of his symbols, there is a big inscription with the name and titles of Federico on the ceiling of the *studiolo*, the core of the Duke's private apartment and possibly the most secret place in the palace, devoted to reading and meditation. Furthermore, there are inscriptions in another area for meditation, that of the *Cappella del Perdono* (Chapel of Forgiveness) and the *Tempietto delle Muse* (Little Temple of the Muses).[34] Although present in a much less obtrusive way than elsewhere, Federico's acronyms and symbols are not wanting in the service areas either. On the ceiling of the (alleged) laundry there is the Montefeltros' eagle and 'FE. DVX' is clearly legible on the chimney cowl of the servants' hall, as is 'F.D.' on the chimney cowl of the kitchen. Possibly they were intended to remind the staff of their master's presence but they can also be interpreted as clues to the fact that, all in all, the boundaries between private and public areas were quite blurred. Was it not in the kitchen, although located in a basement, where the dishes for official banquets were prepared? Should not the kitchen be 'public' according to the *Ordine et officij*?[35] Seemingly, even if on one hand the *studiolo*, the *Cappella del Perdono* and the *Tempietto* were envisaged as places for meditation, on the other they were proudly displayed to the most illustrious guests as (particularly the *studiolo*) a kind of triumph of Federico's exquisite taste.[36]

Thus, albeit with some limitations, the inscriptions (and symbols) that are the work of expert stonecutters give us some clues to the function of the various areas of the palace.

But what are we to make of the graffiti? Are these present only in the service areas and are they more hidden, as would seem to fit with writings done without the knowledge or even against the wishes of the masters of the house, in keeping with the definition of graffiti accepted by many scholars? In fact, in service locations such as the stables, the storage rooms, the laundry and the snow-house (*neviera*), there are practically none (perhaps also because there were no suitable surfaces: the walls here are of unplastered brick, and the doors are almost all without jambs, as previously mentioned). A few graffiti, most of them probably very late, are present in the latrines.[37] There were probably a great many in the kitchen, but successive repainting of the walls has largely blanked them out, and we can guess at their presence and extent only thanks to some panels that have recently been deliberately left without repainting and thanks to the fact that some graffiti were carved into the wall and therefore still remain partly legible despite the coats of paint covering them, whereas others were done with charcoal.

Although therefore present in the kitchen, there are not many graffiti in the service areas. There were also a few (if we exclude the door jambs on the main staircase) on the second floor which was completed by Guidubaldo II (Duke from 1538 to 1574) and intended, during the ducal period, to be occupied by part of the ducal family and the court (the Duchess Lidia della Rovere, in particular, had her apartment there); and later for staff in the period of the legates.[38] Scattered to some extent throughout the palace, as far as can be established at this stage of my research, graffiti probably reach

their maximum density in the entrance to the ceremonial courtyard, in the ceremonial courtyard and in the so-called throne room (Pl. 5, ground floor, nos. 30, 21; first floor, no. 14h), though being very numerous in other areas too: on the ground floor in room 26d, under the porch of the *Cortile del Gallo* (no. 6), in the loggia between the towers (no. 2) and, on the first floor, in the *sopralogge* (no. 11), in rooms 13f–13i and 19a, 19b and 19f as well as, in this case too, in the loggia between the towers (no. 2); in other words, near to public areas and/or walkways. They are, thus, mainly present in spaces with a high institutional value and/or characterized by the passage of numerous persons, in part visitors and in part members of the staff. Inside the palace[39] the areas where inscriptions and symbols are more concentrated largely coincide with the areas where graffiti are more numerous, even though there is not a perfect overlapping among them, nor are inscriptions, symbols and graffiti located exactly in the same places. Graffiti are mainly concentrated on walls or door jambs that people could reach without a ladder, while inscriptions and symbols are on architraves and ceilings.

In fact, when we see how particularly numerous graffiti are in the more public areas it is perhaps in some respects quite obvious; precisely because they were public, these areas were accessible to a greater number of people. Nonetheless this line of argument is incomplete: the fact is that in these areas it could not have been easy to act unbeknown to, and against the wishes of, the masters of the house, if only because there were guards present.[40]

In conclusion, inscriptions (and symbols), though present almost overall in the palace, were mainly concentrated in those areas of the palace intended to have public and institutional functions, and they help us for this reason to distinguish them. Conversely, the presence of graffiti in no way helps us to understand which were the domestic, service and/or private areas. As for graffiti, the hypothesis – formulated above – that it might be mostly characteristic of private and domestic areas has not been confirmed: rather the contrary. And if the placing of the graffiti naturally raises some questions for us about whether they were really always done unbeknown to and against the wishes of the masters of the house, a more careful analysis of who was writing on the walls can only dismantle this certainty for once and all, prompting us to revise the opposition between inscriptions and graffiti and to come up with a different interpretation of the writings on the walls and their meaning.

Walls speak volumes

I Crescentino Ricciarelli corporal in the provincial troop have been 12 days in prison in this room in March 1819 without any reasons [he means that he was innocent] and have been for 33 months a soldier of N[apoleon] Emp[eror] Vivat.[41]

People visiting the building, who are perhaps unaware that some parts of it were a prison for a while, learn from this graffito that in 1819 such was the case and that the very room where these words can be read was indeed used

as a jail.[42] Before I started the research I am partially presenting here, nobody had systematically studied the graffiti of the Urbino palace. Nevertheless, some of them have been used precisely to work out the changing use of the rooms at different periods.[43] The graffito cited above allowed, for instance, Luisa Fontebuoni[44] to find confirmation of the fact that the proposal (which she found in a written source of 1810) to use an apartment on the ground floor of the palace as a jail was put into effect. It is quite common for prisoners to leave drawings and writings on the walls of their cells, and several studies have been devoted to graffiti of this kind.[45] What interests us here, however, is that a graffito, therefore an example of non-institutional writing according to the distinction made by many scholars, tells us about the transformation of part of the palazzo into a custodial institution. This might seem like wordplay, but it is not.

However, in the Palace of Urbino writings and drawings by prisoners are rare. The large majority of the authors were not inmates. Their identity may often surprise us. For instance, not far from the graffito by Ricciarelli we find others such as the following: 'To [?] his great Eminence and most Reverend Lord Cardinal Delci Legate in 1660 To [?] the most Illustrious Vice-legate Monsignor Montecatini'; 'Gaetano de Cavalieri Vice-legate in the year 1711'; 'Monsignor de Cavalieri joined the Legation on December 4, 1710 and was raised to the presidency of the *Sacra Consulta* on the fourth day of March 1712 he was head of government from 2 April 2 the whole of October of the aforementioned year and after All Saints left for Rome'; 'Antonio Spinelli Vice-legate 1745 1746' and others like them.[46] If we go up to the first floor, into the first room of what is known as the 'appartamento della Jole' (Pl. 5, first floor, no. 13i), we notice three coats of arms graffitoed onto the embrasure of the second window.[47] The one at the top is the coat of arms of the Chigi Pope Alessandro VII (1599–1667, Pope from 1655); the one in the middle, under a large cross with the heart of Jesus, is the coat of arms of Cardinal Scipione Pannocchieschi d'Elci (1600–70), a Sienese, the legate to Urbino from 1658-62, whose name (written however as 'Delci'[48]) is mentioned in a graffito – as well as on a tablet – on the ground floor.[49] The third coat of arms is that of the vice-legate Carlo Montecatini, from Ferrara, who is also mentioned on the ground floor.[50] Carved on the wall, therefore, with extreme expertise and in order of hierarchy, we find the coats of arms of the three greatest authorities ruling over Urbino around 1660.

While it is unclear who is the author of the coats of arms, it seems likely that the authors of some, at least, of the writings were the legates and vice-legates, which is to say the masters of the house themselves. Before going into the crucial question of the identity of the graffiti authors, it is worth bearing in mind that the writings left by the legates, the vice-legates and their servants also help us to pinpoint which rooms were for their use. 'On the sixth day of June 1690 his Excellency Monsignor Alb … [illegible] vice-legate came to this room' appears for example on the jamb of a door on the ground floor of the palace.[51] Other sources enable us to fill out this barely legible piece of graffiti: from December 1688 (and until September 1690) the vice-legate was Rinaldo

degli Albizi. Thus why should he come to the room as late as June 1690? In fact, a new legate, Giacomo Cantelmi, had arrived at the *legazione* in May. This probably implied some change in the accommodation and that, at the beginning of June, Albizi moved into a different room.[52] In its turn the graffito enables us to supplement the information available to us, thanks to other sources on the function of different areas of the palace. A journal of 1703 tells us, in fact, that while at the time the vice-legate's apartment was on the 'third' floor, in the past it had been 'on the right-hand side of the ground floor'.[53] This source, however, gives us neither any precise indication of the rooms used by the vice-legate, nor any exact date, while our graffito allows us to establish with certainty that in 1690 the vice-legate did indeed reside on the ground floor, at least for a while, and in the same apartment where in the nineteenth century Ricciarelli would have been imprisoned. Furthermore, the authors of the journal, the *Monsignori* Origo and Lanciani, sent to his fatherland, Urbino, by Pope Clemens XI to make inquiries and suggest how to increase the honour of the city, maintained that the new vice-legate should go back to the ground-floor apartment, which at their time was 'kept extremely badly' and used in part as 'carriage storeroom' and in part as accommodation for the lackeys of the vice-legate.[54]

In fact, at least up to now I have not found any graffito by the next two vice-legates, Giovanni Battista Altieri (1703–1706) and Francesco Maria Barbarigo (1706–10). Conversely, as shown above, there are some graffiti mentioning the presence of the vice-legate Gaetano de' Cavalieri (1710–15) precisely in areas identified as the vice-legate's apartment on the ground floor. A 1720 inventory confirms that the apartment of the vice-legate was there, and there we found the name of the vice-legate Antonio Spinelli (1744–47).[55] Other graffiti let us guess that, later in the century, the vice-legates lived (also?) on the first floor. 'D.O.M. ['Deo optimo maximo'] on the 8 August 1788 Monsignor Cavriani Vice-legate came to this apartment', we read in a first-floor room. This is signed 'Antonio Colombari Bolognese Valet'. The vice-legate's surname is in fact almost illegible, but we know that at the time this office was held by Federico Cavriani.[56] Fontebuoni tentatively suggests that the room where this graffito is to be found was at the time occupied by a cultural academy, the Accademia degli Assorditi,[57] but the presence of this piece of writing prompts us to think that it formed part of the suite of rooms where the vice-legate lived.

Other pieces of writing tell us also about the place of residence of less important figures. On the jamb of the door that gives access from the spiral staircase of the northern tower to the *piano nobile* can be read, for example: 'There lived in these rooms the Most Illustrious Judge [*auditore*] Campelli from Spoleto a Noble Gentleman in the Legation of his Excellency Cardinal Spada' (therefore between 1681 and 1688).[58] Not very far from this, on the jamb of one of the doors of the famous study (*studiolo*) of the Duke, the *auditore* himself wrote: 'I B Pascalis Campelli';[59] he was clearly a man who was greatly concerned to leave visible traces of his presence in the palace. Not far from

2.1 Graffito likely made by the Duke Guidubaldo II della Rovere, Ducal Palace of Urbino, 1548. Courtesy of the Sovrintendenza per il Patrimonio Storico-Artistico e Demoetno-antropologico delle Marche, Italy

this, on the jamb of one of the doors of what in the ducal period was the antechamber (*guardacamera*) in the Duke's apartment, a graffito notes: 'rooms of the secretary Boncori 1691'.[60]

All of these autobiographical writings, and many others in a similar vein, made by individuals wishing to leave some trace of their presence in the Palace of Urbino, where they had come to carry out specific tasks in the apparatus of pontifical power, patently call into question the definition of graffiti given above. These writings are without doubt informal and graphically different from official inscriptions, but they are indubitably not the clandestine work of someone acting by stealth, or even against the will of the masters of the house.

The graffiti, however, date not only from the papal period. Quite the contrary: when Urbino came directly under papal dominion in 1631, the palace was already full of writings and drawings. Even in the ducal period the authors of such writings can surprise us. '1548 hora 21 dux vidit uxore[m] cuius adventus sit felix ac perpetuo duret',[61] observes what is perhaps the best-known of the palace writings (Fig. 2.1).[62] Incised with a sharp object on the wall of the loggia of the ducal apartment, it is traditionally attributed to Duke Guidubaldo II (1514–74, acceded to power in 1538), who in that same year of 1548 married Vittoria Farnese (1521–1602) (see Pl. 7).

Actually, the use of the third person ('the Duke') instead of the first ('I') raises some doubts about the identity of the writer. Nevertheless the content and the tone of the sentence make this attribution plausible. The previous year, indeed, Guidubaldo had lost his first wife, Giulia da Varano, who died aged only 23 (1524–47). They had been forced to marry when he was 21 and she only 11 for state reasons (Giulia was the only heir of the ruling family in the Duchy of Camerino, close to that of Urbino). The marriage had not been happy and also caused a conflict with the Pope, who feared the fusion of

the two duchies and eventually was able to annex the Duchy of Camerino to the Papal State.[63] After this experience, Guidubaldo probably hoped that his second marriage would be happy, would not be followed by any other, and would not be troubled by any further conflicts with the Pope (his new wife Vittoria was a granddaughter of Pope Paul III). These are exactly the feelings expressed in the writing on the wall.

This graffito, which is simultaneously a note of record, an intimate confession and an expressed wish for happiness, is incised on the wall of one of the loggias, where graffiti of an erotic and/or introspective nature abound, as if the splendid view to be enjoyed from here had made it a suitable place for amorous encounters,[64] sighs of longing for the reigning beauty of the moment or melancholic reflections. In similar vein is the mysterious graffito which notes: 'I have never [illegible] felt so melanchol[ic] I Federigo D', which still leaves us with the question of identifying the author: Federico of Montefeltro? The (melancholic) court painter Federico Barocci, patronized by Francesco Maria II? The last, hapless heir to the dynasty, Federico Ubaldo? Some other Federico?[65] The writing seems to hail from the sixteenth or seventeenth centuries rather than the fifteenth. If confirmed, this dating would exclude Federico da Montefeltro as a possible author. Furthermore, over the last letter, seemingly a 'D', there is a Z line that creates a kind of 'X', thus suggesting the word 'dux'. This would exclude Barocci, too. As for Federico Ubaldo, he indeed normally signed only as 'Federigo' but his writing is quite different from that on the wall.[66] The mystery has still to be solved.

But let us go back to Guidubaldo II. Significantly, in what is known as the 'apartment of the Duchess', there is a piece of writing that actually records the arrival of his wife Vittoria: 'on the 30th day of January 1548 the Illustrious lady Vittoria Duchess of Urbino came for the first time to Urbino at the 22nd hour'.[67] Guidubaldo, who according to the previous graffito glimpsed the lady at the twenty-first hour, saw her therefore (presumably from that very loggia) around an hour before her actual arrival, an arrival that someone at court deemed it appropriate to 'record' on the wall of the apartment that was intended for her (the same one, by the way, that, 250 years later, in 1788, would receive the vice-legate Cavriani). Guidubaldo and Vittoria were to have nine children and would be together for 26 years. At least in part, the wish expressed in the writing on the wall of the loggia was fulfilled, even though their family life was afflicted by the death at young ages of six of their nine children.[68]

Speaking of parents and children, one might well ask whether Guidubaldo had learned to write on the palace walls from his mother, Eleonora Gonzaga (1493–1550) (Pl. 8). 'Eleonora Ducissa Urbini De Rvere',[69] that is, 'Eleonora Duchess of Urbino de Rovere' (Fig. 2.2), we read on the jamb of the door of one of the ground-floor rooms that at that time, as far as we know, formed part of the quarters of the ducal family (moreover, in the same part of the palace where the vice-legates were to stay and where, much later, Ricciarelli was to be held prisoner).

2.2 Graffito probably made by the Duchess Eleonora Gonzaga della Rovere, Ducal Palace of Urbino. Courtesy of the Sovrintendenza per il Patrimonio Storico-Artistico e Demoetno-antropologico delle Marche, Italy

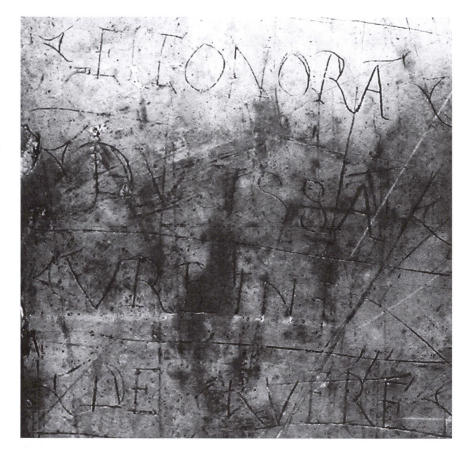

There is little doubt that this name does, in fact, refer to Guidubaldo's mother. The only other Eleonora della Rovere living in this period was actually one of Guidubaldo's own daughters, named after her grandmother, who died at a young age. It seems, besides, probable enough that it was the elder Duchess herself who wrote this graffito, which, containing only her name and title without any viva, comment, report, etc. looks like a signature or tag. Therefore, it was not only representatives of the Pope, but also very probably members of the Duke's family who wrote on the walls of their fine palace.[70] Why?

Federico and his emulators

We have already referred to the fact that the oldest pieces of writing discovered so far date back to a period actually preceding the construction of the palace at the time of Federico da Montefeltro, or referring to its very beginning. In certain respects, however, it may have been the palace itself, as Federico wanted it to be, which prompted people to write on its walls, on the jambs of its doors and on its columns, and in particular to leave on them a sign of

their own identity, something analogous to what today would be called a tag. This does not mean, however, that such writings are peculiar to the Palace of Urbino; on the contrary, in early modern times wall writings were common in palaces, castles and churches as well as on external walls, rocks, etc. For England, Juliet Fleming has even suggested that 'the bulk of early modern writing was written on walls'.[71] Yet in the case of Urbino the obsession of Federico with his name seems to have had a peculiar role in stimulating people to write on the walls.

We have noted that the palace greets those who enter its ceremonial courtyard with a long inscription in which Federico affirms his own role as the instigator of the building and lists his own victories and virtues. But this is not the only instance when we 'encounter' Federico's name on the walls of the palace; as we have said, the initials F.C. and FE. DVX are repeated obsessively. Nearly everywhere one turns one's gaze it is impossible not to see Federico's name evoked. Of course what we see, in these cases, are elegant letters carved by the best stonemasons. Yet in several places I have found the same initials roughly carved on the walls of the palace with a simple sharp object;[72] but by whose hand? Some imitator of the Duke or the Duke himself? It is hard to say. We cannot however rule out the possibility that Federico himself wrote on the walls of his palace. Nonetheless, there is no doubt that the obsessive repetition of his name prompted imitation: in 1682 a certain Jacob Buggenwasser (probably a Swiss Guard) wrote his own name right under FE. DVX, in fine striking characters, on the architrave of a door; in 1766 a certain 'Niclaus Müller von Ruswil' did the same.[73]

Perhaps for this reason, alongside the names of easily recognizable figures, the walls of the palace are crowded with those of minor figures and perfect strangers who might perhaps become identifiable only through long and difficult researches and with a bit of luck. Even at a mere glance it seems clear that men and women who were extremely different in terms of power, culture, social position and geographical origin shared this passion for leaving traces of themselves on door jambs, columns and walls (providing scholars with important sources for the study not only of their relationship with the writings and their graphics skills, and sometimes their perceptions of themselves, but also the functions of the rooms and the numerous aspects of life within the palace). Let us look at some examples.

As the reader might perhaps recall, the author of the 1788 graffito that records the arrival of the vice-legate signs himself: 'Antonio Colombari Bolognese Valet'. And his name, like that of others (the vice-legate Cavalieri, the auditors Campelli and Spinucci, the likely Swiss Guard Jacob Buggenwasser, etc.), appears also in other pieces of writing, one of which states: 'Antonio Colombari Val. of Monsig. the Vice-Legate in the year 1788'.[74] In fact there are numerous pieces of writing that can be attributed to valets, footmen, lackeys, grooms and guards. These are graffiti made either by court staff or by the servants of visitors from outside. It is interesting to observe from the writing practices of the lower and lower-to-middling social strata how those writings left by the

servants also provide us with information about their masters, since many of them have chosen to mention not only their own names but also those of their masters (for example, 'Domenico Corradini Servant of Monseigneur Spada Vice-President of Urbino 1728' and 'I Paolo Merlini Servant to His Eminence Stoppani 1747', both in the 'throne room'[75]).

Like others, lackeys and servants often leave writings on the walls with the intention of recording specific events, often introduced with 'on the day', 'on the', and furnishing the date, and even sometimes the time of day. Or else they leave drawings which, when linked with other sources, can be associated with precise events. In the kitchen, for example, there is a charcoal drawing of one of the gates of the city, the Valbona gate, which can be seen quite clearly from the kitchen windows. This gate was built in 1621, on the occasion of the wedding of Federico Ubaldo and Claudia de' Medici. It is possible that the drawing was done at that very time.[76] There are, however, several writings that do not refer to specific events but rather to cyclical time, connected to the routine of palace life: 'remember whose turn',[77] in other words, 'remember your turn', is written in charcoal on what would have been the intrados of the original door of the room behind the stove for the bath, in the palace basements, near a sketch offering the traditional iconography of Duke Federico. Making sure that the bath was regularly heated and supplied with hot water probably meant that those whose job it was had to observe a rota for performing these tasks.[78]

While in this case we have an example of the palace routine in its 'domestic' functions, there are also references to the palace routine in its 'institutional' functions. 'I was on guard on the 5th day of August'[79] writes an anonymous graffitist on one of the doors of the 'throne room', without telling us either his name or the year, but presumably at some time in the 1500s: a note probably referring to the changing of the guard. There are, besides, a great many writings during the period of the legates left by soldiers of the Swiss Guard, in particular in the room identified as the guardroom.[80] Many graffiti inform us about other (quite cyclical) events that involved the palace and were very important in its life – the arrivals and departures of the Duke. As mentioned, the della Rovere had moved the capital to Pesaro as early as 1523. Furthermore, they had palaces in other cities, too. Thus they often moved from one city to the other, from one palace to the other: 'On 24 June of [15]74 his Lord the Duke came in Urbino *post tenebris* [after the darkness]'; 'On the 11 June of [15]77 the Duke left Urbino to Fossombrone'; '1577 on the 25 June Don Francesco arrived from Casteldurante to Urbino'; 'on the first day of October 1589 the Lord Duke left urbino to go to chasteldurante', etc.[81]

In short, in the palace where Castiglione set the dialogues of *The Courtier*, 'the fayrest that was to be founde in all Italy', people wrote and made drawings on the walls, and someone even carved the name of Vitruvius there (Pl. 5, first floor, no. 19f). Would this have been Francesco di Giorgio Martini who certainly worked in this part of the palace refurbishing an

earlier building?[82] A visitor with a passion for architecture? Perhaps we shall never know, but the graffito is there, a witness to the fact that someone, in the architectural jewel that is the palace, thought about one of the founding fathers of architecture. What is more, there are some apparently very old pieces of graffiti that praise 'Elisabetta'. One states: 'Viva the beautiful Isabta Viva'.[83] Who knows how many Elizabeths lived in or passed through the palace at that time, but it is pleasant to think that the anonymous author(s) of these could have been referring to Elisabetta Gonzaga, in whose rooms, after supper, according to Castiglione, 'everye man ordinarelye, at that houre drewe where the Dutchesse was, the Lady Elizabeth Gonzaga':

There was then to be hearde pleasaunte communication and merye conceytes, and in every mannes countenaunce a manne myght perceyve peyncted a lovynge jucoundenesse. So that thys house truelye myght well be called the verye mansion place of Myrth and Joye. And I beleave it was never so tasted in other place, what maner a thynge the sweete conversation is that is occasioned of an amyable and lovynge companye, as it was once there.[84]

The palace walls also tell us, however, about less idyllic aspects of court life: 'Witless ladies and maidens because you have scant [est]eem for the me[n] of the court'[85] is the apparent content of one graffito carved on the same loggia where by tradition Guidubaldo II himself expressed his wishes about his wife; and on the loggia of the floor below an anonymous author devotes eight bitter lines of verse to the court, which he describes as a 'sea of pain', 'where you will ever weep and struggle' and where 'tyrants are adored even like gods', so much that 'thus little by little you go to the devil'.[86]

Not only are there a great number of writings and drawings, but the variety of themes is enormous too. These range from straightforward names, perhaps with a date, to reflections on life or society; from drawings of phalluses to the taking of political positions ('Long live Flanders by sea and by land'[87]); from descriptions of this or that woman as a whore to vivas aimed at some member of the ducal family; from the most varied drawings, sometimes extremely fine, to short chronicles, relating to a wide range of different occurrences: bolts of lighting, snowfalls out of season and other meteorological phenomena; marriages, both 'important' like that of the Duke and less notable ones ('On the 12 September of 1557 cintia paco[missing]ta was married in the na[me] of God'[88]); quarrels among members of the staff; events which were relevant almost only from the vantage point of the life in palace, such as the arrival and departures of the Duke as well as 'grand historical' events,[89] like the victory won by Emperor Leopold over the Turks laying siege to Vienna, in 1683:

A.P.R.M.
[Ad perpetuam rei memoriam; that is, in perpetual memory]

To His Eminence Spada Legate of Urbino
The news arrived
today the 20th September 1683

that His Caesarean Majesty Leopold
the Emperor
remained victorious
in the war of the
Ottoman against Vienna

Carl'Antonio Amanti
from San Marino
Secretary
of Monsignore Massimi
Vice-legate[90]

Writing on the walls

In the Ducal Palace of Urbino, even the masters of the house, from the members of the Duke's family to representatives of the Pope, took pleasure in writing on the walls, and, apparently, were in no way severe with those who did the same; in fact, it would seem to be the contrary. Thus the walls play host to an enormous variety of writings which bear witness to the different functions of the palace in different periods and to the life that went on inside it: from grandiloquent inscriptions celebrating its public and institutional function to graffiti expressing amorous and matrimonial concerns, probably even of members of the ducal family, reminding us that this building was a focus of family life. A series of graffiti on a jamb door in a room which, at that time, was occupied by members of the Duke's family, possibly even by Vittoria Farnese,[91] makes particularly clear the intermingling of political issues and family life in the rooms of the palace. They are vivas addressed to Francesco Maria II, the firstborn of Guidubaldo II and Vittoria. Here is an example: 'Viva Franc.° Maria II Viva ten years on the 11th day of September MDLIX'[92] (Fig. 2.3). The ages mentioned in each graffito are different, and beneath each one there is a horizontal line. After some initial surprise, I realized that they were tallies of the height of the little Francesco at different ages, and thus clues of a certain concern, both familial and political, towards the growth of the future Duke.

Graffiti of this type prompt us to compare past and present. In part the writings and drawings of the palace can be classified in terms that continue to apply to contemporary graffiti, but in part they are profoundly altered. The chronicle-like notes are, in particular, a genre that is by now virtually extinct, though even today we can read names and dates on walls. It is in fact writings of this kind, similar in many respects to the official inscriptions meant to commemorate this or that event, that play an important role in sometimes making the distinction a slippery one between inscriptions understood as official writings and graffiti, understood as spontaneous writings and drawings, devoid of any official character and made without the approval, or against the wishes, of the masters of the building.[93]

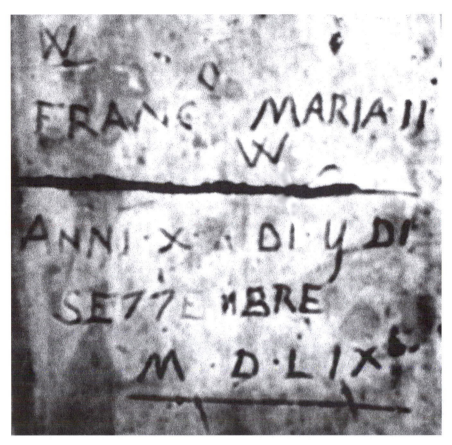

2.3 Vivas addressed to Francesco Maria II della Rovere and line measuring his height at the age of ten, 1559. Courtesy of the Sovrintendenza per il Patrimonio Storico-Artistico e Demoetno-antropologico delle Marche, Italy

As shrewd and careful scholars, Kraack and Lingens are actually perfectly aware of the fact that the distinction between inscriptions and graffiti is not always applicable to the real state of things; they record for example the case of those priests who allowed the faithful to make writings and drawings at least in some parts of churches; and the hotel-keepers who, far from being irritated by the scribblings left by their regular customers, frequently regarded them as a form of useful publicity which enabled them to advertise the fact that even important figures had been their guests.[94] At least in part this would seem also to be true of the Ducal Palace in Urbino, whose walls were (and are) likewise a 'showcase' of the personages who lived in it and visited it.[95]

Visitors, moreover, often loved (and love) to leave visible traces of their passage there. And not just those who visited the palace for brief periods, but also those who 'visited' it in order to discharge functions held by them, such as those of legate, vice-legate, judge, etc. In the impermanence of their periods in office, legates and vice-legates were simultaneously 'visitors' and 'residents' of the palace, masters in the house for however long or short a time their legation or vice-legation lasted. Their practice of writing on the walls had been forestalled by much more enduring masters of the house;

that is, members of the ducal family. With Federico taking the lead, present by name in almost every corner of the palace in order to reaffirm himself as its owner and inspiration, it is very likely that some members of the ducal family also used the walls to write their names, leave records or make commentaries.

By way of interpretation I should like to suggest that it was precisely the monumental and 'public' nature of the palace that stimulated the production of writings and drawings. Federico had proudly and obsessively indicated to everyone entering it that he was its master and guiding hand: the palace itself, just as he had conceived it, was not only to fulfil public functions but it also took for granted an audience: an audience of visitors and readers of the writings that the Duke had set on its walls. This was a mechanism that could be reproduced on a different scale; after Federico, other masters of the house would in turn leave official inscriptions and tablets as well as informal writings. Also conceived from the very start as a surface for texts, the palace lent itself to being written upon and read. And so not only the masters of the house, but other residents and visitors also left graphic traces of their presence, in a multiplication of writings and drawings that differed in kind, quality, content, language, period and authorship – a crescendo of writings and drawings that bore witness to, and simultaneously enlarged, the public nature of the palace. If in some respects these writings can seem like acts of vandalism that deface this monument, in other respects they cannot fail to be regarded as a tribute to its importance and to that of its masters, to the extent that for centuries many of those who lived in, or visited it, were unable to resist the temptation of leaving traces of their presence in so august a place.

In saying this I do not wish to reduce the plurality of intentions that no doubt animated the authors of the writings on the walls of the ducal palace. Nor do I wish to exaggerate their specificity, given that the 'culture' of leaving traces of the self on walls by means of writings and drawings had been extremely widespread for centuries. Certainly, it was already the occasional object of condemnation by the time Federico da Montefeltro was building his palace in Urbino, especially if writings and drawings were made in holy places.[96] Nevertheless, this practice continued to flower for centuries, subject increasingly to censure, from what we can tell, as it was gradually abandoned by the nobility and became exclusively a practice of other social groups,[97] albeit with specific forms (such as the absence of any heraldic connections). This was, however, a slow process, as indeed shown by the walls of the Ducal Palace in Urbino.[98] The theory I have sought to put forward in this essay is that the proliferation of writings on these walls was stimulated chiefly by the public, institutional and monumental aspect of the palace, even though they inform us about various aspects of its private and domestic one.

In the light of my line of argument, it is worth concluding with a return to the three binary oppositions from which we set out (inscriptions ↔

graffiti; institutional ↔ domestic; public ↔ private). Certainly, the boundary between inscriptions and graffiti has proved to be more fluid than was foreseen and, above all, articulated in an unexpected way, in the sense that it has not proved possible to distinguish the former from the latter along the axis of authorized/unauthorized. Significantly, some authors prefer the category of 'exposed writings' (*scritture esposte*), which includes any type of writing exposed in public spaces on walls, monuments, etc.[99] This category, too, however, does not seem sufficient to classify the variety of wall writings present in Urbino: even though, as mentioned, I believe that precisely the public character of the palace stimulated people to write on the walls, I cannot ignore that many writings were written in rooms that were mainly (though not exclusively) private. Certainly, while 'the prohibition against writing on the interior walls of a house is now deeply internalized', this was not the case in early modern times.[100]

Nonetheless, it has also been impossible to use inscriptions (on the one hand) and graffiti (on the other) as indicators of public and institutional spaces by contrast with private and domestic ones, and this is not only, and not so much, because the distinction between the two has appeared much less clear than one might have expected, but also because all types of writings and drawings visible today in the palace are particularly numerous in those areas more open to the public and with a more conspicuous institutional dimension. In conclusion, for this reason, the unusual choice of source for this piece of work, writings on walls, confirms the difficulty of making clear distinctions between private and public spaces, albeit separate, in a palace that was the seat of public powers. On the other hand the density of the writings (of any type), while indicating that the public-institutional dimension tends to overlap and rob space from the private-domestic sphere, seems to remains an indicator of the areas of the palace that were more open to the public and with a more marked institutional character.

Notes

* I am very grateful for their comments to the editors of the volume, Sandra Cavallo and Silvia Evangelisti, and to the colleagues who took part in the international conference, *Domestic and Institutional Interiors in Early Modern Europe* (London, Victoria and Albert Museum, 19–20 November 2004). Several friends and colleagues gave me useful suggestions about my research on graffiti. I wish to thank Franco Bacchelli, Ugo Berti Arnoaldi, Bruno Breveglieri, Glauco Maria Cantarella, Antonio Castillo Gómez, Asher Colombo, Giuseppe Cucco, Angela De Benedictis, Patrizia Delpiano, Tommaso di Carpegna Falconieri, Sabina Crippa, Patrizia Dogliani, Daniela Frigo, Luisa Fontebuoni, Margareth Lanzinger, Barnaba Maj, Monica Miretti, Adelina Modesti, Gianluca Montinaro, Ottavia Niccoli, Paolo Prodi, Carla Salvaterra, Alba Tontini and Riccardo Paolo Uguccioni. I am grateful to the Sovrintendenza per il Patrimonio Storico-Artistico e Demoetnoantropologico delle Marche, and particularly to Benedetta Montevecchi and Agnese Vastano, as well as the personnel of the Galleria Nazionale delle Marche, for facilitating my research and for their interest in it. I proposed an initial analysis of the

graffiti in the Palace of Urbino in Raffaella Sarti, 'Graffitari d'*antan*. A proposito dello scrivere sui muri in prospettiva storica', *Polis*, 21 (2007), 399–428 (available online at <http://www.mulino.it/rivisteweb/scheda_articolo.php?id_articolo=25691>).

1 The quotation is taken from an English translation, *The Book of the Courtier* by Sir Thomas Hoby (1561) as edited by Walter Raleigh, for David Nutt, Publisher, London, 1900. It was transcribed by Risa S. Bear at the University of Oregon during the summer of 1997. This edition is provided to the public for non-profit purposes only; the design is copyright © 1997 The University of Oregon: see <http://www.uoregon.edu/~rbear/courtier/courtier.html> (first book). The Italian original text is as follows: 'Alle pendici dell'Appennino, quasi al mezzo della Italia verso il mare Adriatico, è posta, come ognun sa, la piccola città d'Urbino; la quale, benché tra monti sia, e non cosí ameni come forse alcun'altri che veggiamo in molti lochi, pur di tanto avuto ha il cielo favorevole, che intorno il paese è fertilissimo e pien di frutti; di modo che, oltre alla salubrità dell'aere, si trova abundantissima d'ogni cosa che fa mestieri per lo vivere umano. Ma tra le maggior felicità che se le possono attribuire, questa credo sia la principale, che da gran tempo in qua sempre è stata dominata da ottimi Signori; avvenga che nelle calamità universali delle guerre della Italia essa ancor per un tempo ne sia restata priva. Ma non ricercando piú lontano, possiamo di questo far bon testimonio con la gloriosa memoria del duca Federico, il quale a' dí suoi fu lume della Italia; né mancano veri ed amplissimí testimonii, che ancor vivono, della sua prudenzia, della umanità, della giustizia, della liberalità, dell'animo invitto e della disciplina militare; della quale precipuamente fanno fede le sue tante vittorie, le espugnazioni de lochi inespugnabili, la súbita prestezza nelle espedizioni, l'aver molte volte con pochissime genti fuggato numerosi e validissimi eserciti, né mai esser stato perditore in battaglia alcuna; di modo che possiamo non senza ragione a molti famosi antichi agguagliarlo. Questo, tra l'altre cose sue lodevoli, nell'aspero sito d'Urbino edificò un palazzo, secondo la opinione di molti, il piú bello che in tutta Italia si ritrovi; e d'ogni oportuna cosa sí ben lo fornì, che non un palazzo, ma una città in forma de palazzo esser pareva.' See Baldassar Castiglione, *Il libro del cortegiano* (Milan: Garzanti, 2003), 17–19 (1st edn: Venice: nelle case d'Aldo e d'Andrea d'Asolo, 1528).

2 Amedeo Quondam, 'Introduzione', in Castiglione, *Il libro del cortegiano* (2003), VII–LI (in part. VIII–IX).

3 In spite of numerous studies, discussion is still ongoing about the planning of the palace. Certainly Luciano Laurana directed the construction site between 1468 and 1472 (but he had probably worked there already in 1466; see Jerez Höfler, *Der Palazzo Ducale in Urbino unter den Montefeltro (1376–1508). Neue Forschungen zur Bau- und Ausstattungsgeschichte* (Regensburg: Schnell & Steiner 2004), 123. Scholars also discuss the role of Duke Federico da Montefeltro himself and of Francesco di Giorgio Martini, as well as those of Maso di Bartolomeo, Leon Battista Alberti, Piero della Francesca, Bramante and still others. This is not the appropriate place to examine the issue. For an overview of different interpretations see Pietro Zampetti and Rodolfo Battistini, 'Federico da Montefeltro e il Palazzo Ducale', in *Il Palazzo di Federico da Montefeltro*, ed. Maria Luisa Polichetti (Urbino: Quattroventi, 1985), 51–66 (the issue is also discussed in most of the essays collected in this book); Paolo Dal Poggetto, *La Galleria Nazionale delle Marche e le altre Collezioni nel Palazzo Ducale di Urbino* (Urbino and Rome: Novamusa del Montefeltro e Istituto Poligrafico dello Stato, 2003), 19. The bibliography on the palace is extensive. For a recent discussion see Höfler, *Der Palazzo Ducale in Urbino*.

4 Visible in the main courtyard, on the jamb of the door of today's bookshop (for the location see Pl. 5, ground floor, no. 27).

5 Maria Luisa Polichetti, 'Nuovi elementi per la storia del palazzo: restauri e ricerche', in *Il Palazzo di Federico*, ed. Polichetti, 137–79 (esp. 163–4). Polichetti refers to the date 1449 or 1455 written in the intrados of a door later closed by the staircase of honour (*scalone d'onore*, Pl. 5, ground floor, no. 33), near to the graffiti drawings of two fortresses. Polichetti tentatively suggests that the construction of the palace (which included older buildings) might have started in 1454 (*ibid.*). I have recently found a graffito in the *Cortile del Gallo* with an earlier date (or so it seems): 'AD 1453' (Pl. 5, ground floor, no. 6). Actually Polichetti mentions another graffito present in the basement (which I was not able to find) with the date of 1453 (*ibid.*, 161), but in her concluding remarks only mentions the date that can be interpreted as 1449 or 1455.

6 Detlev Kraack and Peter Lingens, *Bibliographie zu Historischen Graffiti zwischen Antike und Moderne* (Krems: Medium Aevum Quotidianum, 2001), 9–10. See also Detlev Kraack, *Monumentale Zeugnisse der spätmittelalterlichen Adelsreise: Inschriften und Graffiti des 14.–16. Jahrhunderts* (Göttingen: Vandenhoeck & Ruprecht 1997), 9–14, and references therein. Luc Bucherie, 'Mise en scène des pouvoirs dans les graffiti anciens (XV–XVIIe siècles)', *Gazette des Beaux-Arts*, CIII, 1 (1984), 1–10 (p. 1) defines graffiti as unofficial images or writing; analogously, Norbert Siegl stresses the fact that they are writings and drawings made at no one's behest, while observing that in the variant of modern spray-paint graffiti the concept can also be extended to those produced to official commission – see Norbert Siegl, *Kulturphänomen Graffiti* (Vienna: Institut für Graffiti-Forschung, 2007, <www.graffitieuropa.org/kultur1>). There is a rich literature, mainly produced by scholars other than historians, on different types of wall writing in ancient, medieval and (to a lesser degree) early modern times. Besides works mentioned in previous and succeeding notes, see for instance Giovanni Geraci, 'Ricerche sul proskynema', *Aegyptus*, 51/1 (1971), 3–211; Armando Petrucci, *La scrittura. Ideologia e rappresentazione* (Turin: Einaudi, 1986), 149–64; Luca Canali and Guglielmo Cavallo, *Graffiti latini. Scrivere sui muri a Roma antica* (Milan: Bompiani, 1991); Luc Bucherie, 'Graffiti et histoire des mentalités. Genèse d'une recherche', *Antropologia Alpina*, Annual Report, no. 2 (1990–91), 41–64, with information on the development of studies of graffiti in France; *Scrittura e figura. Studi di antropologia della scrittura in memoria di Giorgio Raimondo Cardona*, special issue of *La Ricerca Folklorica*, vol. 31 (1996), 1–160, ed. Attilio Bartoli Langeli and Glauco Sanga; Attilio Bartoli Langeli et al., *La città e la parola scritta*, ed. Giovanni Pugliese Carratelli (Milan: Credito italiano, Garzanti, Scheiwiller, 1997), esp. the essay by Fabio Troncarelli, 'I muri parlano', 457–64; *Los muros tienen la palabra: materiales para una historia de los graffiti*, ed. Francisco M. Gimeno Blay and Maria Luz Mandingorra Llavata (Valencia: Departamento de historia de la antiguedad y de la cultura escrita 1997); *Visibile parlare: le scritture esposte nei volgari italiani dal Medioevo al Rinascimento*, ed. Claudio Ciociola (Naples: Edizioni Scientifiche Italiane, 1997); Juliet Fleming, *Graffiti and the Writing Arts of Early Modern England* (London: Reaktion, 2001); Thomas Northoff, *Graffiti. Die Sprache an den Wänden* (Vienna: Löcker, 2005); Antonio Castillo Gómez, *Entre la pluma y la pared. Una historia social de la escritura en los Siglos de Oro* (Madrid: Akal, 2006); *Pietra, scrittura e figura in età postmedievale nelle Alpi e nelle regioni circostanti*, special issue of *Archeologia postmedievale*, 10 (2006), ed. Tiziano Mannoni et al.

7 In fact, at the beginning of the sixteenth century Urbino experienced other troubles, too. In 1502–1503 it was occupied by the son of Pope Alexander VI,

Cesare Borgia ('Valentino'). Later, after the death of the della Rovere Pope Giulio II, his successor, Leo X (Giovanni de' Medici, 1513–21), assigned the duchy to his nephew, Lorenzo de' Medici (1516). Urbino went back to the della Rovere family in 1521. On the history of Urbino in the fifteenth and sixteenth centuries, see for instance James Dennistoun, *Memoires of the Dukes of Urbino Illustrating the Arms, Arts, and Literature of Italy from 1440 to 1630* (London: Longman, Brown, Green and Longmans, 1851); Robert de La Sizeranne, *Federico di Montefeltro capitano, principe, mecenate (1422–1482)*, trans. Carmine Zeppieri (Urbino: Argalia, 1972; orig. publ. as *Le verteux condottiere: Federigo de Montefeltro duc d'Urbino: 1422–1482* (Paris: Hachette, 1927); Cecil H. Clough, *The Duchy of Urbino in the Renaissance* (London: Variorum Reprints: 1981); *Federico di Montefeltro. Lo Stato, le arti, la cultura*, ed. Giorgio Cerboni Baiardi, Giorgio Chittolini and Pietro Floriani (Rome: Bulzoni, 1986); Leonardo Benevolo and Paolo Boninsegna, *Urbino*, 3rd edn (Rome-Bari: Laterza, 2000; 1st edn 1986); Marinella Bonvini Mazzanti, *Battista Sforza Montefeltro. Una 'principessa' nel Rinascimento italiano* (Urbino: Quattroventi, 1993).

8 The term 'istituzionale' is first attested in the Italian language as late as 1928: Manlio Cortelazzo and Paolo Zolli, *Dizionario etimologico della lingua italiana* (Bologna: Zanichelli, 1979–88), *ad vocem*.

9 In fact the Pope had sent a governor as early as 1625. On this period see *Gli ultimi Della Rovere: il crepuscolo del Ducato di Urbino*, ed. Paolo del Poggetto and Benedetta Montevecchi (Urbino: Quattroventi, 2000); Paolo Dal Poggetto, 'La Galleria Nazionale delle Marche nel Palazzo Ducale: Collezioni fruizioni allestimenti', in *Il Palazzo di Federico*, ed. Polichetti, 105–24 (esp. 105); *ibid.*, *La Galleria Nazionale*, 16–17, 30, 33–5; Monica Miretti, *Sul viale del tramonto*, n.d., available online at <www.uniurb.it/storia/edocs/ducato_di_urbino.pdf>; Fert Sangiorgi, *Documenti urbinati. Inventari del Palazzo Ducale (1582–1631)* (Urbino: Accademia Raffaello, Arti Grafiche Editoriali, 1976), 17, 199–315. Several precious paintings and statues which had remained in Urbino were taken to Rome by the first legate, Antonio Barberini, brother of Pope Urban VIII (1623–44), while Pope Alexander VII (1655–67) allowed the transport to Rome of the immensely rich library of the dukes (Francesco Maria II had left his books and manuscripts to the community of Urbino, which sold them cheaply to the Pope in 1657; see Luisa Fontebuoni, 'Destinazioni d'uso dal sec. XV al XX', in *Il Palazzo di Federico*, ed. Polichetti, 185–302, esp. 228).

10 In some periods, particularly in the eighteenth century, instead of the legate there was a representative of the Pope called *presidente* who, however, performed the same functions as the legate; see Carlo Stramigioli Ciacchi, 'Araldica ecclesiastica. La Legazione di Urbino-Pesaro. Pontefici, Governatori, Cardinali Legati, Presidenti, Delegati apostolici e Vicelegati', *Frammenti*, 5 (2000), 149–239 (esp. 154).

11 Raffaella Sarti, *Europe at Home. Family and Material Culture, 1500–1800*, trans. Allan Cameron (New Haven CT and London: Yale University Press, 2002), 31–3; orig. publ. as *Vita di casa. Abitare, mangiare, vestire nell'Europa moderna* (Rome-Bari: Laterza, 1999). On the word *famiglia* in the sense of staff or court see *'Familia' del principe e famiglia aristocratica*, ed. Cesare Muzzarelli (Rome: Bulzoni, 1988). On the case of Urbino, see esp. Cecil H. Clough, 'La "familia" del duca Guidubaldo da Montefeltro e il *Cortegiano*', in Muzzarelli, vol. 2, 335–47.

12 The concept of family did not necessarily presuppose any implication of domesticity even when it referred only to the staff. In Urbino, in particular, not all the members of the *famiglia* in the sense of staff lived in the Ducal Palace;

see for instance Paolo Peruzzi, 'Lavorare a corte: "Ordine et officij". Domestici, familiari, cortigiani e funzionari al servizio del duca d'Urbino', in *Federico di Montefeltro*, ed. Cerboni Baiardi et al., vol. I, 225–96 (esp. 266–8); Clough, 'La "famiglia" del duca Guidubaldo', 338–9.

13 The *bargello* was responsible for overseeing public order.

14 Obviously, the use of *famiglia* in the sense of ducal staff implied different 'mechanisms' and in particular the hiring of new servants. On these 'mechanisms' see Sabine Eiche, 'Behind the Scenes of the Court', in *Ordine et officij de casa de lo illustrissimo signor duca de Urbino*, ed. Sabine Eiche (Urbino: Accademia Raffaello, 1999), 45–80.

15 Polichetti, 'Nuovi elementi', 172; Fontebuoni, 'Destinazioni d'uso', 224–5.

16 Fontebuoni, 'Destinazioni d'uso', 248.

17 *Ibid.*, 242, 253, 255–7.

18 *Ibid.*, 277; Dal Poggetto, 'La Galleria Nazionale'; Dal Poggetto, *La Galleria Nazionale*, 33–4.

19 Now most of the palace is occupied by the Gallery and the offices of the Sovrintendenza per il Patrimonio Storico-Artistico, but until recently parts of it were still used for other purposes. Until the 1960s there was, for instance, a cooperative wine store (*cantina sociale*, see Fontebuoni, 'Destinazioni d'uso', 270) and until a few years ago other rooms were occupied by a school, the Istituto d'Arte (Dal Poggetto, *La Galleria Nazionale*, 301).

20 Polichetti, 'Nuovi elementi', 152–3.

21 'L'intrata, le scale, le andate, et li porteci et tucti li lochi dove se ha andare fino ala camera del signore', *Ordine et officij*, ed. Eiche, 124–5. This text had been already published by Giuseppe Ermini in 1932; see *Ordini et offitji alla corte del Serenissimo Signor Duca di Urbino* (Urbino: Regia Accademia Raffaello, Società Tipografica Editrice Urbinate, 1932).

22 Peruzzi, 'Lavorare a corte', 229; *Ordine et officij*, ed. Eiche, 104–5, 124–6.

23 'La cucina generale vole essere publica.' There should also be a little kitchen for the cook of the Duke, while other cooks should be in charge of preparing meals for the *famiglia* and still others for foreigners and noblemen. *Ordine et officij*, ed. Eiche, 118.

24 Allen J. Grieco, 'Conviviality in a Renaissance Court: The *Ordine et Officij* and the Court of Urbino', in *Ordine et officij*, ed. Eiche, 37–44: 'Meals were not only a pretext for splendid conviviality, but were also meant to impress all those who visited a court as well as those who never actually visited it but read or heard about feasts, in which conspicuous consumption played an important role. The grandeur of court banquets was meant to be broadcast to a more general public as is attested by the detailed descriptions of feasts that circulated as early as the fourteenth century … Descriptions of banquets also served the purposes of political propaganda, as the grandeur and wealth of a court was also measured by the variety and quantity of food served during banquets and on special occasions of all kinds' (37–8).

25 Fontebuoni, 'Destinazioni d'uso', 194. Being located in the basement, they are not visible in Pls 5 and 6.

26 *Ordine et officij*, ed. Eiche, 101.

27 John Larner, 'Introduction', in *Ordine et officij*, ed. Eiche, 5–11 (esp. 9). See also John Easton Law, 'The *Ordine et officij*: Aspects of Context and Content', in *Ordine et officij*, ed. Eiche, 13–35 (esp. 20–25); Peruzzi, 'Lavorare a corte', 234–49, 265, 278; and esp. *Ordine et officij*, ed. Eiche, 127–8.

28 Peruzzi, 'Lavorare a corte'; Fontebuoni, 'Destinazioni d'uso'.

29 Dennistoun, *Memoires of the Dukes of Urbino*, vol. 1, 420 (quotation); Luciano Ceccarelli, *'Non mai'. Le 'imprese' araldiche dei Duchi di Urbino, gesta e vicende familiari tratte dalla corrispondenza privata,* ed. Giovanni Murano (Urbino: Accademia Raffaello, 2002), 18.

30 The palace is immense and I still have to analyse in detail some parts of it, particularly in the basements.

31 The doors of many of these rooms have no architraves or jambs.

32 Actually Fontebuoni ('Destinazioni d'uso', 186, 188) thinks that the room usually defined as *tinello* was the 'general kitchen' mentioned in the *Ordine et officij*, while the room usually defined as a kitchen was the Duke's kitchen of the *Ordine et officij*.

33 See also Polichetti, 'Nuovi elementi', 153. The door to the southern tower in the 'Cortile del Gallo' (Pl. 5, ground floor, no. 5) has an architrave with the acronym F. C.

34 'FEDERICVS MONTEFELTRIVS DVX VRBINI MONTISFERETRI AC DURANTI COMES SERENISSIMI REGIS SICILIAE CAPITANEVS GENERALIS SANCTAEQVE ROMANAE ECCLESIAE GONFALONERIVS MCCCCLXXVI'; see Dal Poggetto, *La Galleria Nazionale*, 125–6, 141–3. For the location of these rooms see Pl. 5, ground floor, nos. 26a, 26b, 26c (Chapel and Temple) and first floor, no. 14b (*studiolo*).

35 *Ordine et officij*, ed. Eiche, 118.

36 Dal Poggetto, *La Galleria Nazionale*, 125.

37 I found some graffiti on the door jambs of one of the two doors of the latrine (which I still have to analyse); Fontebuoni ('Destinazioni d'uso', 252–3) mentions some graffiti in the latrines but probably quite recent (late eighteenth or nineteenth centuries).

38 *Ibid.*, 201, 218; Dal Poggetto, *La Galleria Nazionale*, 211.

39 On the external walls, particularly (but not only) on the architraves of doors and windows, there are symbols and inscriptions (especially F. C. and FE. DVX), while, as far as I can judge, there are few ancient graffiti, concentrated on the door jambs. The question is whether in the past there were also graffiti on the walls, which have since disappeared, or whether such writing never existed.

40 In other cases for which we have information, such as the castle of Issogne, in Val d'Aosta, the graffiti are also particularly numerous in the more public areas; see Omar Borettaz, *I graffiti nel castello di Issogne in Valle d'Aosta* (Ivrea: Priuli & Verlucca, 1995), 42, 50.

41 'Io Crescentino Ricciarelli Caporalle della provinciale sonno stato giorni 12 in questa Canbera in pregione dell 1819 marzo senza cagi°ne sono stato mesi 33 soldato di N[apoleone] imp [?] e viva'. A slightly different transcription in Fontebuoni, 'Destinazioni d'uso', 255: 'cambra' instead of 'canbera'; 23 instead of 33; after the N, omission of the letters that can perhaps be read as 'imp'.

42 The graffito is in the splay of the window of room no. 26d on the ground floor (Pl. 5).

43 Some of the graffiti in the Ducal Palace at Urbino are well known and have been used in publications relating to the palace or to the history of graffiti (for example *Il Palazzo di Federico*, ed. Polichetti; in particular Polichetti, 'Nuovi elementi', and Fontebuoni, 'Destinazioni d'uso'; Giorgio Batini, *L'Italia sui muri* (Firenze: Bonechi, 1968)). However, there has never been any systematic work done on them that is comparable, for example, to the work of Borettaz on the castle of Issogne in Val d'Aosta (Borettaz, *I graffiti nel castello di Issogne*) or that of Pucci on the loggia of the Palazzo del Principe in Genoa (Italo Pucci, 'I graffiti del *Palazzo del Principe* Andrea Doria in Genova', *Archeologia postmedievale*, 10 (2006), 141–54).

44 Fontebuoni, 'Destinazioni d'uso', 255.

45 By 1888 Cesare Lombroso's book *Palinsesti del carcere* (Turin: Bocca, 1888) had been published. The graffiti in the Palermo Inquisition prison were studied by Giuseppe Pitrè (1841–1916), with his posthumous work *Del Sant'Uffizio di Palermo e di un carcere di esso* (Roma: Seli, Soc. Ed. del Libro Italiano, 1940). This book was partially republished in Giuseppe Pitrè and Leonardo Sciascia, *Urla senza suono. Graffiti e disegni dei prigionieri dell'Inquisizione* (Palermo: Sellerio, 1999), 47–173. Leonardo Sciascia became interested in these graffiti and his text – *Graffiti e disegni dei prigionieri dell'Inquisizione* (Palermo: Sellerio, 1977) – was also republished in *Urla senza suono* (9–30). For more recent studies, see Adriano Prosperi, 'Un muro di parole. Graffiti nelle carceri bolognesi', in *idem, America e Apocalisse e altri saggi* (Pisa-Rome: Istituti editoriali poligrafici internazionali, 1999), 195–201; Umberto Eco, 'Graffiti di San Giovanni in Monte', in *San Giovanni in Monte. Convento e carcere: tracce e testimonianze* (Bologna: Bologna University Press, 1995), 130–38; Luc Bucherie, 'Graffiti de prisonniers anglais au château de Tarascon (Bouches-du-Rhône): l'exemple du H.M.S. sloop of war Zephir (1778)', *Archeologia postmedievale*, 10 (2006), 205–16; Castillo Gómez: *Entre la pluma y la pared*, 146–53.

46 'Al'[?] Em.^mo Rev.^mo S.^re Card.^e Delci Leg.^to delli 1660 Al'[?] Ill.^mo Mons.^re Montecatini V. Leg.' (Pl. 5, ground floor, no. 2, that is, balcony); 'Gaetano de Cavalieri Viceleg.^to l'Anno 1711' (for a photo of this graffito see Sarti, 'Graffitari d'*antan*', 406, Fig. 5); 'Monsignor de Cavalieri arrivò in Leg.^ne alli 4 di Xbre 1710 e fu promosso alla P della Sac. Consulta il dì 4 Marzo 1712 sostenne il governo in capite dalli 2 aprile a tutto ottobre d.° e partì dopo i Santi per Roma'; 'Antonio Spinelli V:Legato 1745 1746' (all in the same room where Rusciadelli's graffito is engraved, Pl. 5, ground floor, no. 26d).

47 For a photo of these coats of arms, see Sarti, 'Graffitari d'*antan*', 407, Fig. 6.

48 Stramigioli Ciacchi, 'Araldica ecclesiastica', 158, 178.

49 The graffito is on the balcony (Pl. 5, ground floor, no. 2). The tablet on the ground floor (Pl. 5, first floor, no. 9) states: 'PRINCIPIS EMINENT.^MI SCIPIONIS CARDINALIS DELCII SENENSIS VRBINI DE LATERE LEGATI QVI ANNVIS AVLICI SPHOERISTERII CENSIBVS HVIC ATTRIBVTIS ACADEMIAE REM LVDRICAM IN SAPIENTIAE VSVM CONVERTIT RECTORES HOC INTER INNVMERA PVBLICAE VTILITATI CONGESTA HVMILLIME RECOLVNT BENEFIVM MDCLX' (Fontebuoni, 'Destinazioni d'uso', 227). D'Elci is also commemorated by a plaque in what is now via Puccinotti ('POST PRONVNCIATVM CONSENSV PLAUSUQ. UNANIMI HUIUS CIVITATIS PROTECTOREM PRINCIPEM EMINENTISS. SCIPIONEM CARDINALEM EX COMITIBUS ILCII SENENSEM URBINI DE LATERE LEGATUM QUI GLORIOSO REGIMINI MAXIMA IN EANDEM SUPER ADDIDIT BENEFICIA PUBLICAE GRATITUDINI ET FORTUNAE CONSULTUM EST ANNO DOMINI

MDCLXI'. The plaque is noted also on the website <http://www.chieracostui.com/costui/docs/search/schedaoltre.asp?ID=4575>, from which I have taken the transcription).

50 Giovanni Battista di Crollalanza, *Dizionario storico-blasonico delle famiglie nobili e notabili italiane estinte e fiorenti* (Bologna: Forni, n.d.; orig. publ. Pisa: Presso la direzione del Giornale araldico, 1886–90), vol. II, 162.

51 'Adi 6 giugno 1690 arrivo in questa stanza s.e. Monsignor Alb [illegible] vicelegato' (Pl. 5, ground floor, no. 27).

52 Stramigioli Ciacchi, 'Araldica ecclesiastica', 185–6.

53 'Al Pian terreno … su la mano destra'; see Biblioteca Universitaria di Urbino, Fondo del Comune, ms 72, *Diari e lettere ed altre interessanti notizie concernenti il viaggio di Mons. Origo e Lancisi da Roma in Urbino*, c. 124r, partially reproduced in the *Regesto documentario*, ed. Luisa Fontebuoni, in *Il Palazzo di Federico*, ed. Polichetti, 355–421 (esp. 399–402). In fact there is no third floor. The author possibly refers to the second floor, while Fontebuoni ('Destinazioni d'uso', 228) suggests that he lived in the so-called 'appartamento della Jole' (Pl. 5, first floor, nos. 13a–13i).

54 It was 'tenuto pessimamente' and used in part as 'rimessa de Calessi'. The journal was a report of Origo's and Lanciani's inquiry but was materially written by Origo, *ibid.*, 400. Pope Clemens XI was born Giovan Francesco Albani in 1649. He was elected in 1700 and died in 1721.

55 44. On the series of the vice-legates, see Stramigioli Ciacchi, 'Araldica ecclesiastica', 231–2. I have only found a graffito by a member of Barbarigo's staff. Fontebuoni, 'Destinazioni d'uso', 244, ground floor, no. 25.

56 'D.O.M. Alli 8 Agosto 1788 vene in quest'Apartamento Monsignor Cavriani Vicelegato Antonio Colombari Bolognese Cameriere fece.' In Sarti, 'Graffitari d'*antan*' (413), I omitted the vice-legate's name when I reproduced this quotation. On the identity of the vice-legate, see Stramigioli Ciacchi, 'Araldica ecclesiastica', 233. For the location of the room see Pl. 5, first floor, no. 19f.

57 Fontebuoni, 'Destinazioni d'uso', 246.

58 'Abitò qui in queste stanze L'Ill.^mo Sig.^re Auditore Campelli da Spoleto Nobile Cavaliere sotto la Legatione dell'E:^mo Cardinal Spada' (Pl. 5, first floor, no. 1). For the period when Fabrizio Spada was the legate, see Stramigioli Ciacchi, 'Araldica ecclesiastica', 184.

59 'Io B Pascalis Campelli' (Pl. 5, first floor, no. 14b). The *auditore* or *uditore* was a judge.

60 'Stanze del segretario Boncori 1691' (Pl. 5, first floor, no. 14c).

61 The English translation reads '1548 at 21 hours the Duke saw his wife whose arrival may be happy and may last forever' (Pl. 5, first floor, no. 2). In early modern times hours were counted from dawn onwards; thus hours changed according to the seasons.

62 For instance, this graffito is cited by Batini, *L'Italia sui muri*, 14, who, however, transcribed 21 as VI. and by Harald Olsen, *Urbino* (Copenhagen: Bogtrykkeriet Hafnia, 1971), 48.

63 See for instance Ceccarelli, '*Non mai*', 114–15, 129.

64 There are also graffiti that suggest amorous encounters in other parts of the palace: on the jamb of a door giving access to the first floor from the narrow

spiral staircase in the northern tower, we can read 'Felice.Dolce.Aventuroso.Loco Fabio Lan.^{no}'; that is, 'Happy.Sweet.Eventful.Place Fabio Lan.^{no}' (Pl. 5, first floor, no. 1).

65　'Io non mi [illegible] ritrovai [arritrovai?] mai piu tanto malenconi[co] Io Federigo D'. Federico Ubaldo, an uneasy young man, died at the age of 18, maybe murdered; see for instance *Gli ultimi Della Rovere*, ed. Dal Poggetto and Montevecchi; Miretti, *Sul viale del tramonto*. Barocci was already described as a melancholic painter in contemporary sources. On his personality see Rudolf Wittkower and Margot Wittkower, *Born under Saturn: The Character and Conduct of Artists: A Documental History from the Antiquity to the French Revolution* (London: Weidenfeld & Nicolson, 1963), 79–81; Maria Rosaria Valazzi, 'Le arti "roveresche" e il tramonto del ducato di Urbino. Federico Barocci e Francesco Maria della Rovere', in *Federico Barocci. Il miracolo della Madonna della gatta*, ed. Antonio Natali (Cinisello Balsamo: Silvana, Amici degli Uffizi, 2003), 105–21.

66　See for instance the series of letters he wrote to his father in the State Archive of Florence, Ducato di Urbino, Cl. I F.106: a 182, 1611–22 Della Rovere Federico Ubaldo Lettere al padre da Pesaro. Obviously writing on a wall is different to writing on paper, but nonetheless in this case even single letters are often made in a different way on the wall and on paper, thus suggesting that the author of the graffito was probably not Federico Ubaldo.

67　'Adi 30 di Genaro 1548 la S.^{ra} Ill.^{ma} Vittoria duchessa di Urbino vene in Urbino la prima volta hore 22' (Pl. 5, first floor, no. 19f).

68　Numerous websites provide information about the genealogies of aristocratic families. On the della Rovere line see, for example, <http://genealogy.euweb.cz/italy/rovere.html>.

69　In Sarti, 'Graffitari d'*antan*', 410, I have erroneously transcribed 'Ruvere'. For the location see Pl. 5, ground floor, no. 26f.

70　This was the case in the Castle of Issogne, too; see Borettaz, *I graffiti nel castello di Issogne*, 38, 48.

71　Fleming, *Graffiti and the Writing Arts*, 50.

72　For a photo of an example of these graffiti see Sarti, 'Graffitari d'*antan*', 412, Fig. 10. In this paper I wrote that I found three 'FE. DVX' graffiti but subsequently I have found others.

73　Both these doors are located at the main entrance to the palace, before the ceremonial courtyard (Pl. 5, ground floor, no. 30). In Sarti, 'Graffitari d'*antan*' (412) I transcribed 'Nicolaus' but actually 'Niclaus' is correct.

74　'Ant.^o Colombari Cam. Di Monsig. V.^e Legato l'anno 1788' (Pl. 5, first floor, no. 19f).

75　'Domenico Corradini servitore di Mons. Spada Vece. Presid.^e di Urbino 1728'; 'Io Paolo Merlini Servidore dell'Emo Stoppani 1747' (Pl. 5, first floor, no. 14h). Filippo Spada was *vicepresidente* from 1726 to 1731; Stoppani was *presidente* from 1747 to 1754, and legate from 1754 to 1756, see Stramigioli Ciacchi, 'Araldica ecclesiastica', 232–3.

76　Polichetti, 'Nuovi elementi', 155.

77　'Recordat dello turno'.

78　Polichetti, 'Nuovi elementi', 160–61.

79 'Io fui di guardia alli 5 di agosto' (Pl. 5, first floor, no. 14h).

80 Fontebuoni, 'Destinazioni d'uso', 228, 240 (Pl. 5, ground floor, no. 29). Guards
 and soldiers often left writings and drawings on the walls; see for instance Pucci,
 'I graffiti del *Palazzo del Principe*'.

81 'Adi 24 di giu.º del LXXIIII venne il S. duca a Urb.º post tenebris' (Pl. 5, first
 floor, no. 14h); 'Adi 11 di giugno del 77 il S. Duca se parti D'Urbino per
 Fossobrone'; '1577 Adi 25 di gigno arivò don Fra.^{co}' da C.te a Urbino' (Pl. 5,
 first floor, no. 13i); 'A di primo de ottobre de 1589 il Signor ducha si parti di
 urbino per andare a chasteldurante'. In the graffito, located on the first floor,
 on the door between the Sala Volponi and Room VIII, 'per' is written with the
 characteristic shortened 'p'; the same happens in the previous graffito. The 'l'
 and the 'n' of Casteldurante are missing, but the 'e' and the 'a' preceding them
 have a short line above them. Similarly the 'm' is missing in 'Fossombrone' in
 the other piece of graffito.

82 Dal Poggetto, *La Galleria Nazionale*, 183.

83 'W la Isabta bela W'. This graffito is carved right on the door jamb of the
 entrance to the room known as the 'sala delle veglie' where, according to
 tradition, the conversation took place that was later re-elaborated in literary
 form by Castiglione in *Il libro del cortegiano* (Pl. 5, first floor, no. 19a). However,
 according to Fontebuoni, 'Destinazioni d'uso', 216–17, at the time this part of
 the palace was occupied by Giuliano de' Medici (1497–1516), an exile in Urbino
 between 1494 and 1512, whereas the Duchess would have lived in another part
 of the palace (Pl. 5, first floor, rooms 13a–13i). Nonetheless, this does not rule out
 the possibility that this graffito (like other 'vivas' to Elisabetta scattered in the
 palace, as for instance in the *soprallogge*, Pl. 5, first floor, no. 11) may indeed refer
 to the Duchess. In 'Graffitari d'*antan*', 415, I wrongly identified the apartment
 of Elisabetta suggested by Fontebuoni with some rooms now occupied by the
 Sovrintendenza, and transcribed the name in the graffito as 'Isabeta' instead as
 'Isabta'.

84 Castiglione (or Castilio), *The Book of the Courtier* (<http://www.uoregon.edu/
 ~rbear/courtier/courtier.html>).

85 'Pazze Donne Donzelle perche poco [esti]mate gli ho[mini] della corte'. In the
 graffito 'donne' is written 'doñe' and 'donzelle' is written 'donelle', with a tilde
 on the 'o'. Some letters are illegible because of a hole in the wall (Pl. 5, first floor,
 no. 2).

86 'Mar di duol', 'ove stenti e sospir mai sempre hai', 's'adorano per dei anco i
 tiranni', 'in mal'ora così ne vai pian piano' (Pl. 5, ground floor, no. 2).

87 'W la Fiandra per mare e per terra' (Pl. 5, first floor, door between no. 15 and no.
 13i).

88 'Adi 12 de 7bre del 1557 Fu sposata la cintia paco[missing]ta col no[me] de dio'
 (Pl. 5, ground floor, no. 5).

89 This is also the case in other palaces and castles where graffiti are present on the
 walls; see for instance Borettaz, *I graffiti nel castello di Issogne*, 50–51; Luisa Miglio,
 'Graffi di storia', in *Visibile parlare*, ed. Ciociola, 59–71.

90 'A.P.R.M. All'E:^{mo} Sp:^{da} Leg:^{to} d'Urb:º Venne Avviso A di 20 7.^{bre} 1683 che La C.^a
 M.^a di Leop:º Imp:^{re} era restata vittoriosa nella Guerra dell'Ottom:^{no} contro Vienna
 Carl'Anto: Amanti da San Marino Seg:^{rio} di Monsig.^{re} Massimi V.Leg.^{to}' (Pl. 5,
 ground floor, no. 26d). Leone de' Massimi Jacovacci was vice-legate between
 1679 and 1685, see Stramigioli Ciacchi, 'Araldica ecclesiastica', 228.

91 As mentioned, when Vittoria first arrived at the palace, she very probably had her apartment on the first floor, while later her apartment is identified with one on the ground floor which was to become the residence of the vice-legate; see Fontebuoni, 'Destinazioni d'uso', 211.

92 'W Franc.º Maria II W [horizontal line] anni X adi 11 di settembre MDLIX' (Pl. 5, ground floor, no. 26d). In 1559 Federico Maria II was 10 years old, yet he was not born on 11 September 1549 (as one might believe on reading the writing on the wall), but on 20 February of that year. See, for example, <http://genealogy.euweb. cz/italy/rovere.html>.

93 For this reason, in the preceding pages I have often preferred the more generic terms 'writings' and 'drawings' to the word 'graffiti', though I have sometimes used it, primarily to avoid irritating repetitions. Of course, it cannot be ruled out that as my researches proceed there will emerge forms of stigmatizing the practice of writing on walls that have not emerged so far.

94 Kraack and Lingens, *Bibliographie*, 23, 26. Bucherie, 'Mise en scène', 2, does not regard votive images as graffiti, for the reason that, although their making is reminiscent of graffiti, they had an official character.

95 In the castle of Issogne, from the seventeenth century onward the graffiti on the walls are no longer as numerous as in previous times. According to Borettaz (*I graffiti nel castello di Issogne*, 47) this change mirrored the decadence of the castle.

96 The Dominican of Ulm, Felix Fabri (c. 1441–1502), in his *Evagatorium* (an account of the author's journey to Palestine in 1483–84 which can be found online at <http://chass.colostate-pueblo.edu/history/seminar/fabri.htm>) for example, harshly denounced nobles visiting holy places in Palestine who were moved by vanity to leave signs with their names and coats of arms, or else wrote and drew their names and coats of arms on the walls, or carved them on columns with sharpened metal tools – in perpetual memory, Felix deemed, not of their nobility but their fatuity.

97 This idea is expressed in a particularly clear way in the summary of Kraack's book, which can be viewed online, in English too: <http://mitglied.lycos.de/ graffitiforschung/Kraacken.html>.

98 According to Kraack, *Monumentale Zeugnisse*, 381–2, the spread, in the seventeenth century, of the *album amicorum*, a notebook that these travellers carried with them, in which they recorded or had others record coats of arms, names and other details relating to the important personages that they visited, led to the decline of the practice whereby nobles carved or inscribed their own names and coats of arms on walls. If we are to judge by the walls of the Ducal Palace of Urbino, the practice of nobles carving their own coats of arms seems in fact to have lasted at least until the end of the seventeenth century while that of writing their own names lasted much longer.

99 Petrucci, *La scrittura*; *Visibile parlare*, ed. Ciociola.

100 Fleming, *Graffiti and the Writing Arts*, 30.

The Oxford college as household, 1580–1640*

Louise Durning

The university colleges of early modern Oxford and Cambridge present the historian of domestic space with illuminating examples of an 'other' domesticity, a form of social organization that appears to be, at once, both institutional and domestic. These corporate households were, in theory at least, exclusively masculine spaces; private, self-governing societies of (mostly) celibate men and boys who lived, ate, studied, socialized and worshipped in community, cared for by male servants. In this, they share some continuities with the predominantly masculine character of the aristocratic household of the period but with the significant distinction that their internal functioning was designed to sustain and reproduce not the conjugal family but the collective itself, and to maintain it in perpetuity, in accord with their charters of foundation.

The aim of this chapter is to investigate this distinctive form of household organization through a consideration of selected aspects of lived experience in the daily life of the community. In particular, it will focus upon experiences in Oxford in the period from 1580 to 1640, a time which saw a profound shift in the demographics of university attendance, with enlarged numbers of students and increasing levels of participation by aristocratic and gentry families, and a subsequent realignment of social interactions within the collegiate community. The early modern college emerged as a more complex social unit than its medieval predecessor, accommodating sub-groups of men and boys differentiated by a broader spectrum of age, academic status, length of tenure and legal relationship to the foundation. How did the collegiate societies adapt to this new social 'landscape', and how were these overlapping groupings managed and contained? The programmes of new building and rebuilding of college complexes that are such a distinctive feature of the early decades of the seventeenth century have frequently been explained as a direct response to this expansion, but in attempting to answer these questions, this paper will focus on the ways in which relationships between members of the household within these transformed communities were reshaped and on the

role of material, behavioural and spatial practices in defining these. It will also consider the ways in which affective relationships may have been fostered *by* the imagined communities of past and future members of the house.

The collegiate house and household

By the beginning of the seventeenth century there were 16 colleges in Oxford, varying in size, wealth and antiquity. The oldest colleges, Merton, Balliol and University Colleges, dated back to the thirteenth century while the most recent foundation, Jesus College, was scarcely 30 years old. The earliest foundations had been largely graduate societies, providing a protected environment in which fellows could be supported while studying for higher degrees, with the intention of producing a cadre of educated clergy and servants of the state. Few of these made statutory provision for undergraduate members of the community, although these, usually called 'scholars', became increasingly common in later foundations. Until the sixteenth century the vast majority of undergraduate students of the university rented accommodation in the unendowed hostels, or academic halls, run as private enterprises by individual Masters, or lodged with townsfolk.[1]

The collegiate fellows did, in this sense, constitute an elite within the university, but the colleges had no constitutional role in its government, which was vested in the corporate body of Masters of Arts, and the colleges existed alongside the university as private households. These collegiate societies present a distinctive form of institutional organization. Each was an autonomous legal entity, a perpetual foundation supported by endowments of land and regulated by its own body of statutes. The men who were maintained by these foundations were not the passive recipients of charity from external authorities but the active managers of the corporate household, its lands and income. Internal government of the corporation was in the hands of the head of the house and the fellows, with ultimate recourse to an external Visitor, in almost all cases a Bishop or Archbishop, who had authority to conduct periodic visitations of the college and give rulings on the interpretation of the statutes.

The statutes of the foundation defined the numbers who would be supported from the landed endowments which maintained it – a head of house, the fellows, and, in some cases, scholars, and one or more chaplains. At the summit of the household hierarchy stood the head of house, variously called Master, Warden, President, Provost, Rector or Principal. Although charged with the governorship of the household, the scope of his authority was not equivalent to that of the head of a dynastic house. In many of the earlier, and smaller, foundations, he was, rather, *primus inter pares*, elected from, and guardian of, the household of fellows. His role was that of custodian and chief negotiator of the external business affairs of the college while internal governance and decision-making was to a large extent shared with the body of fellows, or

with a group of senior fellows. The master and fellows were sustained in their operations by a complement of statutory household servants, usually comprising at least a cook, a porter, a butler and a manciple (provisioner). These servants provided some of the household functions but the household officers, such as might be found in a domestic household, were recruited from among the fellowship, who shared between them important offices such as bursar and dean.

By the fourteenth century a distinctive architectural form had evolved to house these academic communities, consisting of a chapel, dining hall and residential accommodation, disposed around an enclosed quadrangle. This was given its fullest development in the grand foundation of New College, Oxford, established in 1379 by William of Wykeham, Bishop of Winchester, and erected in one build to a unified and coherent plan. This was atypical, however, and many foundations began their corporate life in existing buildings, adding and rebuilding as space and finances permitted.[2]

The quadrangular collegiate plan has prompted comparisons with both monastic houses and with the form of the late medieval and early modern courtyard house of the gentry and aristocracy, but though it shares some superficial similarities with each of these types its functions and meanings were distinct.[3] These differences are most readily exemplified through consideration of the form and placing of the residential accommodation.

The monastic dormitory system, for example, was never employed at any of the colleges, where the preferred arrangement was for two-storey lodging ranges consisting of separate chambers opening off shared staircases, each with its own entrance to the quadrangle. The principal room, the chamber itself, provided a communal sleeping space for two, three or four fellows, with wooden-framed studies partitioned off at the corners for individual use, reversing modern expectations of privacy and community. The staircase system materializes a particular understanding of the social relationships implicit within the collegiate community and suggests a degree of equality and autonomy for their occupants. Using the language of space-syntax theory we might describe these as 'shallow' plans, where each chamber is equidistant from the court and on the same level of access as the hall and chapel.[4] This equality is consistent with the predominantly graduate character of the earliest colleges, and their constitution as a community of equals, of fully adult status. Similar arrangements of lodging ranges are also found in colleges of secular priests and in gentry houses where they provided accommodation for higher household officers or for guests.

This seeming equality of status implied in the residential accommodation is less apparent in the habitual organization of the hall, where the two daily meals were taken in common by the entire household. It was customary to maintain three or more tables in hall and the statutes of the colleges usually contain precise regulations for their membership. Academic life in colleges, and in the university as a whole, was shaped by hierarchies of seniority, performed and made visible through patterns of precedence in seating and in

processions, through rituals of deference and through varieties of dress. As in the organization of halls in gentry and noble houses, seating arrangements in college hall mirrored the rank order of the household although in the distinctive sub-culture of the universities this order was based on academic degree. In the statutes of Magdalen, for example, the high table was to be reserved for the Vice-President and the Reader in Divinity, the doctors of theology, law and medicine and bachelors of theology.[5] In other respects too, the function and siting of the collegiate hall differs from that in dynastic households. The distinctions experienced in noble and gentry houses between high and low ends of the hall did not have quite the same meaning in a college, where there was no lord or ruling family to whose apartments it formed a subsidiary space. Very rarely does the collegiate hall form part of a processional route for elite members of the household or their guests and in most Oxford colleges the hall was conceived as self-enclosed space, even as a freestanding building, with no communication to other spaces beyond the dais end.[6]

The transformation of the medieval college

Although many of these characteristics of the plan and organization of the pre-Reformation collegiate household continued unchanged into the early modern period, in other important respects the collegiate institution was transformed, under the impact of a combination of social, material and political factors. With the needs of successive sixteenth-century regimes to enforce religious orthodoxy, of whatever kind, upon potentially dissident bodies, the universities became increasingly subject to state intervention.[7] During Elizabeth's reign the colleges, which had not previously occupied any statutory role within the government of either university, emerged as the favoured instruments for the exercise of discipline and, at both universities, the heads of houses came to form a ruling oligarchy within the universities. The crown interfered directly in elections to headships and elections to fellowships were equally subject to crown and court influence.

From the 1560s there was also a rapid increase in the number of students attending the halls and colleges of Oxford, bringing marked demographic shifts not only in their age-profile but also their social composition. The precise quantification of this expansion, and the explanation of its causes and character, has been the subject of much prosopographical and statistical analysis and, although the interpretation of these results has been debated, the overall picture of growth in undergraduate numbers in this period is undeniable.[8]

This great expansion of collegiate membership was mainly in the class of private students, known as 'commoners', who paid for board, lodging and tuition at their own expense, taking their meals, or 'commons', alongside the statutory members of the household, but having no legal relationship to the foundation. Such privately funded participants in collegiate life had been

known since the earliest days of the colleges but the medieval commoners had been mostly graduates, perhaps staying on in Oxford in the hope of picking up a fellowship, as well as older clerics or ex-fellows, for whom the collegiate environment provided a convenient communal home in the later stages of life. Statutory permission for the admission of undergraduate commoners seems to have been first formalized in the 1479 statutes of Magdalen College, which allowed for the sons of 20 noblemen or other magnates to be accommodated at their own expense in the college, under the guidance of a tutor who would direct their studies.[9] Similar provision for the admission of non-statutory undergraduates was made at all subsequent collegiate foundations and by the mid-seventeenth century all but two of the 18 colleges in Oxford were admitting undergraduate commoners. In some cases, as for example at Exeter College, this class outnumbered the statutory fellows and scholars.[10]

Analysis of the social composition of these reconfigured collegiate societies suggests that they encompassed a broader social range than their medieval predecessors. The commoner class included sons of noblemen and gentry as well as 'plebeians', a capacious category comprising sons of merchants, yeomen and artisans. How did the colleges adapt to these demographic shifts? Mark Curtis saw in these transformed colleges an image of social integration, in which these varied social ranks were 'all bred together in learning', imbibing the rudiments of a 'common culture'.[11] This reading minimizes the conflicts and stresses attending this expansion in the undergraduate body, particularly as it affected the balance of rank and honour within the household and the maintenance of decorum in the rituals of daily life. While the colleges had functioned for centuries as routes for upward social mobility, enabling career advancement opportunities for the 'poor' scholar, the influx of commoners must have created a contrasting possibility, that of a loss of honour for the more socially elevated commoners, engendered by the intermingling of social ranks. It is possible to identify, well in advance of the large-scale building programmes of the seventeenth century which reshaped the physical accommodation of college personnel, the emergence of a range of visual, spatial, material and fiscal strategies which seem designed to contain the potential threat to social order embodied in the new social landscape of the college.

Patronage and privilege: defining the commoner

From the mid-sixteenth century onwards there appears an accelerating tendency to establish further sub-divisions of rank within the non-foundationers. These arrangements were usually linked to requirements for additional payments to be made to the college, in cash or kind, in return for material and spatial privileges which allowed visible distinctions to be maintained between the wealthier and the less wealthy commoners, and,

at the same time, allowed for a realignment of the relationships between commoners and the fellows of the foundation.[12]

This is most clearly evident in negotiations over dining arrangements in the hall, which was, as has already been noted, a key locus for the enactment of social relations within the life of the community. Although in domestic households of the early modern period the hall was losing its role as the primary dining space for the gentry and aristocratic family, in favour of smaller spaces separate from the extended complement of servants and retainers, in the institutional household this continued to be the principal public space. At a number of colleges in the late sixteenth century evidence can be found of dispensations being made for commoners to eat at tables of higher status than their academic rank would permit.[13] At St John's College in 1591, for example, the President and senior fellows agreed to grant William Burrel, 'the extraordinarie favour as to permitt him to take commons at his own chardge at the President's table', a grace related to his gift to the college of two pieces of table silver; a standing salt and cup.[14] Similarly at Merton College, in 1595, the Warden and fellows agreed to the request of Sir John Wolley, one of the Queen's privy councillors, that his son be allowed to take his meals at the bachelor fellows' table, the college judiciously calculating that this favour would be likely to 'retain and increase the good will of the petitioner'. Like Burrel, young Wolley also made a present to the college of a silver cup, engraved with his name and coat of arms.[15]

Within a decade such *ad hoc* arrangements for preferential dining were becoming more systematized, providing the scions of the wealthy and the upwardly mobile with a visual and spatial distinction appropriate to their rank. Merton College codified its position on superior commoners in 1608, resolving to admit up to 12 sons of persons 'of great name', with the requirement that a silver cup be presented to the college on admission.[16] Balliol College followed suit in 1610 and at St John's College it had become standard practice by 1613 for commoners to gain access to fellows' commons for an increased fee and the gift of a silver cup.[17]

This redrawn hierarchy of social distinctions was further codified in the creation of a new terminology, and the designation 'gentleman commoner' or 'fellow commoner' was in widespread use by the second decade of the seventeenth century. The meanings of this new distinction are made vivid in a resolution entered in the Lincoln College register for 1606:

It shall be lawful for the Rector and fellows to choose and admit into their company at their table, garden and other public places in the college scholars called by the name of Fellow-Commoners such as are or were the sons of Lords Knights Gentlemen of good place in the Commonwealth upon condition that at their admission they should pay the college the sum of £4 of current English money to be employed in plate or books … except it shall please any of them to bestow any greater value in plate or books for a memorial of them in the college to succession. And if they will use any napkins at the table in the hall, they shall at the time of their admission deliver to the Bursar either half a dozen napkins or six shillings to buy the same. Their privileges

shall be these (i) they shall sit in the church and chapel and have their names in the buttery book next after the fellow chaplains and scholars of the house (ii) they shall not go bow in the College to the fellows nor be bound to correction as the other commoners of the College used to be.[18]

This statement of the requirements for, and privileges attendant upon, admission to the new rank of Fellow-Commoner gives a particularly clear picture of the important spatial, material and behavioural markers which defined status relationships in college. The dispensation from gestures of deference and from normal disciplinary structures was as significant as seating arrangements in chapel and access to the gardens in establishing the privileged relationship between these students and the fellows.[19]

The importance of the treatment of names in the buttery book, and the implied equation between this and seating in chapel, may be less immediately obvious, but it points to a further material form in which status was represented within the communal life of the colleges. These books recorded the payments owed for additional food and drink purchased from the college buttery but they also had a further meaning as the *de facto* register of members of the household and it was customary to list the names of the household members – fellows, scholars, commoners and servants – according to seniority. Clearly, these new fellow-commoners were to inhabit a privileged space on the pages of the written records of the college as well as within the spaces of its chapel and hall.[20] A further example of this practice can be found in the St John's College accounts for 1616–17 where the list of payments of caution money (a deposit paid by commoners on entry) is arranged, for the first time, in order of the table at which the commoners sat, providing a remarkably clear textual representation of the distribution of diners in the hall. Of the 30 names recorded, 16 were listed as sitting at the masters' table, two at the bachelors' table, and nine at the commoners' table. The remaining three men, who paid a smaller amount of caution money, were listed under a new designation as 'under-commoners'.[21]

It is also evident from these documentary sources that boys of the highest status were granted courtesy titles, being styled 'Master', as the MAs were, rather than being designated by their surname alone, as was customary for undergraduates. Given that most of the boys would have been aged between 15 and 17 on admission (with some as young as 12 or 13) and thus considerably younger than those fellows or less privileged commoners who had spent the requisite seven years obtaining their Master status, this was a significant distinction.[22] If these titles were used in verbal address as well as in writing, this would have introduced a further aural formality to the status represented by their differential dining rights.

At first sight, the nature of these special exemptions and courtesies suggests that sensitivity to differences of social rank was negotiated through age-related markers, with high-status boys being accorded honorary 'adult' status, but in the context of collegiate life these courtesies

conveyed a more specific status, as honorary MA, or even honorary fellow. This suggests that pre-existing patterns of academic hierarchy habitually observed within collegiate households, between Wardens and Fellows, between senior fellows and junior fellows, between Doctors, Masters, Bachelors and undergraduates, provided a convenient and easily adaptable form for accommodating the aspirations and expectations of the nobility and gentry.

It is important to observe the significant role played by gifts of plate in these status transactions. These appear at first as *ad hoc* 'bribes' but quickly become mandatory donations, specified by medium and cost. A silver drinking cup to the value of five or six pounds rapidly became the standardized form for the gentleman commoner's gift on admission to his college.[23] Silver spoons were also a common requirement and at St John's College, from 1608, a spoon worth ten shillings, and engraved with the donor's name, was to be required of every new commoner, whether especially privileged or not.[24] These spoons and cups later became part of the college's common stock of plate but would have been used in hall by their donors during their time of residence. The commoner who sat at his privileged table, eating with a silver spoon and drinking from a silver cup engraved with his own name, was thus further visually differentiated from those of lesser rank, who sat at different tables and ate with more homely utensils. Here, again, the model of customary transactions between fellows and the foundation may have provided a pattern for negotiating the relationship of the commoner to the household. Heads of houses and former fellows, beneficiaries of the charity of the foundation, were significant donors of plate to their colleges and, since at least the mid-sixteenth century, it had been customary for fellows to be required to present a piece of plate to the college on their attainment of the MA, and so, by extension, on their ritual admittance to a higher table in hall. The presentation of a piece of plate by the commoner mirrored this ritual crossing of status boundaries.

As all this suggests, the phenomenon of the compulsory gift needs to be understood as more than simple financial opportunism on the part of the college and seen in terms of its symbolic or representational meaning. The request for, and bequest of, a piece of plate was not only a material transaction, it was also a way of understanding a relationship. Recent scholarship on the historical sociology of gift-exchange has emphasized the centrality of the gift to medieval and early modern social transactions and its role in materializing obligations and expectations between giver and receiver.[25] The ostensibly 'commercial' transaction between college and commoner was, by the gift of plate, repositioned within an action that could be understood in terms of an honour relationship between friends: the college extends its hospitality and the recipient, even though paying for it, recognizes the bond of friendship with the host. This understanding of the commoner as a 'guest' in the household was enshrined in the statutes of Pembroke College, a new foundation established in 1624:

In as much as in a well-ordered house, guests and outsiders should be entertained politely and kindly, it is our decision that commoners living in College at their own expense shall enjoy the public amenities of the College, with benefit of the hall, library, chapel, buttery, the common service of staff, and the honour, respect and privilege appropriate to their rank.[26]

Contemporary practice suggests that this relationship between guest and host was also experienced as the sign of a patron–client relationship, with the understanding that the bonds so fostered between colleges and their wealthy friends would result in further gifts or acts of patronage. There is an interesting insight into the mechanics of such transactions in a letter from a fellow of St John's College, counselling his sister on her husband's obligations following the recent admission of their son to fellow's commons:

I hold it his best course rather to rewarde future deserte, than to beginne with a liberall hande … Mr Wrenne [the boy's tutor] & the Colledge will one day deserve the love both of you and your sonne & then a good worde or deede for either will not be ill bestowed, but till you finde the event … I would wish you not to be over liberall to either.[27]

Another example from the same college provides a further insight into the management of giving and receiving gifts. In 1616 the college sold one of its pictures, a gift from a former commoner, to Sir Thomas Lake, Secretary of State, who had much admired it. The account of the sale in the college register records the careful negotiation with Lake, who had clearly expected the college to make a present of it to him. This they did, but only in return for a sizeable donation of £20 towards building works then in progress. It was further decreed that the original donor of the picture, whose gift had been thus converted into cash, was now to be incorporated into the list of benefactors to the building. This delicate dance of etiquette illustrates the social transactions of gift-giving: the college receives a financial benefit at the same time as maintaining the goodwill of a potentially powerful patron, whose 'naked' request is redirected into a different kind of gift-exchange, honourable to each party. Honour is also done to the original donor, whose gift had become the currency in this transaction, and whose memory is reinscribed in a new context.[28]

Rebuilding and new building: Merton, Wadham and St John's

The patron–client relationships signified by these gift exchanges were to be a significant factor in the financing of the new building schemes which were such a marked feature of the early seventeenth century at both Oxford and Cambridge. By 1640 all but two of the Oxford colleges had initiated major building schemes to extend or upgrade their available accommodation, with Oriel and University Colleges embarking on ambitious plans for a complete reconstruction. In addition, two new college foundations were established;

Wadham in 1610 and Pembroke, founded in 1624 within the already existing buildings of Broadgates Hall.[29]

Many of these schemes were funded by bequests from a range of donors. At St John's College in 1596–97, for example, Robert Berkely, a newly entered commoner, gave generously to the building of a new library and chamber block, in return for which the college agreed to set aside two chambers formed in the vacated old library for the use of himself and a servant, 'for and during his naturall life'.[30] Berkely was further honoured by being included amongst the party who laid the foundation stone for the new building and his arms were displayed in the great east window with those of each donor to the scheme.[31]

Other building programmes were due to sizable donations by single benefactors. At Lincoln College the opening up of a second quadrangle followed close upon its resolve to admit fellow-commoners in 1606. The first phase of the scheme was largely funded by Sir Thomas Rotheram, a fellow of the college and collateral descendant of one of the founders. At the adjacent Exeter College, one of the largest in numbers of students but architecturally the least distinguished, an extensive series of building works was set in train and by the 1620s it had acquired a new gatehouse, lodging block, chapel and hall. A written survey of the newly enlarged college, compiled by Rector Prideaux in 1631, records the extent of the buildings and a formal commemoration of the benefactors who funded them.[32] John Peryam, a Devon merchant who gave £560 towards the building of the accommodation block, styled 'Peryam's Mansions', is praised as an exemplary benefactor who 'neither conditioned with the Colledg in any sort for the disposing of the lodgings, with Refrence to himself or any of his … God rayse us many such to follow his example'. Like commendation is given to Sir John Acland, 'formerly of this college', who enabled the college to build the new hall.[33] Prideaux's praise of Peryam reveals, by implied contrast, that donors to buildings or their families could expect to maintain some form of patronal rights over them.

While the need to house increasing numbers of students was one of the major motivations behind the colleges' solicitation of these benefactions, the form that the resulting buildings took should be investigated in relation to those developments in social practice already discussed. How far were these new schemes of building shaped by concerns for the maintenance of spatial distinctions between different sub-groups within the college? This is less easy to establish with certainty, since the nature of college record-keeping in the period does not always make it possible to identify the specific occupants for each room and thus to establish a precise reconstruction of patterns of occupation. However, such documentation that does survive suggests that at least some of these schemes were shaped by a concern to establish a more explicit spatial separation of fellows, scholars and commoners.

The building of a new quadrangle at Merton College in 1608–10 during the Wardenship of Sir Henry Savile (Pl. 9) provides one interesting example of an emphatic spatial reorientation of the household, although in this instance the

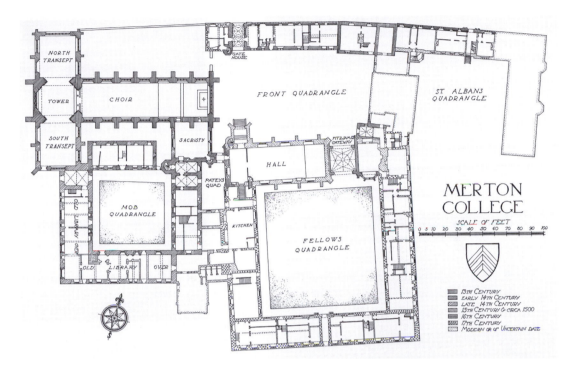

3.1 Merton College, Oxford, plan. © Crown copyright, NMR

effect was to provide a sharper distinction within the fellowship. From the first, the chambers in the new quadrangle were occupied by the senior fellows of the college and the existing fourteenth-century quadrangle was redefined as a space for the junior fellows, sharing rooms with undergraduates, an arrangement which mirrors in the spatial divisions of living accommodation the separation of tables at hall, between bachelor and master members of the household.[34]

The location of each quadrangle within the college site and their different means of access further emphasizes the separation of the two groups. As can be seen from the plan (Fig. 3.1), these two spaces were not physically connected. The old quadrangle (later called Bachelors' Quad or Mob Quad) stood at the western end of the hall, behind the chapel. The site chosen for the new quadrangle lay to the east side of the hall, in a space formerly part of the Warden's zone. The new building is visually and physically related to his lodgings: a grand vaulted archway, added by Warden Fitzjames in 1497 to connect these to the hall, was 'borrowed' in the new design to provide an honorific entrance to the fellows' quadrangle. The upper floor of the east range also provided a long gallery to serve the adjoining Warden's Lodgings, a prestigious complement to his already extensive accommodation.[35] Fellows' Quadrangle was built on a grand scale, occupying an area twice that of the older quad. It was also taller, being a full three storeys in height, rather than the two storeys that had been the limit of previous collegiate building, and was provided with larger chambers, rising in height with each storey,

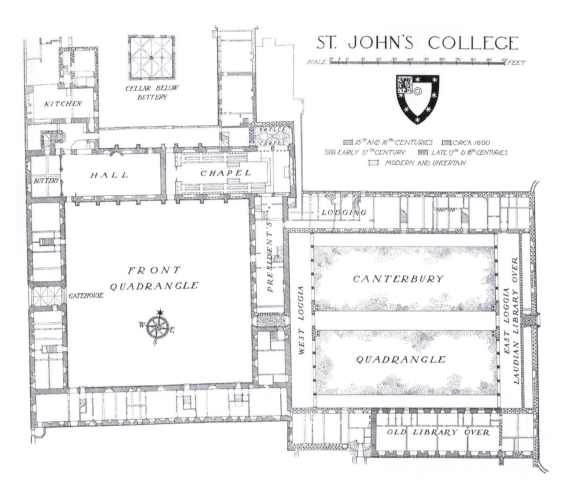

ST. JOHN'S COLLEGE

SCALE

15TH AND 16TH CENTURIES ▨ CIRCA 1600
EARLY 17TH CENTURY ▨ LATE 17TH & 8TH CENTURIES
MODERN AND UNCERTAIN

KITCHEN

CELLAR BELOW
BUTTERY

BAYLIE
CHAPEL

BUTTERY HALL CHAPEL

LODGING

PRESIDENT'S

FRONT
QUADRANGLE

GATEHOUSE

CANTERBURY

QUADRANGLE

WEST LOGGIA

EAST LOGGIA
LAUDIAN LIBRARY OVER

OLD LIBRARY OVER

3.2 St John's
College, Oxford,
plan. © Crown
copyright, NMR

and more generous fenestration than had been customary. The prestigious
entrance formed by the Fitzjames arch was matched on the range opposite
by a grandiloquent frontispiece of the classical orders, making an honorific
frame for displays of arms of Savile, the College and the Crown and with
niches for statuary.[36]

The 23 sets of chambers provided unprecedented standards of comfort for
collegiate fellows. Each set comprised a large full-width chamber and two
studies, but since each fellow occupied a chamber to himself, one of these two
supposed studies could have been intended for a separate sleeping space.[37] If
this was the case, then the complement of rooms for each Master fellow would
have satisfied contemporary expectations of the space standards appropriate to
a gentleman, with outer chamber, inner chamber and closet, and ample space
for the accommodation of a personal servant.[38] Fellows' Quad acts as a reminder
that perceptions of the social status of college fellows were also changing.

This combination of spatial zoning and superior standards of
accommodation is also evident in the new quadrangle added to St John's
College in 1630–36 (Fig. 3.2 and Pl. 10).

The development of this site had begun in the 1590s with the building of the new freestanding library and chamber block mentioned above, in the garden space behind the front quadrangle. Rental lists in the college accounts indicate that these new chambers were, from the beginning, inhabited by fee-paying commoners.[39] In the 1630s this block was absorbed into the building of a complete new quadrangle erected at the expense of William Laud, Bishop of London, Chancellor of the University and himself a former scholar, fellow and President of the college. By the time of its completion Laud had been elevated to the Archbishopric of Canterbury and from an early date the space has been known as the Canterbury Buildings or Canterbury Quadrangle.[40] In keeping with the height of his social elevation, the highest public office yet obtained by any fellow of the college, the scale of Laud's benefaction was suitably magnificent. The new quadrangle was to provide for an extension to the President's lodging, a new library space, and a complement of superior chambers, all housed in buildings of self-conscious architectural distinction. The east and west sides of the quad were dignified with columnar frontispieces framing bronze statues of the king and queen and flanked by arcaded walks, their spandrels carved with personifications of the arts and virtues.[41]

Laud gave explicit instruction that the new chambers were to be reserved for the exclusive use of commoners, from whose fees the college was to be assured a regular income.[42] The occupants of the quadrangle can be reconstructed from the annual accounts of the college in which the rentals received from the 'Canterbury Buildings' are recorded as a separate item. Rentals for the two single and nine double chambers were graduated from £7 per annum for the best room down to £3 per annum, reflecting their size and degrees of comfort, with rooms on the upper floor more desirable than those on the ground floor.[43] Those commoners who could afford it would not be expected to share rooms with tutors or undergraduates of lower rank. They would, in effect, be able to maintain a separate apartment, either alone or shared with another young man of similar social status, in a space architecturally distinguished and separated from the other members of the college.

As at Merton, the aggrandisement of the President's accommodation was also an important feature of the scheme. This already substantial Lodging, which had its own hall, kitchen, buttery, great chamber, parlour and subsidiary chambers, gained considerable space in the immediately adjacent north and west ranges of Laud's new work. A new kitchen and parlour were formed in the north range, together with an elaborate carved staircase leading to an enlarged great chamber and principal bedchamber beyond. As at Merton College, there was also to be a gallery for the President, extending over most of the western arcade of the new buildings.[44] This new suite of rooms on the upper floor of his lodgings would have enabled the President to maintain greater 'state' than had been possible before, appropriate to the increased prestige of the office.

3.3 Wadham
College, Oxford,
plan. © Crown
copyright, NMR

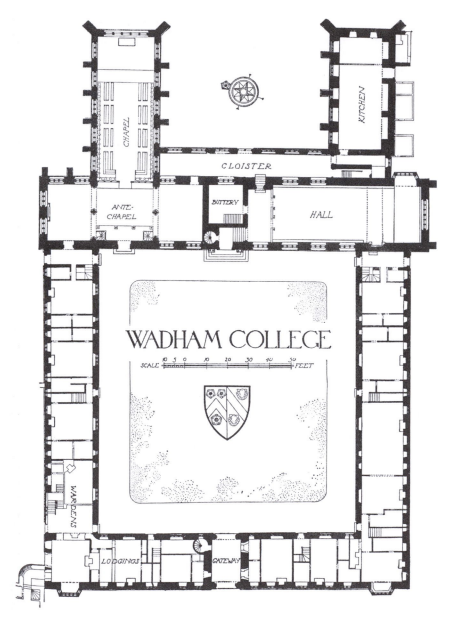

The design of Wadham College, a completely new foundation established
by Nicholas and Dorothy Wadham in 1611 (Pl. 11 and Fig. 3.3)[45] provides
an interesting indicator of early seventeenth-century expectations of what a
college ought to be and what was required, and of continuities and differences
with previously established patterns of building.

Like the medieval New College, the complex was designed as a single
quadrangle, encompassing all the functions of the college within a single
space, with chambers arranged around three sides of the court, and a fourth
side given over to the chapel and hall. In the treatment of the accommodation

ranges, however, it followed closely the example set in the recently completed Fellows' Quad at Merton, in height and in the spacious dimensions of the chambers. How, in practice, was this traditional single-quadrangle plan adapted to serve different social requirements?

Two documents preserved in the Wadham archives provide an unusually clear account of the distribution of different members of the household. These 'chamber books', both begun in the 1620s, list the succession of occupants in each rented chamber with their date of entry and exit, and specify the chambers occupied by the fellows.[46] These documents reveal that the segregation of ranks within the college was largely organized by floor level. The fellows, each allotted an ample set to himself, occupied most of the middle floor and upper floor chambers in the quadrangle while the ground-floor chambers, the least comfortable, were probably occupied by undergraduate foundationers and college servants.[47] There is a significant exception to this organization in the treatment of two complete staircases, those immediately adjacent to the hall and the chapel. These appear to have been, in practice, entirely reserved for wealthy commoners, here free from the disciplinary presence of a fellow, and adjacent to the most prestigious public spaces of the college – the hall and chapel. The wealthiest commoners could even pay to occupy a complete set of rooms by themselves, as in the case of Sir John Portman, already a baronet at the time of his matriculation in the 1620s, who rented the whole of the middle chamber on the chapel staircase. The example of Wadham College demonstrates how useful the medieval staircase system continued to be as a model for collegiate planning. Each staircase, and each chamber opening from it, could function as a self-contained unit, an ideal structure for the maintenance of privacy and autonomy in the communal household.

In reviewing the transformation of Oxford in the early modern period, James McConica argued that it was through a 'mixture of adaptation and opportunism' that the colleges of Oxford and Cambridge survived the disruption of the Reformation and emerged with an expanded role serving the social and educational needs of a broad lay constituency.[48] This paper has attempted to identify some aspects of that process of adaptation through examination of the kinds of social relationships these institutions fostered, and the way these relationships were made visible through behaviour or through material signifiers such as gifts of plate. The provision of new accommodation, and of standards of decorum and propriety appropriate to the maintenance of social difference, facilitated the participation of elite groups within the life of the college. No less important was the opportunity offered for the development of strong bonds of identification between these honorary members of the household and their host, which found expression through exercise of patronal relationships. As perpetual institutions, the colleges provided attractive loci for the commemoration of family name and honour. Distinguished non-foundationers, co-opted into the dynastic succession of fellows and heads, could secure a permanent place within this alternative genealogy through the continuing visibility of their presence

and their bounty. Silverware engraved with their name and arms, buildings marked with their heraldry in stone and glass and named for their donors, even the written record of their presence in college documents – through these memorials the collegiate institution bound past members into the present and the future life of the house.[49]

Notes

* I would like to thank C.S.L. Davies, Andrew Hegarty and Michael Riordan for their assistance in the preparation of this paper and for arranging access to archival material. I am particularly grateful to my colleague Clare Tilbury for her incisive comments on earlier drafts and for many kindnesses during the research.

1 See James McConica, 'The Rise of the Undergraduate College', in *The History of the University of Oxford: vol. 3, The Collegiate University*, ed. James McConica (Oxford: Clarendon Press, 1986), 1–68.

2 For overviews of collegiate planning and architecture see Robert Willis and John Willis Clark, *The Architectural History of the University of Cambridge, and of the Colleges of Cambridge and Eton*, 4 vols (Cambridge, 1866), vol. 3, part III; John Newman, 'The Physical Setting: New Building and Adaptation', in McConica (ed.), *The Collegiate University*; and 'The Architectural Setting', in *The History of the University of Oxford, vol. 4, Seventeenth-Century Oxford*, ed. Nicholas Tyacke (Oxford: Clarendon Press, 1997). See also Mary D. Lobel and Herbert E. Salter (eds), *The Victoria History of the County of Oxford*, vol. 3, *The University of Oxford* (London: Oxford University Press for the University of London Institute of Historical Research, 1954).

3 For example, Willis and Clark, *Architectural History*, vol. 3, part III, chapter 2.

4 For an example of the application of space syntax theory to descriptions of household relationships, see Roberta Gilchrist, *Gender and Material Culture: The Archaeology of Religious Women* (London and New York: Routledge, 1994), chapter 6.

5 Statutes of Magdalen College, 1479, 'De mensis Praesidentis, sociorum et scholarium, et de modo sedendi in eisdem', printed in *Statutes of the Colleges of Oxford*, 3 vols (Oxford: J.H. Parker, 1853), vol. 2, 49–50. Guests and strangers were to be seated 'ad status gradus dignitates et promotiones eorundem'.

6 See Louise Durning, 'Woman on Top: Lady Margaret Beaufort's Buildings at Christ's College Cambridge', in *Gender and Architecture*, ed. Louise Durning and Richard Wrigley (Chichester and New York: John Wiley, 2000) for discussion of a case where the hall does form part of a processional route.

7 Penny Williams, 'State, Church and University 1558–1603', in *The Collegiate University*, ed. McConica, 397–440.

8 See Lawrence Stone, 'The Size and Composition of the Oxford Student Body 1580–1909'; and James McConica, 'Scholars and Commoners in Renaissance Oxford', in *The University in Society*, 2 vols, *vol.1, Oxford and Cambridge from the 14th to the Early 19th Century*, ed. Lawrence Stone (Princeton NJ and London: Princeton University Press, 1974), 3–110 and 151–82; Mark H. Curtis, *Oxford and Cambridge in Transition, 1558–1642* (Oxford: Clarendon Press, 1959); James McConica, 'The Collegiate Society', in McConica, ed., *The Collegiate University*,

645–732; Elizabeth Russell, 'The Influx of Commoners into the University of Oxford before 1581: An Optical Illusion?', *English Historical Review* 92/365 (1977), 721–45; Stephen Porter, 'University and Society', in *Seventeenth-Century Oxford*, ed. Nicholas Tyacke.

9 Statutes of Magdalen College, 1479,'De extraneis non introducendis ad onus collegii', 60. The description in the statutes of these magnates as 'friends of the college' suggests that this development was motivated more by a recognition of the potential benefits to the college arising from the cultivation of alliances with powerful patrons, than from any financial gain from their rents and fees.

10 Of the total household of 206 in 1612, 134 were commoners, 37 were poor scholars and 12 were servitors; see Charles W. Boase, *Registrum Collegii Exoniensis* (Oxford: Oxford Historical Society, 1894), cviii.

11 Curtis, *Oxford and Cambridge in Transition*, 266.

12 At the other end of the social scale a class of poor scholars or servitors provided a servant class for the commoners and fellows.

13 The Statutes of Magdalen College had already made provision for the noble commoners to sit at high table.

14 St John's College Archives (SJCA), College Register, vol. ii, p. 1, 25 November 1591. Burrel was also dispensed from certain scholastic exercises, provided he attend chapel, show due reverence to the officers, senior fellows and other superiors and 'preserve the peace of the college'.

15 John R.L. Highfield and Geoffrey H. Martin, *A History of Merton College, Oxford* (Oxford: Oxford University Press, 1977).

16 George C. Brodrick, *Memorials of Merton College* (Oxford: Clarendon Press, 1885), 71–2.

17 For St John's, see Bodleian Library MS. Eng. Hist. c. 481, fol. 23, Letter of Christopher Wren to Sir William Herricke, 26 April 1613. Wren, a fellow of the college and tutor to Herricke's son, describes the requirements for entry to fellows' commons: ' I can thus far certifie you on knowledge that it is noe more but a piece of plate, between v and vi pounds and v or vi pounds over and above his sett allowance yearly'.

18 Lincoln College Archives, Medium Registrum, fol. 51, May 1606, cited in Vivian H.H. Green, *The Commonwealth of Lincoln College, 1427–1977* (Oxford: Oxford University Press, 1979), 158–9, n.7.

19 The lenience shown towards commoners was a frequent source of tension within the colleges. In 1616 Merton College rescinded its 1608 resolution to admit gentleman commoners because of their disruptive influence on college discipline; see Brodrick, *Memorials*, 72.

20 At Exeter College the names of particularly distinguished commoners were kept on the Buttery Books long after they had left, as a memorial of their connection with the college. Kenneth Padley, 'Revising Early Modern Exeter', *Exeter College Register* (2000), 38–45, 43. The memoirs of Anthony Ashley Cooper, at Exeter in the 1630s and already a Baronet, give further evidence of the prestige attached to these documents. It was a matter of honour that his name on the Buttery Book 'bore twice the expense of any in the university', his large expenditure standing as a public record of his liberal hospitality to deserving poor students. See Boase, *Registrum Collegii Exoniensis*, cx.

21 SJCA, Computus Annuus 1616/17, fol. 32. Under-Commoners may have been those who bought their provisions directly from the buttery, rather than being served at table.

22 For computations of the average ages of different social groups see Stone, 'Size and Composition', 29–33.

23 See Helen Clifford, *A Treasured Inheritance: 600 Years of Oxford College Silver* (Oxford: Ashmolean Museum, 2004) for an account of the forms and meanings of academic plate. See also Philippa Glanville, *Silver in Tudor and Early Stuart England* (London: Victoria and Albert Museum, 1990).

24 SJCA, College Register, vol ii (1591–1624), 413, entry for 1 December 1608. Commoners already in residence were not obliged to provide a spoon, but were encouraged to do so 'of their own bounty'.

25 See esp. Felicity Heal, *Hospitality in Early Modern England* (Oxford: Oxford University Press, 1990); Natalie Zemon Davis, *The Gift in Sixteenth-Century France* (Madison WI: University of Wisconsin Press, 2000).

26 English translation of chapter 12 of the Statutes of Pembroke College (1629), 'De Commensalibus sive comminariis', cited in Clifford, *A Treasured Inheritance*, 30.

27 Bodleian Library, MS. Eng. Hist. c. 481, fol. 21, letter from Thomas May to Lady Herrick, 18 April 1613.

28 SJCA, College Register, vol. ii, 604, entry for 18 August 1616. The picture is discussed in *Queen Elizabeth's Book of Oxford*, ed. Louise Durning (Oxford: Bodleian Library Publications, 2006), 123, n. 48. The retention of the donor's name here is analogous to the practice of re-engraving the name and arms of the original donor on items of college plate which had been melted down and refashioned into a new utensil. See Clifford, *A Treasured Inheritance*.

29 See Newman, 'Architectural Setting', for a survey of all the new building schemes and their principal benefactors.

30 SJCA, College Register, vol. ii, 73, entry for 7 December 1595–96.

31 William H. Stevenson and Herbert E. Salter, *The Early History of St John's College* (Oxford: Clarendon Press for the Oxford Historical Society, 1939), 295.

32 An abridgement of Prideaux's survey is printed in Boase, *Registrum Collegii Exoniensis*, 311–20.

33 *Ibid.*, 317, 318. Peryam had not been a member of the college but was related by marriage to the Rector.

34 Broderick, *Memorials*, 75; Highfield and Martin, *A History of Merton College, Oxford*, 200.

35 An inventory of the Warden's lodgings taken in 1544 lists a hall, kitchen, buttery, two parlours, five chambers, a great chamber and a chapel. It is transcribed in *Registrum Annalium Collegii Mertonensis*, ed. John M. Fletcher (Oxford: Clarendon Press for the Oxford Historical Society, 1974), 102–4. New College and Magdalen College had similarly extensive lodgings for their heads of house.

36 Newman, 'Architectural Setting', 148. Savile probably contributed a large proportion of the building costs, which totalled more than £2000, with the remainder paid from the college's own accumulated funds.

37 *Ibid.*, 149.

38 For analysis of chamber distributions in domestic households of the period, see Nicholas Cooper, *Houses of the Gentry, 1480–1680* (New Haven CT and London: Yale University Press, 1999), 296–7.

39 SJCA, Computus Annuus, 1598–1604, fol. 8v, rentals for 1598/9.

40 SJCA, Computus Annuus, 1637/8, fol. 52, lists the rents 'ex Aedificiis Cantuariensibus'.

41 The definitive account of the project is Howard Colvin, *The Canterbury Quadrangle: St John's College Oxford* (Oxford: Oxford University Press, 1988).

42 *Ibid.*, 89.

43 These rents are comparable with those recorded at Wadham College for 1654. See note 48 below. The £7 room, however, is significantly more expensive than the best rooms at Wadham, rated at £6.

44 Colvin, *The Canterbury Quadrangle*, 79–84.

45 See Clifford S.L. Davies, 'A Woman in the Public Sphere: Dorothy Wadham and the Foundation of Wadham College, Oxford', *English Historical Review*, 118/478 (2003), 883–911. Dorothy Wadham was the daughter of Sir William Petre, a major benefactor to Exeter College in the 1560s.

46 Wadham College Archives (WCA), 9/1, 9/2.

47 The 1654 rentals rated the ground floor chambers at £3 per year and the upper and middle floor chambers at £5 per year, with two rated at £6: WCA 9/2.

48 McConica, 'Scholars and Commoners', 180.

49 This commemoration could extend to burial in college chapels, in the company of past fellows and heads of house. Sir John Portman, the gentleman commoner of Wadham, died while in residence and was commemorated by a grand architectural monument erected in the most prestigious location, on the north side of the altar, a place usually reserved for college heads. It was later removed to the ante-chapel. See also Stefanie Knöll, 'Commemoration and Academic "Self-Fashioning": Funerary Monuments to Professors at Oxford, Tübingen, and Leiden, 1580–1700' (DPhil. diss., University of Sussex, 2001).

Domestic spatial economies and Dutch charitable institutions in the late sixteenth and early seventeenth centuries

Jane Kromm

Charitable institutions built or enlarged in the Netherlands during the early modern period were indebted to domestic models and practices on several levels. Unless quarantine was an issue, these establishments were sited within or alongside the residential fabric of the city, and were approached through the same kinds of entrances and gateways as were most other buildings in the Dutch urban setting. The format adapted by many of these institutions can be traced back to two earlier prototypes which were at once domestic and institutional. These are the enclosed cloisters common to monastic communities, and the separate but connected dwellings or little houses around a courtyard that were known as 'hofjes' and occupied almost exclusively by elderly women.[1] Both models united communal space with a degree of privacy, a necessary and desirable mixture for the newer charitable yet secular foundations that were variously hospital, hospice, almshouse and asylum.

Along with the courtyard paradigm and the separate, private room, civic institutions also adapted design features that were then evolving in contemporary residential architecture, especially the *voorsael* or *voorhuis*, as the front room or entrance hall was called, and the gallery. Both gallery and *voorsael* were spaces identified with establishing and facilitating communication and contact, and the *voorsael* especially was the location where the transition from public to private was accentuated. Facilitating the spatial as well as the human negotiations that occurred around entrances and with communal spaces was of great interest to those public institutions charged with the responsibility for the welfare of private citizens. The governing bodies of these establishments were often concerned with issues relating to protocol and observation, those socio-visual practices attached to entry areas, gallery spaces and the thresholds of smaller units or cells. A concern with the ritual practices associated with threshold locations was another part of the larger

focus on the boundaries between public and private, and this too influenced the design of charitable institutions in the direction of residential prototypes. The heightened sensitivity to access as well as containment also reinvigorated approaches to the fabric of these buildings, leading to a new attentiveness to the public orientation of these sites and to their sculptural decoration. This chapter will investigate the spatial arrangements and exterior decoration at two Dutch institutions – St Caecilia's *gasthuis* (hospital) in Leiden and the *dolhuis* (asylum) in Amsterdam – as a means of exploring the symbolic economy of prospect and vantage, of visible access and spatial complexity, that characterized Dutch domestic interiors as well as civic institutions in the early modern period.

The history and construction of Dutch charitable institutions

The reorganization and rebuilding in the Netherlands of establishments dedicated to the care of the ailing, the poor and the disabled, were concentrated in two principal periods of activity, from 1590 to 1620, and again from 1650 and after.[2] This impressive degree of charitable industriousness among the Dutch was the result of benevolent motives traceable to several causes. Conventions established by Erasmus that exhorted individuals to participate in charitable activities remained strong in local customs despite the devaluation of such acts in Protestant theological arguments. A dramatic increase in the vagrant poor from the late sixteenth century onwards also made the provision of care for the impoverished and homeless a matter of acute concern in Dutch cities and across Europe as well.[3] At the same time, elite groups were increasing their prosperous status, and many were anxious both to preserve the social hierarchies that made their successes possible, and to offset their obvious material advantages through donations and public service.[4] Civic authorities across the provinces distributed properties confiscated from convents and monasteries to the new secular, municipal institutions for their use. In the event that these sites were insufficient or decayed, new buildings were planned to make the institutions viable. Many subsequent improvements to existing sites or plans for entirely new establishments favoured an enclosure model, a standard format to which early hospital design in general was also indebted.

Derived from the Latin *hospes*, meaning both 'host' and 'guest', the earliest establishments filled many functions, from hospital to that of hospice, hostel or guesthouse.[5] The favoured format was a large open ward with high vaulted ceilings and sometimes, but not always, the space was divided by aisles.[6] Inhabitants had an uninterrupted view of the chapel or altar at one end of the ward, an arrangement that recollects its origins in medieval monastic complexes.[7] The addition of buildings often took the form of a range around a courtyard, while some wards that originated as monastery infirmaries had their own cloisters, and both tendencies contributed to the dominance

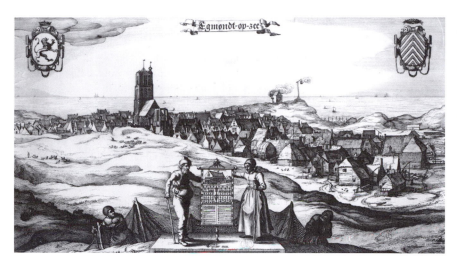

4.1 C.J. Visscher, lottery poster for the new *gasthuis*, Egmond aan Zee, 1618, Rijksmuseum. Photo: Rijksmuseum

of the enclosure model.[8] Developments within the open ward itself can be traced to practical concerns for warmth, but also to an increasing interest in the fundamental value of privacy, with the result that curtained beds or beds in cubicles, and eventually self-contained small rooms or cells, became increasingly common.[9] These separate spaces were associated, like the hospitals themselves, with multiple uses, and can be found variously as the designated accommodation for the contagious, the insane, the elderly and the rich.[10] In the Netherlands in particular, provisions for accommodating the elderly poor developed along the slightly different lines of the beguinage, where members of the lay female nursing order known as the Beguines resided in rows of individual small houses around a courtyard.[11] Throughout the Middle Ages and beyond, this arrangement, known as *'hofjes'*, was extended more generally as a protected form of lodging for impoverished elderly women.[12] Most of the early hospitals in the Dutch provinces along with the *hofjes* were also formed around courtyards or were originally parts of cloisters. The *gasthuis* at Delft, for example, had its origins as the *hospitium* or guesthouse of a cloistered order.[13] All over Europe as well as in England, these institutions had supervisory staffs that functioned like 'surrogate households', and here the regulated hierarchies of domestic models were pervasive.[14] As the large open wards became more differentiated spaces through the introduction of domestic architectural elements such as reception areas, second-storey galleries and private rooms or cells, the residential aspects of hospital/hospice structures were significantly reinforced.[15]

Lottery posters as architectural sources for Dutch institutions

The particular features of charitable institutions formed through the complicated circumstances of absorbing and renovating pre-existing buildings that were later supplemented by purpose-built components must

be adduced from a mixture of source materials that combine actualities with representations, and so require a series of investigative and reconstructive operations. Original buildings might remain in whole or in part, but in their absence, plans and topographical maps can provide evidence of a premise's earlier characteristics. For Dutch institutions in particular, elaborate lottery schemes were a popular fundraising method, and these were regulated by civic governments as part of their responsibility for the city's charitable operations; charters permitting the lotteries had to be obtained from state authorities.[16] Lotteries were then advertised by posters that presented detailed information about the lottery drawing and its regulations.[17] Many of these posters or charts show the prizes that players might win as an inducement to their participation, and a number also displayed an image of the building which stood to benefit from the lottery's proceeds. An early view of the asylum in Amsterdam adorns the upper half of the institution's *loterijkaart* printed in 1591–92 by H.J. Muller from an anonymous design (Pl. 12).[18] The principal building is shown at the right, with elaborate gables and a façade accented with a classical frontispiece whose Doric columns at the base and Ionic above follow the formula for the correct usage of the orders. Between the Ionic columns are the heraldic shields of the asylum's original founders, along with inscriptions celebrating their charitable enterprise. At the next level are the city's arms surmounted by a niche in which the tiny figures of a prostrate nude man lying at the feet of a sedate female personification can just be seen. This façade adjoins a lower structure that appears rough or not yet finished: it consists of four ranges around a courtyard inside which a formal garden and rows of individual rooms or cells are visible. The façade here is decorated with a more sophisticated classical apparatus around the entry (although there is no door indicated as yet) in which Corinthian columns bracket both levels, with the uppermost terminating in a small pediment. The second level contains a depiction of the building's interior where the courtyard configuration, formal garden and small cell doorways are clearly delineated. In the centre foreground of this architectural rendering is a seated figure in a loose robe posed with the depleted air of classical melancholia. The very small figure in the pediment above sketches a similar air of dejection and hopelessness. Both figures and the plain unfinished structure they adorn must be the intended beneficiaries of the lottery's projected winnings. If these poignant elements failed to stir potential donors, then the neat rows below filled with the range of prizes on offer should do so, as the repeated forms of vessels, tazzas, roemers (drinking glasses), spoons and money bags present a mesmerizing picture of accumulation and acquisitiveness. Despite these enticements, the truly dominant feature of the poster is the building's detailed appearance.

Other posters survive that supplement displays of an institution's fabric, actual or projected, with additional details specific to that site and its operations. In 1618, the supervisors or 'fathers' of the *gasthuis* in Egmond aan Zee asked the notable printmaker C.J. Visscher to design their lottery

poster. A topographical view by Visscher celebrates this particular lottery, and shows two elderly citizens standing beside the poster with the town in the background (Fig. 4.1).[19]

The original hospital had been destroyed in 1572 by Spanish troops and while it was subsequently replaced, the institution remained in need of funds for maintenance and upkeep, and this the lotteries provided. Visscher's print gives a composite view of the town, with civic and residential buildings clustered together around its venerable church. The hospital building itself is almost in the precise centre of the print, and it is shown again as the principal image in the uppermost field of the lottery poster. Set off by a platform, a ring of netting and an audience of two other aged characters, the foreground scene recalls in a quite subtle and rustic way the theatrical events that often accompanied lottery sales and drawings. As an inducement to participants, the elderly citizens are represented as deserving examples of the clientele the establishment would serve, and the prominent pair stands most respectfully and dutifully beside the *gasthuis* poster. Their deportment emphasizes the distinction between the deserving poor, as opposed to the disorderly, undeserving poor, an emphasis that strengthened from the latter part of the sixteenth century onwards.[20] This poster is shown as *loterijkaarts* were typically displayed or as they were carried in processions. The paper is suspended from a turned wooden post and stabilized by rods top and bottom in an arrangement similar to that used for hanging maps in Dutch houses. This way viewers could easily see the lottery's rules and regulations in the lower register, the prizes that might be won delineated in the middle register – mostly vessels and tableware – and, in the dominant position, the *gasthuis* building and its ambient exterior spaces. These architectural and functional elements in fact comprise the major pictorial focus on the poster. The image underscores the *gasthuis*'s comfortable accommodation evident in the ample proportions of the building and in the beneficial degree of ventilation promised by the many windows. A protective awning over the principal entrance creates a sheltered space for travellers, guests and residents, and this simple exterior feature accentuates the customs of hospitality that *gasthuises* traditionally served.

Gable relief sculpture at charitable sites and its architectural significance

A similar, if more substantial, focus on a premise's appearance, its accessibility and its ability to provide assistance was also the dominant ornamental trait of the gable relief sculptures that appeared with increasing frequency from the 1590s onwards. Many of these reliefs were quite basic with simple inscriptions and heraldry, but others were visually ambitious, with depictions of the clientele served, the interior appointments of the facility or the building's approach and threshold. Two sites in Haarlem offer good examples of this type of exterior gable decoration. St Elisabeth's

gasthuis occupied a complex of buildings on the Groot Heiligland, the institution having absorbed the premises of a religious order previously situated there. The relief tablet surmounting the entrance to the *gasthuis* is dated 1612 and is believed to be the work of Lieven de Key, the city's principal architect and mason-sculptor (Pl. 13).[21] Now set into a classical framework from later in the century, the gable stone represents a narrative scene in which an ailing person is brought to the hospital on a stretcher carried by attendants. At the left, their progress is witnessed by a group of anxious neighbours or family members who demonstrate their concern in broad gestures and facial expressions. At the right is their destination, a haven of a hospital interior shown in ever-diminishing perspective as a seemingly endless series of measured arches and tranquil, ordered spaces. The relief informs passers-by of the hospital's location and purpose, but it also presents a most dramatic contrast between the chaos and disorder that sickness brings to family and neighbourhood and the beneficial effects of the institution delineated entirely in structural form as an orderly, interior space. Community pride in its fledgling emergency services, along with the local specificity such a feature interjected, no doubt also contributed to making de Key's narrative one that served both the institution and the public very well. The relief informs the viewer about the architectural elements of the institution, and contrasts its open, orderly spatial characteristics with the dramatic disorder at its threshold.

An even greater emphasis on an institution's premises can be seen in the polychrome relief also attributed to de Key that dates from 1624 and is located above the entrance to St Barbara's *gasthuis* (Pl. 14).[22] Unlike the idealized sequence of classical arches that typified the St Elisabeth relief, here the steep perspective offers a view into an interior whose structure and fittings are clearly local and vernacular in character. Along one wall are the recessed, curtained beds where patients are attended by family or staff, and above is a gallery whose railings were used for airing linens.[23] The hospital's entrance and ample, hooded fireplace are located on the opposite wall. Two elderly women converse in the foreground; perhaps the gesture of the stooped one with the cane denotes that she is the principal speaker is seeking alms or assistance. This is hardly the exciting scene of emergency services and dire suffering proffered at St Elisabeth's, but a view that reassures the spectator through its calm, beneficial and accommodating characteristics. These features in effect offer a variant handling but a similar kind of visible proof that access and assistance were well within the purview of responsible charitable establishments. An inscription below the image commemorates the principal donor of the institution, Hugo van Assendelft, as the generous individual who made this accommodation possible, and offering proof that the public acknowledgement of such gifts and benefactors was a major consideration in the exterior decoration of most institutions. A significant number of surviving reliefs like these from St Elisabeth's and St Barbara's delineate the entryways or modes of access, the spatial coordinates and the

suitable accommodations to be found within. The reliefs are positioned so as to accentuate the entry area, the transitional space that separates the outside from the inside and that constitutes that boundary at the building's threshold. Portals of this type bring elements of the interior to the institution's façade, and each emphasizes the way into the facility as a practical, signage issue, as well as a representational opportunity.

St. Caecilia's *gasthuis*/hospital in Leiden

Alongside the scattered or isolated examples of gable reliefs and lottery prints, there are some individual sites that are rich in both surviving architecture and several forms of documentation. This is the case at St Caecilia's *gasthuis* in Leiden, where parts of the original building were incorporated into later additions, and where some exterior decoration and a lottery poster have also survived. A drawing from 1586 by Salomon van Dulmanshorst provides a record of the medieval St Caecilia cloister whose buildings were gradually modified or replaced to create the hospital, making this location a good example of the strategy whereby confiscated conventual properties were adapted to a solely charitable use.[24] A new building was erected in 1598 to accommodate the ailing, the plague-stricken and the insane all in one complex.

Reconstructions of the site that describe the facility when it was still a religious foundation include a residential cloister, chapel, kitchen, a porter's room beside the entrance, and several small, self-contained units known as '*huisjes*' or little houses, with all arranged around an inner courtyard. Subsequent alterations made possible by lotteries became the occasion for competing designs whose strengths and weaknesses were subject to debate by the university faculty. Several of these various proposals have survived, and they typically combine a range of residential spaces around a courtyard, with very small rooms designated for the insane and larger individual units referred to again as *huisjes*, along with larger sickrooms able to accommodate as many as 56 beds.[25] A reconstruction of the site following the actual alterations of 1598–1600 similarly shows large rooms described as sickrooms and capable of handling many beds, small cells for the insane, and numerous *huisjes* distributed along the different ranges around courtyards. Ten of the *dolhuis* cells are still *in situ*, and they are small and dark, with doors and with hatch openings approximately 14 inches (35 cm) square and 3 feet (90 cm) from the floor. In the plan, the *huisjes* by contrast are two to four times the size of the cells, and so offer spaces that are more like the civic or privately endowed *hofjes* that accommodated the poor, the elderly or transient guests in the hospital/hospitium/almshouse tradition.

The entrance to the *gasthuis* remained the groin-vaulted passage that had served as the original doorway for the cloister. Here, interior and exterior arches terminated in small grotesque heads, of which only the pair

4.2 Isaac van
Swanenburg,
Leiden lottery
poster, 1595,
Cabinet des
Estampes,
Bibliothèque
royale de la
Belgique,
Brussels. Photo:
Library

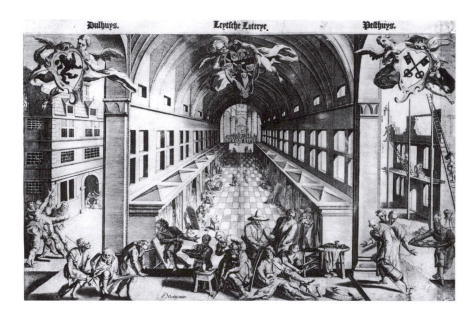

4.2 Isaac van Swanenburg, Leiden lottery poster, 1595, Cabinet des Estampes, Bibliothèque royale de la Belgique, Brussels. Photo: Library

on the façade remain. Above the door, a sandstone cartouche surrounded by strapwork bears the date of 1614, although there is some evidence suggesting that it might actually have been in place as early as 1600.[26] The cartouche, inscribed 'S. Caecilia's Gasthuis', identifies the building precisely at the former cloister entrance as a hospital or hospice, and so publicly acknowledges the site's transformation from a religious foundation to a city charity.

All of the actual improvements undertaken from this time at St Caecilia's were made possible by the lottery of 1595–96. This was a major event that included a rhetoricians' festival in which ten chambers were invited to compete with Leiden's own group.[27] Isaac van Swanenburg, the city's leading artist and a *gasthuis* official whose son would later achieve renown as Rembrandt's first teacher, designed the image for the *loterijkaart*, and it was engraved by Jacques de Gheyn II (Fig. 4.2).

Most of the print shows the hospital's orderly but overflowing premises, with the proposed *pesthuis* (plague hospital) and *dolhuis* (asylum) occupying the right and left margins respectively as completely separate buildings. Numerous sick and disabled people gather at the hospital's entrance in the foreground awaiting assistance and admission. In the nave-like space beyond, other patients, assistants and curtained bed-cubicles are visible. The *pesthuis* is still under construction, so there are no patients there, but the asylum is a completed and substantial three-storeyed structure. Its many ample, barred windows on each floor reveal inmates who are observing the commotion below where two disturbed men are being forcibly brought into the building. No surviving plans from St Caecilia's resemble this arrangement, and so the depiction is most certainly an imaginative architectural composite. Nevertheless, the engraving importantly calls attention to many critical

spatial and domestic aspects of the site, including the interior space opened up for observation and inspection, and the particular focus on architectural features that facilitate access and ease accommodation. The result is an impressive combination of exterior architectural specifications with opened-up interior vistas.

Monumental and retrospective, the large vaulted space recalls the nave-like wards of medieval hospitals like those at Beaune, Angers or Bruges, and serves as a reminder of St Caecilia's origins as a religious foundation. Within the vast and draughty accommodation, the individual needs of patients are met through a combination of service, ventilation, comfort and privacy. The foreground reception area is busy and full of commotion, but assistance is shown being efficiently – even graciously – given. Access, accessibility and hospitable reception are accentuated in this portrayal of the entry area, a space that opens up a view that extends both laterally and back into the body of the ward. In the completed *dolhuis* structure where the print indicates that some degree of differentiation and specialization of treatment was attempted at St Caecilia's, the practice of sequestration is judiciously handled, as only the violent and disorderly are being forced unwillingly into the institution.

A number of the critical elements from this *loterijkaart* also appear in a painting on copper that originally decorated the exterior cartouche above St Caecilia's portal (Pl. 15).[28] The painting was perhaps even part of the lottery fundraising efforts, since it was in this position by the late 1590s, but removed shortly thereafter, presumably to make way for the more formal sandstone tablet. While *in situ*, however, the plate brought the same mixture of spatial and architectural concerns familiar from the relatively ephemeral lottery poster to the institution's actual doorway in concrete form. The anonymous painting condenses the engraving's elements, retaining the row of curtained beds with incumbents being visited by dutiful family members, the arrival of a new patient, and a raving man being carried into one of the cells, now presented all together in one cropped view. This condensation, however, is more than just an effective aesthetic solution, because it also re-creates the mixed-use aspect of the hospital's space, and unites the disparate spatial modules of the actual St Caecilia's. Only the lofty vaulted ward construction and the *huisjes* or little houses are not represented, but while there is no reference at all to the former, the latter are suggested by the cohesive spatial ambience of the scene that projects something of the *huisjes'* intimate, simple self-sufficiency. The scene's main focus, though, is not so much on recreating the separate and different kinds of spatial accommodations available at St Caecilia's, as it is on the way one gained access to them. The plate's design presents a composite view of the hospital's ambient spaces as places of transit and transition. Combining a dynamics of access and ingress with some of the interior specifics of the institution, the painting was then set at the building's threshold for all passers-by to see.

The *dolhuis*/asylum in Amsterdam

A similar relationship between the architectural and spatial iconography of an institution's *loterijkaart*, the actual fabric of the building and its exterior decoration also characterizes the *dolhuis* at Amsterdam, whose lottery poster was discussed at the beginning of this essay. Nothing of the original *dolhuis* premises has survived except for its garden sculpture, but there are numerous topographical prints that, in addition to the *loterijkaart*, describe the building complex in some detail.[29] Sited on land that had been part of the St Ursula cloister, the first *dolhuis* consisted of 11 *hofjes* connected around a courtyard. A bequest in 1561 by Henrik and Christina Boelens provided the initial support for expansion, and it is their family arms that decorate the principal entrance in a public acknowledgement of their generous donation. This exterior decoration is visible above the doorway of the building located at the right in the lottery poster (Pl. 12). Below is the inscription: 'This House of God was founded on Love [which is] mild by nature / And restrains madness, which spares neither self nor others'.[30]

This simple charitable statement retains the traditional hospital designation of '*Domus Dei*', but is very modern in its sentiments, acknowledging the impact of madness on the community and attempting to forestall any notion that restraint is motivated by anything other than love. Between 1592 and 1615, further improvements were made possible by the institution's increasingly prosperous circumstances along with a series of successful lotteries. These alterations include an extension to provide for 20 additional *huisjes*, or small houses, around a courtyard and ornamentation for the exterior façade, as well as a formal garden. The construction was undertaken by Hendrik de Keyser and his workshop who were responsible for much of Amsterdam's civic rebuilding in this period.[31] Their addition is the new courtyard of *huisjes* shown at the left in the poster along with the bare beginnings of that façade's ornamentation. The relief as depicted in the *loterijkaart* did not materialize, but a gablestone of similar design was completed by the de Keyser workshop around 1615.[32] While this too has not survived, it is known from seventeenth- and eighteenth-century prints and drawings (Fig. 4.3).

This relief offers an intriguing combination of interior and exterior architectural motifs and spaces. The large vaulted space identified with the traditional hospital ward has been conflated with that of the cloister courtyard composed of *hofjes* or *huisjes*, so the scene seems to be both outside and inside at the same time. The little houses or cells punctuate the lower wall at measured intervals, and the upper storeys evidence a variety of window types and niches that are neither entirely plausible nor even structurally compatible. The vault itself is decorated with floral and geometric designs and it ends in a semi-circular, latticed space behind which several figures can be seen looking toward the spectator and down into the room below. Here in the foreground of the ample interior are only two sets of figures of caregivers and the ailing. A man gives a drink to a dishevelled woman pulling her hair, and a woman offers

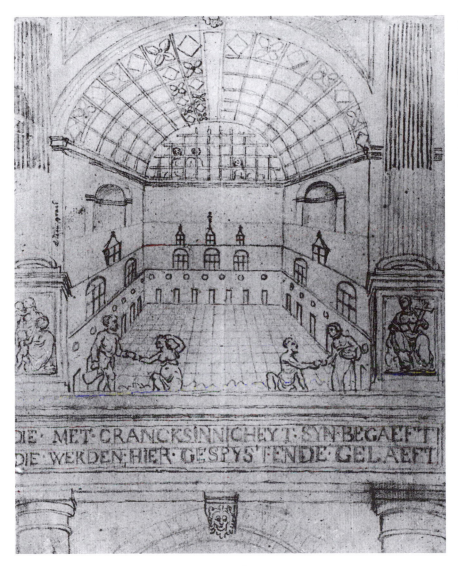

food to a man scantily clad in a loincloth. Both recipients of care are dutiful and respectful, but they clearly evince the signs of the most agitated forms of madness as indicated by their disorderly attire, their exposed bodies and the gesture of self-abuse. This part of the relief recalls the traditional imagery of the Seven Acts of Mercy, and these conventions continued to provide the standard for benevolence in art as well as life. The verse inscription below is attributed to Joost van den Vondel, and it clearly reinforces the acts of mercy focus: 'Those who are gifted/visited with [hosts for] insanity / Are here fed and their thirst quenched.'[33]

Many venerable attitudes regarding illness and insanity are invoked here. The inscription deploys the guest/host conflation familiar from the Latin *hospes* (hospital, hostel, hotel, guest, host, etc.) and extends it even to the physical

body of the ailing person. This in turn recalls similar customary notions, in which the mad were viewed as gifted and therefore special before God, and also as being visited by a particular affliction, rather than responsible for bringing it on themselves.

Like the phrases, the relief accommodates the senses of visiting and of hosting, of entering and being received into a premise, and does so in spatial terms that foreground the hospitable acts of reception and provision. The relief's wide and deep view beyond the threshold and into the institution's interior reveals the kind of ordered and therefore safe household that was lauded in Dutch moral essays and celebrated in paintings after the mid-century. Certainly this sense of order was something to which charitable civic institutions also aspired. Such orderly spaces, however, can only be appreciated through the act of viewing and by visibility itself. These states and circumstances are underscored by the relief's design, as the background onlookers, the caretakers and the recipients are depicted so as to unify spatial boundaries and to bring the private into public sight. As with all hospitals in this period, Dutch institutions were organized along a household model, and here it was common for resident supervisors to be addressed as 'father' or 'mother', so it is not surprising to find that domestic constructs also affected the design and decoration of asylum and *gasthuis* spaces.

Conclusion: common spatial models for domestic and institutional interiors

The portal imagery and lottery designs from St Elisabeth's, St Barbara's, and St Caecilia's *gasthuises* and from Amsterdam's *dolhuis* all demonstrate a preoccupation with the threshold and entry spaces of their institutions. In domestic as well as institutional design, the spatial module where the private interior becomes publicly accessible is known as the *voorsael* or *voorhuis*, literally the front room or front hall or fore-house of the building. It is the space that links the house or any structure directly with the street, and so provides a transitional area between the interior and the outside world.[34] This is not an inert space, but a place for activity that was sometimes used as a business or work space in addition to serving as the principal reception area. Conduct books acknowledge the complexity of this *voorhuis* space, defining protocols for gaining entrance and access to certain areas of the house and describing behaviour suitable for this somewhat ambiguous, transitional hall.[35] Most *voorhuises* span the entire width or frontage of the house. As represented in the designs of the architect and engineer Simon Stevin from around 1600, the *voorhuis* is both a reception point and a connecting area linking street with entry, stairs and more private inner rooms. Stevin saw the *voorhuis* as a kind of Roman front courtyard brought into the body of the house, a transposition that turned an external space of access into the building's interior. In Stevin's plans the *voorhuis* extended

through the house, offering access and views into adjacent and rear spaces. Subsequent designs of *voorhuises* tend towards a smaller space, maintaining the full width of the building's frontage, but continuing through the house as a sometimes narrow conduit.[36] Yet even the smaller *voorhuises* continue to offer a significant view into the body of the house where parts of other rooms, doorways or stairs may be glimpsed, resulting in a limited vista of domestic spatial units. The *voorhuis* space is usually studied in design history as a shrinking module that gradually loses ground to the other rooms of the house, but in Dutch houses it never becomes a simple vestibule or a space that blocks the view into the rest of the house. However, even when this reduction occurs in Stevin's plans, Heidi de Mare has emphasized that the architect continued to uphold and to emphasize the symbolic importance of the space as a boundary for negotiating access and ingress.[37] We know from aphoristic writings like those of Jacob Cats that guarding the boundaries of the house was one of a wife's most important duties, such that a great deal of emphasis was consequently placed at the house's threshold area.[38] De Mare contends that this border issue was the motivation behind householders' interest in ornamenting doorways, cleansing doorsteps and sills, and in being attentive to guidelines for deportment at this location.[39]

When the earlier, more extensive form of the *voorhuis* is shown in perspective, it describes a space much like that depicted in the Amsterdam *dolhuis* relief, providing a view through the body of the structure and a sense of the space on either side and beyond the rear wall. This *voorhuis* type was that favoured by Stevin, and it is likely that de Keyser would have been attentive to his contemporary's challenging ideas.[40] At the *gasthuis* sites studied in this essay, the *voorhuis* area of the buildings varied in extent, but nevertheless the space was a principal foreground preoccupation. Correspondingly, the emphasis on transitions at thresholds – the symbolic economy with which this space was invested – was an acute concern for institutions identified with hospitality, assistance and almsgiving. And while visual access and a deep view into domestic space is a combination associated primarily with Dutch genre painting, it is clear that institution portals and lottery prints exhibited these spatial preferences from the 1590s onwards, making them important precursors for what would become a major theme in Golden Age painting.

The gable ornamentation and lottery ephemera of Dutch charitable institutions re-create the motifs of the transitional entry space, the *voorhuis* or *voorsael*, and introduce composite views of their establishments' interiors. These motifs, whether wards, little houses or cells, are represented so as to underscore the traditional role hospitality played at such sites, and to emphasize inclusiveness and visible activity over exclusion and isolation. The focus on charity is a demonstrable one that elevates observation and accessibility as equal partners in the performance of charitable acts. Informative exterior decoration at civic institutions and their fundraising posters exploited a dynamics of prospect and access, of display and

observation, and so highlighted the potential of their boundary spaces, as a way of endorsing and encouraging the charitable participation of citizens in the material realities of the active life.

Notes

1 John D. Thompson and Grace Goldin, *The Hospital: A Social and Architectural History* (New Haven CT: Yale University Press, 1975), ch. 3; Dieter Jetter, *Grundzüge der Hospitallgeschichte* (Darmstadt: Wissenschaftliche Buchgesellschaft, 1973); Lenie Peetoom and Letty van der Hoek, *Door Gangen en Poorten naar de Hofjes van Haarlem* (Leiden: Stichting Uitgeverij Barabinsk, 2001), 11.

2 For this development in civic architecture and social responsibility, see Jonathan Israel, *The Dutch Republic. Its Rise, Greatness and Fall 1477–1806* (Oxford: Clarendon Press, 1995), 353–60; Marjolein t'Hart, 'The Glorious City: Monumentalism and Public Space in 17th-Century Amsterdam', in *Urban Achievement in Early Modern Europe*, ed. Patrick O'Brien et al. (Cambridge: Cambridge University Press, 2001), 128–50. On the two building periods, see Pieter Spierenburg, *The Broken Spell* (New Brunswick NJ: Rutgers University Press, 1991), 186.

3 From 1560 to 1640, wandering vagrants and other so-called 'masterless men' were a serious problem, overwhelming cities and congregating on the outskirts of towns. For this situation in the Netherlands, see Israel, *The Dutch Republic*, 123–4, 442–511. It was this increase in disorderly vagrants that contributed to the emphasis on the 'deserving poor' in public assistance programmes.

4 Sheila Muller, *Charity in the Dutch Republic* (Ann Arbor MI: University of Michigan Press, 1985); Simon Schama, *The Embarrassment of Riches* (New York: Knopf, 1987); Anne E.C. McCants, *Civic Charity in a Golden Age: Orphan Care in Early Modern Amsterdam* (Chicago IL: University of Chicago Press, 1997); and Israel, *The Dutch Republic*, 353–60.

5 Nikolaus Pevsner, 'Hospitals', in his *A History of Building Types* (London: Thames & Hudson, 1979), 131.

6 Thompson and Goldin, *The Hospital*, 20–21; Pevsner, 'Hospitals', 140–42.

7 Thompson and Goldin, *The Hospital*, 4; G.T. Haneveld, *Oude Medische Gebouwen van Nederland* (Amsterdam: R. Meesters, 1976), 14.

8 The hospital founded at Kües in 1442 had its own cloister and the Hôtel Dieu at Beaune (1443–51) had its buildings ranged around a courtyard; see Pevsner, 'Hospitals', 142. The infirmaries at both Cluny and Canterbury had their own cloisters; see Thompson and Goldin, *The Hospital*, 19.

9 Thompson and Goldin, *The Hospital*, 22, 41.

10 Pevsner, 'Hospitals', 141; Thompson and Goldin, *The Hospital*, 41.

11 This format might be based on that of Carthusian monasteries. Thompson and Goldin, *The Hospital*, 46; Peetoom and van der Hoek, *Door Gangen en Poorten*, 11.

12 Peetoom and van der Hoek, *Door Gangen en Poorten*, 11.

13 Haneveld, *Oude Medische Gebouwen*, 15.

14 Christine Stevenson, *Medicine and Magnificence: British Hospital and Asylum Architecture 1660–1815* (New Haven CT: Yale University Press, 2000), 3.

15 A number of historical pressures combined to favour the increasing differentiation of institutional spaces. Urbanization, an increasingly secular responsibility for providing charitable services and the growing numbers of those requiring assistance all contributed to the need for smaller, subdivided spaces. These could accommodate more people while also supporting a degree of privacy widely regarded now as standard and humane; Israel, *The Dutch Republic*, 354; Stevenson, *Medicine and Magnificence*, 12, 13, 17. While lay citizens favoured continuing the courtyard plan, they did so on a necessarily less monumental scale than that of the great monastic complexes, and this also made for more differentiation and smaller accommodation; Thompson and Goldin, *The Hospital*, 19, 79. Certain constituencies (lepers, plague victims, the insane, elderly) traditionally were associated with smaller enclosed spaces for a variety of functional reasons; Thompson and Goldin, *The Hospital*, 20, 41, 45. The combined relevance of the 'hospitable house' model also reinforced the desirability of an essential resemblance between hospital/hospice interiors and domestic spaces; Stevenson, *Medicine and Magnificence*, 17. From among the adapted residential forms, Stevenson contrasts the cells' derivation from the monastic tradition with that of the gallery, which was derived from palatial structures; *ibid.*, 9.

16 Rudolf E.O. Ekkart, 'Ein Leidse Loterijkaart uit de Zestiende Eeuw', *Leids Jaarboekje* 66 (1974), 113; Israel, *The Dutch Republic*, 354–5. Israel elaborates further: 'Charitable foundations were administered on a week-to-week basis by committees of "regents", closely connected with the town government [and] under the general supervision of town hall and consistory, …'; *ibid.*, 356.

17 Anneke Huisman and Johan Koppenol, *Daer compt de Loterij met Trommels en Trompetten. Loterijen in de Nederlanden tot 1726* (Hilversum: Verloren, 1991).

18 Janna Beijerman-Schols, 'Platenatlas. Een Keuze uit de Drie Atlassen', in *Geschiedenis in Beeld*, Janna Beijerman-Schols et al. (Zwolle: Waanders Uitgevers, 2000), 86–7.

19 *Ibid.*, 109.

20 See Israel, *The Dutch Republic*, 424–511.

21 For St Elisabeth's, see Haneveld, *Oude Medische Gebouwen*, 75. On de Key, see Muller, *Charity in the Dutch Republic*, 31, 243, n. 118; Mariette Polman, *Het Frans Halsmuseum* (Haarlem: Vrieseborch, 1990).

22 Peetoom and van der Hoek, *Door Gangen en Poorten*, 154; Haneveld, *Oude Medische Gebouwen*, 77.

23 A similar arrangement could be found at the Oudemannenhuis in Haarlem; see Polman, *Het Frans Halsmuseum*, 75.

24 Haneveld, *Oude Medische Gebouwen*, 109–10; H.A. van Oerle, 'Het Caecilia-Gasthius een onderzoek naar de bouwgeschiedenis van het Caecilia-gasthuis …', unpublished MS, Museum Boerhaave, Leiden.

25 van Oerle, 'Het Caecilia-Gasthuis', figs 12–18.

26 *Ibid.*, 65.

27 Ekkart, 'Ein Leidse Loterijkaart', 112–22.

28 The plaque is in the Lakenhal Museum, Leiden. There is some controversy regarding the date of this work. While some scholars suggest a date of c. 1650, documentation indicates that this plate (or one very like it) was in place outside the institution in the 1590s.

29 C.A.L. Sander, 'Het Dolhuys of Dolhuis Ande Vesten of de Kloveniersburgwal', *Maanblad amstelodamum*, 45 (1958), 29–40; Jan Wagenaar, *Amsterdam in Zyne Opkomst*, 2 vols (Amsterdam: Isaak Tirion, 1765), vol. II, 307–11.

30 The original Dutch is 'Dit Godhuis is gestigt, uit liefde milt van aert; En toomt de Dolheid, die zich zelfs noch niemant spaert.'

31 Elisabeth Neurdenburg, *Hendrik de Keyser* (Amsterdam: Scheltma and Holkema, 1930); R. Meischke, 'Het Amsterdamse Fabrieksambt van 1595–1625', *Bulletin von Koninlijke Nederlandse Oudheidkundige*, 93 (1994), 100–124.

32 Wagenaar, *Amsterdam in Zyne Opkomst*, 308, 310.

33 The Dutch is 'Die met Crancksinnigheyt syn begaeft / Die werden hier gesppyst ende gelaeft.'

34 Heidi de Mare, 'The Domestic Boundary as Ritual Area in Seventeenth-Century Holland', in *Urban Ritual in Italy and the Netherlands*, ed. Heidi de Mare and Anna Vos (Assen: Van Gorcum, 1993), 109–31; Mariet Westermann, *Art and Home. Dutch Interiors in the Age of Rembrandt* (Zwolle: Waanders, 2001); John Loughman and John Michael Montias, *Public and Private Spaces* (Zwolle: Waanders, 2000); C. Willemijn Fock, 'Semblance or Reality? The Domestic Interior in 17th-Century Dutch Painting', in Westermann, 83–101.

35 De Mare, 'The Domestic Boundary', 122–4; Loughman and Montias, *Public and Private Spaces*, 28.

36 Westermann, *Art and Home*, 29–30.

37 De Mare, 'The Domestic Boundary', 122–4.

38 On Cats's description of the housewife's duties, see his *Houwelick* (Middelburg: J.P. van de Venne, 1625).

39 De Mare, 'The Domestic Boundary', 122–4.

40 A portrait medallion by de Keyser has been tentatively identified as Stevin. See Wilhelmina Halsema-Kubes, 'Hendrick de Keyser', in *Dictionary of Art*, ed. Jane Turner (London: Macmillan, 1996), vol. 18, p. 8.

The housing of institutional architecture: searching for a domestic holy in post-Tridentine Italian convents

Helen Hills

We cannot think of interiors without thinking of bodies – the denial of the body reveals itself as nothing other than the embodiment of denial.[1]

This chapter seeks to turn from the architectural historian's habit of thinking in terms of extensive or measurable space, to thinking instead in terms of intensive space; that is, of space whose significance lies precisely in its insusceptibility to measurement. It does this by considering interstices and margins within architectural spaces – specifically within architectural spaces of the early modern convent – and within the epistemologies conventionally brought to bear in analysing institutional architecture.

The phrase 'the domestic and the institutional' implies that the domestic is not institutional, and the institutional not domestic. But, arguably, the domestic/institutional dichotomy is a modern scholarly antinomy, rather than something rooted in early modern culture. In early modern Europe there was no 'domestic' outside the constraints of the institutions of both family and social class, arguably the period's most powerful institutions.[2] And, a corollary to that, which of the many varied early modern institutions can be claimed as being beyond reach of familial ambitions or domestic considerations? In this chapter, assuming both that the family was an institution, and that the domestic was necessarily institutional and institutionalized, I ask what part of the domestic might lie beyond the institution of the family home and, challenging the received wisdom that the domestic is inherently secular, I search for a 'domestic holy'. I turn to the architecture of southern Italian aristocratic female convents to address these issues.[3] Thus I want both to think beyond the dichotomy of 'domestic' and 'institutional' with regard to the convent; and to resist the tendency within early modern studies of conceiving of convents either as constituted from without (by Trent, by ecclesiastical authority, by religious orders conceived as external to convent culture) or as produced from within (a tale of exemplary individuals or of convent culture

usually presented as homogenous). I want not merely to see these spheres as inter-penetrative and to recognize the convent walls as 'porous' (in both directions), but I want also to consider those epistemological 'limits' that are also enunciative boundaries of dissonant, possibly even dissident, voices of the familial-institutional inmates; that is, to consider the margins and interstices within convents themselves. Thus this chapter searches for a domestic holy interior within the margins of post-Tridentine aristocratic female convents in Rome and Naples.

Not only could families leave a dynastic imprint on the fabric of convents, as is relatively well known, but I suggest here that an internal conventual familial patronage system co-existed with that dynastic familial patronage system. While external patronage tended towards self-advertisement and was usually identified with a single clearly identifiable intervention (such as a new organ), patronage by individual nuns within convents often consisted of contributing towards a high-cost project (such as a new dormitory) and, although almost always unmarked and invisible to the unknowing outside world, it was carefully recorded in conventual records. Furthermore, drawing in particular on the manuscript history by Domenica Salamonia (written 1653–56) of the aristocratic Dominican convent of SS Domenico e Sisto in Rome, I demonstrate that nuns created for themselves a 'domestic holy', inside those recently produced marginalized 'interiors of interiors' of convent life and its architectures. I suggest the 'domestic holy' interiors produced by nuns within aristocratic female conventual institutions in seventeenth-century Italy were a direct response to enclosure as prescribed by the Council of Trent.[4] Thus they represent something of a paradox whereby institutional attempts to draw sharp boundaries between interior and exterior, between enclosed conventual institution and blood family, served to produce not only porous boundaries and enclosed interior spaces perforated by those very spaces from which they were supposedly separate, but new spaces of resistance to those very institutional efforts. The domestic holy interior examined here thus challenges widely held notions of the interior, the domestic, the institutional and the holy in this period, as well as allowing us to understand convent architecture not only in terms of the strident and dominant voices of Trent and ecclesiastical visitations, so ably amplified by historians, but in terms of the less readily heard voices from the devotional and architectural margins.

I first interrogate the term 'interior' to show that a simple interior/exterior dichotomy is particularly problematic for an understanding of convent architecture; and second, I problematize the institutional/domestic opposition.

The problem of the 'interior'

I turn first to explore the porous, ambiguous and contradictory boundaries between 'interior' and 'exterior' in aristocratic female convents of southern Italy. Superficially, with its emphatically sturdy walls, grilled windows and

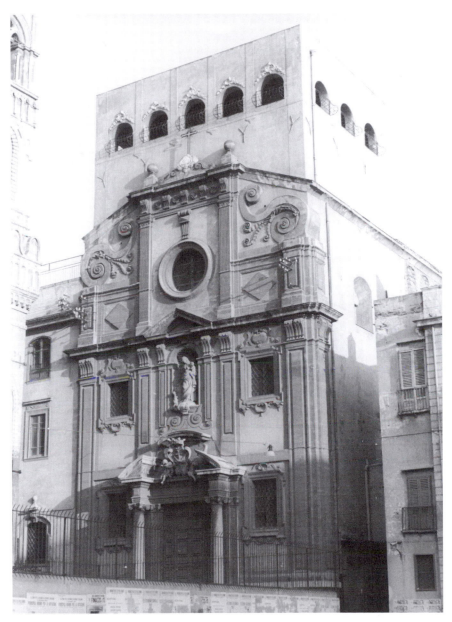

5.1 The inaccessible convent: Sta Maria di Monteoliveto, Palermo, the convent church and part of the convent complex. Photo: © Helen Hills

heavily rusticated doorways, conventual architecture proclaimed a sharp dichotomy between the exterior and excluded (mundane) and the interior and enclosed (secluded and devoted to religious concerns) (Fig. 5.1). Just as in textual representations, steadfast virginity and sealed interiors were articulated through a rhetoric of fortification, so in architecture, barred entrances, steep staircases and turn-wheels declared an impermeable enclosure defending the orifices of the conventual body.[5] It was architecture that was made to carry the burden of enclosure and the protection of virginity.[6]

Convents had to be apparently impermeable, because gaps or holes, however small, were regarded as posing temptation, specifically sexual temptation. Episcopal visitations focused overwhelmingly on signs of architectural improbity or incontinence.[7] In his *Tromba Catechista* (1713), much used by nuns in early eighteenth-century Naples, Antonio Ardia SJ directly links a young monacand's access to a window to her loss of commitment to Christ and her subsequent spiritual death:

A damsel, brought up most honourably … in correctitude and virtue, … called
by God to be his Spouse, and moved by his voice, was negotiating to enter a
convent. But, meanwhile, inattentive to her own withdrawal, she began to make
accommodation for a few amusements. Soon she relished a little gap in the windows,
[which allowed her] to see freely, and she even began not to feel torment at being seen
… and, little by little, sometimes with a glance, sometimes with a message or a letter,
she committed herself so fully to a young man's ardour, that she reached the point of
desiring him … her heavenly Spouse already forgotten.[8]

Architecture, then, was represented as encouraging probity or abuse, and as fashioning temptation and desire. Convent walls, like the body of the nun smothered in a habit, were to be sheathed from temptation and made impenetrable: architecture and the nuns' body were conflated.[9]

In spite of the architectural rhetoric of a clear distinction between interior and exterior, convent architecture can be seen instead to be composed of several series of gradations and of interiors within interiors, to perform a recessive slippage of margins and interstices. Any simple exterior/interior distinction was undercut in three principal ways: by spatial permeability; by visual porosity; and by their paradoxical advertisement – the celebration of the interstices.

Conventual regulation depended on an architectural system premised on the hermeneutics of depth: visitors were allowed to enter the convent to varying degrees of depth, according to their gender, social status and ecclesiastical regulation.[10] Thus the architecture of the Franciscan convent of Sta Maria di Gerusalemme in Naples was designed in such a way that even when a nun was ill, contact with a doctor was minimal and strictly precluded straying sight or touch, as Carlo Celano reported in 1692:

There enter into the convent no doctors, or blood-letters, except in case of extreme
necessity … There is a large room, longer than it is wide, where an altar stands
on which each morning Holy Mass is celebrated; to the inner part are the small
cells of the infirmary; and each little cell has a small low window, looking in at the
aforementioned room, through which the sick nun can listen to the mass from her
bed, and be seen by the doctor. To be bled, there is a place, arranged so that the blood-
letter can see only the [nun's] foot or arm, where he has to prick the vein.[11]

Conversely there were 'exteriors' within 'interiors'. Visitors' parlours, located near the street and public entrance, marked a liminal area, within convent walls, but were not part of the architectural system open to nuns. A drawing of the parlours at Sta Maria Donn'Albina of c. 1689 indicates how convent parlour architecture regulated the bodies, both of inmate nuns,

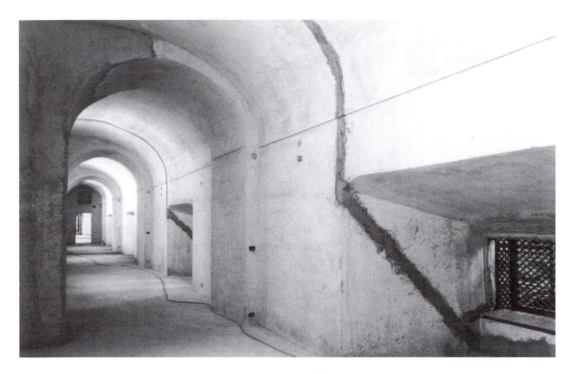

and their visitors (Pl. 16). Visitors were separated by gender, with male and female visitors in separate parlours. The earlier system (on the right) had separate parlours for nuns, for male visitors and for female visitors, all on the periphery of the institution. The new system (on the left) boasts an expanded parlatory for men – one wonders whether male visitors had been overflowing intrusively into the covered courtyard while waiting their turn at the grilles. In the later arrangement, nuns in conversation with male visitors were removed from the outermost perimeter of the convent, their parlour drawn further in, and the men kept firmly on the outer edge of the complex. Furthermore, the grilles that previously held nuns apart from their interlocutors are now enhanced by an architectural addition that appears to extend spatially the distance of separation.[12] Thus, while there is more zealous attention to the separation between nun and lay, male and female, nevertheless, accommodation of visitors within the convent walls continued; indeed, convent architecture's drive to taxonomize spatially extended increasingly to its visitors.

After enclosure, a hermeneutics of depth was echoed in an hermeneutics of height. It was above all the convent church that was stratified spatially in height. After Trent nuns were not allowed inside the public churches to worship or participate in the Mass, but were relegated instead to their clerestory-level choirs, often high up at east or west ends of the church nave, and to convent corridors, also at clerestory level, from where they could look down through grilled openings (*gelosie*) at the performance of the Mass in the convent church below (Fig. 5.2).[13]

5.2 Sta Maria Donnaregina (Nuova), Naples. Interior passageway at clerestory level around the convent church, showing flanged *gelosia* providing view of convent church below. Photo: © Helen Hills

Thus, post-Tridentine convent churches can be best imagined as two systems, a lower and inner church for laity and an outer and higher church, enveloping it, for nuns. Two groups of worshippers – layfolk and nuns – were kept separate from each other while participating in a shared Mass. But here were played out the paradoxical hermeneutics of height: nuns were held loftily high above the congregation and, from their privileged position, their gaze triumphed over the space and people below. Yet the architecture simultaneously locked them in as passive, albeit privileged, observers, participating in the services from within their own restricted spaces, suspended on high.[14] The elevated nuns, expelled from the church nave, occupied a separate architectural system surrounding the public church interior in their hidden peep-holed corridors and choirs (Fig. 5.2 and Pl. 17). Outside the public church, but deeper inside the convent, nuns occupied spaces that can be figured both as interiors of the public church and as its exterior. They at once participated in church services and communicated with the public church visually and aurally and through all their senses, while also being barred from it in body. While prayers and singing might bind public church and nuns' corridors and choirs together as one space in sound, grilles and *gelosie*, together with the physical elevation of the nuns, held them apart. Above all, in those churches with raised east-end nuns' choirs, towering above the priest officiating at Mass, nuns could not only look out beyond their formal enclosure, but their relationship to the holy was marked vertically, emphatically different from lay populations. That spiritual difference reached its height at the climax of the Mass, when the priest turned towards them and away from the congregation in the nave (Fig. 5.3).

Interiors which figured as both interiors and exteriors of the public church, and recesses beyond those interiors, in both depth and height, produced spatial ambivalences, which disturbed any simple 'interior' and 'exterior' division. It was those spatial ambivalences that privileged excluded groups, and produced new forms of inaccessible holiness and holy inaccessibility.

Although bodies rarely passed between these separate interiors, the gaze could do so, and indeed convent church architecture brilliantly orchestrated the gaze through its deeply flanged *gelosie*, grilles and gratings, the perforations and punctuations of enclosure. As nuns were transformed into observers after Trent, the politics and architecture of sight became correspondingly more important. Within their convents nuns could see, but not be fully seen. Convent architecture granted the power of the gaze asymmetrically, affording nuns pleasures denied to laity. There was an explosion in the seeing of enclosed nuns, even as their being seen was increasingly limited, both in relation to looking into the public church; and looking beyond their enclosure from roof terraces and belvederes.[15] Control of sight was organized in terms not only of the building, but of the nuns' bodies themselves. Thus two systems – body and building – functioned in correlation, producing interiors which proffered glimpses of other, further and forbidden interiors (Figs 5.2, 5.3, 5.4 and Pl. 16).

5.3 Sta Maria di Gesù delle Monache, Naples, raised east-end nuns' choir. Photo: © Helen Hills

Convent churches, therefore, offered no simple interior/exterior division. Instead they operated as a porous membrane, more permeable in some directions than in others; a membrane of interstices.

Convent churches functioned like an inverse version of Foucault's famous panopticon.[16] Unlike Foucault's model which organizes sight, and allies the gaze to forces of control and surveillance, thereby identifying the gaze with

5.4 Sta Maria della Sapienza, Naples, *gelosia* in the nave, 17th-century Neapolitan craftsmanship. Photo: © Helen Hills

power, conventual visual economies were organized around the secret, and depended on a notion of the gaze as debasing to their most valuable currency. Arguably, the *possibility* of catching sight of enclosed nuns served to enhance the symbolic and strategic value of convents as protectors of the chaste and vulnerable. As Michel de Certeau has observed, secrecy is not only the state of a thing that escapes from or reveals itself to knowledge, 'it designates a play between actors ... The secret introduces an erotic element into the field of knowledge.'[17] Thus architecture eroticized the spaces it ostensibly kept chaste and advertised the presence of those it ostensibly kept hidden. These sexualized optics of visual dominance dissolved a simple exterior/interior dichotomy into an infinite regress of interiors, which were not simply a hermeneutics of depth.[18] In these fabulously decorated Russian-doll-like convent churches it was the hidden that organized a social network, interiors within interiors, interiors outside interiors, which were displayed as privileged secrets.[19]

Celebrating the interstitial

Grilles and grating were the architectural analogue of the secret. Doors, doorkeepers, parlours, gratings and grilles served to fracture, even while apparently emphasizing, an interior/exterior divisional dichotomy. The very dividers that visually separated lay and nun, outside and inside, were also the porous points of contact – and they were emphasized by ornate gilding to catch the light and to draw the eye. Thus while grilles shielded nuns from scrutiny,

and rendered them anonymous and unidentifiable, they simultaneously fetishized tantalizing snatched glimpses of a veil, a face, a hand (Figs 5.2 and 5.3). The dangers associated with the female gaze help to explain the lavish attention given to the grilles which screened enclosed women, making their eyes invisible.[20] These devices did not, of course, prevent nuns from looking. In fact, the screened *gelosie* and the raised choirs of baroque churches elevated the female gaze to unprecedented heights, as we have seen. Nor was the sacred space of the church de-eroticized by the grilles. The invisible presence of the nuns, who could be glimpsed indistinctly as they moved about and heard as they sang, was tantalizingly erotic; but because nothing clear could be seen, the eroticization became generalized, impersonal, architecturalized, as if emanating from the convent church itself, rather than from individual nuns. The grilles were fashioned to billow into church space, to glint in shafts of sunshine sashaying through windows in dim-lit interiors, and to throw intricate knotted patterns of light and shadow onto nuns' faces and choir walls. Knitting bodies and buildings together through pierced apertures of light like welding beams, gratings, grilles and *gelosie* were significant players in that production, their apparent fragility and immateriality belying their productive capacity (Fig. 5.3). Grilles and *gelosie*, intricate engagements of wrought iron, dashed with gilt, at once served to turn peep-holes into highly wrought cages and into glinting lairs, to perforate church and convent enclosure, and to both bind them together and thrust them apart. Thus what is 'enclosed' was always at issue, precisely as it was also apparently settled.

Domesticizing holiness

I have argued above that the sophisticated architectural machine of convent architecture produced multi-layered interiors, systems of boundaries and borders whose inter-relationships were inherently ambiguous and ambivalent.[21] I turn now to consider how nuns domesticized and personalized the interiors within interiors that were the clerestory corridors (from which they had visual access to the public church), and how they rendered institutional space outside their cells homely. I argue that nuns can be said to have personalized or domesticized the holy, or at least specific aspects of devotion, as they sought to carve out personalized devotions and informal altars (*altarini*) outside of formal church space.

In considering the inter-connections between domestic and conventual interiors in early modern Italy, scholars have to date generally approached the problem by searching for dynastic markers and signs of familial presence, or domestic comfort within convents, especially within nuns' cells.[22] Indeed, the early modern convent was intensely porous, as has now been demonstrated by a formidable scholarship. The high walls of enclosure did not prevent familial interests from influencing conventual politics. From Milan to Palermo convents were everywhere informed by familial pressures and requirements.

However, scholars have perhaps too readily viewed the family and the convent as inherently oppositional institutions.[23] Nuns continued to be daughters even after taking vows. Despite apparently breaking with blood-ties and social demands through their vows, those bonds often remained a lively and important aspect of their conventual lives. Likewise, families did not give up daughters who became nuns; instead the convent became another space to be inscribed by those families and clans.

Convent interiors were domestic in another sense, too. As families or clans dominated specific convents, the institutional world assumed strongly familial overtones.[24] To take one example, typical of many similar circumstances: in 1541 Fulvia Caracciolo, aged two, was enrolled at the same aristocratic Benedictine convent of S Gregorio Armeno in Naples where her mother, Ippolita, had also entered as a child and from which she had left to get married and have children, returning aged 60 to the convent.[25] Fulvia's aunt, Lucrezia, was abbess for six years and Fulvia's sisters, Anna and Elionora, took vows along with her in 1541. In other words, in the convent Fulvia, like many other noblewomen in the grander female convents during this period, surrounded by members of her family and secure in the institution's status, was – almost literally – at home. While, in principle, more than two members of the same family were not allowed to enter the same convent, in practice convents readily accepted gifts and extra payments to accept them.[26] Thus the institutional was familiarized and domesticated, just as the familial was institutionalized. Indeed, the very name of the convent of S Giuseppe dei Ruffi proudly proclaims the extent to which it was in the hands of its founding family, the Ruffo, from its foundation in 1604.[27]

Dynastically marked patronage: domesticating the convent

The antinomy between the 'institutional' and the 'domestic' (or the 'familial') offers an inadequate framework also for the analysis of patronage of art and architecture within convents.

Familial identities and lineages were articulated and reinscribed inside convents in many ways. The usual way to do this was for a family to emblazon a specific art work they had paid for with their coat of arms; and the most usual site for such inscription was the conventual church. In fact, dynastically marked patronage was focused almost exclusively on the conventual church, the most visible site for the tussles of familial and monachal patronage and rivalries. This was the convent's most public space, the liminal space where convent and city intersected and, therefore, the place where an intervention – whether visual or oral, an inlaid marble altar or a sung Mass – would reach both audiences.[28]

The self-advertising patronage, for instance, of Fabrizio Ruffo at S Giuseppe dei Ruffi in Naples, ensured that his generosity there should not be easily forgotten (Fig. 5.5). He arranged that his chapel should be prominently

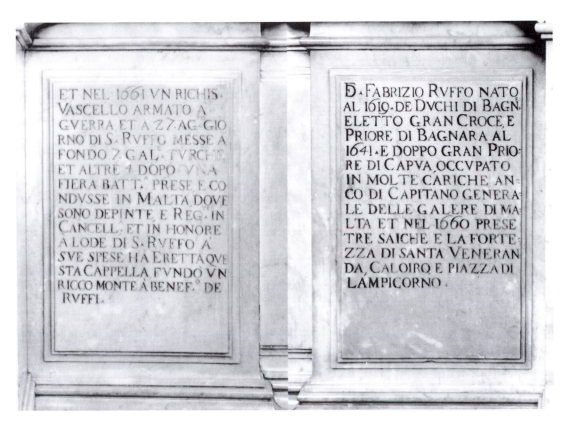

ET NEL 1661 VN RICHIS·
VASCELLO ARMATO A
GVERRA ET A 27·AG·GIO
RNO DI S· RVFFO MESSE A
FONDO 7·GAL· TVRCHE
ET ALTRE 4 DOPO VNA
FIERA BATT. PRESE E CO
NDVSSE IN MALTA DOVE
SONO DEPINTE, E REG· IN
CANCELL· ET IN HONORE
A LODE DI S· RVFFO A
SVE SPESE HA ERETTA QVE
STA CAPPELLA FVNDO VN
RICCO MONTE À BENEF.° DE
RVFFI·

Ð· FABRIZIO RVFFO NATO
AL 1619· DE DVCHI DI BAGN·
ELETTO GRAN CROCE, E
PRIORE DI BAGNARA AL
1641· E DOPPO GRAN PRIO·
RE DI CAPVA, OCCVPATO
IN MOLTE CARICHE AN=
CO DI CAPITANO GENERA·
LE DELLE GALERE DI MA·
LTA ET NEL 1660 PRESE
TRE SAICHE E LA FORTE=
ZZA DI SANTA VENERAN
DA, CALOIRO E PIAZZA DI
LAMPICORNO·

inscribed with his name, coat of arms and details of his offices and naval achievements. Sometimes the domestic was made institutional in even less compromising fashion. Gigantic family coats of arms – which, more directly than any other sign, represent the blood family and its lineage – aggressively claim some Palermitan conventual churches as first and foremost dynastic spaces. Thus the Aragona family's massive coats of arms, on each side of the chancel in the Benedictine convent church of the Immacolata Concezione in Palermo, imprint that most sacred area with the claims of dynasty.[29] Familial presence is not transmuted in terms of patronage to an object of everyday conventual life, but dynastic claims subsume the holiest part of the church.

There are, of course, many dangers in presupposing an isomorphic reflection between the representations of dynastic lineage and those existing in family affairs.[30] The expensive architecture and fantastic decoration, which publicly declared the religious devotion of a particular family and allowed it to secure acceptance or influence within the conventual system, was also the mode by which convents demonstrated the high social class of their inmates, their wealth and standing. In turn, convents could exploit this display to compete with their counterparts in order to persuade the wealthiest and most powerful aristocratic families to lodge their daughters there rather than elsewhere. Thus it is that prestigious convents were able to retain their pre-eminence for decades, even centuries. Moreover, the strong visual dynastic identifications

5.5 Fabrizio Ruffo's chapel in S Giuseppe dei Ruffi, Naples, inscriptions on pedestals of altar columns (the left pedestal is shown on the right of this image). Photo: © Massimo Velo

made in convent churches may indicate not only that families were eager to have their name connected with such centres of spiritual and social prestige, but also that heads of patrician families feared the independence of their daughters inside those very institutions, and consequently chose to affirm the claims of lineage precisely where they faced their sharpest challenge, even obliteration.

Thus conventual patronage operated at several levels and from several different starting points simultaneously. Nuns' families intervened in various ways in the foundation, expansion and decoration of convents and their churches, usually to consolidate a daughter's position either on entry to a convent or in its organizational structure. Inside the convent nuns drew on familial resources and on their independent wealth to extend and decorate their institution, only occasionally marking their gifts with their name. The institutional was shot through by the familial, even where it was strictly excluded. But if the dynastic was imprinted in the convent and especially in the convent church by external patrons determined to mark those holy spaces with their family name or coat of arms, patronage within convents by individual nuns often assumed a radically different form, and was most usually unmarked and anonymous.

Unmarked internal patronage

Enclosed nuns – as individuals or in groups – acted as patrons on a remarkable scale.[31] Most often individual nuns undertook to pay for part of the convent complex or its decoration, rather than to commission and pay for a specific art work. The convent church of SS Domenico e Sisto in Rome, for example, was built by unanimous contribution of monies received by the nuns as inheritances or as allowances (*livelli*) and also by their own work.[32] Its church façade unusually allows enclosed nuns to see out over the city from which they were barred, as if insisting on the ambiguity of their situation (Fig. 5.6).

While patron nuns frequently paid for individual artworks, such as new altars and new altarpieces and were particularly likely to give money for pyxes, ostensories and other accoutrements of the Mass, not all their patronage by any means was focused on single or readily identifiable parts of their convents. Nuns often made payments towards the completion of the decoration of several chapels or other parts of the church. For instance, Sister Maria Constanza Gesualdo gave 30,000 ducats to her convent of the Sapienza in Naples in 1630 on condition that 28,000 ducats be spent on 'the building and decoration of the church' and 2,000 be spent on the acquisition of a suitable *apparato* for the church.[33]

Even while Fabrizio Ruffo stamped the nave of the church of S Giuseppe dei Ruffi with his name and fame, individuals from that same clan who were inmates of that convent paid for a range of objects and furnishings – mostly

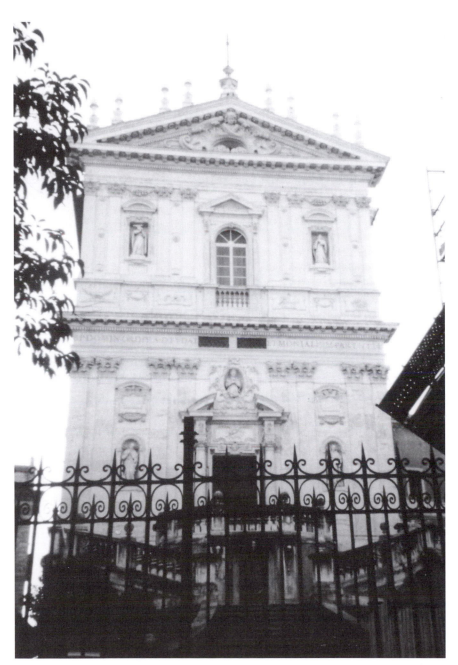

with Eucharistic connotations – without self-advertisement. The most lavish of
these, Dionisio Lazzari's inlaid main altar, was paid for in instalments between
1674 and 1688 by nuns Chiara Maria Ruffo, Ippolita Caterina Ruffo and Maria
Geronima La Gira.[34] Sister Ippolita, in many instalments, eventually spent
over 2,000 ducats on this altar.[35] The gilt copper pyx (*custodia*), also designed
by Lazzari, for the same church was paid for at least in part by sister Chiara

Maria Ruffo in 1668.[36] These interventions, however, are not marked visually on the objects themselves in dynastic terms for the benefits of outsiders; but they were all carefully recorded within conventual records, in institutional memory systems.

Occasionally, patronage from within by nuns and from without, especially by aristocratic women, assumed identical form in expression. For examples, intense devotion to the holy image of the Virgin, reputedly by St Luke, preserved in the church of SS Domenico e Sisto in Rome prompted nuns and laity alike to donate generously to its celebration. While Olimpia Aldobrandini, Duchess of Mendula, donated a pair of candlesticks with silver angel supports, a silver lamp and other gifts, in gratitude for the birth of a child to her daughter Margherita Duchess of Parma, the nuns, too, demonstrated their devotion to that image by donating gold or precious stones, golden reliquaries, necklaces and strings of pearls, vases and flowers, and indeed 'everything which served its devotion'.[37] In such cases, institutional and domestic devotion assumed identical form.

When nuns chose to pay for specific aspects of their convent's building or decoration, they stipulated the church far more often than other parts of the conventual complex. Remarkably, at SS Domenico e Sisto in Rome the corridor, running round the whole nave of the outer church, with grated *gelosie* through which to follow masses, was paid for by Sister Maria Lucretia Lanti.[38] More typically, all the chapels in that new church were built 'entirely through the devotion of some nuns, who variously built them at their own expense'.[39] On the whole, nuns lavished patronage most conspicuously on objects related to the Eucharist and on those drawing attention to their exclusive or cloistered status. Domenica Salamonia, revelling in the list, conjured up such church adornments apparently without end:

The gifts of all the furnishings and holy decorations made by the pious nuns in the service of the said church, are of such number, that it would take a long time to count the quantity of vases, candlesticks, crosses, chalices, vestments, lamps, torches, thuribles, basins, jugs, missals, glories, lecterns, angels, reliquaries, silver heads and other silver things, too, as well as it is richly equipped with antependia, chasubles, copes, tunics, baldachins, embroidered brocades and velvets.[40]

Thus nuns used their patronage to mark themselves in the public eye as virginal lady nuns, rather than as members of a particular blood family.

Payments by individual enclosed nuns frequently departed from the standard forms of patronage celebrated by art historians, where an individual patron, art work and artist can be neatly lined up in explanatory terms. As we have noted, individual nuns frequently made payments which were non-specific, such as providing a financial contribution towards buying land for conventual expansion or towards the purchase of a particularly expensive item, without marking that work to show this (as with a coat of arms or inscription). Their gestures, known to us now only from conventual records, were not extroverted in the conventional terms in which art patronage is

usually understood. Although these interventions were made to affect the world beyond the institution by glorifying the convent and its church, they were not made to enhance the nun's name *outside* the convent. Much of this patronage remained anonymous to outsiders' eyes, and consisted of relatively small financial contributions swallowed up in protracted and expensive interventions, which contributed towards institutional ends, rather than in the acquisition of a specific object ear-marked by a patron. But the visual and external anonymity of this patronage should not blind us to its significantly introverted nature. Patron nuns' interventions served to enhance their standing within their convents: such unmarked patronage was recognized as being for the good of the institution as a whole, a sign of their devotion and of their self-effacement and institutional subordination. It was, therefore, their *individual* reputation *within* the convent as well as their *institutional* reputation *outside* that nuns safeguarded and enhanced through such patronage. For while they were anonymous to the world outside, these acts were, as the nuns involved fully knew, carefully recorded in the records within their own institutions. In short, it is a mistake to assume either that contributions that were invisible to outsiders were also invisible or anonymous to insiders, or that they mattered less within convent politics than the boastfully advertised contributions from outsiders; for this is incorrectly to assume that the epistemologies of dynasty functioned homologously inside and outside conventual institutions, or even that all power and influence were located outside the convent walls.

The nun's cell as domestic *habitus*

In one area, however, the familial and homely strongly stamped the institutional. That was the nun's cell.[41] Many nuns rendered their cells domestic refuges. Despite their vows of poverty, some nuns boasted a significant array of luxury goods, furniture and furnishings in their cells and dormitories.[42] Gossip outside convent walls told of fabulous riches. But no exaggeration was needed to reveal the palatial riches of Sta Chiara in Naples, which in 1560 had 380 inhabitants and an annual income of 7,000 ducats. That wealth persisted after Trent: 'there one sees the vastest dormitories furnished with every commodity for their seemly recreation', observed the Neapolitan historian Carlo Celano in 1693.[43]

Nuns represented themselves as aristocrats, as well as virginal nuns in the design of their surroundings – an indication that their *habitus* persisted beyond their taking vows. In her history of her convent of S Gregorio Armeno, written in 1577, Abbess Fulvia Caracciolo explained that when she entered in 1542, before standardized enclosure was forced on it, there were about 50 nuns, each of whom had separate domestic arrangements, with servants, various rooms and withdrawing rooms, kitchens and cellars.[44] In some convents, even after formal enclosure, the buying and selling of cells and small rooms

occurred on a free-market basis, and nuns often had their own private rooms, furnished to suit their taste and pocket.[45] At S Paolo in Milan, the cell doors of Paola Antonia Sfondrati and her kinswomen trumpeted the family crest, thereby dynasticizing this most domestic of convent spaces.[46]

Cell inventories and nuns' wills convey a picture of comfort, sometimes even of splendour, in spite of the efforts of ecclesiastical authorities. The Regular Canonesses of the Lateran at the Regina Coeli convent in Naples between c. 1643 and c. 1679 cherished paintings, gilt reliquaries and crucifixes in their cells, as one might expect, but they also enjoyed ebony writing desks, silk clothes, crystals, and faience plates (the Abbess Maria Giacinta Tomacelli, who died in March 1675, owned 16 such plates).[47] Amongst the possessions of Teresa Capano at the same convent were a silver watch and a crown; and, when she died in the 1640s, Elisabetta del Tufo left possessions including books, crystal objects and china, 12 paintings, a clock and a coffee mill.[48] Against the prescriptions of austerity and unworldliness, these objects insist upon comforting and stimulating the body, satisfying appetites, affording human contact and evoking exotic lands.

Within convent culture, such objects were not necessarily regarded as impediments to holiness. Sister Maria Villani (1584/5–1670), the future founder of the convent of Divino Amore in Naples, arranged that her cell at S Giovanni Battista should be 'very well decorated, with chairs, paintings, desks, and other inessential curiosities, and in particular that there was introduced there a rich and precious clock.'[49] She later renounced such self-indulgence to undertake an austere and selfless life, but, at this stage her growing reputation as an exceptionally devout nun was unblemished by the luxury goods surrounding her person.

While convent culture might endorse such indulgence, reforming churchmen did not. The allure of sumptuous materials, comfortable furniture, soft bedlinens and beautifully decorated cells is apparent not only from the inventories of individual cells which record the rich furnishings, but also from conventual regulations which sought to impose austerity and denial of the body. For example, in seven Diocesan Synods held by Archbishop Filomarino in Naples between 1642 and 1662, 38 decrees regulated nuns' behaviour including stipulations that they should refrain from ornaments and not keep paintings, carpets and other such objects in their cells.[50] Episcopal visitations also reported on the contents of cells and dormitories. In her cell at the convent of S Arcangelo a Bajano in Naples, Giulia Caracciolo relished an impressive range of fine objects to indulge all the senses, as is known to us from a visitation report of 1577 by the Vicar General of Naples. In her cell, Sister Giulia revelled in paintings representing the distinctly unbiblical subjects of Aurora, Cefalus, Diana and Endymion, furnishings of ebony and ivory, carvings, busts in black and white marble, crystal vases with real and artificial flowers, a beautiful Persian carpet, the finest quality bedlinen, and – like a metaphor for vanity and cupidity – a large mirror that reflected objects at twice life-size. In her small oratory, a small statue of the Virgin stood on a marble prie-dieu, a guitar

hung on one side; on the other stood a silver vase for holy water, a masterpiece of carving. When the visitor pointed out the inappropriateness of these fine objects for a nun, Sister Giulia, without a hint of embarrassment, countered, 'Upon my faith, His Excellency would need time to waste to spend it on my furnishings.' And when the Vicar General ordered her to be silent, she burst forth:

So it does not satisfy your capriciousness that I burn myself up here in cruel solitude? I, born of the noblest blood on earth, deprived of my freedom and of my rights, am not able even to enjoy these innocent objects? So it's a crime to adorn my prison when my relatives make ill use of my worldly belongings? You, minister of Heaven, you come here to commit cruelties beyond my family's savagery, you who preach charity come here to take away from a wretched woman a last and frivolous illusion and to remind us of a cruel and harsh fact: that age in which [because] we had no capacity to know worldly things, they tricked us into renouncing our life![51]

Making play of the 'innocence' of the objects and of her own innocence to the 'worldly' trickery which had snatched her own worldly things from her and imprisoned her in the convent, Giulia Caracciolo insists on her creature comforts as both a sign of her worldly high birth and some small compensation for the loss of her birth privileges. Here we see how the politics of monachization exacerbated tensions within the Church over obedience to the vow of poverty in a convent inhabited by women with a pronounced sense of entitlement, quick to resent any curb on their privileges. In these examples, the model is of the 'domestic' being transplanted to an institutional interior, and recognized as 'domestic' not only because it reproduces aspects of palace living and furnishings, but actually represents high birth; indeed, even compensates for the loss of its comforts. Objects like these, treasured in cells, were not simply luxurious hints of rebellion or aspects of 'the domestic' brought into the institution, but marked aristocratic nuns' social rank, maintained their *habitus* and fundamentally altered the conditions and nature of convent life.[52]

Searching for a domestic holy

The search for markers of the dynastic and the domestic through art patronage and the rich furnishings of nuns' cells has allowed us far better to understand the degree to which aristocratic nuns maintained their noble *habitus* within grand convents, but it tends to both ignore the communal spaces of conventual complexes, which were of central importance to the organization of post-Tridentine convents, and, worse, to present the domestic exclusively in terms of the secular, in assuming that the holy is inherently non-domestic.[53] No sustained attention has been paid to the ways in which holiness within conventual interiors was rendered domestic and personal. And little, if any, consideration has been focused on how nuns themselves

described, or reflected on, the interiors of their institutions in their writings. I now turn to do just that.

Although inventories and other sources revealing the contents of nuns' cells and their convents are common, nuns' own accounts of the *devotional* aspects of convent life are a less common but extremely valuable source. To date scholars have used nuns' chronicles primarily to illuminate non-devotional aspects of their social, political and institutional lives.[54] While that work is valuable, it is important not to reduce the institutional to the non-devotional and even more crucial not to regard the devotional as somehow *a priori* or innocent of social and political inflection. The rest of this chapter mines Sister Domenica Salamonia di Gesù's 'Memorie del Monastero di SS. Domenico e Sisto', a five-volume history of the convent of SS Domenico e Sisto in Rome, written between 1653 and 1656, which contains a history of the Catholic Church, of her convent and of its inmates, in order to shed light on the 'domestic holy'.[55]

Salamonia's 'Memorie' bears witness to the ways in which convent life was experienced and represented in domestic and familial terms. I am not suggesting that this was either new or exceptional.[56] Rather, I seek to draw attention to the degree to which post-Tridentine conventual life remained imbricated, despite enclosure, with the domestic and the familial, and to emphasize the degree to which this involved the *aristocratization of conventual holiness*.

Salamonia's account is riven by the evocations of family and blood relationships which suffused convent life. She refers to St Dominic as the nuns' 'Holy father', and speaks of the first Dominican nuns as 'like his first-born daughters'.[57] Her assiduously documented necrology with its brief biography of each nun (not in itself unusual in convent records) establishes a family tree or dynasty for the convent. The structures and vocabulary of the family are, of course, conventional for both religious devotion and monastic institutions, based on the notion of 'the Communion of the Saints'.[58] However, at SS Domenico e Sisto (as in other convents) we find that nuns deliberately created personal 'lineages' within the convent.[59] For instance, nuns assumed the monachal name of 'Cecilia', after the first nun there.[60] Other nuns took their names in honour of particular predecessor nuns. For example, in c. 1600 the daughter of Marc'Antonio Iacovacci (deceased), was provided with a conventual dowry by Alessandro Colonna, and assumed Angela as her monastic name in honour of Sister Angela Colonna.[61] Sometimes nuns' names were assumed after real blood *conventual* relations. Sister Eugenia de' Rossi (professed 1576, d.1599), for example, took that name after her deceased aunt Eugenia, who had also been a nun at the convent.[62]

The 'domestication' of conventual devotional life assumed the form, too, of the desire for the ancestral body. When in 1573 the nuns translated from S Sisto to SS Domenico e Sisto in Magnanapoli, 'many in tears showed their desolation in having to leave that house, where so many holy women – their mothers and sisters – had lived, and whose bones would be left behind'.[63]

Nuns also nurtured particular pious affect and reverence for specific holy martyrs, confessors, virgins and widows, who were not related to them, adopting their names, relics and the celebration of their feasts.[64] Their special devotion to certain saints prompted some to search for their relics and, having obtained a good number, to display them in reliquaries. Thus in 1660 they held a procession to receive the body of St Eleutherius, Roman Bishop and martyr, found in a cemetery in Rome by Monsignore Ascanio Rivaldi and given to his sister, Florida Rivaldi, a nun at SS Domenico e Sisto. The relic was placed in the choir of the nuns' upper church inside the altar of 'the Virgin of the Grottoes'.[65] Thus convent, relics, and the bodies and names of apostles and nuns were closely identified with each other. Holiness was personalized, relics brought 'home', and names were inscribed to deploy new holy identities across place and time.[66] Salamonia binds history, the gospels and nuns' biographies tightly together, personalizing the institutional, forging the institutional domestic and familial together through *devotional*, rather than simply dynastic, connections, to produce a domestic holy.

Architectural articulations of the domestic holy

Just as holiness was domesticized and familialized through patterns of naming and evocations of lineage within the conventual family, so nuns can be seen to have articulated a domestic holy architecturally. Architecturally, the convent and its church were not only marked by family, but were riddled with interstitital spaces, unfathomable to those without, which were dedicated to the cultivation of a domestic holy. Ensconced in their clerestory-level corridor and choirs, enclosed nuns could see down into the lateral chapels of the convent church, and follow masses there (Figs 5.2 and 5.3). But they had no physical access to these chapels, and were expressly barred from entering the convent church, except in special circumstances.

In many enclosed convents inmates compensated for their exclusion from the convent church after Trent not only through those elevated east-end choirs, but by favouring areas directly accessible exclusively to them, including the cloisters, *gelosie* passageways and corridors, where they established their own small, informal shrines and altars (*altarini*) for their own devotions (Pl. 17). These places were rendered special, with relics, decoration, prayer-stools and *altarini* installed by individual nuns, depending on their special devotions. At SS Domenico e Sisto in Rome, for example, in Domenica Salamonia's words: 'Some nuns took pleasure in placing small altars and Chapels in various places in the convent, in the dormitories, as much as in the cloisters, garden, and at the top of the staircases, as well as in the very corridors of the church.'[67] Thus a staircase leading to a dormitory at SS Domenico e Sisto was known as 'San Ludovico', after the saint to whom an altar on it was dedicated; and a devout image of the Virgin Annunciate kept in that dormitory, was habitually adorned and processed on the feast of the Annunciation.[68] Significantly, the nuns of SS

Domenico e Sisto decided not to build the windows designed by the *maestri*, which were to have been on the street side of their clerestory-level corridor, but to build there instead three small altars, like small chapels, dedicated to St Dominic (an image of St Dominic was donated by Sister Perpetua Passeri; the nun in charge of the altar was Sister Maria Elena Nunez), St Joseph (cared for by Diana Bonese), and St Anne (looked after by Sister Francesca Altemps).[69] Here, rather than open the convent to the city, a decision was made to develop an enclosure corridor in terms of nuns' own devotional interests, beyond the scrutiny of priests and confessors. Thus in this case, the nuns' devotional interests took precedence over their urban visual prominence: a corridor, produced by the precepts of ecclesiastical prescription to ensure the nuns' invisibility and separation from family and laity, was transformed into a space of personal devotion and spiritual transcendence, enhanced by housing devotional objects which were secured through the very familial connections enclosure was intended to deny. The boundary became the place where a new devotional practice began to assert itself. Corridors and interstitial routes designed to efface, hide, enclose and silence, were used by the nuns to gather and focus independent spiritual resources. Thus corridors were transformed from lines of dutiful connection between signal points coordinated by Trent (the choir, the *gelosie*) to be instead bridges gathering *altarini* and relics bestowed by members of their families: in short, places of inner private devotion that transcended the precepts of Trent.

Each tiny chapel or altar had its own saint and its own nun in charge. For example, Sister Girolama Conti, who took the habit in 1584, was responsible for the altar of St Aura, which she restored and gilded, and for which she procured from the then *Vicegirente*, Monsignor Giovanni Battista Altieri, an authenticated part of a finger of that saint.[70] Lamps burned before these small altars, indulgences (both plenary and partial) were sought out for them, and on feast days hymns, antiphons and prayers were sung, with the participation of the whole convent.[71] In arranging for indulgences – 'salutary for the faithful' in the words of the Council of Trent – to be attached to their private altars, inaccessible even to the priesthood, the nuns ensured that these areas of the convent, accessible only to them, were inscribed in their performances of good works, and became significant spiritual areas within the convent. Thus, in the crevices produced by formal enclosure we find new forms of devotion which were able to evade extra-conventual control. Personal, intimate, and yet open to the whole convent, these new forms of devotional activity ran in parallel to the official versions in the convent church below.

Devotion to an image of St Dominic of Soriano in one of the dormitories at SS Domenico e Sisto nicely encapsulates the domestic/institutional relation. In addition to the conventual church dedicated to St Dominic, the nuns wanted an oratory in their dormitories also dedicated to him. To this end, they obtained from Father Giovanni Battista Marini, himself related to one of the nuns, a copy of the miraculous image of St Dominic in Soriano – indeed a holy copy, which had touched the original without so much as

veil or crystal between them. Nuns frequented it by night and day. Soon the chapel glistened with lamps and silver candlesticks, reliquaries stuffed with relics, and it boasted a particularly rich baldachin. Its door was adorned with beautiful marbles. Several nuns took care of this oratory, particularly Sister Maria Lavinia Petronij and, after her death in 1652, Sister Arcangelo Mellii. Noble ladies and secular princesses, having secured papal permission to enter the enclosure, paid homage to it; and Pope Innocent VIII even granted it a plenary indulgence – itself perhaps a way of recognizing the popularity of this little shrine, while trying to bring it under clear ecclesiastical control.[72]

Occasionally Salamonia's chronicle gives us a glimpse of a specific devotion of a particular nun. Sister Prassede Marini (d. 1641) entered the convent in 1594. As a child she had been saved from death after falling from a loggia by the intervention of St Vincent Ferrer in response to pleas from the Venerable Mother Sister Maria Raggi, a Dominican tertiary, and was subsequently intensely devoted to the Passion of Christ and to the Virgin. Marini set up an image of the Virgin of the Rosary above a small altar where, to the light of five candles, she would recite the rosary; on the Feast of the Rosary, she would light a great number of candles and carry the image in solemn procession around the cloisters.[73]

Likewise, Sister Serafina Iacovacci, who entered the convent in 1576 and became prioress in 1628, was particularly devoted to St Barbara, and held an important feast in her honour on her saint's day. During her tenure of the conventual sacristanship, she presented two silver reliquaries containing various saints' relics to the convent, and a rich cross of gold to the image of the Virgin attributed to St Luke.[74] Sister Maria Tenaglini, daughter of a noble Roman family, who professed in 1578, made by her own hand several cloths and friezes, embroidered in inlaid silk and gold, for the altar of St Dominic whom she held in special devotion.[75] Holy gifts like these were remembered within convent records, and probably informally also, in close association with their nun-donor's name and life, thereby binding specific altars and places within the convent, specific devotions and individual nuns in close association. Modern scholars have tended perhaps too hastily to assume that institutional space was inevitably anonymous and homogenous; these practices reveal conventual institutionalized space to have been highly personalized, performative, spiritualized and localized; that is, intensive as well as extensive. In other words, within convents there were both measurable (extensive) spaces and spaces not susceptible to measurement (devotional spaces, relational spaces, referential spaces).[76]

Sometimes one catches a glimpse of how a particular devotion gathered momentum and changed character institutionally. For example, a socially insignificant lay sister at SS Domenico e Sisto, Alessia Peruggina, was wont to pray in front of a niche which held a small paper image of the Virgin. The well-connected Sister Clarice Colonna soon arranged for a chapel to be built there. A few years later, after the chapel was destroyed during the restoration of the garden and cloisters, it was rebuilt on a larger scale at the convent's

expense, and in the course of time, Clarice Colonna arranged for it to be adorned with paintings of the lives of Mary Magdalen, Mary Egiziaca and other hermit saints to whom she was particularly devoted.[77] Thus the humble laysister's Virgin was erased to be replaced by an aristocratic nun's holy images, which were in turn fully institutionalized. In these ways, images were adopted, chapels personalized, and devotions identified with specific nuns and locations within the convent were shifted and superseded in accord with the institutional, economic, political and social standing of individual nuns.

Conclusion

John Bossy has identified as a hallmark of the Catholic Reformation the shift of 'emphasis in sacramental penance from satisfaction following confession to interior discipline preceding it'.[78] Aristocratic female convents in this period demonstrate the degree to which discipline was undertaken *architecturally*, or, rather, the extent to which the disciplined spiritual body was produced architecturally (including at and through its margins). What we see in female aristocratic convents is above all a disciplining of the architectural body. It is important to be alive to the degree to which that disciplined body, in a mode analogous to the architecture which defined and housed it, was in turn perforated and punctuated by the domestic holy, which was, in turn, perforated and punctuated by familial dynamics, social class, the wavering of the erotic. Those perforations of enclosure also occurred architecturally.

A modern conflation between the domestic and the dynastic (blood family) and bourgeois 'home' has tended to obscure the degree both to which convents were indeed familial and necessarily domestic institutions, and to which institutional religious devotion might be rendered domestic. As we have seen above, in the midst of the institutional interior, nuns created their own, quasi-domestic, informal small chapels and altars, devoted to the figures of holiness they most dearly espoused. Thus a sort of parallel system of worship, running internally within the arteries of the convent, inaccessible to non-conventual members, infiltrated the institutional with the personal and domestic, and imprinted holiness with something closely identified with individual nuns themselves.

Ironically, therefore, the spaces produced by Tridentine reform's desire to separate and contain enclosed nuns, such as clerestory corridors or dormitory staircases, which were beyond easy access of either clergy or laity, were also the very spaces in which nuns established their more private and domestic devotions. Burrowing behind the scenes, they set up stations of religious devotion throughout the convent, which supplemented the official religious drama of the conventual church. While it might be reductive to claim that, by these actions, the nuns were simply subverting ecclesiastical authority, nevertheless, they were producing new forms of holiness. Their 'privatization' of devotion, fashioned over the years through the personal devotions

of individual nuns in succession, had a social and institutional function analogous to the personalizing of products in our present-day economy: it articulated intimacy within Church language, devotionalized family connections (via gifts of religious artefacts, images and relics) and familiarized the devotional, thereby supplementing, rather than simply replacing, the official public church devotion. Crucially, nuns enunciated a significant new form of 'domestic holy' within the corridors of their conventual institutions, even as that 'domestic' was perhaps increasingly secured as predominantly aristocratic in tone and tutelage, as with the case of Colonna's usurpation of the modest Peruggina's devotion and its subsequent formal institutionalization. As such, these practices represent a 'domestic holy' interior within post-Tridentine enclosed female convents, which subtly undermined the regime of institutional surveillance and control instituted by Trent, while strengthening the aristocratic tenor of conventual life set in motion by Tridentine reform. Thus, by extending the devotional beyond the institutionally policed zones of church and choir, barriers and boundaries were both exceeded and converted. Inmates' practices reformed the recesses of institutional space into centres of devotional gravity.

Conventual interiors were, as we have seen, necessarily interiors of interiors, which were not organized by simple hermeneutics of depth. Convents produced paradoxical interiors which allowed nuns to challenge enclosure as subordination. It was, significantly, inside those interiors of interiors, within clerestory corridors, staircases and dormitories generated by the desire to shut women up, to ensure spiritual and sexual chastity through physical separation, in precisely those new spaces produced by formal enclosure at Trent, that nuns personalized or domesticized holiness, as they carved out dedicated spaces for their own particular devotions and informal altars outside of formal church space. Thus places of marginalization and separation were transformed into bridges of devotion, transporting nuns into spaces 'beyond'.[79]

If we are not prematurely to 'enclose' early modern architecture within our own epistemological limits, we need to think beyond them: beyond the 'domestic' and the 'institutional' and beyond 'the interior' to the interstitial and the margins, to what troubles and disturbs those boundaries and grand narratives set in motion by such terms. In turn, architectural history needs to attend more carefully to its own boundaries. The very *recesses* of institutionalized conventual space became the sites of the most intricate invasions or pervasions. In those displacements, in that 'border' of the enclosure corridor enfused with *altarini* and intensely personalized devotions, the 'institutional' and 'domestic' became confused; the social and the devotional, the inner and outer, the individual and the conventual became part of each other. In turn, this forces upon us a recognition of space as not so much divided as disorienting, significant not so much in its extensiveness (as the enclosers of Trent believed) as in its intensiveness, as the marginalized nuns discovered for themselves.

Acknowledgements

I am grateful to the British School at Rome for a Balsdon Fellowship in 2003 and to the British Academy for a Small Research Grant (2003) which allowed me to undertake research in Rome and Naples necessary for this article. My thanks to the Prioress and nuns at the Dominican convent of Sta Maria del Rosario for allowing me to consult manuscripts in their archive. The responses to an earlier version of this paper given at the Domestic and Institutional Interiors Conference (V & A, November 2004) were useful and stimulating: I would like to thank Henry Dietrich Fernández in particular. Marilyn Dunn offered helpful information on prominent patrons at SS Domenico e Sisto in Rome.

Notes

1 Judith Butler, 'Variations on Sex and Gender', in *Feminism as Critique*, ed. Seyla Benhabib and Drucilla Cornell (Minneapolis MN: University of Minnesota Press, 1988), 133.

2 A reader suggests that social class is simply a category of analysis rather than an institution. Such an approach overlooks the complexity of the discussion of class and its institutionalization. It is the *institutionalization* of class which informs my argument here; and it depends on the notion that the relationship between class and culture is itself historical (not simply an analytical category manufactured by historians). For the institutionalization of class, see esp. Pierre Bourdieu, 'What Makes a Social Class?', *Berkeley Journal of Sociology*, 32 (1987), 1–18; *idem, Outline of a Theory of Practice*, trans. Richard Nice (London: Cambridge University Press, 1986), esp. 16–22, 72–94, 171–82. For class as an ontological category, see Nicholas Dirks, *Castes of Mind* (Princeton NJ: Princeton University Press, 2003); for a discussion of the significance of the *processes* of classification, class not as a set of fixed categories but as pervasively embedded in culture, see Mike Savage, 'Culture, Class, and Classification', in *The Sage Handbook of Cultural Analysis,* ed. Tony Bennett and John Frow (Los Angeles and London: Sage, 2008, 467–87. For class and gender, see Beverley Skeggs, *Formations of Class and Gender* (London: Sage, 1997).

3 Unhelpful dichotomies between the domestic and the devotional, especially with regard to Catholicism, persist in early modern scholarship. Thus Marc Foster claims, 'The public and communal nature of baroque Catholicism, together with its churchliness and clericalism, left little space for the kind of domestic devotions and family piety that developed in Protestant regions': see Marc R. Foster, 'Domestic Devotions and Family Piety in German Catholicism', in *Piety and Family in Early Modern Europe. Essays in Honour of Steven Ozment*, ed. Marc R. Foster and Benjamin J. Kaplan (Aldershot and Burlington VT: Ashgate, 2005), 110. Recent art historical scholarship committed to qualifying such dichotomies nevertheless often retains a model of the 'public' sphere as pre-existing the 'private' domestic one. See, for instance, Patricia Fortini-Brown, *Private Lives in Renaissance Venice. Art, Architecture and the Family* (New Haven CT and London: Yale University Press, 2004). By contrast, see the special issue of *Quaderni storici*, 3 (2001) devoted to domestic religion; and also Margaret A. Morse, 'Creating Sacred Space: The Religious Visual Culture of the Renaissance Venetian *Casa*', *Renaissance Studies*, 21/2 (2007), 151–84.

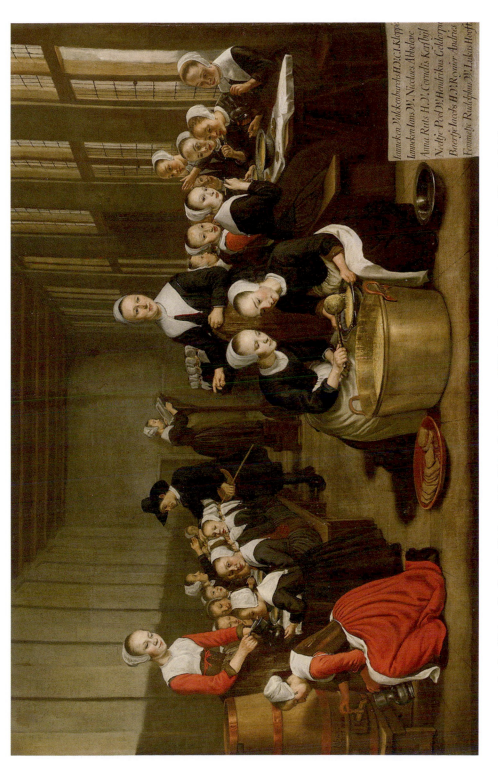

1 Jan Victors, *Feeding the Orphans at the Diaconie Orphanage*, 1658–62, oil on canvas, Amsterdam Historisch Museum

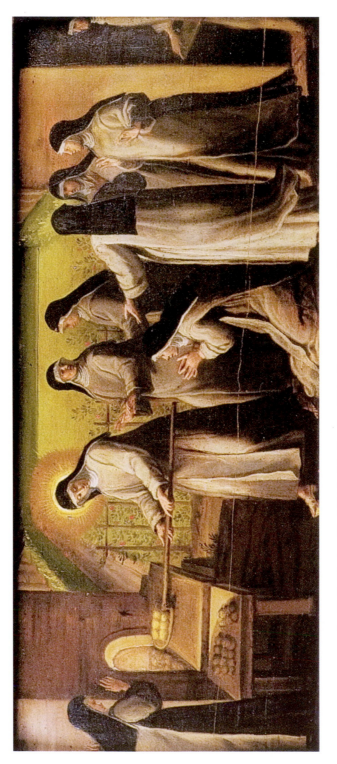

2　Giulio Morina, *The Miracle of the Bread*, c. 1594, oil on canvas, Corpus Domini convent, Bologna

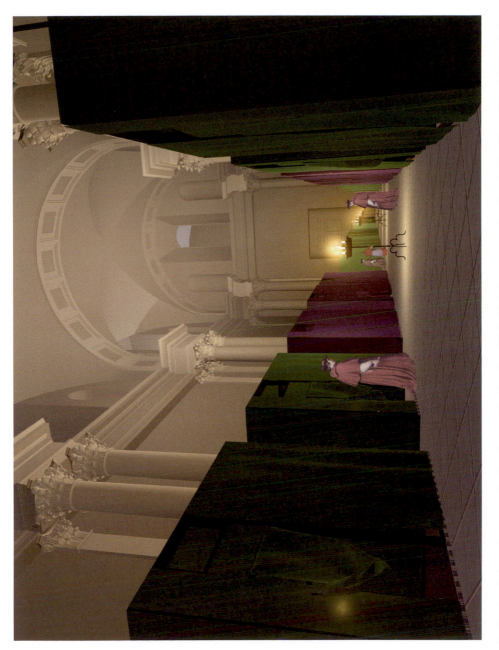

3 Eye-level view of *camerette* (bed enclosures) in Conclave Hall. Digital reconstruction drawing by Henry Dietrich Fernández

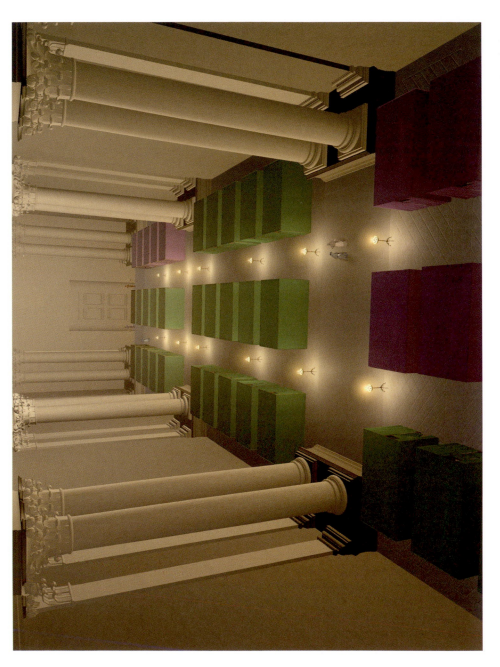

4 Aerial view of *camerette* (bed enclosures) in Conclave Hall. Digital reconstruction drawing by Henry Dietrich Fernández

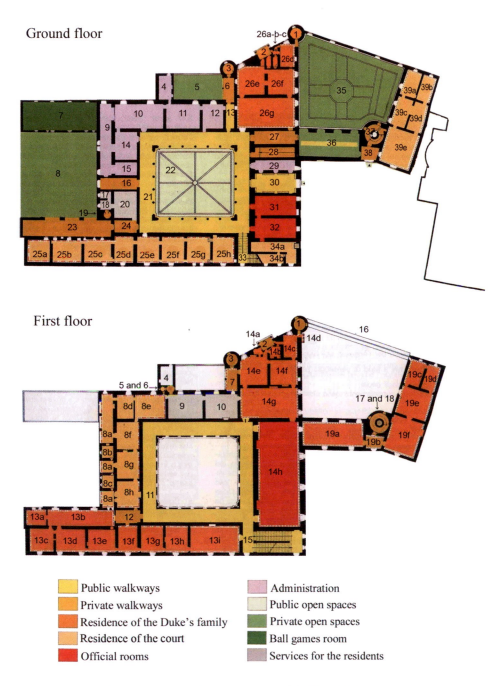

Ground floor

First floor

Public walkways		Administration	
Private walkways		Public open spaces	
Residence of the Duke's family		Private open spaces	
Residence of the court		Ball games room	
Official rooms		Services for the residents	

5 Plans of the ground and first floors of the Ducal Palace in
Urbino in the 15th century, and purpose of the rooms

Source: Luisa Fontebuoni, 'Destinazioni d'uso dal sec. XV al XX', in *Il Palazzo di Federico da
Montefeltro*, ed. Maria Luisa Polichetti (Urbino: Quattroventi, 1985), 185–302 (194–195, plans by
Luisa Fontebuoni and Giuseppe Barbaliscia, courtesy of the author and the publisher)

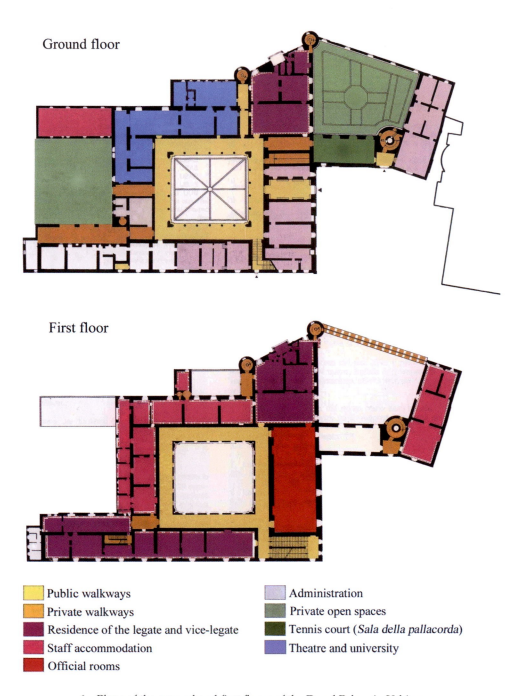

Ground floor

First floor

Public walkways | Administration
Private walkways | Private open spaces
Residence of the legate and vice-legate | Tennis court (*Sala della pallacorda*)
Staff accommodation | Theatre and university
Official rooms

6 Plans of the ground and first floors of the Ducal Palace in Urbino
in the 17th century (after 1631), and purpose of the rooms

Source: Luisa Fontebuoni, 'Destinazioni d'uso dal sec. XV al XX', in *Il Palazzo di Federico da Montefeltro*, ed. Maria Luisa Polichetti (Urbino: Quattroventi, 1985), 185–302 (234–235, plans by Luisa Fontebuoni and Giuseppe Barbaliscia, courtesy of the author and the publisher)

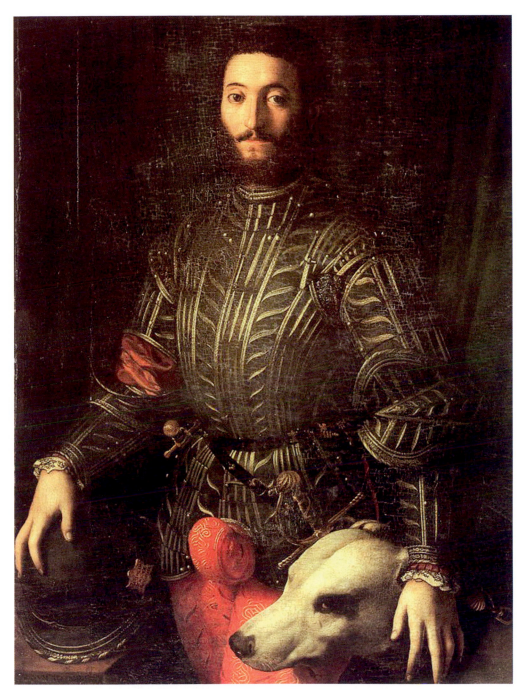

7 Agnolo Bronzino, *Guidubaldo della Rovere* (Guidubaldo
II), 1532, oil on wood, Palazzo Pitti, Florence

Courtesy of the Ministero per i Beni e le Attività Culturali, Italy

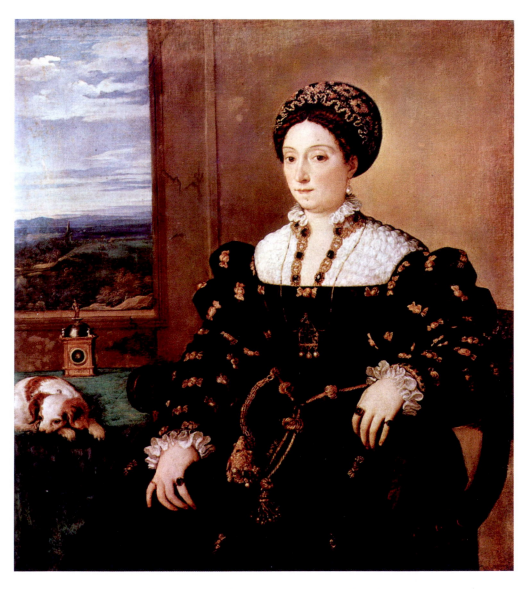

8 Titian, *Eleonora Gonzaga della Rovere*, c. 1536–38, oil
on canvas, Galleria degli Uffizi, Florence

Courtesy of the Ministero per i Beni e le Attività Culturali, Italy

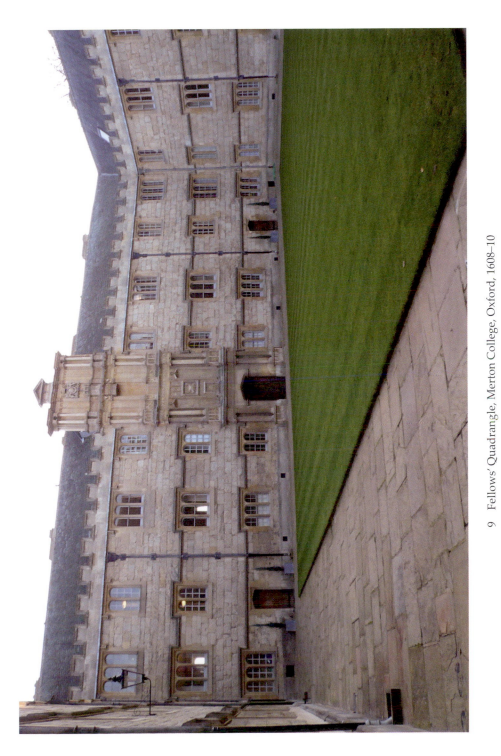

9 Fellows' Quadrangle, Merton College, Oxford, 1608–10

Photo: Louise Durning

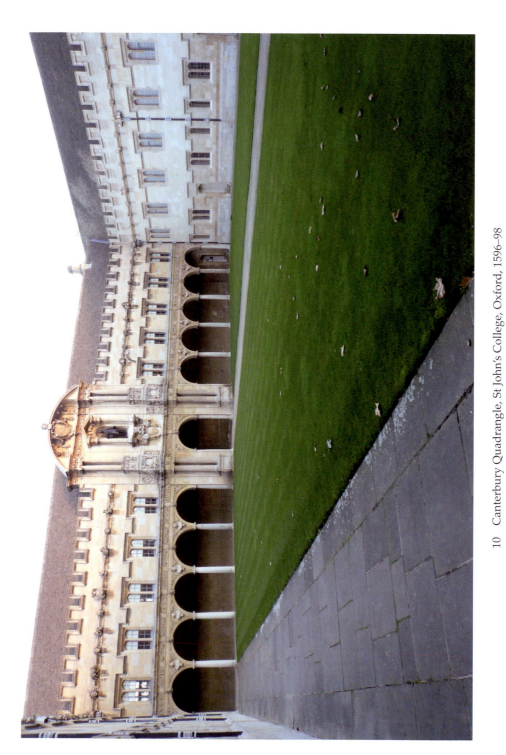

10 Canterbury Quadrangle, St John's College, Oxford, 1596–98

Photo: Louise Durning

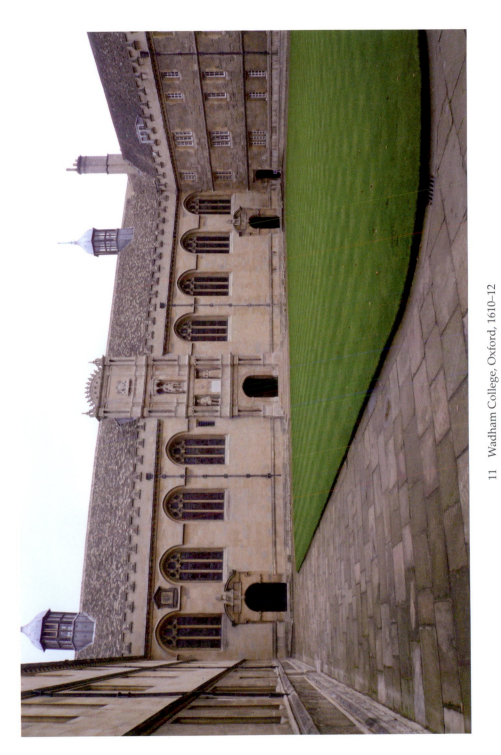

11 Wadham College, Oxford, 1610–12

Photo: Louise Durning

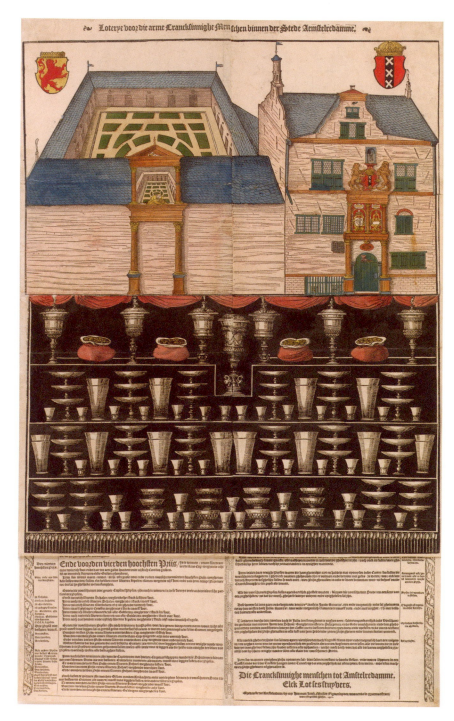

12 Anonymous, Amsterdam lottery poster, 1591–92, publ. H.J. Muller, Rijksmuseum

Photo: Rijksmuseum

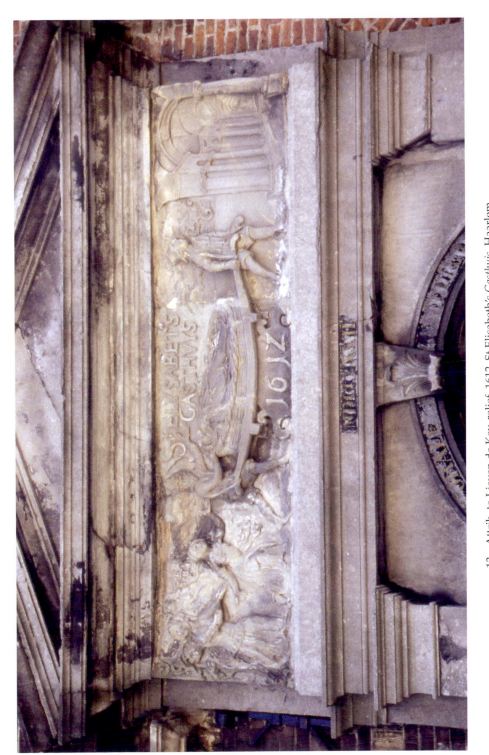

13 Attrib. to Lieven de Key, relief, 1612, St Elisabeth's *Gasthuis*, Haarlem

Photo: Jane Kromm

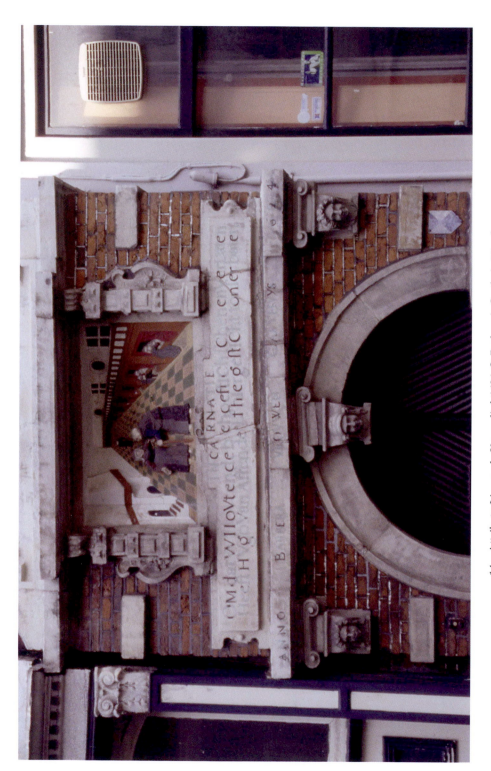

14 Attrib. to Lieven de Key, relief, 1624, St Barbara's *Gasthuis*, Haarlem

Photo: Jane Kromm

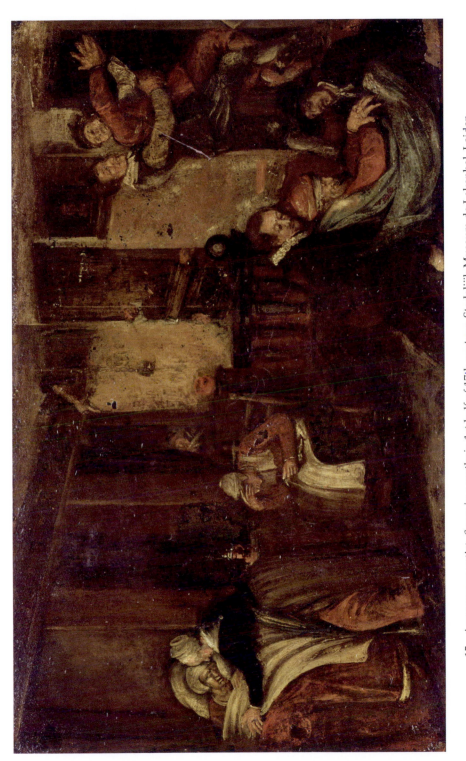

15 Anonymous artist, *Scene in a gasthuis*, 1st half of 17th century, Stedelijk Museum de Lakenhal, Leiden

Photo: Stedelijk Museum de Lakenhal

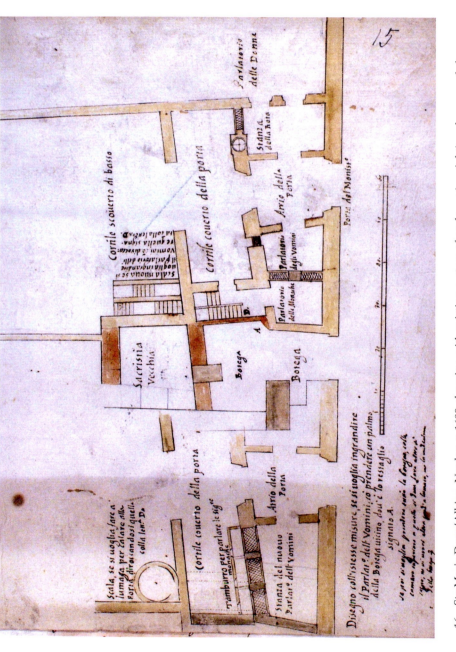

16 Sta Maria Donn'Albina, Naples, c. 1689, drawing with existing system of parlours (on right) and proposed changes (on left), including a new parlour for men, and the introduction of cubicles for nuns in conversation with them

By permission of the Archivio di Stato, Naples

17 S Gregorio Armeno, Naples, interior clerestory-level corridor with *altarini*
Photo: Helen Hills

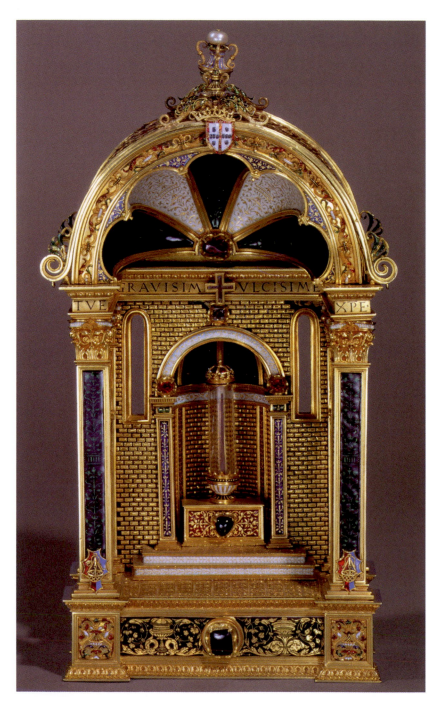

18 Ian Vansteigoltist (Mestre João), Queen D. Leonor's reliquary, c. 1520,
Museu Nacional de Arte Antiga, Lisbon, MNAA, inv. 106 OUR

Photo: José Pessoa

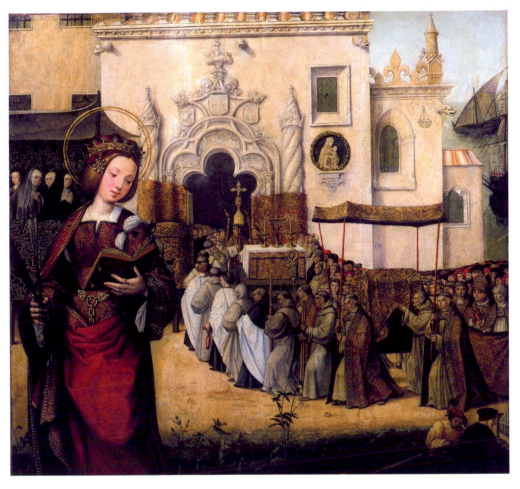

19 Anonymous artist, *Arrival of the Relics of Santa Auta at the Monastery of
Madre de Deus, Lisbon*, reverse, c. 1522, Museu Nacional de Arte Antiga, Lisbon,
MNAA, inv. 1462B Pint. Queen Leonor can be seen, dressed in a tertiary
penitential garment, at the left upper corner, fourth figure from the right

Photo: José Pessoa

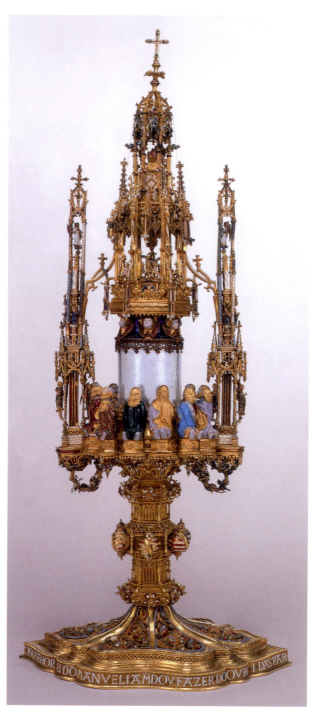

20 Salt-cellar, rock crystal, gold and jacinth, a gift by Catarina de Austria to
Joana de Austria in 1553, Kunsthistorisches Museum, Vienna, KK 2320

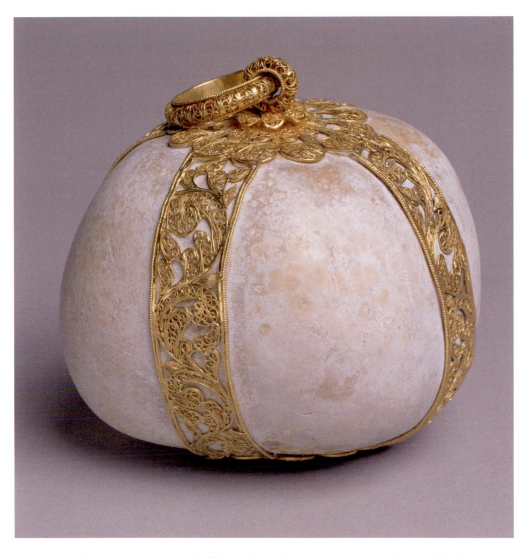

21 Bezoar stone mounted in filigree, Kunsthistorisches Museum, Vienna, KK 996

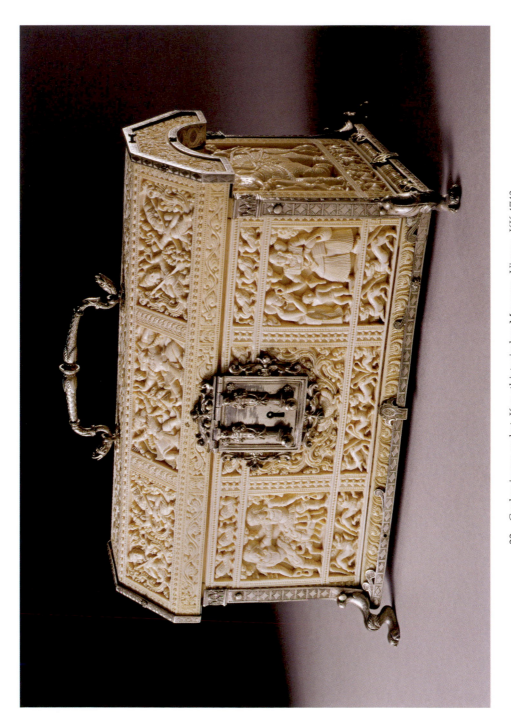

22 Ceylon ivory casket, Kunsthistorisches Museum, Vienna, KK 4743

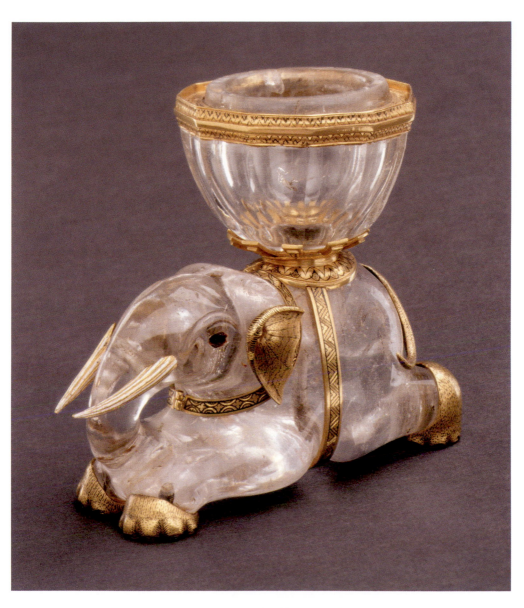

23 Gil Vicente, monstrance of Belém, 1506, Museu Nacional
de Arte Antiga, Lisbon, MNAA, 740 Our

Photo: José Pessoa, 1992

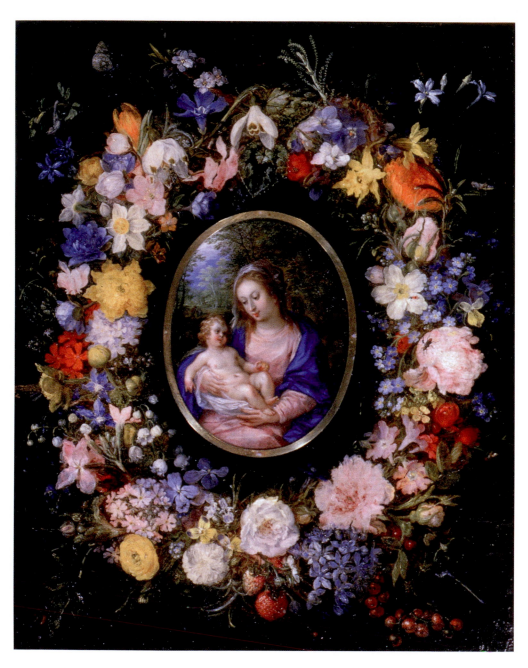

24 Jan Brueghel and Hendrick van Balen, *Virgin and Child in a Garland of Flowers*,
1607–1608, oil on panel, 27 × 22 cm (10⅝ × 8⅝ inches), Ambrosiana, Milan

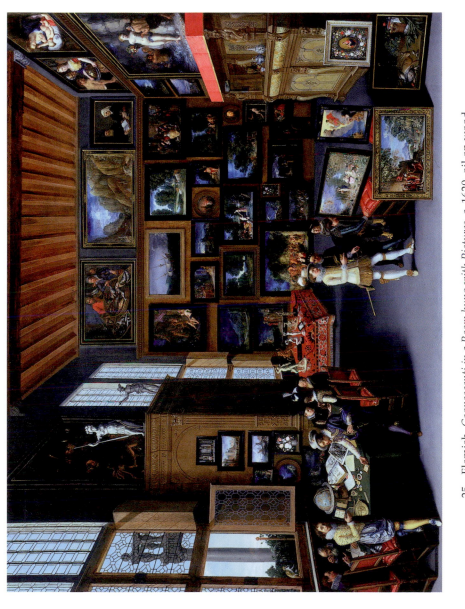

25 Flemish, *Cognoscenti in a Room hung with Pictures*, c. 1620, oil on wood,
95.9 × 123.5 cm (37¾ × 48⅝ inches), National Gallery, London

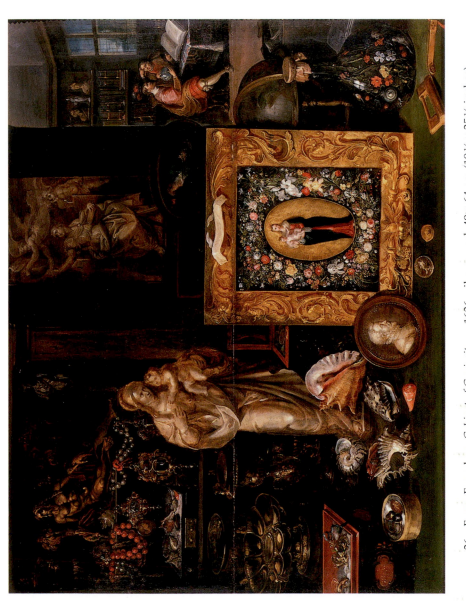

26 Frans Francken, *Cabinet of Curiosity*, c. 1636, oil on panel, 49 × 64 cm (19¼ × 25¼ inches).
Copyright: Historisches Museum Frankfurt/Main

Photo: Margit Matthews

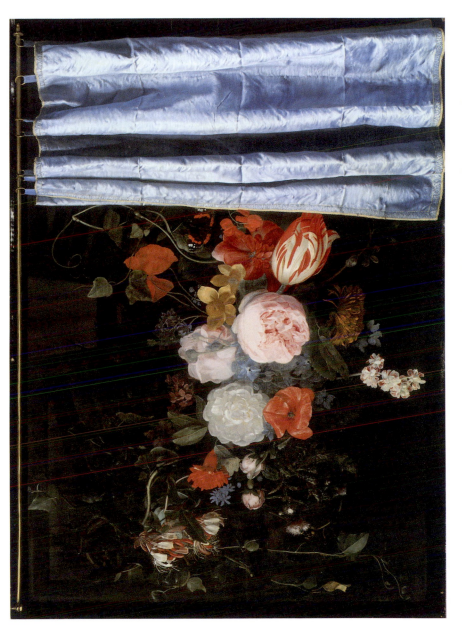

27 Adriaen van der Spelt and Frans van Mieris, *Trompe l'Oeil Still Life with a Flower Garland and a Curtain*, 1658, oil on panel, 46.5 × 63.9 cm (18 ¼ × 25 ⅛ inches), Wirt D. Walker Fund, The Art Institute of Chicago

4 *Decretum de reformatione monialium* presented 20 November 1563 *Concilii Tridentinii actorum*. See *Conciliium Tridentum*, IX, ed. Stephan Ehses (Freiburg: Herder, 1924), 1040–44; The Council of Trent, *The Canons and Decrees of the Sacred and Oecumenical Council of Trent*, ed. and trans. J. Waterworth (London: Dolman, 1848), Hanover Historical Texts Project, available online at <http://history.hanover.edu/texts/trent.html>.

5 St Teresa of Avila's *Moradas* or *Interior Castle* is emblematic in this regard. See Alison Weber, *Teresa of Avila and the Rhetoric of Femininity* (Princeton NJ: Princeton University Press, 1990). For a rich discussion of monastic interiority, albeit without attention to built architecture, see Corrado Bologna, 'L'invenzione dell'interiorità: spazio della parola, spazio del silenzio: monachesimo, cavalleria, poesia cortese', in *Luoghi sacri e spazi della santità*, ed. Sofia Boesch Gajano and Lucetta Scaraffia (Turin: Rosemburg & Sellier, 1990), 243–66. On *architecture* as the privileged mode of separation in and enclosure of convents after Trent, see Francesca Medioli, 'La Clausura delle monache nell'amministrazione della Congregazione Romana sopra i Regolari', in *Il monachesimo femminile in Italia dall'alto medioevo al secolo XVII a confronto con l'oggi*, ed. Gabriella Zarri (Negarine: Il Segno dei Gabrielli editori, 1997), 249–82; Gabriella Zarri, *Recinti: donne, clausura matrimonio nella prima età moderna* (Bologna: Il Mulino, 2000); Helen Hills, *Invisible City: The Architecture of Devotion in Seventeenth-century Neapolitan Convents* (Oxford: Oxford University Press, 2004), esp. 19–61, 120–61; Marilyn Dunn, 'Spaces Shaped for Spiritual Perfection: Convent Architecture and Nuns in Early Modern Rome', in *Architecture and the Politics of Gender in Early Modern Europe*, ed. Helen Hills (Aldershot and Burlington VT: Ashgate, 2003), 151–76.

6 On virginity, see John Bugge, *Virginitas. An Essay in the History of a Medieval Ideal* (The Hague: Martinus Nijhoff, 1975); Agostino Valiero, *Modo di vivere proposto alle Vergini che si chiamano Dimesse ovvero che vivono nelle lor case con voto [...] di perpetua castità* (Padua: Giuseppe Comino, 1744). On architecture's metonymic relation with virginity in female convents, see: Giuseppe Vasi, *Delle Magnificenze di Roma antica e moderna, Libro VIII* (Rome: Niccolò & Marco Pagliarini, 1758), Preface; Agostino Valiero, *La Istituzione d'Ogni Stato lodevole delle donne Cristiane* (Padua: Giuseppe Comino, 1744), esp. 6–8; Hills, *Invisible City*, 45–61; Alain Boureau, 'L'imene e l'ulivo. La verginità femminile nel discorso della chiesa nel XIII secolo', *Quaderni storici*, 75/3 (1990), 791–803; Gabriella Zarri, 'Monasteri femminili e città (secoli XV–XVIII)', in *Storia d'Italia. Annali 9. La Chiesa e il potere politico dal medioevo all'età contemporanea*, ed. Giorgio Chittolini and Giovanni Miccoli (Turin: Einaudi, 1986), 420–29.

7 See, for example, ASV, Miscellanea, Armadio VII, 111 & 112, Acta Sacrae Visitationis Apostolicae SDN Urbani VIII; ASDN, Vicario delle Monache, 471–22 (1606, 1617, 1642) S. Patrizia (S. Visita); Franco Molinari, 'Visite pastorali de monasteri femminili di Piacenza nel sec. XVI, in *Il Concilio di Trento e la riforma tridentina. Atti del convegno Storico internazionale (Trento 2–6 settembre 1963)* (Rome and Freiburg: Herder, 1965), 679–731; Massimo Marcocchi, *La riforma dei monasteri femminili a Cremona. Gli atti inediti della visita del vescovo Cesare Speciano (1599–1606)* (Cremona: Athenaeum Cremonense, 1956). See also Giulia Boccadamo, 'Una riforma impossibile? I papi e i primi tentativi di riforma dei monasteri femminili di Napoli nel "500"', *Campania Sacra*, 21 (1990), 86–122.

8 Antonio Ardia, *Tromba catechista: cioè spiegazione della dottrina cristiana* (Naples, 1713), vol. 2, 103–104.

9 The conflation between nuns' bodies and architecture was more marked than that between other groups and the architecture that represented them, such as

aristocratic palaces or hospitals for the sick. This is because convents did not simply represent nuns in the city fabric, but replaced them visually.

10 The hermeneutics of depth denoting privileged access also applied in secular circumstances, such as the palaces of Roman cardinals or the court of Louis XIV at Versailles, where visitors were granted relative access depending on status. See Patricia Waddy, *Seventeenth-Century Roman Palaces: Use and Art of the Plan* (Cambridge MA: MIT Press, 1990).

11 Carlo Celano, *Notizie del bello dell'antico e del curioso della Città di Napoli*, ed. Giovanni Battista Chiarini (Naples: Agostino de Pascale, 1858), vol. III, book 1, p. 75.

12 The additional spaces do not appear to be separate booths. The changes introduced in the project are designed to bring nuns into greater institutional control and not to afford them greater privacy. The apertures of the 'tamburro' appear to be too narrow to function as doorways. Instead the 'tamburro' appears to be a listening box through which sound alone could travel.

13 For the emergence of elevated east-end nuns' choirs in Counter-Reformation Naples, see Anthony Blunt, *Neapolitan Baroque and Rococo Architecture* (London: Zwemmer, 1975), 43, 100–101; for their development and spiritual implications, see Hills, *Invisible City*, 139–60. Some convent churches had elevated choirs at east and west, such as S Gregorio Armeno in Naples (with three nuns' choirs): see *ibid.*, 151–5, 174–5. Nuns' choirs at ground level behind the main altar at the east end developed far earlier: see Luciano Patetta, 'L'Età di Carlo e Federico Borromeo e gli sviluppi delle chiese "doppie" conventuali nella diocesi di Milano', in *L'architettura a Roma e in Italia (1580–1621), Atti del 23° Congresso di storia dell'architettura*, ed. Gianfranco Spagnesi (Rome: Centro di Studi per la storia dell'architettura, 1989), 169–70; *idem*, 'La Tipologia delle chiese doppie dal Medioevo alla Controriforma', in *Storia e Tipologia: cinque saggi sull'architettura dela passato* (Milan: Clup, 1989), 11–71; Maria Teresa Fiorio, *Le chiese di Milano* (Milan: Credito Artigiano, c. 1985), 84. For the use of eastern choir and western gallery in the Franciscan double monastery church of Königsfelden between the fourteenth and sixteenth centuries, see Carola Jäggi, 'Eastern Choir or Western Gallery?: The Problem of the Place of the Nuns' Choir in Königsfelden and Other Early Mendicant Nunneries', *Gesta*, 40/1 (2001), 79–93.

14 While medieval convent churches were usually aisle-less rectangles without side chapels, early modern southern Italian nuns' churches, also aisle-less rectangles, frequently had side chapels. Therefore Roberta Gilchrist's interesting suggestion that the form of medieval conventual churches was determined by the fact that nuns could not perform Masses may require revision. See Roberta Gilchrist, *Gender and Material Culture: The Archaeology of Religious Women* (London: Routledge, 1994), 97. The absence of aisles in post-Tridentine churches was determined not by lack of demand for separate Masses (which persisted), but by the imperative of allowing nuns to watch the Mass from up above, unimpeded by columns and aisles. After Trent the Eucharist became markedly more important, especially to women. The accommodation of lateral altars which allowed the performance of many Masses throughout the day and even simultaneously and which could be readily observed by nuns from their clerestory-level corridors, is crucial in this regard.

15 For the ways in which convent architecture developed so as to permit the enclosed gaze to travel beyond enclosure, see Hills, *Invisible City*, 120–38.

16 The principle of the panopticon is an annular building with a watch tower at its centre and cells around its periphery. Backlighting allows the supervisor to watch the prisoners in the cells, but they cannot see whether they are being observed or not. Thus the architecture participates in the system of surveillance. See Michel Foucault, *Discipline and Punish: The Birth of the Prison*, trans. Alan Sheridan (Harmondsworth: Penguin, 1977), 195–230.

17 Michel de Certeau, *The Mystic Fable. Vol. I: The Sixteenth and Seventeenth Centuries*, trans. Michael B. Smith (Chicago IL and London: University of Chicago Press, 1982), 97–8.

18 Such an observation connects to accounts of the sexualization or charisma of sacred space (though not conventual space) by Daniel Bornstein and Adrian Randolph. See Daniel Bornstein, 'Women and Religion in Late Medieval Italy', in *Women and Religion in Medieval and Renaissance Italy,* ed. Daniel Bornstein and Roberto Rusconi (Chicago IL: Chicago University Press, 1996), 1–27; Adrian Randolph, 'Regarding Women in Sacred Space', in *Picturing Women in Renaissance and Baroque Italy*, ed. Geraldine A. Johnson and Sara Matthews-Grieco (Cambridge: Cambridge University Press, 1997), 17–41. The very purity and enclosure of young virgins made convents irresistible to certain sexual appetites and imaginations.

19 This idea is derived from de Certeau, *The Mystic Fable*, 97.

20 See Bornstein, 'Women and Religion in Late Medieval Italy'.

21 A reader objects to the notion that architecture can be regarded as 'a machine' and dismisses this reading as 'derivative of Foucault'. This is not an argument that can be developed at length here, but two points are worth noting. First, the application of the term '*macchina*' to architecture, of course, vastly pre-dates Foucault. The term was early applied to transformative machinery, engineering apparatus, military vehicles and the like. It was applied to temporary *apparati* such as obelisks and triumphal arches from at least the fifteenth century (see Vannocchio Biringuccio, *La pirotecnia* (Venice: Fiori 1540), 166; Giovanni Pietro Bellori, *Le vite de' Pittori, scultori, ed architetti moderni* (Rome: Mascardi, 1672), I, 242; and Cosimo Bartoli's translation of Leon Battista Alberti, *L'Architettura di Leonbatista Alberti, tradotta in lingua Fiorentina da Cosimo Bartoli* (Florence: Torrentino, 1550), 299; and Baldassare Castiglione uses the term '*macchina*' to refer to a building: 'I Tedeschi … negli ornamenti furono goffi e lontanissimi dalla bella maniera dei Romani, li quali, oltre la macchina di tutto l'edificio, avevano bellissime cornice, belle fregi, architrave, colonne ornatissime di capitelli e basi e misurate con la proportione dell'uomo e della dama'; see *Il cortegiano*, ed. B. Maier (Turin: Einaudi, 1950), 623. Likewise, Palladio uses the term to refer to large structures such as amphitheatres: Andrea Palladio, *I Quattro libri dell'architettura* (Venice, 1570), Book I, cap. 12. More significantly, in thinking about architecture as a machine, we allow architecture to be productive, to alter social relations and systems. This usefully shifts away from what is perhaps to some historians a more familiar model: that of architecture as simply passive product of pre-existing social relations which are generally posited as the cause of that architecture and supposedly continue unchanged after its building. For further discussion of these issues, see Andrew Benjamin, *Architectural Philosophy* (London and New Brunswick NJ: Athlone Press, 2000), esp. 107–26; Jacques Derrida, 'Architecture Where the Desire May Live', in *Rethinking Architecture: A Reader in Cultural Theory*, ed. Neil Leach (London and New York: Routledge, 1997), 319–23; Mark Wigley 'Untitled: The Housing of Gender', in *Sexuality and Space*, ed. Beatriz Colomina (Princeton NJ: Princeton Architectural Press, 1992), 327–89; Helen Hills, 'Too Much Propaganda', *Oxford Art Journal*, 29/3 (2006), 446–55. For *macchine* as theatrical, architectural or urban

interventions in early modern Europe, see Alice Jarrard, *Architecture as Performance in 17th-Century Europe: Court Ritual in Modena, Rome, and Paris* (Cambridge: Cambridge University, 2003), esp. 26–8, 208–12; Lauro Magnani, 'Temporary Architecture and Public Decoration: The Development of Images', in *Europa Triumphans: Court and Civic Festivals in Early Modern Europe*, ed. J.R. Mulryne, Helen Watanabe-O'Kelly and Margaret Shewring (Aldershot and Burlington VT: Ashgate, 2004), 250–60.

22 On nuns' cells, see: Elissa Novi Chavarria, *Monache e gentildonne: un labile confine. Poteri politici e identità religiosa nei monasteri napoletani secoli XVI–XVII* (Milan: Franco Angeli, 2001), 120–27, P. Renée Baernstein, 'Vita pubblica, vita familiare e memoria storica nel monastero di San Paolo a Milano', in *I monasteri femminili come centri di cultura fra Rinascimento e barocco*, ed. Gianna Pomata and Gabriella Zarri (Rome: Edizioni di Storia e Letteratura, 2005), 297–312; Silvia Evangelisti, 'Rooms to Share: Convent Spaces and Social Relations in Early Modern Italy', *Past and Present* (2006), Suppl. 1, 55–71; Silvia Evangelisti, '"Farne quello che pare e piace…": l'uso e la trasmissione delle celle nel monastero di Santa Giulia di Brescia (1597–1688)', *Quaderni storici*, 30 (1995), 85–110; Hills, *Invisible City*, 115–19.

23 On the porosity of the convent, see, for instance, P. Renée Baernstein, *A Convent Tale: a Century of Sisterhood in Spanish Milan* (London: Routledge, 2002); Hills, *Invisible City*, 19–44, 62–89; Michele Miele, 'Monache e monasteri del Cinque-Seicento tra riforme imposte e nuove esperienze', in *Donne e religione a Napoli, secoli XVI–XVIII*, ed. Giuseppe Galasso and Adriana Valerio (Milan: Franco Angeli, 2001), 91–138; Gaetano Greco, 'Monastero femminile e patriziato a Pisa (1530–1630)', in *Città italiane del '500 tra riforma e controriforma* (Lucca: Maria Pacini Fazzi, 1988), 313–39; Novi Chavarria, *Monache e gentildonne*; Jutta G. Sperling, *Convents and the Body Politic in Late Renaissance Venice* (Chicago IL: University of Chicago Press, 1999); Carla Russo, *I monasteri femminili di clausura a Napoli nel secolo XVII* (Naples: Arte Tipografica, 1970). For convent and family as oppositional institutions, see P. Renée Baernstein, 'In Widow's Habit: Women between Convent and Family in Sixteenth-century Milan', *Sixteenth Century Journal*, 25/4 (1994), 787–807.

24 For discussion of these dynamics in northern Italian convents, see Baernstein, *A Convent Tale*; Sperling, *Convents and the Body Politic*; Sharon Strocchia, 'Sisters in Spirit: The Nuns of Sant'Ambrogio and their Consorority in Early Sixteenth-Century Florence', *Sixteenth Century Journal*, 33/3 (2002), 735–67.

25 Roberto Pane, *Il Monastero di S. Gregorio Armeno* (Naples: Arte Tipografica, 1957), 48.

26 For Neapolitan examples, see Hills, *Invisible City*, 62–89; Maria Antonietta Visceglia, 'Linee per uno studio unitario dei testamenti e dei contratti matrimoniali dell'aristocrazia feudale napoletana tra fine Quattrocento e Settecento', *Mélange de l'Ecole française de Rome*, 95 (1983), 393–470.

27 ASN, Corp. relig. sopp., S Giuseppe dei Ruffi, 4922, fols 1, 4, 6; Hills, *Invisible City*, 105–7.

28 Thus the organ of the Dominican convent of Sta Maria della Vittoria in Milan was marked prominently with the Omodei family name; Baernstein, *A Convent Tale*, 124.

29 For this church and its iconographic programme, see Helen Hills, 'Iconography and Ideology: Aristocracy, Immaculacy and Virginity in Seventeenth-Century Palermo', *Oxford Art Journal*, 22/1 (1999), 16–31.

30 Diane Hughes recognized this danger in 1988. See Diane Owen Hughes, 'Representing the Family: Portraits and Purposes in Early Modern Italy', in *The Evidence of Art: Images and Meaning in History*, ed. Theodore K. Rabb and Jonathan Brown (Cambridge: Cambridge University Press, 1988), 7–38.

31 The bibliography on nuns' patronage of art and architecture after Trent has grown enormously in recent years. Definitive early interventions were made in this regard by Marilyn Dunn: 'Nuns as Art Patrons: The Decoration of S. Marta al Collegio Romano', *Art Bulletin*, 70/3 (1988), 451–77; see also Mary-Ann Winkelmes, 'Taking Part: Benedictine Nuns as Patrons of Art and Architecture', in *Picturing Women in Renaissance and Baroque Italy*, ed. Geraldine A. Johnson and Sara Matthews-Grieco (Cambridge: Cambridge University Press, 1997), 91–110; Jeryldene Wood, *Women, Art and Spirituality: The Poor Clares of Early Modern Italy* (Cambridge: Cambridge University Press, 1996).

32 Archivio di S. Maria del Rosario, Rome (ASMR), 'Opere della Salamonia: Memorie del Monastero di SS. Domenico e Sisto' (hereinafter referred to as Salamonia, 'Memorie'), vol. 2, fol.108. The new church was built from 1611 when the nuns of S Sisto transferred to Monte Magnanapoli, where there was a small church dedicated to the Madonna della Neve, with a convent of Dominican tertiaries. Salamonia, 'Memorie', fols 37–45; Vasi, *Delle Magnificenze di Roma, Libro VIII*, 23.

33 A dispute followed when Sister Maria Constanza fell ill and moved to the convent of Donna Regina where she renewed her vows. Both convents claimed her money; see Antonio Colombo, *Il Monastero e la Chiesa di S. Maria la Sapienza* (Trani, 1901), 34. At the same church Sister Giacinta Spinelli paid for work in several chapels. She paid over 367 ducats to complete the Chapel of the Nativity in 1667, including frescoes by Giacinto de Popoli (on the vault, the lunette, medallions on the pendentives and decorations flanking the altarpiece), the paintings of St Anne and the Virgin, the stuccowork framing the paintings on the side walls, including some work by Marco di Notarnicola, and the paintings' frames. *Ibid.*, 56–7.

34 ASN, Corp. relig. sop., S Giuseppe dei Ruffi, 4926, n.p. The altar is reproduced in Hills, *Invisible City*, pl. 6.

35 ASN, Corp. relig. sop., S Giuseppe dei Ruffi, 4926, n.p.

36 On 14 July 1688 Sister Chiara Maria Ruffo completed payments to the goldsmith Matteo Treglia of 3,000 ducats for this pyx: 'a Sig[no]r Matteo Treglia Orefice ducati dittanta [sic] cinque, quali sono à complim[en]to di ducati trecento atteso q[ua]li altri l'hà ricev[u]ti … quali som[m]o p[er] li intiero prezzo di materiali, come di magistero della cassetta, seu custodia tutta di rame indorata fatta da esso p[er] la chiesa di d[ett]o no[st]ro Mon[aste]rio secondo la forma del modello et ordine datoli dal Sign[no]re Cavaliere Dionisio Lazzari'; ASN, Corp. relig. sop., S Giuseppe dei Ruffi, 4926, n.p.

37 Salamonia, 'Memorie', vol. 5, fols 14r–14v.

38 *Ibid.*, vol. 5, fol. 60r.

39 '[T]utte dalla divotione di alcune monache, che diversamente, l'hanno app.e spese fabricate'. *Ibid.*, vol. 2, fol.108r.

40 *Ibid.*, vol. 2, fol.109r.

41 This has been demonstrated in scholarship dealing with convents from both north and south of Italy. For the literature on nuns' cells in northern Italian

convents, see footnote 22 above. Such an accumulation of goods was, of course, far from restricted to the convent. Early modern Italy witnessed a remarkable increase in the production, accumulation and display of goods in the secular domestic sphere also. See Cissie Fairchilds, 'Consumption in Early Modern Europe: A Review Article', *Comparative Studies in Society and History*, 35 (1993), 850–58; Marta Ajmar-Wollheim and Flora Dennis (eds), *At Home in Renaissance Italy* (London: V&A Publications, 2006).

42 That cells might be lavishly adorned is now well documented. See, for instance, Russo, *I monasteri femminili*, 88–91; Silvia Evangelisti, 'Moral Virtues and Personal Goods: The Double Representation of Female Monastic Identity', in *Women in the Religious Life*, ed. Olwen Hufton (Florence: European University Institute, 1996), 27–53; Hills, *Invisible City*, 90–119. See also footnote 22 above.

43 Celano, *Notizie del bello*, vol. III, book 2, 425.

44 ASN, Corp. relig. sop., S Gregorio Armeno, 3435, 'Esemplare delle nobili memorie della Reverenda D. Fulvia Caracciola', fol.125r.

45 When Sister Nicoletta de' Rossi died in June 1779 at the Regina Coeli convent in Naples, she left two cells and two small bedrooms (*camerini*) which sold for 30 and 20 ducats respectively. For this and other examples in Naples, see Hills, *Invisible City*, 116–17. For Brescia, see Evangelisti, '"Farne quello che pare"'.

46 Baernstein, *A Convent Tale*, 115.

47 ASN, Corp. relig. sop., Regina Coeli, 1975, fasc.12 n.10. Valuable goods were generally given or sold on to family members or to other nuns; battered goods and old clothes were usually given as alms.

48 Undated document, ASN, Corp. relig. sop., Regina Coeli 1975, fasc.12 n. 4, unfoliated. To judge from its handwriting and position relative to dated documents, it dates from the 1640s.

49 'Già disponeva farsi una Cella molto bene adobbata, di sedie, quadri, scrittorj, ed altre superfluità curiose, ed in particolare introdurvi un ricco, e prezioso orologio': Domenico Maria Marchese, *Vita della Ven. Serva di Dio Suor Maria Villani dell'Ordine de' Predicatori, fondatrice del monastero di S. Maria del Divino Amore di Napoli* (Naples: 1674, repr. Naples: Vincenzo Orsino, 1778), 69.

50 The Diocesan synods were held in 1642, 1644, 1646, 1649, 1652, 1658 and 1662.

51 Quoted by Franco Strazzullo, *Edilizia e Urbanistica a Napoli dal '500 al '700* (Naples: Arte Tipografica, 1995), 223.

52 Thus, in spite of the recurrent insistences of the prescriptive literature which survives plentifully, it is an error to interpret the domestic and the institutional oppositionally: the aristocratic *habitus* could and did mark both palatial and conventual dwellings.

53 For consideration of holiness in secular residences as indicated by the possession of religious objects and artefacts, see Renata Ago, 'Collezioni di quadri e collezioni di libri a Roma tra XVI e XVIII secolo', *Quaderni Storici*, 3 (1997), 663–83; Marta Ajmar, 'Introduction' to 'Special Issues: Approaches to Renaissance Consumption', *Journal of Design History*, 15 (2002), 207–9; Caroline Anderson, 'The Material Culture of Domestic Religion in Early Modern Florence, c. 1480–1650' (PhD diss., University of York, 2008).

54 See Lucia Sebastiani, 'Cronaca e agiografia nei monastery femminili', in *Raccolte di vite di santi dal XIII al XVIII secolo: strutture, messaggi, fruizioni* (Brindisi: Fasano,

1990), 159–68; Kate J.P. Lowe, *Nuns' Chronicles and Convent Culture in Renaissance and Counter-Reformation Italy* (Cambridge and New York: Cambridge University Press, 2003); Silvia Evangelisti, 'Angelica Baitelli, la storica', in *Barocco al femminile*, ed. Gilia Calvi (Bari: Laterza, 1993), 71–95.

55 Salamonia, 'Memorie', 5 vols. See footnote 32 above.

56 The idea of dynastic female holiness in baroque Sicily is explored by Sara Cabibbo, 'La santità femminile dinastica', in *Donne e Fede: Santità e vita religiosa in Italia*, ed. Lucetta Scaraffia and Gabriella Zarri (Rome: Laterza, 1994), 399–418; Sara Cabibbo and Marilena Modica, 'Identità religiosa e identità di genere: scritture di famiglie nella Sicilia del Seicento', *Quaderni storici*, 83 (1993), 415–42. For an exploration of the tensions between domestic virtue and monastic discipline, see Daniela Solfaroli Camillocci, 'L'obbedienza femminile tra virtù domestiche e disciplina monastica', in Scaraffia and Zarri, 269–84.

57 Salamonia, 'Memorie', vol. 2, fol.109r.

58 'We, being many, are one body in Christ, and every one members one of another.' Romans 12:5.

59 See also Strocchia, 'Sisters in Spirit'.

60 Salamonia, 'Memorie', vol. 2, fol.18r. Blessed Cecilia Romana of the Cesarini family was the first woman to receive the Dominican habit; by order of Pope Gregory IX in 1223 she went to Bologna to found another convent, and died in 1280 in odour of sanctity; see Vasi, *Delle Magnificenze di Roma, Libro VIII*, 23. The term 'monachal' means 'of a monk or nun'.

61 Salamonia, 'Memorie', vol. 4, fol. 36r.

62 *Ibid.*, vol. 4, fol. 66r.

63 *Ibid.*, vol. 4, fol. 5r.

64 *Ibid.*, vol. 2, fol. 110r.

65 *Ibid.*, vol. 5, fol. 68v.

66 A reader suggests that these are 'secular practices'. This is to suggest that cultural practices are fixed and static and that their meanings are independent of their location. My argument departs from such a view in according spatial and architectural location far greater significance and the conception of *practice* much greater fluidity. Thus space in this article is not conceived as simply passive locus for cultural activity, but rather as actively shaping the production of activities and meanings. Spatial dis/location is never accidental or irrelevant to message or meaning. Thus the devotional practices described here can be seen as deliberately *referencing* secular and domestic practices, but they were no longer circumscribed within either the familial or the secular domain. The change of location does not simply mean that an unchanging action is transferred from one space to another while the spaces and messages themselves remain unchanged; rather, a 'translation' of place and action occur together, thereby altering both. Thus secular familial practices are 'conventualized', the domestic is institutionalized and the institutional domesticized. A full discussion of this argument is not possible here, but see Gilles Deleuze and Félix Guattari, *A Thousand Plateaus: Capitalism and Schizophrenia*, trans. Brian Massumi (London: Athlone Press, 1988), 474–514.

67 Salamonia, 'Memorie', vol. 2, fol.110r.

68 *Ibid.*, vol. 5, fol. 54v.

69 *Ibid.*, vol. 5, fols 60r–61r.

70 *Ibid.*, vol. 4, fol. 89v. The relic was already lost by Salamonia's day.

71 *Ibid.*, vol. 2, fol.111r.

72 *Ibid.*, vol. 5, fol. 58r–58v.

73 *Ibid.*, vol. 4, fol. 109r–110r.

74 *Ibid.*, vol. 4, fols 74r–74v.

75 *Ibid.*, vol. 4, fols 75v–76r.

76 For full discussion, see Deleuze and Guattari, *A Thousand Plateaus*, 474–500.

77 Salamonia, 'Memorie', vol. 5, fol. 55r.

78 John Bossy, *Christianity in the West, 1400–1700* (Oxford: Oxford University Press, 1985), 127, 133.

79 The reference is to the 'beyond' of the margins and of interstitial in space, time, and culture evoked by Homi Bhabha. See Homi Bhabha, *The Location of Culture* (London: Routledge, 1994), 1–18.

Part II
The meaning and use of objects

From court to cloister and back again:
Margherita Gonzaga, Caterina de' Medici and
Lucrina Fetti at the convent of Sant'Orsola in Mantua

Molly Bourne

Founded in 1603, the Poor Clares convent of Sant'Orsola in Mantua was home in the early seventeenth century to three extraordinary women, each instrumental in forging the closely knit relationship that existed between the institutional interiors of the convent and the princely spaces of the Gonzaga court.[1] The first and most important, Margherita Gonzaga d'Este, was the founder of the convent, oversaw its construction and appointed its spaces with an exceptional collection of artwork, reliquaries and precious objects. In 1603 Margherita withdrew to live there permanently, although she never took vows and remained exempt from the restrictions of enclosure. Margherita's special status enabled her to cultivate a private female court at Sant'Orsola, where she surrounded herself with marriageable Gonzaga princesses and young women from patrician families. At the convent she received visitors and political ambassadors in her richly decorated private apartments and continued to participate directly in Gonzaga dynastic affairs, her patronage and political influence serving as a bi-directional catalyst for the movement of people and objects through the convent's walls. The second woman, Caterina de' Medici Gonzaga, lived in Sant'Orsola for about eight months following the death in 1626 of her consort, Duke Ferdinando Gonzaga. As a Gonzaga widow, Caterina benefited from monastic exemptions similar to those Margherita had enjoyed earlier, and her presence in the convent established another important link between court and cloister. The third, Lucrina Fetti, was a nun-painter who entered Sant'Orsola in 1614 and remained there for the rest of her life, contributing to the decoration of the convent. As the sister and daughter of professional painters, Lucrina was from a decidedly lower, artisan class. In fact, of the three women examined in this study, only Lucrina took the vows of the Poor Clares and followed the Order's rules of enclosure. However, as the sister of Gonzaga court painter Domenico Fetti, and portraitist

of the Gonzaga princesses who lived in the convent, Lucrina enjoyed greater freedoms than were commonly allowed in post-Tridentine female monastic settings. The experiences of Margherita, Caterina and Lucrina suggest that despite the stringent institutional reforms that were being implemented during this period, the space of the convent could offer women more flexible possibilities for political and artistic expression than they might otherwise experience outside its walls.[2]

Margherita Gonzaga and the foundation of Sant'Orsola

Margherita Gonzaga (1564–1618) was the first-born daughter of the Duke and Duchess of Mantua, Guglielmo Gonzaga and Eleonora d'Austria, and in 1579 became the third wife of the Duke of Ferrara, Alfonso II d'Este.[3] In Ferrara the young Margherita engaged in charitable and secular activities alike, founding a number of pious institutions and assembling a collection of precious liturgical objects and paintings by important Emilian artists. She was also a notable sponsor of dance, and many of the 'balletti della duchessa' for which the Este court was known at the time were dedicated to her.[4] Still childless when her consort died in October 1597, Margherita decided to return to Mantua in order to be closer to her beloved brother Vincenzo Gonzaga, by then duke. She departed Ferrara only two months later, shortly before the arrival of the papal troops and that city's dramatic devolution, and arrived in Mantua accompanied by 50 cart-loads of possessions, including her personal *quadreria* and numerous reliquaries, luxury textiles and objects in silver.[5] Back in her native city, Margherita devoted her energies and considerable income to the creation of Sant'Orsola. In a solemn ceremony held on 30 October 1599, Margherita received 12 virgins in her apartments in the Ducal Palace, where she personally dressed each woman in the brown tunic and white veil of the Ursulines. After taking communion in Margherita's chapel, they crossed the city accompanied by nuns from other convents and crowds of onlookers, arriving at the buildings in the delle Borre neighbourhood (present-day via A. Mori) that had been purchased by Margherita and prepared for their use.[6] The choreography of this foundation ceremony, originating in Margherita's apartments and ending on the opposite side of the city, underscored a spatial relationship between court and cloister that would remain tightly coupled throughout Sant'Orsola's early history.

On 26 July 1603 the nuns, now numbering 20, were relocated to their definitive home in Mantua's Pradella neighbourhood, located over one kilometre from Palazzo Ducale on the western edge of the city (present-day Corso Vittorio Emanuele II), where Margherita had acquired and begun to renovate a more extensive property for this purpose. According to Tiberio Guarini, Margherita's chaplain and author of an important early chronicle on Sant'Orsola written shortly after her death in 1618, closed carriages were used to transfer the nuns and their personal effects to the new convent,

where they were accommodated in a structure containing two oratories and a large dormitory overlooking a garden.[7] Guarini notes how later that year, on the feast day of Saint Ursula (21 October), Margherita announced her own intentions to move permanently to the convent:

On October 21 of the year 1603, without making her plans known, [Margherita] celebrated the Feast and participated in spiritual recreation with her Virgins, coming from the court to the new palace [*dalla Corte al nuovo palazzo*] and spending the entire day engaged in masses and divine offices. When evening came and everyone believed she would return to her usual apartments at court, she let it be known that she wished to live and die here with her Virgins, ordering that her things, which had not yet been moved so as not to raise suspicions about her intentions, be brought to her ... After shedding many reciprocal tears, her brother the *Serenissimo* Duke Vincenzo and the *Serenissimo* Prince Francesco left the good Margherita in the palace [*palazzo*] and returned to Court.[8]

Guarini's choice of the word '*palazzo*' suggests that Margherita's residence was a separate structure immediately adjacent to, and adjoining, the convent itself. Perhaps her apartments were located in a palace that she had purchased to form the nucleus of the new convent, which was then constructed or modified around it.[9]

Shortly after entering Sant'Orsola, Margherita received permission from Pope Clement VIII for the nuns to adopt the Order of the Poor Clares. According to Ippolito Donesmondi, a contemporary Mantuan chronicler of ecclesiastical history, she also received a series of personal exemptions from the Clarissan rules of enclosure, including the stipulation that she and as many as eight ladies-in-waiting of her choice were not required to take vows nor wear the Clarissan habit, and were free to come and go from the convent as they wished.[10] Significantly, Margherita also obtained papal authorization to receive family members in her apartments at Sant'Orsola, provided that visitors did not pass through the spaces reserved for the nuns. In 1612 Pope Paul V reconfirmed Margherita's privileges, informing her that:

The happy memory of Pope Clement VIII, my predecessor, having in the past sent similar letters in the form of a brief, conceding among other things that for your consolation your brother, the dearly departed Duke Vincenzo of Mantua, alone or with his children, but without any attendants, might enter and see you as often as is desired in the monastery of Sant'Orsola of Mantua, founded by you, remaining in your rooms as long as is desired, even dining there, as long as your rooms that are entered are completely separate from the residence of the nuns, and that these same nuns not be seen by Duke Vincenzo and his children ... the passage of Duke Vincenzo and his children through the residence of the nuns is expressly forbidden.[11]

Indeed, later accounts make clear that after the death of her brother Vincenzo in February 1612, Margherita continued to be consulted regularly on important political matters by the new duke, her nephew Ferdinando, as well as by visiting diplomats who considered audience with 'Madama Serenissima di Ferrara' an obligatory stop on their official itinerary. In the account of his

September 1615 visit to Mantua, for example, Venetian ambassador Giovanni
Mulla remarked that:

Madama di Ferrara lives outside of the Ducal Palace [*fuori di palazzo*], withdrawn in
order to follow a religious life of her own election. She has erected a convent next
to her residence and lives like a monastic [*ha ereto come un monasterio a canto della
sua casa e mena una vita come monastica*]. She greatly enjoys the company of princess
Eleonora [Gonzaga] and the education of princess Maria [Gonzaga] … She displayed
satisfaction in the visit I made to her in the name of the Venetian Senate … Crown
prince Vincenzo [II Gonzaga] participates in the Council as often as he likes, and for
especially difficult political matters he consults with duke [Ferdinando Gonzaga] and
with Madama di Ferrara, who has the finest judgement in state affairs and is a woman
of great wisdom and much knowledge in all things, even though, as I mentioned, she
chooses to live a life that is withdrawn as much as possible.[12]

If Margherita's private rooms were located within the enclosed spaces of
the convent, as they appear to have been, her authorization to receive non-
professed guests there, both male and female, is unusual, and underscores
the flexibility with which Tridentine rules of enclosure could be applied,
especially in the case of convents housing aristocratic members.[13]
Ultimately, her position as the founder of Sant'Orsola, yet one who took
no vows and continued to maintain close social and political ties with the
Gonzaga court, enabled her to straddle these two different worlds: one
religious, female and institutional, the other secular, predominantly male
and courtly.

Margherita Gonzaga at Sant'Orsola

Once Margherita took up residence at Sant'Orsola, her efforts to expand
and decorate the convent proceeded more rapidly. Taking advantage of
her prestigious family connections, Margherita appointed court artist and
architect Antonio Maria Viani to design the convent's external, public
church, a splendid octagonal structure that is virtually the only portion of
the complex that survives today.[14] Viani's church is featured prominently in
Domenico Fetti's monochrome lunette (Fig. 6.1), which depicts the architect
presenting a model of it to his patroness.[15]

On 26 June 1608 the cornerstone of the church was ceremonially laid by
the Bishop of Mantua, Margherita's cousin Francesco Gonzaga, who together
with Duke Vincenzo had been instrumental in promoting the project.[16] By
February 1613, construction was complete and celebrations lasting several
days were held to mark the occasion. These included a procession held on 17
February in which a statue of the Virgin, accompanied by musicians and a
reported 2,000 soldiers, was solemnly transported from the Cathedral, located
next to the Palazzo Ducale, to Sant'Orsola. The next day Bishop Francesco
Gonzaga officiated over the consecration of the nuns' inner church, which
had been richly adorned with precious textiles and reliquaries (many from

Margherita's own collection), as well as new wooden choir stalls (created by a German master) that could accommodate 40 nuns.[17]

The nuns' inner church was decorated with paintings created between 1604 and 1614 by predominantly Emilian painters, revealing both the familiarity that Margherita had acquired with artists from this region during her tenure as Duchess of Ferrara, as well as her lack of interest in Mantuan artists. The large central altarpiece, by a Ferrarese painter, depicted the *Agony in the Garden*, while the flanking chapels contained, on the left, a copy of Annibale Caracci's *Lamentation* and, on the right, a copy of Correggio's *Adoration of the Shepherds* (more commonly known as *La Notte*), each topped by smaller canvases, one depicting Saint Clare and the other Saint Ursula.[18] Early accounts indicate that Sant'Orsola's outer, public church was similarly adorned with costly fabrics, reliquaries and precious liturgical objects such as candlesticks made of ebony, amber and gilded silver.[19] Once again, Margherita's choice of artists for the three altarpieces in the outer church reflects her privileged position

6.1 Domenico Fetti, *Margherita Gonzaga Receives a Model of Sant'Orsola from Antonio Maria Viani*, c. 1619, canvas, 245 × 276 cm (96½ × 108¾ inches), Museo di Palazzo Ducale, Mantua, inv. 12684. By concession of the Ministero per i Beni e le Attività Culturali

at the Gonzaga and Este courts alike. Ludovico Caracci and Carlo Bononi, authors of, respectively, the *Martyrdom of St Ursula* (main altar) and *St Clare Driving Away the Saracens* (right altar) were both important Emilian painters not normally active in Mantua, while Viani, Gonzaga court artist and architect of the church, was responsible for the third altarpiece, *The Virgin Presents Saint Margaret to the Trinity* (left altar).[20] Together, these works presented a clear iconographic programme that celebrated Saints Ursula (the patron saint of the church), Clare (the founder of the Clarissan order) and Margherita (name-saint of the founder and patron of the convent).

While the accounts of Sant'Orsola by Donesmondi and Guarini are especially valuable since they date from Margherita's lifetime, both are limited to descriptions of the outer and inner churches, presumably because neither author was given access into other parts of the convent. For a glimpse inside the cloistered walls we must rely upon three eighteenth-century sources. The first is a book dated 1763 by Giovanni Cadioli, founder of Mantua's Accademia di Belle Arti, who describes both churches as well as Margherita's apartments, the convent chapter room, refectory, orchard and upstairs dormitory.[21] Cadioli, himself a painter, was primarily interested in identifying the most significant paintings in the convent, and omits most other objects from his account.[22] The second, a 111-page inventory of the convent that was drawn up at the time of its suppression in 1786, is by far the most detailed description of the complex.[23] The notary responsible, Angelo Pescatori, moved systematically through the convent and listed the contents of each room. Although Pescatori rarely gives the artists' names for the numerous works of art he recorded, his account concludes with a separate record of more than 76 paintings by 'excellent painters' that had been identified as worthy of preservation by Giovanni Bottani, then director of Mantua's Accademia.[24] The third and final document of importance for a reconstruction of Sant'Orsola is a ground-floor plan of the convent created in 1786 to complement Pescatori's inventory (Fig. 6.2). The plan's accompanying key of numbered rooms indicates that the complex contained more than 160 distinct spaces distributed on two floors, with an additional attic floor (*granaio*) above and cellars (*cantine*) below, as well as an oratory – part of which survives today – that was located in the convent's garden and used for meditation (see Appendix).[25] Although both inventory and plan record the situation at Sant'Orsola more than 150 years after Margherita's death, the physical structure of the convent had probably changed little in the intervening years. And, given the nearly cult status that Margherita achieved at Sant'Orsola in her posthumous years, we may speculate that the distribution of the paintings listed in the inventory – especially those located in her apartments – approximates their arrangement in the years closer to her lifetime. Nonetheless, because inventories are by their very nature deceptively subjective and selective, we must still use this document critically and with caution, seeking corroboration from additional sources wherever possible.[26]

On the 1786 plan (Fig. 6.2), the outer and inner churches are clearly visible at the lower right (labelled, respectively, 1 and 2). Aside from the external

6.2 Plan (1786) of the convent of Sant'Orsola, ground floor. Archivio di Stato di Mantova, Piante di Conventi Soppressi, 20bis, concession no. 15/2006

sacristy (3), which according to Pescatori's inventory contained no artworks, the only other spaces of the convent accessible to most laity were the entrance hall (10), the 'Room of the Wheel' where visitors and relatives could leave personal items for the nuns (14), a large room (*camerone*) with locked door that provided access into the cloistered areas (9), and two parlours where guests could speak through grates to the nuns inside (15, 7). Of these, only the two parlours contained any artwork: in the smaller parlour to the left of the entrance hall (15) there was a single framed painting on canvas of Christ *Salvatore*, while in the larger parlour at right (7) there were three small framed portraits of religious figures and another painting depicting a city in flames.[27]

This small group of only five pictures in the external rooms of the convent stands in contrast to the more than 200 paintings that Pescatori located in its enclosed spaces (not including the nuns' richly decorated inner church). Of

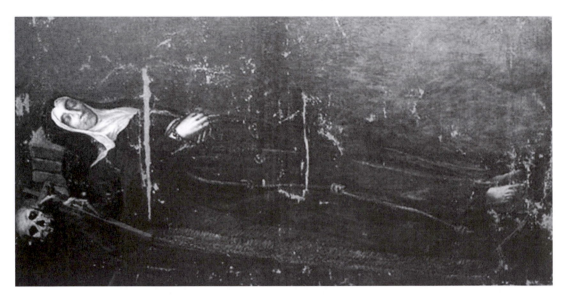

6.3 Anonymous Italian artist, *Funerary Portrait of a Clarissan Nun* (Margherita Gonzaga?), c. 1618, canvas, 115 × 200 cm (45 × 78¾ inches), Museo di Palazzo Ducale, Mantua, inv. st. 767. By concession of the Ministero per i Beni e le Attività Culturali

these, approximately 180 depicted religious subjects, predominantly scenes of the Passion, the life of Christ, and images of the Virgin or of various saints, while an additional 34 consisted of painted portraits. Not surprisingly, the religious-themed paintings were clustered in rooms dedicated to communal functions, where they could serve in the spiritual education of the nuns. For example, the entrance atrium into the convent itself (11) contained nine paintings of religious subjects and two portraits,[28] the Chapter Room (possibly 60) displayed 13 spiritually themed paintings plus an altarpiece of the *Deposition*,[29] and the Refectory (55) contained an additional 13 religious paintings, including Domenico Fetti's monumental *Multiplication of Bread and Fishes*.[30]

A clear reminder of the Gonzaga identity of the convent was found on the cloistered side of the 'Room of the Wheel' (13). Here, in addition to eight paintings of religious subjects, there were two portraits, one a large canvas depicting an unnamed Gonzaga princess and the other a framed canvas portrait of 'Duchess Margherita Gonzaga d'Este, founder of this monastery'.[31] The most intriguing portrait of Margherita, however, was to be found in the nuns' inner sacristy (8) where, like her portrait in the previously mentioned space, it would be seen exclusively by the nuns. Here, together with 14 paintings depicting saints, the Virgin and scenes of the Passion, was 'a large painting with a black frame representing the Princess founder of this monastery, dead, wearing the habit of a religious'.[32] This funerary painting of Margherita can be identified as the large, damaged canvas now kept in the deposits of Mantua's Museo di Palazzo Ducale that portrays a dead nun dressed in the Franciscan habit of the Poor Clares, lying on a straw mat with her head resting on a stack of three bricks (Fig. 6.3).[33] She holds a strand of rosary beads, and by her side rest a skull and a small wooden crucifix. That this portrait depicts Margherita is supported by her testament of 30 October 1615, in which she asks to be dressed in the habit of her 'beloved nuns' and buried 'without pomp' in

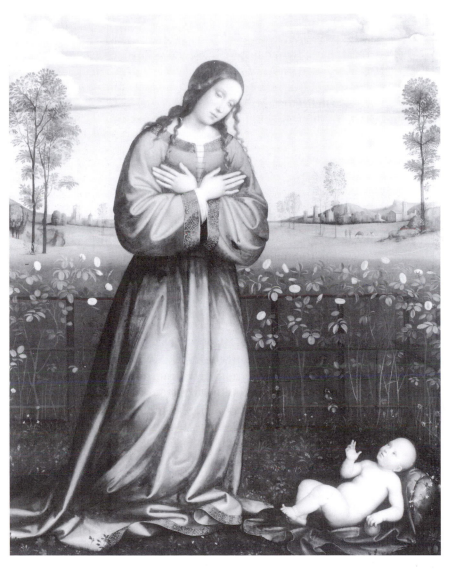

6.4 Francesco Francia, *Madonna Adoring her Child*, c. 1508, panel, 174.5 × 131.5 cm (68¾ × 51¾ inches), Bayerische Staatsgemälde-sammlungen, Alte Pinakothek Munich

the inner church of Sant'Orsola 'using the same customs and rites that are traditionally used by the nuns of this monastery'.[34]

Although her last wishes were austere, the decoration of Margherita's own apartments at Sant'Orsola indicates that she advocated a more opulent form of personal piety during her lifetime. Her suite of at least eight rooms included a chapel for private worship (+) that contained an altarpiece of 'the Madonna intent on contemplating and adoring her Infant Jesus lying on the ground amidst flowers, by the Bolognese Francesco Francia'.[35] This work has long been identified as the large panel by Francia dated around 1508 and now in Munich (Fig. 6.4).[36] Since this painting can be traced to Ferrara in the late sixteenth century, it is likely that Margherita brought it with her when she returned to Mantua in 1597.[37]

Continuing into an adjacent 'camerino' (possibly 33), Cadioli notes a profile portrait by Parmigianino of the famous twelfth-century noblewoman and militant defender of the Church, Matilde of Canossa, an appropriate role model for Margherita.[38] Pescatori, who describes the same portrait, notes that there were also four paintings of the Virgin and other saints in this sumptuous anteroom, which boasted a vaulted ceiling and walls lined with intarsiated walnut wainscotting finished with a decorative marble moulding.[39] In four small, adjacent rooms (all numbered 31) that may have been used as sleeping quarters by Margherita and her attendants, we find at least 19 paintings of religious subjects and a small portrait of a nun.[40]

By contrast, the large room called the 'stanza detta del lavoriero' by Pescatori, and the adjoining space of similar size (both 35), were decorated exclusively with portraits. Significantly, of the 34 portraits that Pescatori describes in the cloistered spaces of the convent, no fewer than 27 were located in these two chambers which, given their large size, the presence of fireplaces in both, and their direct access from the cloister, may have served as Margherita's audience rooms.[41] The space closest to the cloister contained nine unspecified portraits as well as a portrait of a young prince and another of a Theatine friar.[42] In the adjacent room, which communicated with Margherita's chapel and contained two windows that looked out upon the convent's large orchard, no fewer than 14 portraits were displayed. Two of these depicted nuns, while the remaining 12 portrayed Gonzaga princesses – six full-length and six half-length canvases – a virtual portrait gallery of Gonzaga women.[43] These painted likenesses would have clearly reminded both nuns and visitors alike of Margherita's role in creating Sant'Orsola, and of the prestigious ties the convent enjoyed with the ruling dynasty.

Other Gonzaga women at Sant'Orsola

From the time of its foundation, Margherita had actively promoted Sant'Orsola as a sort of 'patrician college' for eligible daughters of the ruling dynasty, many of whom received a rigorous education within the safety of its walls until they reached a marriageable age.[44] During Margherita's lifetime, she was joined by her niece Eleonora and her great-niece Maria, who entered the convent in 1611 and 1613 respectively. Eleonora remained at Sant'Orsola until her marriage in 1622 to Emperor Ferdinand II, while Maria, the only surviving offspring of Duke Francesco Gonzaga and upon whom the future of the dynasty depended, was only four years old when she entered Sant'Orsola, where she remained until her marriage in 1627 to Carlo Gonzaga, Count of Rethel. Maria and Carlo's daughter Eleonora (1628–86) also lived in the convent until 1651 when she married Emperor Ferdinand III, while Caterina de' Medici Gonzaga withdrew to Sant'Orsola frequently in the years between 1617 and 1627, first as consort, and then widow, of Duke Ferdinando Gonzaga. As we will see, formal, full-length likenesses of many of these women were

created by Lucrina Fetti for Sant'Orsola, where they comprised part of the convent's portrait collection of Gonzaga princesses.

Margherita's last will and testament, drawn up on 30 October 1615, provides a final piece of evidence of how she served as a fulcrum for the movement of objects between court and convent. In it, she left 550 *scudi* for her own funerary masses and a staggering 60,000 *scudi* to complete work on the 'fabrica' of Sant'Orsola.[45] Margherita also promised valuable personal possessions to three close female relatives, all of whom were living in convents at the time. To her sister Anna Caterina Gonzaga, widow of the Archduke of Austria, she left a sumptuous octagonal reliquary made of gold that she normally kept near her bedside.[46] To her niece Eleonora and great-niece Maria, both residents at Sant'Orsola, she left her pietra-dura inlaid writing desk (*il mio scrittorio grande miniato dentro et di fuori ornato di diverse pietre*) and a portable silver-gilt cupboard, respectively.[47] In a separate testamentary note written in her own hand on the same date, Margherita left to favourite courtiers and servants objects such as crucifixes, bowls and candlesticks made of silver and ebony, while to Tiberio Guarini, her spiritual advisor and author of the aforementioned convent chronicle, she left 200 *scudi* and 'a painting of the Madonna, copy of the one that is in the chapel of my apartment', clearly a replica of her altarpiece of the *Madonna and Child* by Francesco Francia.[48] While these items were destined to leave the convent upon her death, those that she bequeathed to the nuns who lived in Sant'Orsola would, by contrast, presumably remain within its walls. In the same autograph note, she left to Sister Giuliana Canuti a painting depicting *Christ in the Garden of Gethsemane*, as well as 'the wooden crucifix with a brass figure of Christ that I hold at night', an object of personal value reminiscent of the crucifix that appears in Margherita's funerary portrait (Fig. 6.3).[49] To Sister Laura Maria Fanani she promised a framed painting of the *Holy Family*, while to each of the other sisters in the convent she left a small wooden crucifix and an individual framed painting of a saint, taken from the collection of paintings that she kept 'in my chapel or in the adjacent rooms'.[50] Compared to the more valuable bequests she made to her female relatives, Margherita's gifts to the nuns were of a simpler, more devotional nature, a distinction that reveals the limits of her spiritual kinship to them as opposed to her more powerful ties to family and dynasty.

Caterina de' Medici Gonzaga and Sant'Orsola as a spiritual retreat

Caterina de' Medici Gonzaga (1593–1629) provides us with another example of a woman who served as an important link between the Gonzaga court and the convent of Sant'Orsola.[51] The daughter of Ferdinando de' Medici, Grand Duke of Tuscany, and his consort Cristina of Lorraine, Caterina arrived in Mantua as the bride of Duke Ferdinando Gonzaga in 1617, less than one year before Margherita's death. An extremely pious woman, Caterina did

not relish life at court and frequently retired to Sant'Orsola for prayer and meditation. When her husband died in October 1626, after nearly ten years of childless marriage, Caterina expressed her desire to enter Sant'Orsola more permanently.[52] Without taking the vows of the Poor Clares, she moved into Margherita's apartments and was allowed to receive visitors there, much as Margherita had before. Such behaviour was not unusual, and there is considerable evidence of the important role that post-Tridentine convents played in temporarily or permanently hosting noble laywomen.[53] Although Caterina's plans were thwarted when the Medici appointed her Governor of Siena, a position she held until her death in 1629, she resided in Sant'Orsola for eight months before returning to Tuscany in June 1627. Surviving correspondence from this period provides information about her role in the movement of objects between the convent and the Gonzaga and Medici courts alike.

The most interesting example is found in a letter from the Medici *inviato* to Mantua, Alessandro Bartolini. Following the death of Ferdinando Gonzaga, Bartolini aspired to obtain paintings from the fabled Gonzaga collection for Caterina's father, Grand Duke Ferdinando de' Medici. In Mantua on 14 November 1626, he announced his plans to acquire Correggio's *Ecce Homo*:

I have talked to the duchess [Caterina de' Medici] more than once about obtaining a few good paintings for Our Most Serene Patron, and she tells me that it will be possible. In the meantime she has taken into the convent with her the *Ecce Homo* by Correggio, and it is no copy but is in fact the original. This painting had belonged to Duke Alfonso of Ferrara, and the duchess his wife brought it with her when she returned to Mantua, and she was especially fond of this work.[54]

From Bartolini's letter we can deduce that the Gonzaga *Ecce Homo* had been acquired by Duke Alfonso II d'Este in Ferrara before passing to Margherita, who brought it with her to Mantua in 1597 and later gave it to Caterina, who in turn had taken the painting into the convent with her in October 1626. Although Bartolini believed that this *Ecce Homo* was by the hand of Correggio, it was almost certainly an early copy of the painting now conserved in London, which is considered by most scholars to be the original (Fig. 6.5).[55]

It would appear that the Mantuan *Ecce Homo* did not stay long inside the convent walls and soon entered the Gonzaga collection, for it is listed – still attributed to Correggio – in the Gonzaga inventory of 1626–27 that was completed shortly after Caterina's departure for Tuscany.[56]

Caterina's brief residency at Sant'Orsola overlapped with that of Princess Maria Gonzaga, who in 1627 left the convent to marry Carlo Gonzaga, Count of Rethel. The presence of these two Gonzaga women at Sant'Orsola generated a number of visits to the convent by members of the ruling family and their courtiers, sometimes in considerable numbers. For example, in December 1626 the daughter of Gonzaga official Alessandro Striggi was

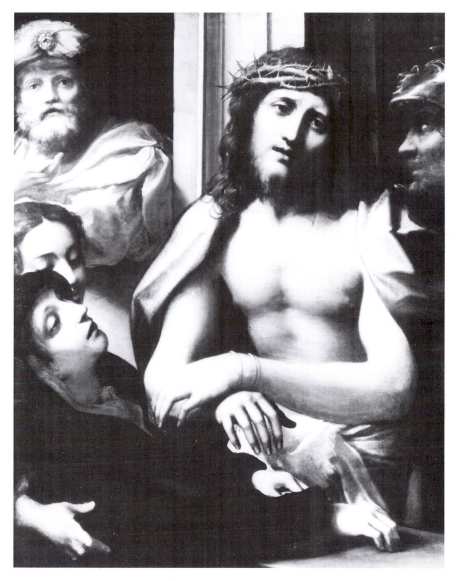

6.5 Antonio Allegri (il Correggio), *Ecce Homo*, c. 1523, panel, 99 × 80 cm (39 × 31½ inches), National Gallery, London, inv. NG15

married 'before the grate in the camerone of Sant'Orsola', probably the large parlour indicated on the 1786 plan (Fig. 6.2, room 7). In a letter dated in Mantua on 9 December 1626, Medici secretary Alessandro Bartolini informed Grand Duchess Cristina of Lorraine that the new Gonzaga duke, Vincenzo II, had attended this ceremony accompanied by Carlo Count of Rethel and more than 20 gentlemen, relatives and members of the court; observing the proceedings from within the convent on the other side of the grate were Caterina de' Medici Gonzaga and Princess Maria, Count Carlo's future bride.[57]

Letters and inventories provide further notice of objects that moved back and forth between court and convent during Caterina's brief sojourn

at Sant'Orsola. While living there she received fine French linens, special Lenten foods and other gifts, and loaned her personal litter to the Duke of Mirandola.[58] Moreover, when Caterina left Mantua six months later, she was accompanied by a mule-train laden with her possessions, including scented glove holders, a service of gilded silver cups and a sugar bowl adorned with the Medici arms.[59] On 19 June 1627, the eve of her departure, Caterina drew up her last will and testament.[60] In it, she left sums of money to her servants and items such as jewellery and jewelled reliquaries to members of the Gonzaga family. Interestingly, in her bequests to the nuns in Sant'Orsola, Caterina closely followed Margherita's earlier example. Sister Giuliana Canuti, to whom Margherita had earlier bequeathed a wooden crucifix with a brass figure of Christ that she 'held at night', received 'a silver *pietà* as a sign of my love for her', while to the other sisters Caterina left individual paintings of saints, just as Margherita had done in her last testament.

Lucrina Fetti: nun-painter at Sant'Orsola

Compared to Margherita and Caterina, the nun-painter Lucrina Fetti (c. 1595–c. 1637) provided a different kind of link between the secular world of the Gonzaga court and the religious realm of the convent. Sister of the more renowned painter Domenico Fetti (1588/9–1623), Lucrina was probably born in Rome around 1595 with the name Giustina.[61] In 1614 she came to Mantua with her brother, who had been invited there by Duke Ferdinando Gonzaga, and on 3 December of that year she entered the convent of Sant'Orsola and assumed the name of Lucrina.[62] Duke Ferdinando personally paid 150 *scudi* for Lucrina's monastic dowry, evidence of the special relationship that she and her brother enjoyed with the court from the outset of their residency in Mantua.[63] Lucrina remained at Sant'Orsola for the rest of her life, creating portraits of the Gonzaga princesses who were raised there and painting religious decorations for the convent. She had probably learned to paint from her brother, whose status as official artist to the Gonzaga provided Lucrina with an important ally at court. Yet as a cloistered nun her access to visual models and artistic training was necessarily limited, and the documentary sources recording her life are few. Only in recent years have scholars attempted to establish a secure corpus of Lucrina's paintings by addressing the problems of her small and qualitatively varied oeuvre, which in the past has often been entangled with that of her brother.[64] Most of her works were created for Sant'Orsola without financial compensation, a typical situation for a nun-painter and one that is comparable to that of the fifteenth-century Franciscan nun Caterina de' Vigri, whose artistic production consisted of small devotional paintings and manuscript illuminations for her convent of Corpus Domini in Bologna.[65]

Lucrina's known paintings can be divided into two categories: portraits and works depicting religious subjects, the latter group being more numerous.

According to the 1786 inventory of Sant'Orsola, the convent's public, external church contained at least ten works by (or at least partly by) Lucrina. Six were located in the chapel dedicated to St Margaret, on the left-hand side of the church. Here, her two small canvases depicting *Saint Mary Magdalene* and *Saint Barbara* were displayed underneath Viani's altarpiece, *The Virgin Presents Saint Margaret to the Trinity*.[66] Fixed into this chapel's side walls were four large canvases also by Lucrina depicting scenes from the life of Christ: *The Annunciation, Adoration of the Shepherds, Visitation* and *Adoration of the Magi*, while similarly positioned in the chapel of Saint Clare on the opposite side of the church were four more canvases by Lucrina illustrating the Passion: *The Agony in the Garden, The Flagellation, The Crowning with Thorns* and *The Road to Calvary*.[67]

Although two of these eight paintings remain untraced, six have been identified.[68] All inscribed with the date 1629 and the abbreviation 'S.L.F.R.F.S.O.', their mediocre quality suggests a sharp decline in the quality of Lucrina's artistic production following the death of her brother in 1623.[69] As a nun-painter living in enclosure, the use of artistic models available within Sant'Orsola was a practical necessity for Lucrina. A particularly interesting example of this phenomenon is found in her above-mentioned *Adoration of the Shepherds* for the chapel of Saint Margaret in the convent's external church, the composition of which is clearly derived from a canvas produced in the 1590s by the Ferrarese artist Sebastiano Filippi, known as 'Il Bastianino'. Margherita Gonzaga had acquired Bastianino's painting while in Ferrara and must have taken it with her to Sant'Orsola, where Lucrina was able to study and reproduce it.[70] It is significant, however, that Lucrina's known works for the convent were not executed until after Margherita's death in 1618.[71] Considering Margherita's documented preference for Emilian painters, and the high calibre of artists at her disposal, Lucrina's artistic activities for Sant'Orsola may have been discouraged during the lifetime of the convent's founder.

It is likely that Lucrina's second group of paintings, portraits of Gonzaga women, were also executed after 1618, and it is in these works that we see the nun-painter qualitatively at her best. Female court portraits required the careful observation and detailed visual record of the sitter's costume, jewels and accessories, qualities abundantly evident in the signed and dated portrait that Lucrina created of Eleonora Gonzaga in 1622, on the occasion of her marriage to Emperor Ferdinando II (Fig. 6.6).[72] In 1786 Bottani attributed this portrait of Eleonora to Lucrina and grouped it with three other full-length portraits of women associated with the Gonzaga court.[73] The first, which may also be by Lucrina, is of a sumptuously dressed woman holding an orb and sceptre, and probably depicts the Empress Anna d'Asburgo, daughter of Margherita's sister Anna Caterina and Archduke Ferdinand of Austria, who in 1611 married Emperor Matthias II.[74] The second, by an anonymous Italian artist and also full-length, depicts Margherita in widow's garb (Fig. 6.7).[75]

6.6 Lucrina
Fetti (after Justus
Suttermans),
Eleonora Gonzaga,
Bride of Emperor
Ferdinando II,
1622, canvas,
200 × 118 cm
(78¾ × 46½
inches), Museo di
Palazzo Ducale,
Mantua, inv. 6826.
By concession
of the Ministero
per i Beni e le
Attività Culturali

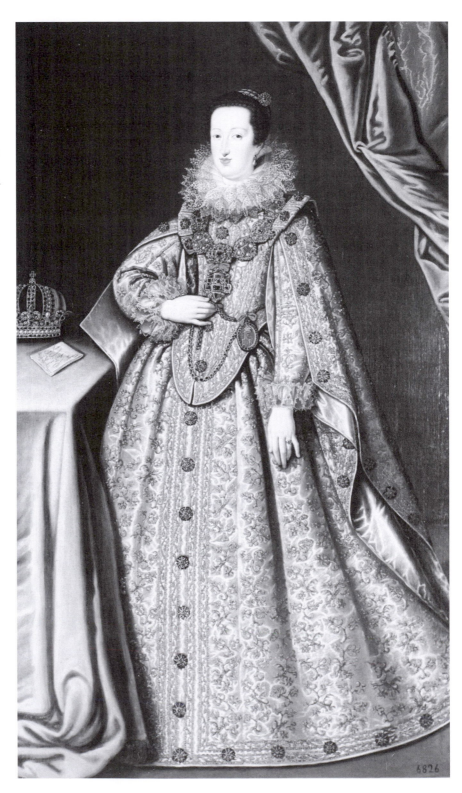

6.7 Anonymous Italian artist, *Margherita Gonzaga as a Widow*, c. 1615, canvas, 204 × 103 cm (80¼ × 40½ inches), Museo di Palazzo Ducale, Mantua, inv. 6862. By concession of the Ministero per i Beni e le Attività Culturali

6.8 Lucrina Fetti
(?), *Caterina de'
Medici Gonzaga (?)
as Saint Helena*,
c. 1620–25,
canvas, 200 × 108
cm (78 ¾ × 42 ½
inches), Museo di
Palazzo Ducale,
Mantua, inv. 6864.
By concession
of the Ministero
per i Beni e le
Attività Culturali

The third, possibly by Lucrina, depicts a woman carrying a cross in the guise of Saint Helena (Fig. 6.8).[76] This last is unique in the group as an allegorical portrait, and has been identified as Caterina de' Medici Gonzaga based on the striking similarity of Saint Helena's features to other known likenesses of Caterina.[77] Instead of being portrayed as her name-saint, Caterina's choice of Saint Helena, a protagonist in the Legend of the True Cross, is best explained by the long-standing veneration of the Holy Cross by Gonzaga rulers and their consorts. The most visible manifestation of this cult is the presence within the Ducal Palace of the small church of Santa Croce in Corte, the upper oratory of which was renovated and decorated by Caterina in the early seventeenth century, shortly after her arrival to Mantua.[78]

All of similar size, these four full-length portraits of Gonzaga women were probably displayed in Margherita's audience rooms, which in the years following her death were gradually adorned with likenesses of the Gonzaga widows and princesses who lived in Sant'Orsola. Here, where they were seen by the nuns and – presumably – select lay visitors who had privileged access, these portraits helped to publicize the prestigious ties that Sant'Orsola continued to enjoy with Mantua's ruling family. This gallery of Gonzaga women also served, quite literally, to celebrate the lives and activities of three notable women from Sant'Orsola: Margherita Gonzaga, Caterina de' Medici and the convent's own nun-painter, Lucrina Fetti.

Conclusion

Our brief survey of Sant'Orsola has highlighted a number of themes central to this book. One is the potential for an institutional interior to be domesticized. In our example, the relaxed application of Tridentine directives to the convent founded by Margherita Gonzaga enabled her to create there a particularly sumptuous apartment, where she was served by non-professed ladies-in-waiting and surrounded by artworks and precious objects brought from her earlier tenure as Duchess of Ferrara. The fact that she regularly received ambassadors and relatives in these rooms and continued to be involved in Gonzaga diplomacy illustrates how models of domestic court protocol could be imported into the convent's institutional setting, further underscoring the fluid relationship between these two spheres. Objects, too, could circulate bi-directionally between court and convent, as with Correggio's *Ecce Homo*, which entered and exited Sant'Orsola as part of a princely gift economy; a related example is found in the small devotional images given to the nuns by Margherita Gonzaga and, later, by Caterina de' Medici, as tokens of their spiritual kinship. Portraits of Gonzaga princesses displayed within the cloistered spaces reflected both the special social status that these women enjoyed during their temporary residence there, as well as the convent's dependency on Mantua's ruling family. By contrast, the professed nuns who lived permanently at Sant'Orsola left their own markers of a simpler kind of domesticity by engaging in cyclical activities

like bread-baking, needlework and private prayer. A special case is found in the nun-painter Lucrina Fetti, whose artistic production of Gonzaga portraits and religious paintings, as well as her special status as sister of court painter Domenico Fetti, enabled her to partially transcend the division between court and cloister, providing yet another example of the blurring of boundaries between interiors public and private, religious and secular, institutional and domestic.

Appendix

List of ground-floor rooms at Sant'Orsola (1786), to accompany convent plan (Fig. 6.2).

1.	Chiesa esterna	37.	Passetto d'ingresso
2.	Chiesa interna	38.	Scala
3.	Sagrestia	39.	Passetto
4.	Luogo ad uso della chiesa	40.	Camera
5.	Altro simile	41.	Sito del sechiaro
6.	Scala	42.	Camera
7.	Parlatorio esterno	43.	Dispensa
8.	Sagrestia interna	44.	Camera per il pane
9.	Camerone	45.	Attrio
10.	Ingresso	46.	Loggia
11.	Ingresso interno	47.	Corridore
12.	Scala	48.	Legnara
13.	Camera per la Madre Rodara	49.	Passetto
14.	Camera per la Ruota	50.	Camera del fuoco
15.	Parlatorio esterno	51.	Scala
16.	Parlatorio interno	52.	Grotta, o sia luogo di orazione
17.	Scala	53.	Capella della B.V. di Loreto
18.	Camera	54.	Corridore
19.	Forno	55.	Refettorio
20.	Camera	56.	Camera
21.	Saletta	57.	Camera
22.	Camera	58.	Passetto
23.	Camera	59.	Dispensa
24.	Loggia	60.	Camera
25.	Loggia	61.	Sito del sechiaro
26.	Loggia	62.	Forno
27.	Corridore	63.	Passetto, e scala
28.	Luoghi comuni	64.	Camera per le biancherie
29.	Corridore	65.	Tinazzara
30.	Luogo ad uso della Sagristia	65½.	Portico rustico
31.	Camere dell'appartamento	66.	Corridore
32.	Passetto, e scala	67.	Buccaderia
33.	Camera	68.	Naranzara
+	Capellina [sic]	69.	Passetto
34.	Passetto	70.	Portico
35.	Due camerini	71.	Pollai
36.	Sala		

Source: ASMn, Piante Conventi Soppressi, 20bis

Notes

1 On the history of Sant'Orsola, see Giovanni Battista Intra, *Il Monastero di Santa Orsola in Mantova* (Mantua: L. Rossi, 1902; first publ. in *Archivio Storico Lombardo*, 3rd ser., XXII, 4 (1895), 67–85); Giuse Pastore, 'Testimonianze di monasteri nella città di Mantova', in *Francescanesimo in Lombardia: Storia e Arte* (Milan: Silvana, 1983), 475–7; Ugo Bazzotti, 'Margherita Gonzaga e il convento di Sant'Orsola', in *Domenico Fetti 1588/89–1623* (exh. cat.), ed. Eduard Safarik (Milan: Electa, 1996), 45–50; Giuse Pastore, 'La chiesa di Sant'Orsola e l'eremo delle grotte', *Quaderni di San Lorenzo*, 4 (2006), 5–20. I wish to thank Stefano L'Occaso for his insightful comments on an earlier draft of this paper. All translations are my own; where necessary, my editorial interventions have been inserted within square brackets.

2 As also argued by Cynthia Gladen, 'A Painter, a Duchess, and the Monastero di Sant'Orsola: Case Studies of Women's Monastic Lives in Mantua, 1599–1651' (PhD diss., University of Minnesota, 2003), who focuses in particular on the lives of Margherita Gonzaga and Lucrina Fetti. *Eadem*, 'Suor Lucrina Fetti: pittrice in una corte monastica seicentesca', in *I monasteri femminili come centri di cultura tra Rinascimento e barocco*, ed. Gianna Pomata and Gabriella Zarri (Rome: Edizioni di Storia e Letteratura, 2005), 123–41.

3 The most comprehensive biography of Margherita remains Alfonso Lazzari, *Le Ultime tre Duchesse di Ferrara e la corte estense a' tempi di Torquato Tasso* (Florence: Ufficio della Rassegna Nazionale, 1913), 159–316; her activities as a patron of paintings are treated by Stefano L'Occaso, 'Margherita Gonzaga d'Este: pitture tra Mantova e Ferrara intorno al 1600', *Atti e Memorie dell'Accademia Nazionale Virgiliana*, n.s. 73 (2005), 81–126.

4 See Kathryn Bosi, 'Leone Martosa and *Martel d'amore*: a *balletto della duchessa* Discovered', *Ricercare*, 17 (2005), 5–69.

5 Lazzari, *Le Ultime tre duchesse*, 292; see also Bazzotti, 'Margherita Gonzaga', 45–6.

6 The dressing ceremony is described by the Mantuan chronicler Gian Battista Vigilio in his *La Insalata. Cronaca Mantovana dal 1561 al 1602*, ed. Daniela Ferrari and Cesare Mozzarelli (Mantua: G. Arcari, 1992), 92.

7 Tiberio Guarini, *Breve naratione e vera historia della fondatione del nobillitissimo monasterio di S. Orsola*, Biblioteca Comunale di Mantova (MS 1088), cc. 31v–32.

8 *Ibid.*, cc. 33v–34.

9 Archival research into Margherita's purchase of properties in the Pradella neighbourhood in the first years of the 1600s might help to clarify this issue.

10 In 1616, Donesmondi described Margherita's freedoms as follows: 'vivendo ritiratamente con quell'altre spose di Christo; eccetto che, non havendo mutato l'habito vedovile, esce talhora per urgenti affari del publico, e della Corte, o per qualche sua particolare divotione' (Ippolito Donesmondi, *Dell'istoria ecclesiastica di Mantova*, 2 vols (Mantua: Aurelio & Lodovico Osanna, 1613–16), vol. 2, 388; anastatic repr., Bologna: A. Forni, 1977). See also Guarini, *Breve naratione*, cc. 40v–41.

11 Copy of brief of Pope Paul V, 29 May 1612 (ASF, MdP 6107, c. 762; a partial transcription is available as Doc. 6153 of the Medici Archive Project database, *Documentary Sources for the Arts and Humanities* (hereafter *Documentary Sources*) at <http://documents.medici.org/>).

12 Arnaldo Segarizzi, *Relazioni degli Ambasciatori Veneti al Senato*, 3 vols (Bari: G. Laterza & Figli, 1912–16), vol. 1, 142–3, 152.

13 On the problems resulting from the entrance of secular spectators, including men, to see convent theatre performances, see Elissa Weaver, *Convent Theater in Early Modern Italy: Spiritual Fun and Learning for Women* (Cambridge: Cambridge University Press, 2002), esp. 79–80, 86–95.

14 Following Sant'Orsola's suppression in 1786, significant alterations were introduced to convert the convent for use as a civic hospital, a function it served from 1811 until 1928. In the 1930s virtually all of the complex except for the outer church was demolished. Pastore, 'Testimonianze di monasteri', 477.

15 Now in Mantua's Museo di Palazzo Ducale, this lunette is the only one known to survive from a series of four, all by Fetti, commemorating Margherita's life. Probably executed shortly after her death, they were displayed in the convent's outer church. See Eduard Safarik, *Domenico Fetti 1588/89–1623* (exh. cat.) (Milan: Electa, 1996), 168–9, cat. 41; Bazzotti, 'Margherita Gonzaga', 47–8.

16 Donesmondi, *Dell'istoria*, vol. 2, 428.

17 *Ibid.*, vol. 2, 492–3; Guarini, *Breve naratione*, c. 61v. By 1613 the nuns at Sant'Orsola numbered 35 (Donesmondi, *Dell'istoria*, vol. 2, 493).

18 For a detailed reconstruction and colour reproductions of all five paintings, see L'Occaso, 'Margherita Gonzaga d'Este', 100–116. L'Occaso proves that the copy of Correggio's *La Notte*, traditionally attributed to Lucrina Fetti, was in fact made in 1604 by the Ferrarese copyist, Francesco Naselli, who was probably also responsible for the copy of Caracci's *Lamentation*.

19 Guarini, *Breve naratione*, c. 72.

20 The works by Bononi and Viani are conserved in the Palazzo Ducale in Mantua, while the altarpiece by Caracci, now lost, is recorded by a preparatory drawing now in the Royal Collection at Windsor Castle. For a reconstruction of the outer church's extensive decorative programme, see Bazzotti, 'Margherita Gonzaga', 47–8; L'Occaso, 'Margherita Gonzaga d'Este', 116–17.

21 Giovanni Cadioli, *Descrizione delle pitture, sculture, ed architetture che si osservano nella città di Mantova, e ne' suoi contorni* (Mantua: A. Pazzoni, 1763), 72–6.

22 For a critical evaluation of Cadioli as a source, see Maria Giustina Grassi, 'Spigolature d'archivio sull'attività didattica e artistica del pittore Giovanni Cadioli (1710–1767)', *Atti e Memorie dell'Accademia Nazionale Virgiliana*, n.s. 65 (1997), 105–20.

23 ASMn, Archivio Notarile (A. Pescatori), b. 7110 (hereafter 'Pescatori'). The portion of the inventory that describes the outer church, which lists the three altarpieces as well as 18 other paintings, was published by Bazzotti, 'Margherita Gonzaga', 49–50. By comparison, another inventory of the outer church and sacristy, drawn up in 1728 (ASMn, Ospedale Versamento 2002, b. 2), lists only a handful of paintings, probably because altarpieces were considered 'fixed decorations' and stood outside of that particular inventory's parameters. See Stefano L'Occaso, 'Per la storia di una collezione', in *Quadri, libri e carte dell'Ospedale di Mantova: sei secoli di arte e storia*, ed. Giuliana Algeri and Daniela Ferrari (Mantua: Tre Lune, 2002), 25–31.

24 Pescatori, cc. 110v–111v. Bottani's list was published by Carlo D'Arco, *Delle arti e degli artefici di Mantova*, 2 vols (Mantua: G. Agazzi, 1857–59), vol. 2, 213–215; anastatic repr., Bologna: A. Forni, 1975.

25 Containing a series of grottos and in need of restoration, this oratory was called the 'grotta, o sia luogo di orazione' in Pescatori's 1786 inventory (Appendix, n. 52). For a discussion and photographs, see Pastore, 'La chiesa di Sant'Orsola', 12–17.

26 For a discussion of the problems associated with the use of inventories in the reconstruction of female monastic communities in Renaissance Italy, see Anabel Thomas, *Art and Piety in the Female Religious Communities of Renaissance Italy: Iconography, Space and Religious Woman's Perspective* (Cambridge: Cambridge University Press, 2003), esp. 100–105.

27 Pescatori, cc. 1v, 2.

28 *Ibid.*, cc. 2–2v.

29 *Ibid.*, c. 11v–12. Cadioli attributed this altarpiece, which remains untraced, to Carlo Bononi (Cadioli, *Descrizione delle pitture*, 74).

30 *Ibid.*, 74–6. On Fetti's *Multiplication* lunette, now conserved in Mantua's Museo di Palazzo Ducale, see Safarik, *Domenico Fetti*, 170–77 (cat. 42).

31 Pescatori, c. 3v. In a related example, an early seventeenth-century inventory of the convent of the Carmelites in Brussels indicates that portraits of Archduke Alberto and Archduchess Isabel Clara Eugenia (daughter of King Philip II of Spain), founders and principal patrons of the convent, were displayed in the outer parlour, where they would have been visible to nuns and visitors alike. See 'Liste des objets donnés au Carmel par les fondateurs', in Concha Torres Sánchez, *La clausura imposibile. Conventualismo femenino y espansión contrarreformista* (Madrid: Asociación Cultural Al-Mudaya, 2000), 110. I thank Silvia Evangelisti for this reference.

32 *Ibid.*, c. 9.

33 Mantua, Museo di Palazzo Ducale (inv. 767). The identification of this work with the painting described in Pescatori's inventory was first made by Stefano L'Occaso (L'Occaso, 'Per la storia', 27 n. 12).

34 ASMn, Archivio Notarile (A. Dall'Oglio), b. 3968ter, c. n.n. (hereafter 'Dall'Oglio'). Another copy of Margherita's will is conserved in ASMn, Archivio de Moll, b. 5 (I thank Stefano L'Occaso for providing the reference to this second copy).

35 Cadioli, *Descrizione delle pitture*, 73–4. In 1786 Pescatori (c. 8) similarly lists this as the only painting in the chapel.

36 Munich, Alte Pinakothek (inv. 994). See Emilio Negro and Nicosetta Roio, *Francesco Francia e la sua Scuola* (Modena: Artioli, 1998), 189–92 (cat. 65).

37 Raffaella Salvalai, 'Margherita Gonzaga d'Este e Giuseppina Bonaparte: vicende di un Collezionismo Minore', *Civiltà mantovana*, 3 ser., 116 (2003), 139.

38 Cadioli, *Descrizioni delle pitture*, 74. This portrait of Matilde of Canossa has recently been identified with a work conserved at the Hermitage in Saint Petersburg; see Salvalai, 'Margherita Gonzaga d'Este', 139–40.

39 Pescatori, c. 10.

40 *Ibid.*, c. 10–10v.

41 The title 'stanza detta del lavoriero' suggests that the space may have been used by the nuns to engage in handicrafts such as lace-making or embroidery, an

activity that does not exclude their earlier use as reception rooms by Margherita. If correct, the issue of access to these spaces is important, as visitors were forbidden from passing through parts of the convent used by, or where they might see, the nuns (see note 11 above).

42 Pescatori, c. 8. The Theatines had particular significance for Margherita, who was responsible for introducing the Order to Mantua, and who financed construction of their new church, SS Maurizio e Margherita, which was built by court architect Viani during the same years that he made Sant'Orsola's outer church. See *San Maurizio in Mantova. Due secoli di vita religiosa e di cultura artistica* (exh. cat.) (Brescia: Grafo, 1982).

43 Pescatori, c. 7v.

44 Intra, *Monastero di Santa Orsola*, 23–9.

45 As a point of reference, two years earlier, in 1613, the price of one sack of grain (measuring 103.82 litres) was 580 *soldi*, with one *scudo d'oro* valued at 10 *lire*, 5 *soldi* (where 1 *lira* = 20 *soldi*). Thus, 60,000 *scudi* was equivalent to 12,300,000 *soldi*, enough to purchase 21,200 sacks of grain (information from ASMn, Senato e Supremo Consiglio di Giustizia di Mantova (Banco Vaini), bb. 177, 205, generously communicated to me by Prof. Marzio Romani).

46 Dall'Oglio, c. n.n.

47 *Ibid.*

48 ASMn, Archivio Gonzaga, b. 332, c. n.n.

49 *Ibid.*

50 *Ibid.*

51 For a biography of Caterina, see the *Dizionario Biografico degli Italiani* (Rome: Istituto della Enciclopedia Italiana, 1979), vol. 22, 358–9.

52 '[Caterina] era talmente accesa nel desiderio di questo ritiramento, che dopo la morte del marito, risolve di lasciare affatto il mondo, ed in abito di religioso racchiudersi in un monastero: e prima fece elezione di quello di Santa Orsola in Mantova' (Fulgenzio Gemma, *Ritratto della Serenissima Principessa Caterina di Toscana Duchessa di Mantova e di Monferrato, poi Governatrice di Siena* (Siena, 1630); edn consulted: Florence: B. Paperini, 1737, 290).

53 See, for example, Magdalena S. Sánchez, *The Empress, the Queen, and the Nun: Women and Power at the Court of Philip III of Spain* (Baltimore MD: Johns Hopkins University Press, 1998); *L'art du XVIIme siècle dans les Carmels de France* (exh. cat.), ed. Yves Rocher (Paris: Musée du Petit Palais, 1982), 101–6; P. Renée Baernstein, 'In Widow's Habit: Women between Convent and Family in Sixteenth-Century Milan', *Sixteenth Century Journal*, 25/4 (1994), 787–807. I thank Silvia Evangelisti for these references.

54 Alessandro Bartolini in Mantua to the Medici Court, 14 November 1626 (ASF, MdP 2954, c. n.n., *Documentary Sources*, n. 6024]). This document was first published, acknowledging my discovery of it, by Stefania Lapenta in Raffaella Morselli (ed.), *Gonzaga. La Celeste Galeria: Le Raccolte* (exh. cat.) (Milan, 2002), 213–14 (cat. 60).

55 London, National Gallery (inv. NG15). See Elio Monducci, *Il Correggio: la vita e le opere nelle fonti documentarie* (Cinisello Balsamo: Silvana, 2004), 134–7, cat. 26/A. The London *Ecce Homo* was created in the 1520s for the Prati family of

Parma, where it remained until at least 1657. See Giancarla Periti, 'Correggio, Prati, e l'*Ecce Homo*: nuovi intrecci intorno a problemi di devozione nella Parma rinascimentale', in *Marche ed Emilia: l'Identità Visiva della 'Periferia'. Studi Sulla Cultura e sulla Pratica dell'arte nel Rinascimento*, ed. Pierluigi de Vecchi and Giancarla Periti (Bergamo: Bolis, 2005), 181–213. The curatorial files at the National Gallery in London document many early copies of this painting (including the Gallery's own NG96); further research might identify the copy acquired by Margherita Gonzaga.

56　'Un quadro dipintovi Nostro Signore Ecce Homo, mezza figura, con cornici di violino, di mano del Correggio, stimato lire 120' (Raffaella Morselli, *Le Collezioni Gonzaga: l'elenco dei beni del 1626–1627* (Cinisello Balsamo: Silvana, 2000), 294, no. 959).

57　Alessandro Bartolini in Mantua to Cristina of Lorraine in Florence, 9 December 1626 (ASF, MdP 2954, c. n.n. (*Documentary Sources*, n. 5786)).

58　*Documentary Sources*, nos 6681, 7248 and 7246.

59　*Ibid.*, n. 6031.

60　ASMn, Archivio Gonzaga, b. 332; a copy is also preserved in ASF, MdP 6105, c. 426ff.

61　On Lucrina, see Myriam Zerbi Fanna, 'Fetti, Lucrina', in *Dictionary of Women Artists*, ed. Delia Gaze, 2 vols (London: Fitzroy Dearborn, 1997), vol. 1, 519–21; *eadem*, 'Lucrina Fetti Pittrice', *Civiltà mantovana*, 23–6 (1989), 35–53; and Gladen, 'Women's Monastic Lives', esp. 148–54, 160–84, all of which, however, contain biographical and attributional errors. For some important corrections, see L'Occaso, 'Margherita Gonzaga d'Este', 100–101, 112–14, 117 n. 124. A useful biographical profile of Lucrina's family, especially her brother Domenico, is provided by Eduard Safarik, *Fetti* (Milan: Electa, 1990), 9–25.

62　Her choice of name was probably inspired by the translation to the outer church of Sant'Orsola in May 1614 of the body of Saint Lucrina, together with the remains of three other saints that had been obtained in Rome through the efforts of Margherita Gonzaga. See Guarini, *Breve naratione*, c. 65ff.

63　Significantly, Duke Ferdinando did not pay spiritual dowries for Lucrina's two sisters, who became nuns at another convent in Mantua and were financially supported by their brother Domenico (Gladen, 'Women's Monastic Lives', 152).

64　The first modern scholar to attempt a reconstruction of Lucrina's artistic output was Pamela Askew, 'Lucrina Fetti', in *Women Artists 1550–1950* (exh. cat.), ed. Ann Sutherland Harris and Linda Nochlin (New York, 1976); edn consulted: New York: Knopf, 1984, 125–30. For important corrections, see L'Occaso, 'Per la storia', 29–31; *idem*, 'Margherita Gonzaga d'Este', 110–14, 117. Further research is still needed to establish a secure biographical profile and oeuvre for Lucrina.

65　On Caterina de' Vigri, see Claudio Leonardi (ed.), *Caterina Vigri: la santa e la città. atti del convegno, Bologna, 13–15 novembre 2002* (Florence: SISMEL Edizioni del Galluzzo, 2004); Vera Fortunati and Claudio Leonardi (eds), *Pregare con le immagini: il breviario di Caterina Vigri* (Florence: SISMEL Edizioni del Galluzzo, 2004). A notable exception to the tradition of the unpaid nun-painter was the sixteenth-century Dominican nun-painter Plautilla Nelli, whose works for lay patrons outside of her Florentine convent of Santa Caterina da Siena generated considerable income. See Jonathan Nelson (ed.), *Plautilla Nelli (1524–1588): The Painter-Prioress of Renaissance Florence* (Florence: Syracuse University Press, 2008).

66 Bazzotti, 'Margherita Gonzaga', 47. The high quality of Lucrina's *Saint Barbara* (Strinati Collection, Rome), signed and dated 1619, may indicate participation by her brother Domenico, while Lucrina's *Saint Mary Magdalene* survives only in a poor-quality copy in the Mantuan church of San Martino. For a discussion and reproductions of both, see Zerbi Fanna, 'Lucrina Fetti Pittrice', 39–41, figs 5, 9.

67 Pescatori, published by Bazzotti, 'Margherita Gonzaga', 50.

68 Although some of these works have been cut down, all were originally roughly the same size (210 × 120 cm or 82½ × 47¼ inches). The *Agony in the Garden* and *Visitation* are in a private collection (first identified and reproduced by Zerbi Fanna, 'Lucrina Fetti Pittrice', 37–8, figs 3 and 4); while the *Annunciation* and *Crowning with Thorns* are owned by the Ospedale Carlo Poma, Mantua (reproduced in *ibid.*, figs 1 and 2). The *Adoration of the Shepherds* has been identified in the Mantuan church of Ognissanti (L'Occaso, 'Per la storia', 39, fig. 9), while the *Adoration of the Magi* has been located in a private collection (see *ibid.*, 30, 39, fig. 8; *idem*, 'Margherita Gonzaga d'Este', 117 n. 124). The *Flagellation* and *Road to Calvary* remain untraced.

69 According to Askew, the inscription stands for 'Suor Lucrina Fetti Romana fecit Sant'Orsola' ('Lucrina Fetti', 125).

70 L'Occaso, 'Per la storia', 38–9.

71 It appears that the nuns' inner church contained no works by Lucrina, while the two-part *Annunciation* (Mantua, Museo di Palazzo Ducale, inv. 707 & 708), long attributed to Lucrina and traditionally identified as having been displayed on a landing of Sant'Orsola's main staircase, has recently been assigned to the German painter Karl Santner. For a discussion and illustrations, see Giovanni Rodella (ed.), *I Dipinti della Galleria Nuova* (Mantua: Tre Lune Edizioni, 2002), 78–81 (cat. 12).

72 Mantua Museo di Palazzo Ducale (inv. 6826). The portrait is signed on the back 'Suor Lucrina Fetti romana in S. Orsola, Mantova, ha fatto, 1622', and is a close copy of a portrait of Eleonora by Justus Suttermans now conserved in Vienna. See *Splendours of the Gonzaga* (exh. cat.), ed. David Chambers and Jane Martineau (Cinisello Balsamo: Pizzi, 1981), 242–3 (cat. 273).

73 'Ritratto della Imp. Eleonora Gonzaga, dipinta dalla Fetti, figura in piedi' (D'Arco, *Delle arti*, vol. 2, 213, no. 23). Although D'Arco transcribed this entry as 'dipinta dal Fetti', suggesting authorship by Domenico Fetti, the original manuscript clearly reads 'dalla Fetti', meaning Lucrina.

74 'Ritratto d'altra imperatrice, figura intiera col mondo in mano' (*ibid.*, vol. 2, 214, no. 24). Oil on canvas, 194 × 113 cm (76¼ × 44½ inches), Mantua, Museo di Palazzo Ducale (inv. 6832). For this identification, see Chambers and Martineau, *Splendours*, 242 (no illus.), who note that this painting is a copy of a portrait of Anna d'Asburgo created in 1613 by Jeremias Günther and now conserved in the Kunsthistorisches Museum of Vienna. If correct, it is likely that the copy in Mantua, here attributed to Lucrina, was painted between 1620 and 1625, after the death of Margherita Gonzaga and contemporary with her other portraits of Gonzaga princesses. Alternatively, it has been argued (Askew, 'Lucrina Fetti', 126 n. 22, no illus.) that the Mantuan painting depicts Empress Eleonora, daughter of Maria Gonzaga and Carlo Duke of Rethel, who lived in Sant'Orsola until she married Emperor Ferdinand III in 1651, when her portrait would presumably have been painted. Considering the painting's stylistic proximity to the others attributed to Lucrina, such a late date seems unlikely.

75 'Ritratto della fondatrice del monastero, figura intiera' (D'Arco, *Delle arti*, vol.
 2, 214, no. 25). Mantua, Museo di Palazzo Ducale (inv. 6862). Now erroneously
 attributed to Sante Peranda, this work has also been given to Lucrina by various
 scholars; see Askew, 'Lucrina Fetti', 125 n. 20; Bazzotti, 'Margherita Gonzaga', 47
 n. 14. Stylistically, however, this painting appears unlike other works attributed
 to Lucrina, and is here attributed to 'anonymous Italian' until further research is
 carried out.

76 'Ritratto d'una figura in piedi grande al naturale, con croce in mano,
 rappresentante S. Elena' (D'Arco, *Delle arti*, vol. 2, 213, no. 22). Mantua, Museo
 di Palazzo Ducale (inv. 6864). First attributed to Lucrina by Leandro Ozzòla, *La
 Galleria Di Mantova. Palazzo Ducale* (Cremona: Tip. Ed. Pizzorni, 1949), 31 n. 229.

77 Askew, 'Lucrina Fetti', 126 n. 23, who compares the sitter's features with those
 in Domenico Fetti's portrait drawing of Caterina de' Medici Gonzaga now
 conserved at Oxford, Christ Church Library. For a reproduction of this drawing,
 see Safarik, *Domenico Fetti*, 282 (cat. 84). Alternatively, Stefano L'Occaso (personal
 communication, June 2009), identifies the sitter as Margherita's niece Eleonora,
 resident of Sant'Orsola until her marriage in 1622 to Emperor Ferdinand II. In
 this case, the choice of Saint Helena is appropriate not only because of her name
 (Elena-Eleonora), but because, like Helena, Eleonora Gonzaga was an empress.

78 Stefano L'Occaso, 'Santa Croce in Corte e la devozione dei Gonzaga alla Vera
 Croce', in Filippo Trevisani and Stefano L'Occaso (eds), *Rubens. Eleonora de'
 Medici Gonzaga e l'oratorio sopra Santa Croce: pittura devota a corte* (exh. cat.)
 (Milan: Electa, 2005), 25–32.

Between spiritual and material culture: male and female objects at the Portuguese court, 1480–1580

*Isabel dos Guimarães Sá**

My main purpose in this chapter is to examine the increasing importance of the possession of luxury objects at the Portuguese court during the century that saw the beginning of the early modern period. We owe to Richard Goldthwaite an excellent survey on the changes in demand for luxury consumption in Renaissance Italy.[1] Goldthwaite, however, presents the Italian case as unique and fails to recognize that an explosion of consumer demand for luxury goods was also taking place in other areas of Europe during the same period. In Portugal, the first maritime empire that traded directly with Asia, the appeal of *orientalia* seems to mark the consumer habits of the royal and princely courts to an extent that has little parallel in Europe before the end of the sixteenth century.[2] Goldthwaite also fails to consider the ways in which patterns of consumption varied according to gender. This distinction becomes essential, in particular, when we consider the consumption of devotional objects such as relics, which Patrick Geary considered as sources of supernatural power that could be supplanted by new and more effective forms of authority.[3] Indeed, this might suggest that state-building and the reinforcement of royal authority made relics less significant to Portuguese kings whilst, as I shall try to argue, they remained crucial possessions for women especially if they did not exert political authority.

Portugal did not boast the variety of rival courts to be found in the Italian peninsula in this period, as the latter was fragmented into many different political units. Nor was there the same dispersal of wealth in the hands of several patrician families, as was the case in Italian cities such as Florence. Instead, wealth was concentrated in the hands of royalty and the higher nobility. The patterns of consumption analysed here will therefore be those of various members of the Portuguese royal family, albeit from different branches. I shall compare female modes of consumption and transmission of luxury goods with male ones, aided by some biographical detail.

An aspect that is particularly striking in the Portuguese case is the apparent contradiction between the persistence among the wealthy of ideals of frugality which discouraged conspicuous consumption and associated it with guilt, and the increased demand for luxury objects through which the Portuguese crown expressed its new prosperity. Indeed, the increased appeal of material possessions occurred in a context in which the attitudes to wealth and the life choices of the rich were still inspired by ideals of sobriety and voluntary poverty. The rise in luxury consumption also took place at a time when the Crown was reorganizing charity along new lines, stressing the importance of the 14 works of mercy, uniting small hospitals into bigger ones, and supervising the way in which the bequests of donors were used. It is not accidental in this context that many of the new luxury goods were for religious purposes and thus associated with religious institutions – above all, convents – and sacred spaces. The importance of a lavish liturgical and devotional apparatus seems in fact to support the idea that in this phase the search for comfort held a spiritual rather than a material meaning.[4] Nevertheless, by the end of the sixteenth century, as we shall see, other forms of consumption began to rival the purchase of devotional and liturgical objects, albeit without achieving the same status as the latter.

The consumption of exotic objects and substances originating in Portuguese maritime trade started with commerce on the East African coast, but was to experience a boom after the discovery of the maritime route to India in 1498. This was largely a form of commerce controlled by the Crown: not only was the king the most important merchant of all, but he could dispose of many commodities that were stored in the warehouses of the Casa da Guiné e da Mina or the Casa da India, on behalf of himself and his relatives.[5] Vasco da Gama's voyage to India was followed by a period of prosperity, which ensured the Portuguese Crown a hegemony that was responsible in large part for the advent of the sovereign state.[6] The reign of D. Manuel coincided with this period (1495–1521), but economic wellbeing declined from the reign of his successor, D. João III (1521–57), onwards. I have chosen to end the period discussed in this chapter in 1580, the year in which Portugal became one of the many possessions of Philip II of Spain's composite domain. By then, Portugal's economic prosperity was over; there was no longer a Portuguese royal court and the consumption of imported Asian artefacts was no longer an exclusively Portuguese phenomenon.

Empire, religion and the state in sixteenth-century Portugal

From the religious point of view, Portugal presents features not much different from those that characterize the rest of Catholic Europe in the sixteenth century. The medieval legacy was responsible for the spread of the mendicant orders and their reformed branches, a wide range of confraternities, a view of charity as path to eternal salvation, the diffusion of the belief in Purgatory,

the proliferation of commemorative and votive masses, and the creation of nunneries that attracted women from noble families.

The reign of D. Manuel is held to be a crucial moment in the history of Portugal for several reasons.[7] Several reforms converged into what might be called the creation of the state. Lisbon became the economic centre of the kingdom, as the main arrival point for overseas merchandise. Although not yet a juridical and administrative capital, Manuel I transformed Lisbon. Squares were built, new streets opened upon a radial axis and laws were passed in order to homogenize the buildings and their construction materials. A new royal palace was built, the Paço da Ribeira, whose ground floor was occupied by the Casa da India, where the riches from the Orient were to be stored.[8] Numerous public buildings were constructed, not only in Lisbon but also throughout the whole kingdom, and the king would subsequently give his name to the *manueline* style, as it came to be designated during the nineteenth century. At a rather early date by comparison with other European monarchies, architecture and urban renewal were therefore used, in Portugal, to express the king's magnificence and power.

D. Manuel also undertook a series of initiatives that together served to enhance the power of the state. He overhauled the system of weights and measures, reformed the coinage and ordered a new compilation of laws that were printed and distributed to the municipal councils. He also tried to consolidate the presence of royal judges in some of these, albeit with difficulty.[9]

Moreover, the Crown, more than private initiative, patronized and funded most of the books that were printed after the introduction of the press in the 1480s. Two members of the royal family account for this evolution: king D. Manuel I and his sister D. Leonor (1458–1525), widow of his predecessor D. João II. Both were the patrons of several of the first printed books in Portugal but while D. Leonor sponsored books strictly concerned with spirituality, the king also promoted the publication of juridical books. Nevertheless, some of the titles of the books they owned were the same.[10]

Both the works they sponsored and the books they possessed contain passages that discuss the issue of the right use of wealth, making reference to a spiritual climate where poverty was a pre-condition for salvation, according to the ethos of the mendicant orders. The underlying principle was very simple: material possessions were seen as obstacles to eternal salvation, and the only solution was either to distribute wealth to the poor, or contribute to the glory of God by furnishing the places where his presence was most felt; that is, sacred spaces. St John Chrysostom (CE 347–407) was a key reference: according to his teaching earthly treasures should be placed in Heaven.[11]

Both D. Manuel and his sister innovated in terms of charitable foundations. The Queen founded the first *Misericórdia* of Lisbon, in 1498, while she was acting as regent for her brother the king during his absence, then the latter dedicated himself to the diffusion of these institutions in his domains. Inspired by the Italian confraternities of *misericordia*, the Portuguese *Misericórdias* were

to perform all the 14 works of mercy. As a result of this royal protection, these confraternities were founded on a homogenous basis throughout all the Portuguese territories. At the same time, D. Manuel continued the work of reorganizing charitable institutions initiated by his predecessors. This programme contained different strands: the inventorying of the properties of chantries, confraternities and hospitals to be carried out by royal officers; the creation of large hospitals uniting smaller units and the awarding of juridical privileges and economic resources to these institutions. I have argued elsewhere that this reorganization of charity can be viewed as one of the elements of state-building in Portugal.[12]

As we shall see, however, the transfer of wealth to the poor was overshadowed by investment in sacred objects.[13] D. Leonor invested in an impressive collection of relics, liturgical vestments and jewellery – the latter designed to decorate sacred images of the Virgin and Child – which she either kept with her or donated to the nunnery she founded, the convent of the Madre de Deus. D. Manuel bestowed this same kind of objects to a range of churches, convents and cathedral sees. This striking wave of donations accounts for a gift economy which provided the patron with a source of immediate legitimacy and increased its overall power and authority while allowing the recipient to establish relations of reciprocity which, over time, became increasingly marked by the negotiation of prerogatives by both parties.

It is significant that so much religious gift-giving on the part of the royal family took place during D. Manuel's reign. The reign of his predecessor had been disturbed by conspiracy and treason, in a context in which competition was still rife between the royal family and other powerful family groups. The generous gifts by D. Manuel I seem to have helped consolidate his position, by defining him as the most important donor. Although his successor, D. João III, continued in this vein, nothing indicates that it was as important to his image as it had been to his father's; instead, the king's authority seems by then to have been sufficiently reinforced and no longer so dependent upon gift-giving.

Women's possessions

In this section I shall discuss the possessions of three women, and in particular the large assemblages of sacred luxury items that characterize their property, as revealed by the post-mortem inventories of their goods. I shall start with D. Beatriz (c. 1429–1506), granddaughter of king D. João I, wife to Fernando Duke of Beja (1433–70), brother of king D. Afonso V, and heir to Henry the Navigator's immense fortune as his adoptive son. The couple founded a Poor Clare nunnery, the convent of Nossa Senhora da Conceição in Beja, which Beatriz was to patronize during her long widowhood. She built the chapel inside the convent's church where she, her husband and children would be buried, conveniently endowed with land and liturgical equipment.[14] The

execution of her will, from which we have the proceedings, demonstrates that other objects not included in the contract that founded the chapel were also donated to this convent. It also shows that she donated, although not in the same quantity, liturgical objects to other local convents in Beja, such as the Franciscan monastery of Santo António. On the whole, her donations included the entire panoply of liturgical apparatus, from textiles to silver and books; they also demonstrate an exclusively local investment, since nothing was bequeathed to either institutions or persons living outside Beja. Interestingly, this document also tells us about her secular property and the employees in her service at the time of her death. There was a pharmacy, complete with every possible spice and substance acquired through maritime trade with Asia; some women, including a female slave, were attached to its service, and it employed also a physician and an apothecary. The pharmacy was bequeathed in its entirety to the convent of Nossa Senhora da Conceição, staff included. The duchess also had a taste for exotica that testifies to the fashion typical of the earlier years of Portuguese expansion, when the African coast was being explored. Not only did she have the latest novelties from Asia, including textiles, tableware and spices, but she kept to the tradition of possessing some African commodities such as two civet cats, some round chairs from Guinea and a parrot. She also owned numerous domestic slaves, which at the time were supplied by either Morocco or the East African coast.[15]

Her daughter D. Leonor (1458–1525), widow to the king D. João II (1455–95) and sister to his successor D. Manuel I, seems to have inherited most of her mother's devotion for mendicant piety. Her fortune came second only to that of her royal brother; it included vast dominions as well as lavish rents granted by the king and paid by several customhouses of the realm.[16] Contemporary chroniclers point to her influence in political affairs, due perhaps to a privileged relationship with her brother.[17] In private, she was a pious and sickly woman, her piety being framed by what is generally termed as *devotio moderna*.[18] At least two of the paintings that depict her show her wearing a tertiary garment (that is, the garment of a lay associate of the monastic organization).[19]

Both her acquisitions and patronage testify to the central role that devotion played in her life. She was the founder and main patron of the Mosteiro da Madre de Deus de Xabregas, at the time located just outside Lisbon, by the river Tagus, a convent for a branch of Poor Clares inspired by the Franciscan reformer Saint Colette of Corbie (1381–1447). The nuns of this convent were recruited mainly from D. Leonor's entourage, and belonged to the highest nobility of the city. The Queen invested in this convent from its foundation and was a frequent visitor although her residence at Paço de Santo Eloi was not in the immediate vicinity of the Madre de Deus.

In her palace, D. Leonor seems to have moved between three religious structures that were under her protection: her private oratory, her chapel and the church of the male convent of St John the Evangelist. These three spaces seem to have been arranged according to a hierarchy of proximity to

the queen, and although not all were used exclusively by her, they formed part of her private religious sphere. The importance of the private oratory though, located next to her bedchamber, seems to have been crucial, because the Queen is said to have spent most of her last decades in bed, as a result of chronic ailments.[20] Both occupied the upper floor of her palace, the Paço de St. Eloi, and communicated with the church of the contiguous male convent of the Loios (St John the Evangelist) through a passageway. D. Leonor was the first queen to organize a private worship on a regular basis.[21] During her lifetime, not only parts of her domestic space had been turned into sacred space but the religious space of the convent had been appropriated and became an extension of her domesticity, given that a corridor connected her palace to its church.

Nevertheless, the queen donated most of her possessions to the convent she had founded, the Madre de Deus. She made an impressive list of gifts to this convent, both during her lifetime and in her testament. In particular, the nunnery inherited the whole contents of both her chapel and her private oratory. Twelve years after her death in 1525, an inventory of all the objects given to the convent was drawn up, which listed all the donations made by D. Leonor and other givers.[22] The Queen is by far the most important donor, in quantity and quality of objects. According to the hierarchical order in which they appear in the source itself, these goods consisted first of all of an impressive collection of relics. These included objects from Christ's passion and hairs belonging to the Virgin Mary; bones and personal possessions from 37 different saints; and relics of Old Testament prophets, such as Daniel and Abraham, were also present. The fragment from the spine of Christ was displayed in a reliquary made of gold with six precious stones (see Pl. 18). Among the male saints special mention should be made of St Anthony of Padua and other Franciscans.

The all-encompassing nature of this collection of relics should be noted: the impressive array of objects relating to the early martyrs, the Passion of Christ, the life of the Virgin Mary, and the founders of the mendicant orders suggests an attempt to evoke the most important moments in the history of Christendom.[23] We know that D. Leonor spared no effort to acquire such relics, and some of them attest to her ability to involve her more powerful relatives. The relics of Santa Auta, for instance, were a donation from her cousin the Emperor Maximilian. As it appears from the correspondence between the two cousins, she was to wait anxiously for the arrival of the relics, and the procession carrying them from the boat to the convent would be one of the most important religious events that took place in Lisbon in those years (see Pl. 19).[24]

Silver came second to relics in the inventory: candles, incense spreaders, crucifixes, chalices, etc. Their importance was due both to their presence on the altar and to their role in the Eucharist. Also, silver had a currency that other inventoried objects could not have; that is, in case of need, silver objects were the ones that could be easily sold or melted down. Finally, a vast collection of

liturgical vestments and altar frontals was listed. Textiles from India (damask, etc.) were abundant, together with velvets and other luxury cloths from Northern Europe. The origins of these objects testify to a common pattern: in Portugal during this period textiles for the liturgical apparatus could still be imported either from Flanders or Italy, but became gradually submerged by Asian imports, equally sophisticated but less expensive.

We know that poverty was one of the main concerns of Franciscan monastic life, and the rule inside the Madre de Deus emphasized both contemplative life and the renunciation of the world: it recommended that the nuns should live according to the Gospel, own nothing, be chaste and obedient.[25] Little is known about the material life of nuns and the interiors of the residential sections of the convent; nevertheless, there are doubts that these precepts were respected if we consider that, upon her death, the lavish furnishings of D. Leonor's private religious structures were passed onto the Madre de Deus. The elderly D. Leonor, in accordance with the principles followed in her devout life, chose to be buried in the ground, in the entrance to the cloister, dressed in a black penitential garment of the Franciscan Third Order (her epitaph reads: 'Here is Queen D. Leonor wife to king D. João II, who is the founder of this convent'). This contrasts, however, with the splendid material possessions, later inherited by the nuns, that adorned her private oratory and her own chapel. It can be doubted that she would have been aware of the contradiction between the splendid material possessions she enjoyed in her lifetime and her devout life. She lived like a tertiary, and most of her possessions were related to her devotional motivations, and she may have thought that her wealth was entirely devoted to God.

We can form an idea of the importance attached to her private devotion by considering the objects contained in her personal oratory: these were a collection of religious objects, including 15 altar frontals, 15 silk curtains and 29 *corrediças* (moveable curtains, used to draw over altarpieces), 8 complete liturgical vestments, 231 books (of which many are of devotional nature) and 37 altarpieces.[26]

It is mentioned in D. Leonor's last will that the relics were kept in her *paço* (palace), some being carried on her body and others kept in a chest at the head of her bed. It was also emphasized that the nuns should never disperse any objects she was bequeathing to the convent.[27] The concern with the preservation of her memory was present all along in her will. The location of her burial site, in a very visible spot in spite of its plainness, the concern that her heritage should not be dispersed but entrusted to an institution that would care for it, and the fact that several objects bore her personal device (the shrimping net) testify to a careful staging of her future presence among the living.

From her domestic and private sphere, her possessions were therefore transferred to the convent after her death, adding to other gifts the Queen and other donors had already offered to the treasure of its church. The tradition of making gifts to this convent was not exclusive to Leonor (though

she clearly had an especially close relationship with it): her own brother Manuel gave it two precious altar frontals with liturgical vestments to match. The wife to the next king, João III, D. Catarina de Austria, offered it the same type of gifts as Leonor. She had indeed chosen the same *paço* and its contiguous convent as her living headquarters during the last years of her life. Other than these three royal benefactors, the inventory lists about 30 gifts from other donors, the majority being women, and most of them nuns in the convent.[28] Nor was D. Leonor the only member of the royal family to found a convent and bequeath her personal devotional possessions to it. In particular, D. Leonor was clearly influenced by the precedent of her mother, D. Beatriz, the Duchess of Beja.[29]

Catarina (1507–78), daughter of Philip the Fair and Juana the Mad, arrived in Lisbon to wed king D. João III in 1525, the year D. Leonor died. She was to be one of the world's first owners of a *kunstkammer*, composed mainly of wonder objects she bought in the East through the agency of royal officers in India.[30] Although she continued the tradition of giving liturgical and devotional items to churches and made donations to religious institutions, it is evident that she was also interested in acquiring entirely different objects. What is most significant about Catarina's collection is its lay character and the reduced attraction that sacred objects exercised upon her, offering thus a profound contrast with the concerns of D. Leonor. It can be said that she brought about a secularization of luxury possessions; rather than being incorporated in any private chapel or oratory the purpose of her collection was to signify mastership of the world through objects that few people could obtain: the 'rarer the better' (Pl. 20).[31]

Natural objects were not to be offered for view in their original form. Goldsmiths mounted them in silver or gold, thus effecting their appropriation by the West. Interest in them was thus political rather than scientific. These objects were not to be studied; curiosity and knowledge about them were secondary, because they were meant to represent domination over other lands and peoples. Moreover, many owed their presence in the collection to the magical powers that were attributed to them, such as bezoar stones, said to act against poison (see Pl. 21). Others, like the preciously carved ivory caskets from Ceylon, were admired for their craftsmanship (see Pl. 22). Catarina was also the purchaser of 29 portraits of members of her family, and invested in Flemish tapestries.[32] Her most frequent residence was the Paço da Ribeira, built by D. Manuel I, where women's (and their childrens') lodgings were completely segregated from men's.[33] Specific habits and practices distinguished the female court from the male; seats, for example, varied according to gender: according to the Moorish tradition, women and children would sit on cushions set in a wooden platform covered in carpets; the Queen herself would sit on cushions whilst receiving ambassadors on her own but, during general receptions, when the king was present, she was to sit on a chair beside him under a platform covered by a canopy, whilst the rest of the family sat on cushions.[34]

Queen Catarina exerted considerable influence over her husband's political decisions until he died in 1557, and she sat in his private council on a regular basis.[35] After the king's death she became regent to the throne during the childhood of her grandchild D. Sebastião (1557–62). Her progeny with King João III was marked by failure: all her nine children died either in childhood or adolescence.[36] This, together with the fact that she had been raised in virtual isolation with her mentally disturbed mother at Tordesilhas, suggests that political strategies might not be the only explanation of her collecting habits; they may have had a deep root in 'an impossibility to invest in human relationships'.[37] It is a fact, however, that her collecting interests were radically different from those of Beatriz and Leonor. In Catarina de Austria's lifetime, the fascination with exotic objects from the East – not just luxury textiles – took root in other European courts. In a period in which exotica were considered as *mirabilia*, Asia was not only a source of the exotic, but also a producer of manufactured goods which could display a sophistication that rivalled the best European craftsmanship, and sometimes surpassed it. Earlier on, Catarina's aunt Margaret of Austria (1480–1530), her father's sister and regent in the Low Countries on behalf of her brother Emperor Charles V, had also based her collection on exotica, but not from Asia. She symbolically incorporated the newly founded Americas as a Habsburg domain in a collection of objects brought by Cortès to Europe after the conquest of Mexico: this collection had been offered to her by Emperor Charles V.[38] Catarina's fascination with the East, however, was imitated, both in Madrid and Vienna, by other Habsburgs, such as Philip II, Ferdinand II, Rudolf II and Emperor Mathias, who also brought together a vast array of curiosities from the East.[39] In Portugal, however, Catarina's collection did not have followers, at least in the royal family. Nor did she choose to mention any *mirabilia* in her own will, drawn up in 1574.[40] It is surprising to see that such objects, that she took so many years to collect, are not mentioned in her testament, which is on the contrary careful to list the religious items she left behind.

When compared to D. Leonor, D. Catarina had only a modest number of relics, as well as liturgical vestments, that were divided after her death among several convents and monasteries. Instead of privileging a single convent, as D. Leonor had done with the nunnery of Madre de Deus, she distributed these possessions to various institutions located not only in Lisbon but also in other areas of Portugal and even Castile. A preference for the Jesuits' main church in Lisbon, S. Roque, where the Queen had a chapel built, can however be detected.[41]

As far as her secular collection goes, even if this is not mentioned in her last will, several inventories, drawn up by the Queen's successive chambermaids, list and describe the objects in relative detail.[42] Also, most purchases are known through the considerable number of documents that have survived from her account books. If both inventories and purchase registers had disappeared, the collection would be unknown to us, as it vanished after her death. It was mysteriously dispersed, and little is

known about what became of its contents.[43] Its fate tells of the vulnerability of profane objects: even if the sacred ones were not entirely immune to dispersal or destruction, the survival of the former was more precarious as they did not command the same respect as devotional ones. Also, we do not know how 'public' was the queen's collection; Jordan believes that the objects were not displayed but kept in locked leather chests in one of the three rooms of her private quarters, which were separated from the king's. If this is the case, few people might have known they existed, and thus it became easier to dispose of the 'treasure' she amassed during decades. In 1564, Ferdinand II of Austria gathered together his scattered collections in a central location, prohibiting their sale or future dispersal.[44] That was not the case with D. Catarina: without legal protection, her collection became vulnerable to political instability and financial difficulties.

Different patterns of female conspicuous consumption seem to emerge out of these three cases. The first two women participate in the ideal of voluntary poverty promoted by mendicant convents; their action is mostly confined to the sphere of devotion and to the patronage of religious institutions; their consumer behaviour is mainly directed to the purchase of lavish liturgical goods. D. Catarina would to some extent continue this tradition but, perhaps as a consequence of her familiarity with political power, she would develop considerably her consumer interests to profane precious objects, brought from all the parts of the world where the Portuguese traded. All these women acquired exotic valuables from the areas into which the Portuguese maritime commerce was expanding, but two of them limited their fruition to religious practices and to private or privatized religious spaces; only Catarina accumulated them independently from their religious use. While the transmission of their most valuable possessions had, in the case of Beatriz and Leonor, a circumscribed and eminently local destination, which reiterated their spiritual and patronage ties with a territory and specific religious institutions, Catarina's donations were much more widely distributed throughout the kingdom. Leonor and Beatriz gave special attention to relics, as did D. Catarina, although to a lesser extent. They did so at a time when relics seemed to have lost appeal among their male Portuguese counterparts, at least for private use. We do not know if this feminization of relics is a specifically Portuguese phenomenon, but it points to a context in which women had to rely mainly on devotion to legitimize their authority.[45] Although this hypothesis stills requires further research, no evidence has been found that might connect Portuguese kings of this period to the construction of collections of relics.

Male possessions

Inventories of the material possessions of kings follow a different pattern from those of their female kin. We shall look at two examples of male members

of the Royal family, D. Manuel I, brother to D. Leonor, and his eldest son and heir D. João III, husband to D. Catarina de Austria.[46] The inventories of the goods belonging to the two men gave clear priority to the recording of weapons, armour and riding equipment, with careful note being made of the ones which the king would use on ritual occasions. Neither of the kings participated in any war during their reign, so these items were used mainly in parades and horse games. The interest of King D. Manuel's inventory of 1505 lies mainly in the listing of thematic tapestries from Flanders that were to decorate the walls of the *paços* he would inhabit.[47] Also, it refers to three separate groups of tents which show the itinerant character still retained by the monarchy in this period. The first consisted of four tents which recreated the king's main palatial rooms – one for the *sala* (reception room), another for a chapel, another used as a bedroom and finally one to be used for wardrobe. A second group included ten *tendilhões* (smaller tents). A last group consisted of eight tents 'for the *misericórdia*', with Latin inscriptions on the spiritual value of charity, though the use to which they were put is still uncertain.

D. Manuel's possessions are striking for the limited number of items of furniture: two folding tables from Nuremberg but no chairs or cabinets. We know that beds existed, because the fabrics that decorated them are mentioned, but the inventory only refers to the portable one where the king would sleep inside the tent that was to be used as bedchamber. Only wooden chests were abundant, supposedly to store objects, namely the previously mentioned tents. Another inventory which is dated 1522, and deals mainly with his wardrobe and jewellery, reveals his taste for Moorish garments, weaponry and *orientalia*.[48] Both inventories were related to conquest and discovery: Islamic objects were part of war booty, because military campaigns in North Africa, albeit without the king's presence, continued during his reign. Asian objects were the ultimate novelties from recently discovered Asian territories. One of the most impressive is the monstrance he offered to his newly founded monastery of Jerónimos, a building specifically built to commemorate Vasco da Gama's discovery of the maritime route to India. Also, the object was made with the first tribute in gold paid to the admiral by the inhabitants of Quíloa (East African Coast) in 1506 (see Pl. 23).

The 1522 inventory, produced a year after the king's death, does not include many objects related to devotional and liturgical functions; those seem to have been included in other inventories that were lost. In any case, neither of the remaining inventories mentions relics, nor does the king's last will. D. João III, whose inventory was drawn up in 1534, 13 years after his succession to the throne, showed the same absence of relics. The criteria used in its ranking was different from the 1505 example we have examined, as it listed items according to their material (gold, silver, other metals, cloth), and it mixed together devotional objects with tableware or ceremonial attire for horse-riding. The number of chests and coffers increased, and there were more pieces of furniture, two big tables being mentioned as well as cabinets and chairs.[49]

Both kings actively patronized churches throughout the kingdom. A detailed study of gift-giving by king D. Manuel I is still to be undertaken, although some historians have already referred to the presence of luxury liturgical cloths and precious objects from Asia in his donations.[50] The recipient convents and churches were located not only in the Lisbon area (the Colletine nunnery of Madre de Deus, the Hieronymite convent of the Nossa Senhora da Pena at Sintra, the Augustinian Convento da Graça and also the Igreja da Conceição de Lisboa) but also as far as in the Atlantic islands of the Azores and Madeira, the Moroccan fortresses or India. These gifts were mainly composed of altar frontals, vestments and altarpieces, together with chalices and crosses.[51] D. Manuel had been giving to churches long before he became king: several donations are known to have been made to churches located in areas that belonged to the Order of Christ whilst he was Duke of Beja, and great master of the order.[52] This is not surprising, since one of the duties of its members was to be responsible for the building of churches and the provision of their liturgical apparatus.[53]

D. João III continued the tradition of gift-giving to religious institutions, although those he chose to patronize were not the same as his father's. Among them was the convent of the military order of Santiago de Espada, whose headquarters were in Palmela, a town within easy reach of Lisbon. The liturgical objects listed are similar to those which might be found in any sacristy, but do not include any relics. The date of this inventory is significant, because it was drawn up shortly after its great master D. Jorge died in 1550, and the order became an official property of the Portuguese Crown in 1551. The inventory not only testifies to the importance of the moment in which gifts were given, but also bears witness to the fact that recipient institutions became in turn donors to other churches within their territories. This was the case with worn-out garments from the convent of Palmela: they could be constantly recycled and/or given to smaller institutions, such as the Misericórdia of Alcochete and to several churches of the area.[54]

Nevertheless, recycling or redistribution was not random: some objects were saved from destruction or did not leave the church to which they were given in the first place. The criteria for the choice of such objects deserves some attention: for instance, the church of the Madre de Deus still keeps in the choir most of the relics that are included in the inventories studied for this chapter, as well as other relics that were added later on. Whilst relics were priceless and their exchange value was not subject to commercial considerations, the gold and silver of which many religious objects were made were valued for their weight and could be melted, even if canon law forbade their secular use, determining that they should be converted into other sacred objects.

The abundant offerings to churches and monasteries not only testify to the kings' concern with eternal salvation, but were also made at a time when a new relationship with ecclesiastic institutions was taking shape. The tradition of religious patronage was not new, and it dated back to the Middle Ages; nevertheless, the pace of donations intensified during D. Manuel's reign,

when major changes were taking place that were to greatly strengthen the king's prerogatives in ecclesiastical matters. The Portuguese kings became autonomous in the choice of bishops, whose appointment was to be subject only to the confirmation of the Holy See, and the Military Orders suffered a process of administrative appropriation by the Crown that culminated in 1551 when the king became by right the grand master of the three existing orders: Christ, Avis and Santiago.[55] Of great importance also was the formation of the Portuguese *padroado*, whereby the Crown controlled the evangelization of its overseas territories and sponsored their ecclesiastic structures.[56]

D. Manuel's donations thus belong to a moment when the Crown was engaged in creating a new balance of power with ecclesiastical institutions, and are evidence of the need to establish with them relationships firmly based on patronage. These were to operate also overseas, from where most new confraternities, both *misericórdias* and others, wrote frequently to the king asking for the donation of altarpieces and banners. The king acted as the protector and patron of the Catholic Church in the Empire. Royal gift-giving therefore formed part of a political strategy aimed at securing a new equilibrium in the relationships between crown and church but undoubtedly had also a wider institutional and territorial significance.

Conclusions

The evidence from the analysis of patterns of consumption amongst members of the royal family in Portugal during the sixteenth century points to a gender divide. In a world where women could have power but not authority, religion seems to have been an instrument by which they made their presence felt and achieve some autonomy from men. Whilst men acquired objects that testified to their secular power, such as weaponry and armour, women were more dependent on the appropriation and creation of personal religious spaces in order to establish an identity of their own. Women of the royal family were especially free to dedicate themselves to such initiatives either as relatively young widows – the examples of Beatriz and Leonor – or as heads of a princely female household, which took the form of a separate quarter in the royal palace – in the case of Catarina de Austria. Relics, in particular, appear to have been essential to female modes of devotion. Both D. Beatriz, Duchess of Beja and mother to Manuel I and D. Leonor, D. Leonor herself and, to a lesser extent, D. Catarina, had to search for forms of authority that were subaltern when compared to their male kin, invested as they were with a political authority that the women could not exercise in their own right, except in periods of regency. This is not to say that men did not value relics: in Portugal, several male monasteries possessed impressive collections that dated back to the foundation of the kingdom. The difference is that relics do not seem to have been privately owned by men, but were kept in institutions, whilst the women we have studied owned them individually before bequeathing them to

religious institutions. The two kings whose possessions we have examined – D. Manuel and D. João III – seem to have had little use for relics during the period when the early modern state was coming into being. Both kings, in spite of keeping in touch with the procedures needed to prepare for their afterlife, seem to have developed a material life in which luxury, tied to the staging of chivalric rituals, played an increasingly important part. Secular possessions, in this context, and especially the ownership of marvellous objects from the maritime empire, seem to have had a role in the formation of the emerging state.

Gift-giving by men was both geographically and institutionally broader in scope than that by women. In the case of patronage of ecclesiastic institutions, as we have seen, donations had the purpose to reaffirm the king as the protector of the Catholic Church in the empire. Also, they could play a part in the renegotiation of relations between crown and church, as in the case of the monarchy's new role in relation to the military orders. In either case, the circulation of things from king to Church seems to have served political rather than devotional purposes. Finally, the importance that material possessions had at this time is a useful reminder that charity to the poor, although crucial to the spiritual comfort of the rich and a pillar of state-building, occupied a relatively small place in the minds and budgets of the members of the reigning elite.

Notes

* Research funded by the project Indoors: Domestic Interiors in Early Modern Portugal (PTDC/HAH/71309/2006, Fundação Ciência e Tecnologia, Lisbon.

1 Richard A. Goldthwaite, *Wealth and the Demand for Art in Italy, 1300–1600* (Baltimore MD: Johns Hopkins University Press, 1995).

2 Joy Kenseth (ed.), *The Age of the Marvelous* (Hanover NH: Hood Museum of Art and University of Chicago Press, 1991); Krzysztof Pomian, *Collectors and Curiosities. Paris and Venice, 1500–1800* (Cambridge: Polity, 1990).

3 Patrick Geary, 'Sacred Commodities: The Circulation of Medieval Relics', in *The Social Life of Things: Commodities in Cultural Perspective*, ed. Arjun Appadurai (Cambridge: Cambridge University Press, 1986), 169–91, esp. 178–9.

4 John Crowley, *The Invention of Comfort* (Baltimore MD: Johns Hopkins University Press, 2001).

5 These institutions stored the commodities related to overseas trade, both those intended for local exchange and those brought in the ships. Casa da Guiné e da Mina dealt with exchanges in East Africa, mostly concerned with gold, slaves, pepper, civet cats and ivory. The trade with Asia would diversify the range of luxury products, among them spices, and would be dealt with by a new institution, the Casa da India.

6 On the significance of maritime trade in royal budgets, see Vitorino Magalhães Godinho, 'Finanças públicas e estrutura do estado', *Ensaios II*, 2nd edn (Lisbon: Sá da Costa, 1978), 29–74.

7 The most recent biographer of D. Manuel I is João Paulo de Oliveira e Costa, *D. Manuel I, 1469–1521: um príncipe do renascimento* (Lisbon: Círculo de Leitores, 2005).

On his court see Susannah Carlton Humble, 'From Royal Household to Royal Court: A Comparison of the Development of the Courts of Henry VII of England and D. Manuel of Portugal' (PhD diss., Johns Hopkins University, 2003).

8 On sixteenth-century Lisbon, see Helder Carita, *Lisboa Manuelina e a formação de modelos urbanísticos na Epoca Moderna (1495–1521)* (Lisbon: Livros Horizonte, 1999); Nuno Senos, *O Paço da Ribeira 1501–1581* (Lisbon: Editorial Notícias, 2002); *idem*, 'A Coroa e a Igreja na Lisboa de Quinhentos', *Lusitania Sacra*, 2nd series, XV (2003), 97–117.

9 António Henrique R. de Oliveira Marques and João José Alves Dias, 'As realidades culturais', *in Nova História de Portugal*, ed. Joel Serrão and António Henrique R. de Oliveira Marques (Lisbon: Presença, 1998), vol. V, 447–504. *Idem*, 'As finanças e a moeda', in *ibid.*, 249–76. On royal judges, Maria de Fátima Machado, *O Central e o Local. A Vereação do Porto de D. Manuel a D. João III* (Porto: Afrontamento, 2003).

10 For an inventory of the books they possessed, see Sousa Viterbo, *A Livraria Real especialmente no Reinado de D. Manuel. Memória apresentada à Academia Real das Sciencias de Lisboa* (Lisbon: Typographia da Academia, 1901); and Isabel Villares Cepeda, 'Os Livros da Rainha D. Leonor, segundo o códice 11352 da Biblioteca Nacional', *Revista da Biblioteca Nacional*, 2nd series, 2/2 (1987), 51–81. D. Leonor sponsored the publication, among other books, of Ludolf of Saxony's *Vita Christi*, works by Christine de Pisan, and *Boosco Deleitoso*, an anonymous work concerned with the spiritual path to perfection and contemplative life. The king, in turn, ordered the publication of catechisms and manuals for confession; see D. Diogo Ortiz, *Catecismo pequeño da doctrina e instruiçam que os xpãos ham de creer e obrar pera conseguir a benaventurança eterna* (Lisbon: Valentim Fernandes e João Pedro de Cremona, 1504). Elsa Maria Branco da Silva (ed.), *O Catecismo Pequeno de D. Diogo Ortiz Bispo de Viseu* (Lisbon: Colibri, 2001); and Garcia de Resende, *Breve Memorial dos pecados e cousas que pertencem ha confissam hordenado por Garçia de Resende fidalguo da casa del Rei nosso senhor*, ed. Joaquim de Oliveira Bragança (Lisbon: Gráfica de Coimbra, 1980). On the attitudes towards charity and salvation expressed by this literature see Isabel dos Guimarães Sá, '"Fui em tempo de cobiça": sociedade e valores no Portugal manuelino através de Gil Vicente', *Revista de Guimarães*, 112 (2002), 57–82.

11 His views on material and spiritual wealth were repeatedly quoted in Ludolf of Saxony's *Vita Christi*, and one of his works was published in 1522, translated by António Frei de Beja, *Traducção da Epistola de S. João Chrysostomo* (Lisbon: Germão Galharde, 1522).

12 Isabel dos Guimarães Sá, 'Catholic Charity in Perspective: The Social Life of Devotion in Portugal and its Empire (1450–1700)', *e-Journal of Portuguese History*, 4 (2004) (pdf/html).

13 Other studies suggest that, in spite of the religious rhetoric on charity and voluntary poverty, the money actually spent on charity was far below the investment on a lavish lifestyle and luxurious commodities. See for instance Mary Hollingsworth, *The Cardinal's Hat. Money, Ambition, and Everyday Life in the Court of a Borgia Prince* (London: Profile Books, 2004). The recent publication of the documents concerning the will and its execution of archbishop of Braga D. Diogo de Sousa also demonstrate higher household expenditures than post-mortem donations to the poor. This archbishop was a court nobleman to whom D. Manuel entrusted the kingdom's most important diocese in 1505. See 'Testamento de D. Diogo de Sousa com os documentos da publicação e execução do mesmo', in Rui Maurício (ed.), *O Mecenato de D. Diogo de Sousa Arcebispo de Braga (1505–1532). Urbanismo e Arquitectura* (Leiria: Magno, 2000), vol. 2, 305–480.

14 See Instituto dos Arquivos Nacionais/Torre do Tombo (henceforth IAN/TT), Gaveta 16, maço 1, doc. 24, 'Contrato que se fez com o mosteiro da Conceição de Beja, a respeito da instituição de capela da infanta D. Beatriz' (1510.02.18). Since the creation of a chapel was a contract, it should have been celebrated while she was alive. As she had died in 1506, it took her son's intervention to legitimize it.

15 The testament of the *infanta* is not known, but the proceedings of its execution have been published by Anselmo Braamcamp Freire, 'Inventário da infanta D. Beatriz 1507', *Arquivo Historico Português*, 9 (1914), 64–110.

16 Her life and property are well known thanks to the work of Ivo Carneiro de Sousa, *A Rainha D. Leonor (1458–1525). Poder, misericórdia, religiosidade e espiritualidade no Portugal do Renascimento* (Lisbon: Fundação Calouste Gulbenkian, 2002).

17 *Crónica do Felicissimo Rei D. Manuel composta por Damião de Góis. Nova edição conforme a de 1566*, 4 vols (Coimbra: Universidade, 1949); and Garcia de Resende, *Crónica de D. João II e Miscelânea* (Lisbon: Imprensa Nacional, 1973) [1533].

18 *Devotio moderna* was a religious movement of the late Middle Ages that originated in the new demands of the laity concerning spirituality, inspired by mendicant devotion. Devout practices were based on the imitation of Christ, penance and prayer. Also, as never before, it witnessed the participation of a large number of women.

19 Lisbon workshop, '*The Arrival of the Relics of Santa Auta at Madre de Deus*', c. 1517, oil on panel 70.5 × 76 cm (27¾ × 30 inches), Museu Nacional de Arte Antigua, Lisbon, inv. 1462 B; Anonymous Flemish, '*The Panorama of Jerusalem or Christ's Passion*', c. 1500, oil on panel 200 × 200 cm (78¾ × 78¾ inches), Museu Nacional do Azulejo, Lisbon.

20 Garcia de Resende, *Crónica de D. João II*, 254.

21 Carneiro de Sousa, *A Rainha D. Leonor*, 176.

22 Biblioteca Nacional de Lisboa (henceforth BNL), cod. 11352, *Relações de bens legados pela rainha D. Leonor e outros inventários do mosteiro da Madre de Deus de Xabregas, 1537–1557(?)*.

23 It should be noted that by the time the inventory was drawn up some confusion had affected the collection, as by then many bones and other objects had lost their *nominae* and thus the reference to the holy characters they belonged to.

24 See IAN/TT, Fundo do Convento da Madre de Deus de Lisboa, docs 13 (1517.04.08), which includes the emperor's letter, in Latin, and its translation, in what seems to be D. Leonor's handwriting, whilst doc. 14 is a letter inquiring about the whereabouts of the relics, whose arrival was anxiously awaited (1518.05.19). On the procession see Kate J.P. Lowe, 'Rainha D. Leonor of Portugal's Patronage in Renaissance Florence and Cultural Exchange', in *Cultural Links between Portugal and Italy in the Renaissance*, ed. Kate J.P. Lowe (Oxford: Oxford University Press, 2000), 225–48.

25 Statutes of the Colletine Order prescribed, among other rules, that their personal wealth should be distributed to the poor. See IAN/TT, Manuscritos da Livraria, n. 1077, *Estatutos de Santa Coleta, sobre a regra de Nossa Madre S. Clara*.

26 Carneiro de Sousa, *A Rainha D. Leonor*, 831 and 178. IAN/TT, Chancelaria D. João III, Livro 44, fl. 68 (1538.05.20). This document quantifies but does not describe

the items. Among them, there were 40 pieces of silver weighing approximately 12.5 kilos, 4 golden ones weighing about 200 grams. An inventory of part of her books demonstrates that most of them were devotional (Cepeda, 'Os livros', 51–81).

27 In Abílio José Salgado and Anastácia Mestrinho Salgado, *O Espírito das Misericórdias nos Testamentos de D. Leonor e de Outras Mulheres da Casa de Avis* (Lisbon: Ed. da Comissão para os Quinhentos Anos das Misericórdias Portuguesas, 1999), 26.

28 BNL, cod. 11352.

29 Both Leonor's parents, Beatriz and Fernando, belonged to the royal family: they were first cousins and both grandchildren of king D. João I. Upon her husband's death in 1470, Beatriz held considerable power, not only due to her land dominions, but also to the control of the Order of Christ in the hands of her underage children. The connection with Isabel the Catholic, her niece, made her an essential element in the relations between Portugal and Castile.

30 D. Catarina is held to have owned the largest collection of non-European objects before the mid-sixteenth century. See Annemarie Jordan, 'Portuguese Royal Collecting after 1521: The Choice between Flanders and Italy', in Lowe, *Cultural Links*, 281. Also by this author, 'Portuguese Royal Collections (1505–1580): A Bibliographic and Documentary Survey' (MA thesis, George Washington University, 1985); and 'The Development of Catherine of Austria's Collection in the Queen's Household: Its Character and Cost', 2 vols (PhD diss., Brown University, 1994).

31 Rudolf Distelberger, '"Quanta Rariora Tanta Meliora", The Fascination of the Foreign in Nature and Art', in *Exotica. The Portuguese Discoveries and the Renaissance Kunstkammer* (exh. cat.), ed. Helmut Trnek and Nuno Vassallo e Silva (Lisbon: Calouste Gulbenkian, 2001), 21–5.

32 Jordan, 'The Development of Catherine of Austria's Collection', 7–14.

33 Boys would leave the womens' quarters during adolescence, but girls would stay. Senos, *O Paço da Ribeira*, 120–22. A foreign visitor to the Portuguese court remarked that men could only present themselves at the threshold of the women's apartments, in which daughters of the royal family were expected to keep to the company of their mothers and sisters, as well as their very young brothers. Giuseppe Bertini, 'The Marriage of Alessandro Farnese and D. Maria of Portugal in 1565: Court Life in Lisbon and Parma', in Lowe, *Cultural Links*, 56.

34 Jordan, 'The Development of Catherine of Austria's Collection', 67.

35 Ana Isabel Buescu, *Catarina de Austria. Infanta de Tordesilhas, Rainha de Portugal* (Lisbon: Esfera dos Livros, 2007), 250–57.

36 One of the children who lived to be 16 years old was the posthumous father of the heir to the throne, king D. Sebastião, who was raised by his grandmother Catarina de Austria. Maria (1527–45) was 18 when she died as the first wife of Philip II, whom she wed in 1543.

37 Jean Baudrillard, 'The System of Collecting', in *The Cultures of Collecting*, ed. John Elsner and Roger Cardinal (London: Reaktion Books, 1994), 11.

38 Deanna MacDonald, 'Collecting a New World: The Ethnographic Collections of Margaret of Austria', *Sixteenth Century Journal*, 33/3 (2002), 649–63.

39 Helmut Trnek, '*Exotica* in the *Kunstkammers* of the Habsburgs, their Inventories and Collections', in Trnek and Vassallo e Silva, 39–67.

40 Her testament is dated 1574, but a codicil was added in 1577, just before her death in 1578 (see Salgado and Salgado, *O Espírito*, 1999).

41 In Salgado and Salgado, *O Espírito*, 1999, 122–3.

42 IAN/TT (Inventario de móveis, vestuário, tapeçarias e utensílios vários) (séc. XVI), Casa Forte, n. 64; (Receita das jóias, peças de ouro e prata da Rainha D. Catarina), 1528, Núcleo Antigo, n. 790; Núcleo Antigo, n. 791 (1534); (Receita do móvel e jóias da Rainha D. Catarina), 1539–43, Núcleo Antigo, n. 792; Núcleo Antigo, n. 754 (1545); Rol de várias despesas de compra de trastes, Núcleo Antigo, n. 932; Livro da Receita de todas peças de ouro … (1545), Núcleo Antigo, n. 793; Livro da câmara da Rainha Nossa Senhora da receita de pedraria … (1550), Núcleo Antigo, n. 794.

43 Annemarie Jordan speculates that some of the objects were stolen by D. António Prior do Crato, a contender for the throne of Philip II, in order to finance military action against the Spaniards (Jordan, 'The Development of Catherine of Austria's Collection', 67). Others were taken to Castile when Philip II visited Lisbon in 1580.

44 Thomas DaCosta Kaufmann, 'From Treasury to Museum: The Collections of the Austrian Habsburgs', *The Cultures of Collecting*, ed. John Elsner and Roger Cardinal (London: Reaktion Books, 1994), 137–54.

45 Evidence concerning Philip II's collection of relics points in the opposite direction, as this king tried to construct political unity through the assemblage of religious objects from his kingdoms, even at the expense of bitter local opposition. See Guy Lazure, 'Possessing the Sacred: Monarchy and Identity in Philip II's Relic Collection at the Escorial', *Renaissance Quarterly*, 60 (2007), 58–93.

46 João Martins da Silva Marques, 'Armas e Tapeçarias Reais num inventário de 1505', in *Congresso do Mundo Português* (Lisbon: 1940), vol. V, t. III, 557–605; Anselmo Braamcamp Freire, 'Inventário da Guarda-Roupa de D. Manuel I', *Archivo Historico Portuguez*, II (1904), 381–417.

47 D. Manuel would have at his disposal several *paços*, either in Lisbon or in the kingdom. He abandoned the one of Alcáçovas for the construction of the Paço da Ribeira, as we have seen, but would often go to the palace of Santos, a summer retreat by the Tagus just outside the city. This inventory from 1505 refers explicitly to its chapel and oratory, but we do not know if the other items refer only to this *paço*. For an overview of the palaces used by the royal family until 1580, see Jordan, 'Portuguese Royal Collections', 9–30.

48 In Freire, 'Inventário da Guarda-Roupa'.

49 Anselmo Braamcamp Freire, 'Inventário da casa de D. João III em 1534', *Archivo Historico Portuguez*, VIII (1910), 261–80 and 367–90.

50 Nuno Vassallo e Silva, 'Precious Objects and Marvels: The Goa–Lisbon Trade', in Trnek and Vassallo e Silva, 27–37; Pedro Dias, *Arte Indo-Portuguesa* (Coimbra: Almedina, 2004).

51 Some examples of these many donations are: IAN/TT, Corpo Cronológico, I-16-37 (donation to the monastery of Penha Longa, 1514.10.14); I-15-83 (donation to the Conceição, 1514.07.06); I-15-70 and I-15-86 (donations to churches in

the island of Faial, in the Azores); I-15-17 (donation to a church in Mazagão, 1514.08.08); I-15-119 (donation to the Misericórdia of Aveiro, 1514.08.26) and I-17-91 (donation to a church in Calecute, India, 1515.03.07).

52 Donations were made between 1489 and 1494, the year before he became king. See IAN/TT, Gaveta 7, maço 18, doc. 1.

53 Isabel L. Morgado de Sousa e Silva, 'A Ordem de Cristo (1417–1521)', *Militarium Ordinum Analecta*, 6 (2002), 118.

54 IAN/TT, Mesa de Consciência e Ordens, *Livro da Prata Ornamentos de Santiago deste Convento de Santiago da Espada, Anno 1555*.

55 Fernanda Olival, 'Structural Changes within the 16th-Century Portuguese Military Orders', *e-Journal of Portuguese History*, 2/2 (2004) (pdf/html).

56 Isabel dos Guimarães Sá, 'Ecclesiastical Structures and Religious Action', in *Portuguese Oceanic Expansion, 1415 to 1822*, ed. Francisco Bethencourt and Diogo Ramada Curto (Cambridge: Cambridge University Press, 2007), 257–9.

The reception of garland pictures in seventeenth-century Flanders and Italy

Susan Merriam

When Antwerp citizen Sara Schut passed away in 1644, she left behind over 100 paintings including landscapes, banquet pieces, still lifes, paintings of the Virgin, scenes from Ovid, and a Brueghel flower piece 'with butterflies on a white ground'.[1] Less familiar than these pictures to modern-day viewers, but well known to seventeenth-century art patrons, was item 12 on the inventory, a 'flower garland with an Our Lady picture'. The picture described is a so-called 'garland painting', a type of image in which a richly painted wreath encircles another, usually devotional, image. The first known garland painting was commissioned by Milanese Archbishop Federico Borromeo from Flemish painter Jan Brueghel in about 1607–1608 (Pl. 24).[2] Working in a collaborative process that had become common in seventeenth-century Flanders, Brueghel enlisted figure specialist Hendrick van Balen to help him complete the work. Each artist executed the portion of the picture in which he was most skilled: Brueghel created the lush wreath and van Balen painted the devotional image in the centre. Such collaborative execution would become a defining characteristic of the garland pictures and, with few exceptions, most garland paintings produced during the course of the seventeenth century followed the Brueghel–van Balen collaborative paradigm.[3] The painting created by the two artists seems to have pleased Borromeo, and eventually he owned at least two others like it.[4]

An important figure in the Catholic Reform movement, Borromeo was both personally and professionally invested in defending the cult of images that had come under attack during the Protestant Reformation. At different points during the sixteenth century, Protestant reformers had critiqued Catholic image practices as idolatrous and wasteful. Miracle-working images drew particularly vitriolic attacks from Protestant reformers who argued that the purportedly divinely made images were in fact mere things produced by human hands.[5] These charges were addressed at the Council of Trent, which issued a series of proscriptions concerning cult images. Borromeo

was one of many clerics (including his famous uncle, Carlo Borromeo) who wished to educate Catholics in the proper production and use of images following Trent's dictates. Borromeo appears to have been eager for the garland paintings to function as a new kind of devotional picture within this context: on a basic level, the garland pays tribute to the very type of cult image the Catholic reformers were attempting to protect.

Borromeo might have been surprised had he witnessed the popular reception of the garland paintings in the Flemish domestic interior, but in fact his decision to commission the first painting from a Flemish artist almost guaranteed this outcome. Borromeo was unusual for an Italian patron in that he was equally attracted to both Italian and Flemish painting.[6] Indeed, while many of Borromeo's Italian compatriots dedicated their highest praise to the monumental history paintings for which Italian painters were well known, Borromeo revelled in the lavishly detailed, carefully observed landscapes and still lifes produced by Flemish artists like Brueghel.[7] Because Italian patrons were not powerfully drawn to Flemish still life painting in any encompassing sense, the garland pictures had no natural audience in Borromeo's country. Another obstacle to the paintings' Italian reception lay in their collaborative production. While collaboration between master still life and figural painters – a practice that produced the garland paintings' distinctive aesthetic – was widespread in Antwerp, it was relatively unknown in Italy. Thus, by virtue of their style and execution, the garland paintings were unlikely to have found a very receptive audience among Borromeo's peers. And in fact, the pictures have almost no reception outside Antwerp and the Spanish Habsburg dominions.[8]

The garland paintings' reception in Antwerp tells an entirely different story: less than a decade after Brueghel produced the first garland picture for Borromeo, the artist was creating garland pictures in collaboration with other Flemish painters in Antwerp.[9] Even at this early stage in the pictures' development, Brueghel and his collaborators were transforming Borromeo's model. Brueghel created a series of images in which the floral garland was changed to a fruit wreath, for instance, and his collaborators depicted (in addition to the Virgin and Child) the Holy Family, and mythological figures in the wreaths' centres.[10] By virtue of their subject matter and size, most of these paintings appear to have been intended for use in the domestic interior.

A little over two decades after Brueghel executed the first garland picture, Daniel Seghers, Brueghel's student and a lay Jesuit, began producing garland pictures in collaboration with other artists.[11] Seghers created dozens of garland paintings and became recognized as the second most influential garland painter after his teacher. According to a document drawn up in the eighteenth century, almost all of Seghers' paintings were given away, primarily to friends, family, important ecclesiastics and political figures.[12] By the mid-seventeenth century, garland paintings (or variations on the form) were being produced by a number of painters, most notably Jan Davidsz. de Heem and Frans Snyders.[13]

In addition to appearing in the domestic interior, the garland paintings were pictured in the space of painting itself – represented in the so-called 'gallery pictures' popularized in seventeenth-century Antwerp (Pls 25 and 26).[14] Gallery pictures show the interior of a well-appointed home in which a variety of paintings and objects are on display. The gallery pictures possess enough convincing details, including the leaded mullion windows, ceiling beams, and paintings recognizably in the style of contemporary artists, to suggest that they might actually document how works of art were displayed in a Flemish home such as Sara Schut's. Indeed, once we have encountered the gallery pictures, it becomes difficult to read a period inventory without envisioning the modes of display they represent. But the gallery pictures are complex pictorial fictions, and the frequent display of garland images in them is not a record of actual practice.[15] Rather, the gallery pictures are a re-imagining of the way paintings and other works of art were displayed in the Flemish interior, which in turn constitutes yet another reception of the garland images. In other words, because the gallery pictures are fictions, they allowed artists to construct narratives about the images they represented. The garland pictures' prominent display in this context suggests that artists were constructing a specific narrative about this new kind of devotional picture. This specific narrative can be said to constitute a pictorial reception of the images.

The garland paintings emerged and became popular during a complex moment in the history of private devotional practice. In the late sixteenth and early seventeenth centuries, investment in private art collections was growing; at the same time, the Catholic Church had compelling reasons to monitor the use of devotional images in both public and private space.[16] Because the garland paintings were displayed in a variety of environments, they offer a striking case study of the devotional image as it was imagined, produced and encountered during this period. I am interested in how the form and meaning of the pictures changed according to their context. In particular, I want to examine how the garland picture – a type of image first used by a cleric with a nuanced understanding of Catholic image theory – was transformed in the domestic interior. Therefore, although some garland paintings did find their way into Flemish churches during this time, I will focus on the middle-class home.[17]

In attempting to illuminate how the pictures were used in a range of spaces I begin by looking at the role they played in Borromeo's Ambrosiana. I argue that while it is true that the garland paintings were linked in fundamental ways to contemporary Catholic ideas about image reform, it is also true that they possessed formal qualities linking them to contemporaneous trends in collecting, specifically the curiosity cabinet. I then follow the images to Flanders, and examine their use in the Flemish middle-class home. Using inventories and the images themselves, I consider how the paintings were displayed in the domestic interior. Additionally, I show how artists and patrons often foregrounded the 'curious' – particularly *trompe l'oeil* – aspects of the

garland pictures, to the extent that their devotional meaning was substantially changed and in some instances completely obscured. Finally, I look at the display of the garland pictures in the space of painting itself, suggesting that painters understood the 'curious' aspects of the garland paintings, and highlighted these characteristics in the space of representation.

The garland pictures in the Ambrosiana

In pursuit of his goal to educate Catholics about appropriate image use, Borromeo wrote two books on the visual arts – *De pictura sacra* (1624) and *Musaeum* (1625) – and founded the Ambrosiana (Milan), an institution encompassing a library, art academy and art museum. The Ambrosiana served as a kind of 'think tank' for the Catholic reform movement: scholars of sacred texts and the Catholic Church researched these subjects in the library, young artists learned the finer points of producing reform art at the academy, and the museum served to educate both young artists and the public alike about the types of art Borromeo believed appropriate to the aims of the Catholic Church.[18]

The garland pictures played a role within the context of the museum as it was used in Borromeo's academy, which brought together contemporary theory concerning arts training with theory concerning the reform of Christian images. Borromeo gained familiarity with current practice in other Italian academies – he had ordered rules from both the Academia del Disegno in Florence and the Carracci Academy in Bologna – and his students followed a typical course of study, including life drawing and copying after other works of art. One exercise assigned to a beginning class, for example, involved drawing the head of the *Laocoon*; a more advanced class was required to produce work after a sculpture by Annibale Fontana. What differentiated the practice of students at the Ambrosiana from that of students at other academies was the variety of superior art works – including the garland paintings – at their disposal, and the emphasis Borromeo placed on using these works for teaching students the Tridentine ideals of historical truth, decorum and decency.

The garland Madonnas exemplified the kind of proper sacred image Borromeo wished to promote in his educational programme in complex ways. On a basic level, the pictures supported the image cult because they represent the Virgin and Child. In the early modern economy of devotional images, pictures of the Holy Mother and Infant Christ (even those of recent vintage, such as the garland paintings) derived value from their connection to earlier miracle-working images of the pair, in particular, the icon believed to have been painted by St Luke.[19] Miracle-working icons proved especially useful to the Church in the aftermath of the Reformation, as they offered divine proof in support of the cult of images. Borromeo's reform aims are reflected in his clear support of this aspect of the Church's image doctrine: he owned a copy of the Santa Maria Maggiore icon, and professed that copies of icon

derivatives – including the garland paintings – partook of some of the power of the original.[20] The garland pictures reiterate this important form, and are thus on one level a validation of it.

The real originality of the garland paintings within the context of the Catholic reform movement, however, lay in their fusion of references to traditional image practices and a sense of historicity with contemporary forms of painting (still life, *trompe l'oeil*) and artistic practices (collaborative execution). The garland paintings were a new type of object, at the same time that they evoked traditional sacred images in their use and form. Indeed, one of the things that made the garland paintings 'new' was the way they self-consciously evoked tradition.

One important tradition – the popular practice of adorning a devotional image with a garland – is directly referenced by the garland paintings.[21] The representation of this practice in the garland paintings works in two ways. On one level, the painted wreath is a tribute to the image depicted in its centre, while on another, the picturing of the garland pays homage to the tradition of adornment itself.

Material aspects of the first garland painting can be linked to earlier cult images and image practices as well. The first garland painting was executed in two parts – the Virgin and Child were painted on a piece of oval-shaped silver, and the still life surrounding the image was painted on copper. Originally, the entire image had been protected by 'a cover ornamented with gold'.[22] Icons had long been constructed from and adorned with valuable materials, precious metals in particular, and while the practice of associating precious materials with devotional objects and images had diminished somewhat by the seventeenth century, Catholic reformers were attempting to revive it.[23] Borromeo's incorporation of gold and silver in his early garland picture seems to address the Church's desire to resurrect this older practice of image adornment. The use of copper can be linked more readily to contemporaneous collecting practices, an issue to which I will return.

While in their layered references to the image cult and older devotional images the garland paintings expressed general aspects of Catholic reform image doctrine, in other ways they represent more specifically Borromeo's Italian context. Borromeo's attraction to Flemish still life and landscape painting was complex, but as Pamela Jones has argued, in an important sense, it was linked to his metaphysics. Borromeo lived during the period of so-called 'Christian optimism', a specific phase of Church reform that celebrated God's creations because they were evidence of his goodness.[24] In 1628, for example, he wrote how he had his room 'ornamented with paintings' and:

… made sure that all of them are excellently done; there is not one vulgar or cheap thing. And the pleasure I take in looking at these painted views has always seemed to me as beautiful as open and wide views (of nature) … Instead of them, when they are not to be had, paintings enclose in narrow places, the space of earth and the heavens, and we go wandering, and making long (spiritual) journeys standing still in our room …[25]

As Jones observes, still life and landscape paintings could function as devotional images within this context because they pictured God-given things. Thus, for Borromeo, the entire image – not just the figures in the centre – could serve as a site for meditation on the divine.

The garland paintings as curiosity images

The set of references evoked by the garland paintings discussed thus far are all consistent with widely understood aspects of the Catholic Reform movement and are reflective of its desire to reform the use of images. Other aspects of the garland paintings must be considered as linked to a different context – the curiosity cabinet.[26] The curiosity cabinet experienced an efflorescence throughout Europe in the sixteenth and seventeenth centuries, and consequently displayed a relatively great deal of individual variation. In general, however, the objects found in the cabinets were characterized by an emphasis on extreme forms of art and nature as well as hybrid forms foregrounding the relationship between *artificialia* and *naturalia*. Indeed, a central question explored in many curiosity cabinets concerned the relationship between things made by nature – coral, nautilus shells, figured stones, misshapen tree limbs – and things crafted by human hands – still life paintings, extraordinarily fine metal work, *automata*.

The seventeenth-century interest in exploring the art–nature relationship reflected a contemporary shift in philosophical debates about the ontological status of things.[27] Around the beginning of the seventeenth century, there had been a shift from classical models insisting on the inferiority of art to nature (because art was derived from nature) to a new model suggesting that art might actually test, and in some cases surpass, nature. This possibility was explored in curiosity cabinets by juxtaposing objects and images that produced discourses about the relationship between nature and artifice. A crystalline rock formation, for instance, posited nature as a creator of form, while *trompe l'oeil* paintings of flowers represented art's imitation of nature. Other objects conflated the creative agencies of nature and art: a painting of mythological figures on alabaster, for example, used the cracks and veins of the stone as landscape elements. Important to recognize is that the discourses about art and nature were also about how things are represented and made.

How might the garland pictures fit into this context? The garland paintings are fundamentally reflective of curiosity culture in the way they explore two types of representation. Widespread discourses about still life painting during the seventeenth century emphasized how artists based their elaborate visual descriptions of natural forms on the close viewing of real flora and fauna. Brueghel made a point of telling Borromeo in one of their exchanges about a still life painting, for example, that the cleric would be pleased by the work in part because 'I … went to Brussels to portray a few flowers from life which cannot be seen in Antwerp'.[28] Although the degree to which still life painters

relied on actual models varied, the wreaths in the garland paintings were at least ostensibly based on the artist's witness of nature. The central picture, in contrast, is an entirely different kind of representation, created not after nature, but after another image.[29]

Another, closely related, way the garland paintings create a 'curiosity image' is through the two artistic styles used in their collaborative execution. The marks made by collaborating artists were of course very different – each painter had developed his own style over time. The resulting stylistic disjunction was often highlighted by the way the specialists approached their subject: still life painters tended to make restrained and in some cases very fine marks, while figure painters such as Rubens worked in what might be termed a more painterly style, characterized by relatively loose brushwork and marks distinct from the objects they describe.[30] The differences between the two styles are thrown into relief by their juxtaposition.

Borromeo was particularly attentive to artistic style – he discussed in *Musaeum*, for example, how Italian and Flemish painting styles each created a particular kind of image.[31] According to Borromeo, what he considered Flemish style – with its emphasis on the description of surfaces and the depiction of variety – was supremely suited to picturing the object world. Italians, whose work was not characterized by the extreme detail found in images created by their Flemish colleagues, were better at depicting emotions, decorum and historical accuracy. In other words, Italian style was preferable for depicting narratives and figures. Borromeo's distinction between styles is important in the context of curiosity culture and the viewing practices it engendered: it suggests that, through comparison of styles, viewers considered the status of things – objects, figures – in relationship to types of representation.

Finally, while the silver and gold used in the first garland painting evoked older practices involving icons, the use of copper for the still life portion of the image evoked another context: copper had become highly valued in the curiosity cabinet because its mirror-like surface enabled painters to produce minute descriptions of objects and the natural world. This interest in detailed observation was related to a contemporaneous aesthetic of the miniature. Painters created images valued for their astonishing display of artisanal skill and novelty, and patrons valued these pictures along with other rarities in their cabinets.[32]

While the Ambrosiana was not a curiosity cabinet, Borromeo frequently responded to Brueghel's work in tones reminiscent of those evoked by the fantastic curiosities found throughout Europe in the seventeenth century. Borromeo delighted in the visual seductions crafted by Brueghel's hand and in the artist's representation of encyclopaedic variety. In *Musaeum*, Borromeo marvelled about Brueghel that 'it also appears that he … wished with his brush to travel over all of nature, because he painted … seas, mountains, grottoes, subterranean caves, and all these things, which are separated by immense distances, he confined to a small space'.[33] Evident in this remark as well is Borromeo's interest in Brueghel's explorations of scale and his ability

to create miniature worlds. This interest is echoed in a comment Borromeo made about Brueghel's famous sketch of a mouse and a rose (Ambrosiana): 'But so that one could also see the mutual contrast of minute things, Brueghel executed on parchment a mouse, some rosebuds and several tiny little animals'.[34] Borromeo's excitement about Brueghel's mimetic skill and his absorption in the artist's manipulation of scale were responses characteristic of encounters with curiosities during this period.

Borromeo's garland paintings emerged within an ecclesiastical context that on many levels must be considered institutional. The Ambrosiana's central goal was to propagate the doctrine of the Catholic Reform movement through the confines of a research institute, museum and academy. Additionally, the garland paintings were shaped to a great extent by Counter-Reformation theories about images. At the same time, however, the garland paintings are a kind of 'curious' image, in the sense that they reflect a curiosity aesthetic and are thus linked to a different set of ideas about images and representation. The curious aspects of the pictures will play an important role in the pictures' Antwerp reception.

The garland pictures in the Flemish interior

Aspects of the garland pictures' use in the Flemish interior can be gauged from inventories as well as the paintings themselves. Antwerp inventories note the appearance of garland paintings in Flemish homes as early as the late 1620s, and by mid-century the paintings are often mentioned.[35] While the inventories are extremely useful, it is important to note that the language used to denote floral garlands in the inventories limits the extent to which we can quantitatively evaluate the garland pictures' use. While in many cases it is clear that the inventory describes a garland painting ('an Our Lady in a flower garland in oil on panel'), in other cases the exact nature of the object described is not clear.[36] An inventory from 1636 lists for, instance, 'a Crucifixion in a flower garland' which could be a three-dimensional crucifix placed in a garland constructed of dried or paper flowers.[37] Finally, the inventories must also be used with care as objects may have been moved around in the process of notation.

Inventories can tell us who owned garland paintings and in what type of home or among what type of objects they might have been found. More specifically, in some instances inventories note how images were displayed.[38] It is common for an inventory to describe how the painting is framed ('in an ebony frame'), for example, and inventories will sometimes state that a curtain hangs over the painting, or that the painting was intended to hang over the fireplace. Jan Baptista Borrekens' (died 1668) inventory mentions a range of displays.[39] In one room, among other works of art could be found, 'against the chimney, a painting, in a carved gold frame ... blooms, painted on copper plate, from velvet Brueghel', four images of the Virgin, 'a large

flower garland with flowers and fruit, van Ykens', 'another picture by Jan Brueghel'.[40] In another room an extraordinary range of still life paintings were displayed: 'on the chimney, a beautiful festoon of flowers and fruits … from Brueghel', 'a flower piece, in a golden frame, painted by velvet Brueghel', 'still another piece, is a wreath, from again velvet Brueghel, with many animals, in-painted with a Mary picture by van Balen, with an ebony frame', and yet another garland 'in the chimney, a painted piece, a festoon of flowers … from Brueghel, the figures from Neefs'.[41] Borrekens was somewhat exceptional in that he owned so many garland paintings, but his inventory does give a sense of the ways paintings were displayed during that time. The inventory notes, for instance, that several paintings hang over fireplaces, that one work is framed in ebony, and that two works have gold frames.

An object's place in the home provides a great deal of information about how paintings and homes were used. Houses in seventeenth-century Antwerp typically located the more public spaces (such as the living and dining rooms) on the lower floors; upper storeys were reserved for more private use.[42] As the lower floors were used for entertaining family and guests, they gave the patron an opportunity to represent his taste and values to an audience, and objects found in these areas took on meaning at least in part by virtue of their relatively public exhibition. The display of garland paintings in these areas suggests that, on one level, they signified the owner's devotion to the Church.[43] In other words, while the family may have used the paintings for religious purposes, the very location of the works in a relatively public space must have also signalled an institutional attachment. Other garland pictures appear to have been found in bedrooms – a 1640 inventory, for example, mentions 'a painting of Our Lady in a flower garland on a panel in a frame' in the room of the deceased person, suggesting that the painting was used for personal prayer.[44] Thus, the work could take on different shades of meaning depending on its placement and audience.

As mentioned above, inventories state that some garland paintings were located above the chimney, an important display area as it was the focal point of the room.[45] Contemporary pattern books provided potential customers with a variety of desirable chimney area display configurations, and as Jeffrey Muller has noted, inventories signalled out the space above the chimney by a distinctive name – works placed here were called '*schouwstuk*' or 'chimney piece'.[46] The fact that the garland pictures were displayed here attests to the high status they were accorded by certain patrons.

To some extent, the placement of the garland paintings over the chimney must have been due as well to the sympathetic fit between the garland pictures – which framed an image – and the fireplace – which framed a space. In this instance, the painting's form can help us flesh out the information supplied by the inventory. The relationship between the fireplace and the painting, for example, was explored through a variation on the original garland picture form, in which *trompe l'oeil* aspects were amplified. A picture by Frans Snyders

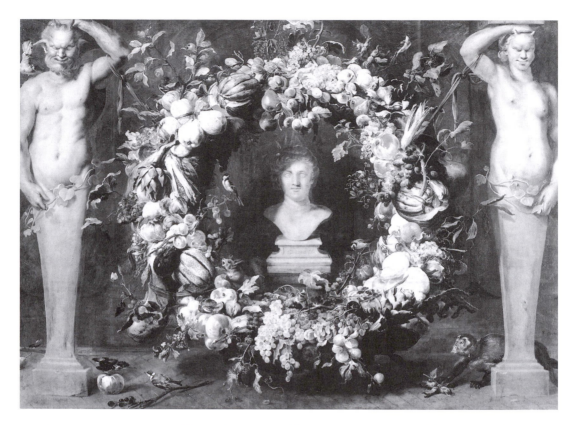

8.1 Frans Snyders, *Still Life with a Bust of Ceres*, c. 1630, oil on canvas, 171.1 × 241.3 cm (67⅜ × 95 inches), Philadelphia Museum of Art, The W.P. Wilstach Collection

now in Philadelphia exemplifies this type (Fig. 8.1). The *grisaille* figures are meant to appear as if they support the mantel, a *trompe l'oeil* trope derived from architectural practice. The space of the fireplace itself is suggested by the recession into depth in the painting (additionally, a fireback can be seen behind Ceres), and the garland, to appear as if hanging from the edge of the actual fireplace.[47]

This relatively decorative variation on the original garland picture can be linked to several reconfigurations of Borromeo's image. Another strong reception of the garland picture playfully manipulated the work's form, changing its basic terms – the wreath and the image – into surprisingly creative variations. An important example of this kind of transformation was the so-called 'floral swag' or 'floral festoon' which extrapolated from the decorative function of the wreath, taking the wreath as subject and framing it. A painting now in Chicago shows how a piece of garland was removed from the wreath, and its *trompe l'oeil* aspects made more pronounced – the form has taken on the heightened realism of *trompe l'oeil*, an effect theatrically emphasized by the inclusion of a fabulously painted curtain, a reference to a story told in Pliny (Pl. 27).[48] Zeuxis, famous for deceiving birds with painted grapes, was outdone by Parrhasius, who painted a curtain so skilfully over one of his pictures that Zeuxis himself was fooled into trying to lift it from the painting. Parrhasius' clever deception was consistently invoked by seventeenth-century still life painters,

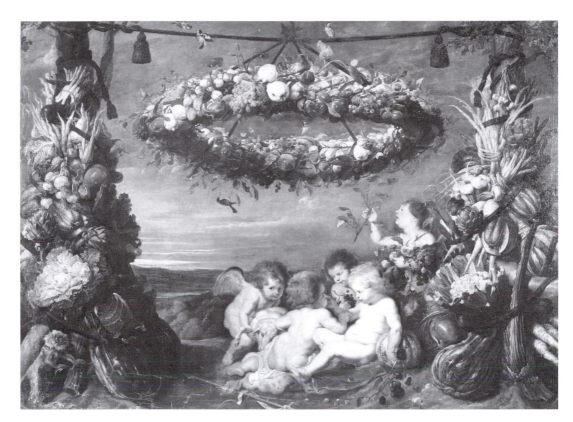

who suggested a link between their genre and antiquity, and who attempted to equal or surpass the famous antique artist's exceptional mimetic skill. It is also worth noting in this context that while we now encounter these festoons as independent images, it is likely that some were used as decorative framing systems. Van Weerden's collection mentioned earlier, for example, mentions '13 pieces of flower festoons' and 'fruit pieces painted around the art collection'.

8.2 Frans Snyders, *The Christ Child with the Infant Saint John the Baptist and Angels,* c. 1615–18, oil on canvas, 198.12 × 266.7 cm (78 × 105 inches), The Fogg Art Museum, Harvard University Art Museums, Gift of James Hampden Robb

Yet another variation on the original garland picture took the form of fruit and vegetable columns supporting a garland suspended between them. Typical is a painting by Frans Snyders now in the Fogg Art Museum (Fig. 8.2). The garland is no longer parallel to the picture plane but, rather, has been placed in the picture so that it encircles the figures of the Infant Christ and St John the Baptist seated below. This variation on the garland picture form alters the *trompe l'oeil* conceit of the original – whereas in the earliest versions the garland was intended to appear as if it was hanging flush with the wall, in Snyders' work, the wreath appears to break the picture plane and extend into our space.

Many of the fireplace pictures, festoons and paintings with fruit and vegetable columns are far removed from Borromeo's first picture in terms of their content. A number of these later pictures show a greater interest in the formal possibilities provided by the wreath–image coupling than in the devotional aspects of the images. This strong reception of the early pictures' form – particularly in relationship to the walls and spaces of the domestic

interior – should not, however, be surprising. The manipulation of the garland picture form in relationship to architecture reiterates an important aspect of the original pictures' composition: on a fundamental level, because the garland paintings represent a painting hanging on a wall, they evoke the relationship between pictorial and architectural space.

Variations on the garland pictures – particularly *trompe l'oeil* images such as the curtained garland collaboratively executed by Adriaen van der Spelt and Frans van Mieris – were produced in an era when an entire discourse had emerged about the marvellous deceits *trompe l'oeil* painting provided. The Dutch art critic Cornelis de Bie, for example, celebrated still life and sometime garland painter Jan Davidsz. de Heem's imitation of nature, so complete that it 'swindled' viewers with its lifelikeness.[49] But while still life painters were lavishly praised for their abilities to best nature, no one was really fooled by these images. Rather, the viewer's excitement was predicated on recognizing the illusion offered by the painting. Indeed, it was the 'seeming real' that entranced viewers – the allure of these pictures derives not from a mechanical replication of the world, but from the transformation of the seen world into a painted surface. In other words, this type of painting asked viewers to think about how things exist in the world, how they are encountered and how they are represented. These issues were explored in nuanced ways in the 'gallery pictures', the garland paintings' second reception.

The garland paintings in the curiosity cabinet

Gallery pictures first emerged in Antwerp in the early decades of the seventeenth century. They remained an Antwerp speciality and were rarely produced outside the city unless by Antwerp emigrés or their students. On one level, the gallery pictures reflect an interest in local artists. Home-grown talents created the majority of the paintings represented, and in several instances paintings that resonated for specific reasons with Antwerp audiences were more prominently displayed than other works.[50] On another level, the gallery pictures speak to issues in visual culture including connoisseurship, collecting and the curiosity cabinet. The garland paintings function in a number of ways in this environment, but I will focus specifically on how they draw attention to aspects of representation and viewing.

The most common type of gallery picture represents a group of paintings, sculpture and objects in a domestic interior. Although these works were created by a variety of artists, they tend to be formally similar: a picture now in the National Gallery, London, exemplifies the type (Pl. 25). Paintings, many of which are in the style of contemporary Flemish painters, line the walls. Well-dressed men discuss a picture on a chair in the centre of the room, while more men gather around a table. They appear to be discussing drawings, maps, cards and scientific illustrations. A Persian rug and sculptures are displayed on a table in the back of the room.

Another, less prevalent type of gallery picture represents a group of objects on a table (Pl. 26). These images typically show paintings and drawings on the wall behind the table, and generally have a space on the right, either open to another room or reserved for a painting that could pass for a window to an exterior view.

Garland paintings appear in the gallery pictures soon after the earliest garland painting emerged in 1608, and are displayed somewhat differently in the full-room and tabletop images. Tabletop pictures tend to draw attention to the garland paintings by placing them on, or behind, the table. In the gallery pictures representing an entire room our attention is also drawn to the garland paintings, as they are always placed somewhere on the edge of the objects represented. In the London image, for example, the garland painting is on the far right-hand side of the room; other gallery pictures display garland paintings on the floor in the centre, or in the back, of the room.[51]

Victor Stoichita has commented on the fact that the garland paintings often appear on the edges of the objects assembled in the gallery pictures.[52] Stoichita notes that the 'inclusion of the "Madonna in a Garland of Flowers" in the "Cabinets of Curiosity" ... bears witness to the process by which the sacred image found a new context in which to exist: the private gallery'.[53] By this Stoichita means that the gallery pictures illustrate how the cult image was integrated into the domestic interior, into a group of paintings and objects of diverse subject matter. His argument is that while 'landscape, still life, and genre painting are "at home" in the domestic interior, the cult picture is a foreign body. It is only by defining itself as an "image aware of being an image" that it can have access to it'.[54] The cult image, according to Stoichita, could be incorporated into a diverse group of art works in the domestic interior only through reframing – by being made into something else. The garland reifies the frame of the religious picture, producing a 'self-aware' image, signalling its changed status. The old cult picture would be out of place in a domestic interior among a group of diverse works of art and objects, as it had been intended for a different purpose – use in church space, or in separate part of the home, set off from works of art.

This argument has at least three problems, it seems to me. First, it makes assumptions about genre that did not exist in the early modern period. As we have seen in the Cardinal's case, for example, pictures could be multivalent – Borromeo meditated on a variety of images including landscape and still life, categories Stoichita seems to ally with 'secular' images. Second, the cult picture had been represented in rooms with other works of art as early as the mid-sixteenth century, that is, well before the emergence of the gallery pictures. Martin van Heemskerck's *St Luke painting the Virgin* (Rennes, Musée des Beaux-Arts), for example, depicts an image of the Virgin and Child within a room filled with antiquities on pedestals and in niches. If one were to speak of a representation prefiguring the entrance of the devotional image into secular space, one must take this type of picture into account. Third, the cult

picture (without a garland) *is* represented in pictures of art galleries. The most famous example is the *Picture Gallery of Cornelius van der Gheest*, in which the Archdukes view the *Madonna of the Cherries* by Metsys.[55]

I would like to offer an alternative interpretation of the garland paintings' role in the gallery pictures: the garland paintings are set apart, or set off, in the gallery pictures because they function as a kind of curiosity object. In other words, the garland pictures' peculiar placement is intended to call attention to their status as special objects. This interpretation seems particularly valid in the case of the tabletop images, where garland paintings are often juxtaposed with objects or images in a way characteristic with curiosity culture – the objects seem to be displayed so as to create comparison between them. In the painting by Francken, for example, one sees the garland picture juxtaposed with a sculpture and a glass beaker filled with flowers (Pl. 26).[56] The three objects are clearly referencing material change and the representation of the holy figure: the sculpture is a three-dimensional representation of the Virgin, metal manipulated by human hands into a form; the painting, a two-dimensional illusion created through the use of oil paint; the flowers, a reference to the Virgin, relatively unmediated, with the *caveat* that their enclosure in glass means they signify differently from completely unmediated nature.

The garland paintings reference a divinely made object – an image not made by human hands – at the same time that they call attention to their own manufacture (through the comparison engendered by their collaborative production). In other words, while their form appears to be relatively simple, the set of associations evoked by the garland paintings is extremely complex and wholly consistent with fundamental aspects of curiosity culture.

This conceptual complexity was always present in the garland paintings. As I pointed out earlier, Borromeo understood how the garland paintings referenced miracle images. Like any Catholic reformer, Borromeo was interested in motivating this aspect of the paintings in support of the cult of images. New in the paintings of curiosity cabinets is the way artists put this aspect of the garland pictures into play with other objects. By locating the paintings in a different constellation, painters suggest that they understood aspects of the garland paintings as they resonated with representational issues in a more general and conceptually complex way. Viewed in this context, the garland paintings are not a late addition to the pictures of collections but, rather, are central to their meaning.

Conclusion

Within the confines of the Ambrosiana, the garland paintings functioned on one level as a kind of prototype for a Counter-Reform devotional picture. Because they evoked traditional Catholic image practices (through the tribute wreath), as well as the devotional image itself, the garland paintings reinforced the emphasis placed on the image cult by the Church during this period. At

the same time, the garland paintings were an attractive new kind of painting reflecting aspects of Borromeo's Milanese context, his personal taste, and contemporaneous practices of making and collecting. The garland paintings could therefore be said to represent an institutional ideal as filtered through a number of lenses: Borromeo's, Brueghel's and van Balen's, and that of the contemporary art world. Thus, while the images were first imagined within the confines of an institution, and with the goals of that institution in mind, the pictures do not reflect institutional aims in any simple way.

The images changed once they were created in large numbers outside the confines of Borromeo's purview. In some cases, these changes were relatively minimal – some collectors clearly intended the images to work as devotional pictures within the private collection, while at the same time the pictures could signal an affiliation with the Catholic Church, particularly when placed in relatively public areas of the home. In other instances, however, the pictures were completely altered and the devotional character of the works was abandoned in favour of their *trompe l'oeil* or 'curious' aspects. Frequently the pictures were transformed so that they were physically linked to the spaces in which they were displayed, as their *trompe l'oeil* elements were put into play with the space of the domestic interior. And while the exploration of decorative and *trompe l'oeil* aspects of the images might have contorted the devotional form as Borromeo understood it, artists' interest in exploring compositional and conceptual aspects of the paintings foregrounds how the garland pictures engage thinking about perception and representation: even in the most decorative of these images, we are asked to consider how images are made, and how we encounter them. In all instances, the garland pictures' transformation suggests the degree to which works of art could shape and be shaped by the space in which they were used. At the same time, the garland paintings assumed a wide range of meanings within seemingly different spaces: Borromeo's first garland painting was representative of institutional aims as well as his aesthetic taste and world view, for example, and the middle-class collector could display a devotional image both with the intention of engaging in private meditational practice, and with the aim of expressing institutional fidelity. The garland pictures thus challenge any simple understanding of the concepts 'institutional' and 'domestic' during this period. Indeed, the ease with which the garland pictures could be mobilized in space to satisfy multiple viewers and produce a range of associations suggests that at least in this instance, and despite the efforts of the Church, the private devotional image was extraordinarily flexible.

Notes

1 J. Denucé, *De Antwerpsche 'Konstkamers': Inventarissen van kunstverzamelingen te Antwerpen in de zestiende en zeventiende eeuw*. Bronnen voor de geschiedenis van de Vlaamsche kunst II (Amsterdam: De Spieghel, 1932), 116.

2 The most comprehensive study of Borromeo's art patronage is Pamela Jones, *Federico Borromeo and the Ambrosiana. Art Patronage and Reform in Seventeenth-Century Milan* (Cambridge: Cambridge University Press, 1993). My analysis in the early portion of this paper is indebted to her research. See also Arlene Quint Platt, *Cardinal Federico as Patron and Critic of the Arts and his 'Musaeum' of 1625* (New York: Garland, 1986); and Clare Coope, 'Federico Borromeo's *Musaeum*' (MA thesis, Courtauld Institute of Art, 1977). For the garland paintings more generally, see David Freedberg, 'The Origins and Rise of the Flemish Madonnas in Flower Garlands: Decoration and Devotion', *Münchner Jahrbuch der bildenden Kunst*, 32 (1981), 115–50. The picture now in the Ambrosiana, Milan, was listed in a codicil to Borromeo's will in 1607 as a painting with an oval in the middle showing a Madonna and Child encircled by flowers. A letter from Brueghel to Borromeo from February 1608 indicates that near the end of 1607, Borromeo asked Brueghel to paint a landscape behind the figures: Brueghel wrote, 'I will not fail to work hard on the little painting of the compartment of flowers in which, according to Your Illustrious Lordship's orders, I will accommodate the Madonna within a little landscape'. Cited in Jones, *Federico Borromeo and the Ambrosiana*, 84.

3 For an introduction to collaboration in Antwerp, see Katlijne van der Stighelen, 'Productiviteit en samenwerking in het Antwerpse kunstenaarsmilieu, 1620–1640', *Gemeentekrediet: Driemaandelijks Tijdschrift van het Gemeentekrediet van België*, 172 (1990–92), 5–15; and more recently, Anne T. Woollett and Ariane van Suchtelen, *Rubens and Brueghel: A Working Friendship* (Los Angeles CA and The Hague: J. Paul Getty Museum and the Royal Picture Gallery Mauritshuis, 2006).

4 Borromeo indicates in the guide to his collection (*Musaeum*, 1625) that he owned three garland paintings by Brueghel and collaborators. Jones, *Federico Borromeo and the Ambrosiana*, 84. Identifying the two paintings Borromeo owned in addition to the Brueghel–van Balen image has been problematized by an exchange of letters between Brueghel and Cardinal Borromeo and his agent Ercole Bianchi. The subject of the letters, a garland painting, has been variously named as the *Madonna and Child in a Garland of Flowers* by Brueghel and Rubens now in the Louvre, inv. no. 1764, and a *Madonna and Child in a Garland of Fruit and Flowers* by Brueghel and Rubens now in the Prado, inv. no. 1418. Evidence seems to point to the Louvre painting having been in the Cardinal's possession. For a review and analysis of the major arguments, see Woollett and van Suchtelen, *Rubens and Brueghel*, 119–20.

5 The reformer Karlstadt, for example, cited a passage from Isaiah in which he recounts how idols were made: 'The idolater burns half the wood in the fire, roasts his meat over it and warms himself: the other half he makes into a god, before which he falls down to worship, calling upon it for deliverance'. Cited in Carl Christensen, *Art and the Reformation in Germany* (Athens OH: Ohio University Press, 1979), 30.

6 Jones, *Federico Borromeo and the Ambrosiana*, 54, 78–84.

7 In *Musaeum*, Borromeo speaks consistently of the excellence of Flemish painters, with special attention given to Brueghel. Brueghel, he says, '[imitated] nature itself not only in colour, but also in talent, which is the highest quality of nature and of art. And if to someone this praise seems exaggerated, let him know that one day the fame of this man will be so great that this praise which I gave to him will seem meagre'. Borromeo's celebration of Brueghel's skill also extended to the diversity depicted by the artist. Borromeo describes a *Series of the Elements* by Brueghel, first noting that '... they are all of marvellous beauty, [and] each

of them stands out for some particular quality'. *Water*'s particular quality, Borromeo writes, is that Brueghel has represented 'so many and such varied kinds of fish as to make one believe him no less skilled at fishing than at painting, and he there collected and disposed in beautiful display every sort of those freaks of nature and refuse of the sea, that are the sea-shells'. Cited in Quint Platt, *Cardinal Federico*, 236–7.

8 In addition to their reception in Flanders, versions of the garland paintings were produced in Spain for a local audience, and for export to the Spanish colonies. See J. Denucé, *Brieven en documenten betreffend Jan Brueghel I en II*. Bronnen voor de geschiedenis van de Vlaamsche Kunst I (Antwerp: de Sikkel, 1934), n. 90, 68–71; and J. Denucé, *Exportation d'oeuvres d'art au 17e siècle à Anvers: La Firme Forchoudt* (Antwerp: de Sikkel, 1931), 31, 41, 98.

9 See most famously the *Madonna in a Flower Garland*, c. 1616–18, by Rubens and Brueghel now in the Alte Pinakothek, Munich, inv. no. 331.

10 For more information on these works see Klaus Ertz, *Jan Brueghel der Ältere* (Cologne: Dumont, 1979), 302–25, 611–17; and, more recently, Woollett and van Suchtelen, *Rubens and Brueghel*, 156–65.

11 An introduction to Seghers can be found in the chapter by Marie-Louise Hairs, in *The Flemish Flower Painters in the Seventeenth Century* (Brussels: Lefebvre & Gillet, 1985), 116–95; see also Fr. Kieckens SJ, 'Daniël Seghers, de la Compagnie de Jésus, peintre de fleurs: Sa vie et son oeuvre, 1590–1661', *Bulletin de l'Academie d'Archeologie de Belgique* (1884).

12 An inventory of these gifts is discussed in Walter Couvrer, 'Daniël Seghers inventaris van door hem geschilderde bloemstukken', *Gentse Bijdragen tot de Kunstgeschiedenis en de Oudheidkunde*, 20 (1967), 87–158. Couvrer used sixteenth- and seventeenth-century literary sources, as well as the inventory, to locate the paintings; this research also served as a check as to the authenticity of the document.

13 For de Heem, see Sam Segal with Liesbeth Helmus, *Jan Davidsz. de Heem en zijn kring* (Braunschweig: Herzog Anton Ulrich Museum, 1991); for Snyders, see Hella Robels, *Frans Snyders: Stilleben- und Tiermaler, 1579–1657* (Munich: Deutscher Kunstverlag, 1989).

14 This genre is discussed in S. Speth-Holterhoff, *Les peintres flamands de cabinets d'amateurs au XVIIe siècle* (Brussels: Elsevier, 1957); and, more recently, in Zirka Zaremba Filipczak, *Picturing Art in Antwerp 1550–1700* (Princeton NJ: Princeton University Press, 1987), 47–72.

15 For a history of the scholarship concerning this issue, see Filipczak, *Picturing Art*, 59, n. 7.

16 See, for example, François Lebrun, 'The Two Reformations: Communal Devotion and Personal Piety', in *A History of Private Life. Passions of the Renaissance*, ed. Roger Chartier (Cambridge MA: Harvard University Press, 1989), 69–109.

17 Here I use the designation 'middle-class' following Jeffrey Muller, who discusses the collections of 'the prosperous and substantial middle-classes – from wealthy merchants and magistrates to humbler professionals, artisans, and lay members of religious orders …' in an analysis of private collecting in seventeenth-century Antwerp: 'Private Collections in the Spanish Netherlands: Ownership and Display of Paintings in Domestic Interiors', in *The Age of Rubens*, ed. Peter C. Sutton (Boston MA: Museum of Fine Arts, 1993), 195.

18 'The Ambrosiana was a public institution legally open to all interested persons. Yet if in theory the Ambrosiana was open to anyone, obviously only the educated elite made use of it; this holds true not only for the library, but also for the museum'. Jones, *Federico Borromeo and the Ambrosiana*, 39.

19 Borromeo used this theory to explain the importance of his own icon copies. Jones, *Federico Borromeo and the Ambrosiana*, 171. For earlier examples, see Maryan Ainsworth, '"A la façon grèce": The Encounter of Northern Renaissance Artists with Byzantine Icons', in *Byzantium. Faith and Power (1261–1557)*, ed. Helen C. Evans (New York and New Haven CT: Metropolitan Museum of Art and Yale University Press, 2004), 545–55. It is also clear from miracle stories in printed books that this notion was propagated throughout Europe in the seventeenth century. Frequently, a tree in which a miracle image had been found would be used to produce 'progeny', which also had the capacity to perform miracles. See Auguste Joseph de Reume, *Les Vierges Miraculeuses de la Belgique* (Brussels, 1856), 167, 547.

20 Jones, *Federico Borromeo and the Ambrosiana*, 85, 122–6.

21 Freedberg discusses this aspect of the images in 'Flemish Madonnas in Flower Garlands', 125–6.

22 Jones, *Federico Borromeo and the Ambrosiana*, 85.

23 An important text on post-Tridentine architecture, art and church furnishings, Carlo Borromeo's *Instructiones fabricae et supellectilis ecclesiasticae*, for example, placed a great deal of importance on the symbolic value of precious materials. Regarding 'shrines, vases, or cases in which holy relics are kept', Borromeo wrote, 'the heads of saints should be enclosed in gold, silver, or gilt-bronze cases', and 'they should be enriched artistically and gilt in accordance with the importance of the relics and in keeping with the means of the church where they are kept'. See Evelyn Carole Voelker, 'Charles Borromeo's *Instructiones fabricae et supellectilis ecclesiasticae*, 1577. A Translation with Commentary and Analysis' (PhD diss., University of Syracuse, NY, 1977; University Microforms, Ann Arbor MI, 1977), 210, 213.

24 Jones, *Federico Borromeo and the Ambrosiana*, 77–84, 89.

25 Cited in *ibid.*, 64.

26 The literature on this subject is enormous; for a good introduction to collections throughout Europe, see Oliver Impey and Arthur MacGregor (eds), *The Origins of Museums: The Cabinet of Curiosities in Sixteenth- and Seventeenth-Century Europe* (Oxford: Oxford University Press, 1985).

27 For a nuanced discussion of this topic, see Lorraine Daston and Katherine Park, *Wonders and the Order of Nature* (New York: Zone Books, 1998), 260–64.

28 Cited in Beatrijs Brenninkmeyer de Rooij, *Roots of Seventeenth-Century Flower Painting* (Leiden: Primavera Press, 1996), 49–50. For an extended discussion of the concept of *naer het leven*, see Claudia Swan, *Art, Science and Witchcraft in Early Modern Holland: Jacques de Gheyn II (1565–1629)* (Cambridge: Cambridge University Press, 2005), 36–65.

29 For a general discussion of these issues see Peter Parshall, '*Imago Contrafacta*: Images and Facts in the Northern Renaissance', *Art History*, 4 (December 1993), 554–79; more specifically, Hans Belting discusses the relationship between the still life as mirror of nature and the pre-existing image ('imago') in Joos van Cleve's *Madonna and Child* from 1511 (now in the Metropolitan Museum of Art,

New York, inv. no. 32.100.57) in *Likeness and Presence: A History of the Image before the Era of Art* (Chicago IL: Chicago University Press, 1994), 474–5.

30 There are of course exceptions: even though Frans Snyders specialized in still life, for example, his brushwork is more akin to Rubens's than that of still life painters such as Seghers and de Heem.

31 Jones, *Federico Borromeo and the Ambrosiana*, 105–7.

32 For an introduction to painting on copper see Michael K. Komaneck (ed.), *Copper as Canvas: Two Centuries of Masterpiece Paintings on Copper, 1575–1775* (New York: Oxford University Press, 1999).

33 Cited in Quint Platt, *Cardinal Federico*, 236.

34 *Ibid.*, 239.

35 See, for example, Erik Duverger, *Antwerpse Kunstinventarissen uit de zeventiende eeuw* (Brussels: Koninklijke Academie voor Wetenschappen, Letteren Schone Kunsten van Belgie, 1984–), 13 volumes. See, for example, vol. 3 (1627–35), 7, 90, 158, 166, 365, 500; vol. 4 (1636–42), 9, 46, 185, 254, 342, 381, 443, 454, 457, 475; vol. 5 (1642–49), 10, 111, 132, 133, 141, 165, 166, 245, 246, 247, 249, 255, 289, 316, 317, 328, 336, 384, 451, 489.

36 *Ibid.*, 1642, 475.

37 *Ibid.*, 1636, 9.

38 *Ibid.*, 1640, 381; 1642, 475.

39 Denucé, *De Antwerpsche 'Konstkamers'*, 252–7.

40 *Ibid.*, 252–3.

41 *Ibid.*, 255–6.

42 For an introduction to the display of paintings in private collections, see Muller, 'Private Collections', 195–206.

43 See, for example, Duverger, *Antwerpse Kunstinventarissen*, 1636, 46; 1642, 454; 1642, 475; 1642, 10; 1644, 265.

44 *Ibid.*, 1640, 381. See also the discussion of a Seghers painting located in Amalia van Solms's bedroom in Peter van der Ploeg and Carola Vermeeren (eds), *Princely Patrons. The Collection of Frederick Henry of Orange and Amalia of Solms in The Hague* (Zwolle: Waanders Publishers, 1997), 208–11.

45 Denucé, *De Antwerpsche 'Konstkamers'*, 252, 256.

46 For decoration see Peter Thornton, *Form and Decoration. Innovation in the Decorative Arts 1470–1870* (New York: Abrams, 1998), 86, 98, 116. Muller discusses the chimney in 'Private Collections', 202.

47 For more on Snyders' pictures in relationship to the fireplace, see Susan Koslow, *Frans Snyders* (Antwerp: Fonds Mercator, 1995), 192–3.

48 This painting was located in a Dutch collection, but is representative of a type commonly found in Flanders. See Pamela H. Smith, *The Body of the Artisan. Art and Experience in the Scientific Revolution* (Chicago IL: Chicago University Press, 2004), 211.

49 Cornelis de Bie, *Het Gulden Cabinet vande edele vry schilder Const* (Antwerp: Ian Meysens, 1661), 217–19.

50 See, for instance, Julius S. Held, 'Artis Pictoriae Amator. An Antwerp Art Patron and His Collection', in *Rubens and His Circle*, ed. Anne W. Lowenthal, David Rosand and John Walsh, Jr. (Princeton NJ: Princeton University Press 1982), 35–64.

51 See, for example, Jan Brueghel and Rubens, *Allegory of Sight and Smell*, 1617–18, in the Prado, Madrid, inv. no. 1394, and Jerome Francken II, so-called *Shop of Jan Snellinck* in the Musées Royaux des Beaux-Arts, Brussels, inv. no. 2628.

52 Victor Stoichita, *The Self-Aware Image* (Cambridge: Cambridge University Press, 1997), 82. Stoichita notes its location at the edge: 'In the early "Cabinets", the presence of this kind of effigy of the Virgin Mary is striking despite the apparent lack of space. It seems to be the collector's latest addition. The degree of contextualization is minimal, one could even say problematic. It is usually found on the extreme right-hand side of the area being depicted, which – as tradition would have it – signifies "at the end".'

53 *Ibid.*

54 *Ibid.*, 88.

55 Discussed at length in Held, 'Artis Pictoriae Amator'. For another example, see Frans Francken the Younger, *Interior of Burgomaster Nicholas Rockox's House*, Munich, Bayerische Staatsgemäldesammlungen, inv. no. 858, in which a diptych representing Christ and the Virgin is displayed in the far right-hand corner.

56 See Joanna Woodall, 'Drawing in Colour', in *Peter Paul Rubens. A Touch of Brilliance,* Stephanie-Suzanne Durante et al. (Munich: Prestel, 2003), 15–16; see also by the same author, 'Wtewael's *Perseus and Andromeda*: Looking for Love in Early Seventeenth-Century Dutch Painting', in *Manifestations of Venus: Art and Sexuality*, ed. Caroline Arscott and Katie Scott (Manchester: Manchester University Press, 2000), 39–68, esp. 60–61.

A home fit for children: the material possessions of Amsterdam orphans*

Anne E.C. McCants

In January of 1741, Elisabeth van Oostrum, a former female charge of the Amsterdam Municipal Orphanage (*Burgerweeshuis*) departed this life. She was unmarried and, at the age of 27, a resident in the household of her older brother and his family. Her possessions were valued at just less than 34 guilders, not nearly enough to cover the costs of her prolonged illness and burial, which totalled over 103 guilders. She had failed to achieve any independent social position during her adult life, and her dismal final accounting was a reflection of this fact. She owned nothing but clothes, four books and a Bible, which was almost certainly the one she had received as part of her standard departure bundle from the Orphanage. This Bible was also her single most valuable possession with an estimated worth of 1½ guilders. (The Orphanage bought its Bibles for distribution to graduating children at an average cost of almost four guilders apiece so clearly this Bible had seen some wear.) On the other hand, she did enjoy a substantial wardrobe by contemporary standards, including seven skirts, five jackets, ten shirts, four pairs of trousers, an overcoat and a nice collection of accessories: sleeves, bonnets, stockings, handkerchiefs, slippers, aprons, a pinafore and even an extra pair of shoes. One full outfit was made of damask, which was most likely the damask suit given to all of the girls by the Orphanage upon their graduation. In any event, the fact that she did not need to acquire basic household goods gave her much more freedom to indulge (if that is the right word) in items for her personal use. Indeed, this is consistent with previous findings for early modern Delft, Paris and much of England, which indicate that within the ranks of the poorest taxpayers it was the single men and women, especially female domestic servants, who had the most diversified wardrobes, much to the distress of their social betters.[1]

So what then should we conclude about Elisabeth's place in her society or about the bumpy trajectory that brought her to her final resting place? Was she impoverished because she had spent time in an orphanage as a

child, lacked an independent social position as an adult, never married or, perhaps most tellingly, failed to acquire enough assets in life to even cover the costs associated with dying? After all, she left her brother (who had also been her benefactor) with a substantial debt of 63 guilders that would never be repaid. She left as well an implicit debt to the Orphanage. Childhood is expensive, and Elisabeth had failed to live long enough to recoup the investment, at least as measured in monetary terms. On the other hand, we might well conclude that Elisabeth had actually managed things reasonably well (given her humble origins and the fact that she happened to die young). After all, she had discretionary income to spend on clothing and accessories for herself, not to mention her unusual access to books. She also demonstrated a remarkable ability to secure medical services. She left at her death unpaid bills for 49 visits from a doctor, a number so unusually high that she must have been on the cutting edge of the commercialization of medicine in the eighteenth century.[2] From this alternative perspective, we might want to see her as an incipient modern consumer whose choices were only cut short by a fatal illness. To complicate matters further, Elisabeth spent her formative years living in an institution rather than in her natal household. As I have argued at length elsewhere, the consumer behaviour and the consequent material environment of an institution, even one intended to substitute for and in many respects mimic the family, manifests itself differently from that of private households. Most importantly, in the institutional setting the agent who makes consumer decisions is not in fact the final consumer of the goods and services purchased.[3] Moreover, the Orphanage was a 'total institution', to employ a concept articulated by Erving Goffman. It provided for every aspect of its inmates' daily needs (food, clothing, shelter and medical care); it alone was responsible for their education, job training and inculcation of social values; and it required their loyalty and respect, over and above what they might already feel to other individuals or groups. Orphans who chose to run away were not greeted with relief (that of having one fewer mouth to feed), but with punishment, most especially to make an example to other children who might be tempted to try escape themselves. The Orphanage, then, was by definition fundamentally incompatible with the familial organization of the rest of society. 'Batch living' insists on its own structures, rules of behaviour and distribution of material resources.[4] To the extent that Elisabeth learned how to become a consumer while in the Burgerweeshuis, concomitant with learning how to read, write, sew, knit and say her catechism, she would have had a rather different sort of training from that which she would have received had she remained at home under the tutelage of parents. Her consumer behaviour, then, as revealed in her final accounting, must be interpreted in the light of all of the (sometimes contradictory) forces at work in her life: the 'consumer revolution' of the eighteenth century, and in particular the proliferation of exotic goods in her home city and international entrepôt, Amsterdam; the

increasing medicalization of illness and disease; the restrictive environment of institutional living; social norms governing the behaviour of unmarried women; and the financial hardships imposed by the loss of parents while at a still vulnerable age.

To make some sense of the resulting conundrum we clearly need more evidence, not only about Elisabeth herself, but about her peers as well. Economic success is enormously difficult to assess in a vacuum. Moreover, this puzzle is about much more than just economic success. A whole host of social and cultural questions present themselves which of necessity complicate the economic analysis. What was important in Elisabeth's life? Was it her marital status (or lack thereof)? Her place of residence? The relationships she had with her brother and his family, or possibly with her own friends? The clothes that she wore? The books that she read (the titles of which are unfortunately lost to us)? Or the choices she could or could not make about how to allocate her resources of money, labour and time? Or was she so burdened by ill health that all the rest of these things receded to the background? We also want to know what meaning Elisabeth attributed to the things in her possession. Was her Bible, or her books more generally, a marker of status in a society which was both pious and increasingly literate? Or was the Bible in particular a durable sign of her former dependence on public charity as a charge of the Municipal Orphanage? Did this material artefact of her past recall her regularly to her duty to pray for her social betters who had so generously ensured her childhood survival in an otherwise harsh urban environment? The answers to these questions depend not so much on the guilder value of the Bible, or any of the other items in her inventory, but on the cultural meanings attached by Elisabeth and her larger society to both the things themselves and to the processes by which they had come into her possession. Her story, when combined with those of others, who like her made up the anonymous majority of Amsterdam's residents, has much to tell us about the material world of a city's most vulnerable residents.

As this discussion has already suggested, however, the snapshot of Elizabeth's material world at death is further complicated by her former residency in the *Burgerweeshuis* in at least two important ways. First, and most obviously, her possessions at death included some items which were clearly given to her by the institution upon her successful graduation from its care. Indeed, graduation served as a critical moment, because it necessitated the retraining of the individual to live successfully outside the institution, after having spent years moulding her or him to live successfully within it. Literally overnight, graduates had to learn to manage their labour time and their consumption on their own, both aspects of their lives which had been entirely overseen for them up to that point by the regents of the Orphanage. Not surprisingly then, graduation rituals from orphanages in the Dutch Republic routinely involved the gifting of material goods, and clothing in particular. At the very least, there had to be clothing to replace the livery-like orphan uniform worn by the children while in residence. This uniform

was itself an essential ingredient for the success of a 'total' institution, as it obliterated differentiation between the inmates, while marking them as utterly distinct from those living outside the walls. Clearly, graduates could not depart from the Orphanage without having new clothing to mark the passage from inmate to urban citizen. Thus, the graduation gift was symbolic as well as functional. In addition to clothing it included a gift of a hat for all of the boys, an essential component of the respectable middle-class adult male wardrobe, some cash (twice as much for boys as for girls in the case of the Amsterdam Municipal Orphanage) and, of course, the Bible already mentioned.

Secondly, and more subtly, Elisabeth's possessions at her death are marked by absence or loss. Whatever possessions Elisabeth had grown up with to the point of her parents' death had been long since alienated. They would have been sold expeditiously to pay off her parents' creditors, and anything remaining after that would have been stored as a cash credit by either the city Orphan Chamber or the Orphanage itself on behalf of Elizabeth and her siblings. Thus, her relatively short life comprised at least three distinct phases in terms of her material possessions and surroundings: the parental home, the institutional home and her final residence as an unmarried boarder in her brother's home. Each of these moments in an orphan's life were characterized by sometimes subtle but potentially extreme differences in material culture, and each transition from one phase to another would have been fraught with risk. It was, of course, this very risk that the Orphanage and other such charitable institutions were intended to mitigate. But it could not be eliminated altogether.

The orphans' household environments

In order to evaluate the multiple material worlds of poor to middling children whose lives were disrupted by the premature death of parents, this paper draws on the extensive household documentation collected in the eighteenth century by the bookkeeper of the Amsterdam Municipal Orphanage (*Burgerweeshuis*) and by the various notaries in its employ. This manuscript material, when combined with the marriage, baptism and burial records of the city archives, allows for the reconstruction of the household circumstances, be they material, financial or demographic, of the families associated with the institution in some form or another. The regents of the Orphanage required that household inventories be drawn up for the estates of all citizen decedents leaving minor children to be cared for at municipal expense. They did this with a view to assessing the ability of those estates to contribute to the costs of maintaining the orphaned children in the institution. The regents also required that inventories be drawn up at the death of former orphans, regardless of whether they had ever married, as long as they did not have surviving children of their own. For unless a childless orphan had

bought out the right (literally called the *uitkoop* or buyout) to name their own heir, the Orphanage had a legal claim to a share of their final estate as well. Thus, the Orphanage held claims against both parents as well as potentially the children themselves when they came to die as adults. This offers the historian a snapshot into the homes of parents raising minor children, as well as into the homes of the institution's own graduates. Over the 42-year period for which inventories have been analysed, 148 former orphans were inventoried, as compared to 708 parents whose death precipitated a new arrival at the institution. (The remaining 56 inventories are accounted for by the deaths of relatives of current orphans who were leaving legacies of one kind or another to those children.[5])

Remarkably, the inventories of 22 former orphans can actually be linked to the inventories of their own parents at death, thereby allowing for the direct examination of the material disruptions to those specific families.[6] For this small sub-sample of the former orphan population then we have the very rare opportunity of evaluating individual-level longitudinal data. Finally, the inventory records also include 11 orphans who died while still resident in the Orphanage, eight of them boys in the late teenage or early young adult years (median age = 19), and three of them older women (median age = 65). The latter had clearly become lifelong residents/employees of the institution. The small number of inventories drawn up on orphans still in residence, despite an institutional mortality profile which would suggest many more deaths of inmates over the four decades under study here, is indicative of the fact that most of the orphans, and seemingly all of the girls, had no personal possessions to even inventory.[7]

What then can this remarkable data tell us about the multiple material worlds of poor to middling orphan children in an early modern urban environment? An answer to this question must begin with what an economist would call a 'comparative statics' exercise. That is, what did each of the successive environments of these children-become-adults contain, and what opportunities for growth, learning, privacy, work and/ or play did they facilitate? We will begin with the *Burgerweeshuis* itself, as that was the one common experience to all of the children, and the easiest to investigate.

The material environment of the Orphanage

The Amsterdam *Burgerweeshuis* was not simply one building, but rather a whole complex of buildings designed to house, feed, clothe and educate between 400 and 900 children between the ages of four and twenty (more or less) at any one given point in time. Social mores dictated that girls and boys had to be fully separated from each other, and young children from their adolescent peers. This meant that each sub-house had to have its own kitchen, dining hall, laundry, workplaces, schoolroom, courtyard, infirmary and, of

course, sleeping quarters. The residential staff of the institution also required separate spaces for their living and eating quarters, while the regents of the Orphanage enjoyed 'front hall' rooms for their business; that is, for holding meetings, admitting new children, bookkeeping and record storage. As all of the inventories made of the *Burgerweeshuis* itself over the centuries make clear, the material possessions of any note (paintings, elegant furniture, exotic objects, silver and porcelain table service, etc. of which there was much) were to be found exclusively in these 'front rooms'.

For the orphans' quarters there was hardly any furniture at all, and nothing decorating the walls. The only visual diversions were to be found in the light streaming in from the windows and in the colourful clothing worn by the children: dresses and trousers/jackets made with vertically alternating red and black bands, the black having been substituted some time in the seventeenth or early eighteenth century for the white in the original city-livery colours of red and white.[8] Most likely, the white proved too hard to maintain and keep clean, while black fabric did not need to be washed nearly so often. Taken altogether, the material world of the institution would have made for a stark contrast with the wider city of Amsterdam, itself the commercial emporium of the whole world during the heady period of the Republic. Indeed, even a more modest comparison with the urban interiors so familiar to us from Dutch genre paintings of the seventeenth and eighteenth centuries suggest a remarkable blandness in the children's quarters, devoid as they were of the otherwise ubiquitous maps, prints, carpets, tiles, pottery, collectibles and other such decoration that dominate depictions of domestic interiors.

To return to the clothing itself, it bears re-emphasizing that it was unique to the inmates of the institution, and would have made an orphan immediately recognizable to anyone outside the institution. All of the orphans had occasion to leave the grounds of the Orphanage every Sunday in order to attend church services, and the older boys on a daily basis for apprenticed work. The distinctive clothing set the children visibly apart from their non-institutional peers with whom they had fairly regular contact. It served as a reminder of place and status for the children wearing it, as well as a salve to the consciences of prosperous burghers who could see their civic good works in action every day. The clothing also served a very practical function, making it easy to identify any child (most often boys) gone astray at the close of the working day. Thus, acquiring alternative clothing was essential to any attempt on the part of an inmate to escape and run away, just as new clothing functioned as the central ritual of graduation. Indeed, to give an orphan street clothing was a criminal offence in the city of Amsterdam, making the acquisition of clandestine clothing especially difficult for the children still in residence. Yet despite the uniform nature of the children's clothing, we do have some evidence which suggests that children might nonetheless have begun to form their own bundle of clothing in advance of graduation. It seems that some additional clothing was allocated to children

as they grew older, a practice particularly well documented for the girls as they could increasingly be responsible for making their own in the sewing or knitting workshops on the premises.[9] Outgrown clothing was either recycled directly to a younger child or, more creatively, the still-good fabric in it turned into a new piece of clothing. Where the children stored their limited clothing remains something of a mystery, but the absence of chests in the inventories of the children's quarters suggests something much less durable – baskets perhaps?

To this picture of almost complete material deprivation (or monotony at the very least) we can add only the information provided by the eight inventories drawn up for boys still in residence at their deaths. Table 9.1 at the end of this chapter presents a list of all the goods found in these eight inventories, along with the number of boys who had at least one of that item in their possession. The last column reports the total number of individual items enumerated, summed across all of the inventories.

Several things are noteworthy about this list. First of all it includes only small items, most often clothing accessories such as buttons, ties, sleeves, borders, clasps, etc., and the occasional small item of personal use such as a case, a snuffbox or a brush. All eight of the inventoried boys owned both buttons and buckles, while only one inventory reveals decorative objects of any kind with a small collection of two drawings and two prints. Moreover, all but one of the inventories also includes a small amount of cash, leaving us to wonder if that were almost a prerequisite for having an inventory drawn up in the first place. Indeed, it seems reasonable to suppose that the buttons and buckles, being primarily identified as made of silver, functioned in this case much more as a store of value than as decorative objects *per se*. If coins and silver buttons and buckles all performed essentially the same service, providing a compact and highly liquid from of savings, then the clear common denominator among the few inventoried current orphans was their access to savings. Whatever else we might speculate about the selection bias of this sample, it seems clear that these boys nonetheless retained few if any possessions which might have been in their parental homes at the time of dissolution, with the possible exception of the drawings and prints. Even these however, might have been the handiwork of the owner or acquired later because of a special interest. (Some of the orphan boys were apprenticed to painters and other decorative artists, although it was by no means common.) The list also reveals a collection of items not terribly well suited to helping an individual get a firm start on householding. It includes very little of practical daily use. Rather it reflects the remarkably limited material world of the orphanage inmate. The only path to individuation (or savings) open to these children was in the acquisition of accessories to their clothing, and even that was narrowly restricted to a small number of boys.

Such claims would be much harder to make if it were not for the fact that we do know quite a bit about the kinds of possessions which were to be found in the parental homes of these children. To begin with, their original homes

offered up a vastly greater variety of different items than the miserly total of 28 found in the orphan boy inventories. Across the entire sample of 912 inventories, 1,248 separate items can be identified, and even among the much smaller number (148) of inventories drawn up on former orphans, 484 different items make an appearance at least once. The material world of the institution, at least in the children's wings, was severely impoverished. This is true even when the standard of comparison is the relatively poor households from which the children had sprung. Indeed, the orphan quarters offer a striking contrast with the regent's front rooms which were so amply supplied with exquisite taste that many of the actual items of furniture, table service and artwork survive to this day and are on display in the Amsterdam Historical Museum, fittingly housed in the complex of buildings which had originally comprised the Orphanage.

Outside the Orphanage

What kinds of homes then did these orphans live in, both before the death of their parents and following their departure from the institution? It would be impossible to examine all of the separate components of their environment individually. But it is possible to compare access to some broad categories of culturally or economically important goods before and after the institutional experience. Table 9.2 lists the percentage of both parental and former-orphan households owning 20 selected goods and the median number of that item owned per household. Table 9.3 reports the same information, breaking down the former-orphan households into those of adults who either never married or were widowed versus those who were married at the time of their death.

Two very clear patterns emerge from this data. The first is that the parental households were more likely to own a range of household goods (beds, decorative objects, tablewares) than were the households of former orphans, while simultaneously demonstrating less diversity in their apparel, even among the most general categories of clothing. Furthermore, the clothing gap intensifies as one moves away from the basic elements of everyday wear such as shirts and trousers towards more discretionary items such as an extra pair of slippers or shoes, handkerchiefs or jackets. Not only did the former orphans own a greater variety of clothing, but they also owned a greater number of individual items as well, despite the fact that they almost always constituted smaller households than the members of the parent population. For example, the former orphans represent 16.2 per cent of the total collection of inventories, and an even smaller percentage of the total number of persons in inventoried households. Nonetheless, they account for 30 per cent of the crinoline petticoats, 30 per cent of the muffs, 31.6 per cent of the raincoats, 34 per cent of the extra shoes, 46.5 per cent of the slippers, 77 per cent of the nightcaps and 100 per cent of the sunhats, to review just a

sample of clothing accessories which were acquiring new importance in the eighteenth century. The former orphans were also disproportionately likely to have in their possession religious books (most likely the Bibles received as part of the standard graduation gift). Given the attention paid by the Orphanage to the education of both sexes, the former orphans are likely to have been much more literate than the population from which they had been drawn as children.

These general observations extend as well to the division of the former orphan group by number of adults in the household. Those households headed by a married couple at the time of death resemble the parental households much more closely than do those of the former orphans living alone. The latter group was dominated by those who had never married and were often living as boarders in another household, much as Elisabeth van Oostrum had been. They tended to be younger than their married peers, and their consumption patterns had not yet begun to mimic those of their own parents. Most remarkably, even the one item we know they had been given at some point, the Bible, seems to have diminished in its incidence as this group advanced in age and across the lifecycle. Only one quarter as many of the married former orphans still had their Bible in their possession at death as did the orphans living alone. One wonders if this trend is simply an artefact of the ageing process, or if something more proactive had taken place. It may be the case that the Bible was eventually sold (or pawned and lost) to help defray the cost of more practical items needed to establish a fully fledged independent household. Or perhaps the social implications of dependency embodied in the Orphanage Bible were intolerable, making the Bible susceptible to discard when full married adulthood was finally attained.

One possible explanation for the stark differences between the parental homes and the subsequent adult homes of the orphans might be that the two groups enjoyed very different levels of wealth. But this is not in fact the case. Both sub-populations showed a high degree of variability in wealth, from households with next to nothing at the close of their lives to those prosperous enough to hold financial instruments of some kind or another. But the median household assets of the parent population and the adult orphan population are nevertheless uncannily similar, at 68.5 guilders for the parents and 62.9 guilders for the former orphans. (See Table 9.4 for a full breakdown of parental and former-orphan households by the sex of the decedent.) It is the composition of their assets that is radically different, not their total ability to acquire assets.

Conclusions

What does all of this suggest about the success of the Orphanage in managing the risk associated with the death of a parent, or about its subsequent ability to place orphan graduates successfully into the world of consumption and work?

The most direct way to address the dynamic component of this question is to consider those 22 cases where we can link a former orphan to his or her own parental household at the time of its dissolution. If we begin by just looking at the simple measure of the total wealth value of the inventories we discover that exactly half of the linked cases show the parents with higher assets than their child later in life and exactly half just the reverse. Moreover, there is no particular pattern to this split by sex of the child, or the length of the interval between the parents' death and that of the child. It is worth bearing in mind, of course, that 22 cases is too small a sample from which to generate meaningful statistical inferences. Nonetheless, the data fails to even hint at a particular pattern, suggesting that the clear differences in ownership patterns between the two populations was not driven by fundamental financial differences between them.

But even if we consider again all 148 cases of former orphans we discover that nearly three-quarters of them (72.3 per cent) fell into the middle wealth category (15–200 guilders in total assets), whereas the parents as a whole only did so in not even half of the cases (43.6 per cent). Of the parents, 31.6 per cent died with less than 15 guilders in assets, whereas only 12.8 per cent of their inventoried children did so. This suggests that the Orphanage was very successful indeed in preventing downward economic mobility among its charges. Indeed, it seems to have promoted some slight upward mobility. However, it is worth noting that it is also the case that very few former orphans made it into the highest wealth category (those with more than 200 guilders of assets at death). Former orphans achieved this distinction only 14.9 per cent of the time, whereas the parents did so 24.7 per cent of the time. If the goal of the Orphanage was to make respectable, hard-working, but still middling citizens out of its charges, it seems to have been wildly successful.[10] Less likely is whether the Orphanage intended to skew the consumer choices of its graduates so markedly towards the apparel items so often considered frivolous by the guardians of early modern civic morality. Almost certainly it did not. However, the limited access resident orphans had to consumer goods, the highly constrained manifestations of colour and variety in the orphan's material environment (essentially in clothing and nothing else) and the gift package of the Orphanage to its graduates, made up almost entirely of clothing and accessories, all worked to promote a particular kind of consumption after the transition from the institution back into normal society. Moreover, that society also happened to be Amsterdam, the emporium of the world in its day, where surely the temptation to acquire frivolous items must have been as great as anywhere else in Europe. The contradictions between that consumption package and the rhetoric of fiscal probity which so dominated the culture of the urban Dutch Republic make it difficult to evaluate the economic situation of someone like Elisabeth van Oostrum, as was noted at the outset of this exploration. However, her story makes a great deal of sense when placed into the larger cultural context of the austere and spare material world of her years in the Orphanage.

Table 9.1 Items found in the orphan-boy inventories

Item	No. of inventories with item	No. of items
Half-shirt	2	3
Vest-shirt	1	1
Over-shirt	2	2
Under-vest	5	8
Under-breeches	1	1
Sleeves	3	13
Sleeve border	4	9
Socks	1	2
Stockings	4	6
Shoes	3	3
Gloves	2	2
Scarf	1	4
Pocket handkerchief	1	4
Tie	6	39

Table 9.2 Ownership of selected items in the parent and former orphan populations

Item	% of parents	Median no.	% of orphans	Median no.
Shirts – all types	63.7	9	85.8	9
Skirts – all types*	30.0	3	53.4	4
Corsets	22.5	1	48.6	1
Trousers	51.7	3	68.2	3
Capes	18.1	1	29.7	1
Jackets	47.0	5	77.0	7
Stockings	20.6	3	47.3	3
Shoes	6.1	3	18.2	3
Slippers	6.5	1	30.4	2
Hats	15.7	1	25.0	1
Handkerchiefs	35.2	10	68.2	12
Damask – any	8.6	1	12.8	1
Silk – any	20.9	2	27.0	2
Prints – all	46.0	4	27.7	4
Games – all	3.1	1	0.7	1
Religious books	15.0	1	29.7	1
Tea/coffeewares	64.8	6	47.3	5
Chocolatewares	3.2	5	0.0	
Sugarwares	8.6	2	6.8	1
Beds	74.3	2	51.4	1

* Includes items more typically understood as dressing gowns and not just skirts in the modern usage of that word. The Dutch word is *rokken*.

Table 9.3 Ownership of selected items among former orphans, living alone or married

Item	% singles	Median no.	% married	Median no.
Shirts – all types	91.0	8	88.5	9
Skirts – all types	60.3	4	50.8	3
Corsets	57.7	1	44.3	1
Trousers	70.5	3	73.8	3
Capes	35.9	1	24.6	1
Jackets	79.5	7	83.6	5
Stockings	64.1	2	27.9	3
Shoes	24.4	2	6.6	1
Slippers	48.7	2	11.5	1
Hats	21.8	1	24.6	1
Handkerchiefs	79.5	14	60.7	7
Damask – any	15.4	1	11.5	1
Silk – any	34.6	2	19.7	2
Prints – all	20.5	2	39.3	4
Games – all	0		0.2	1
Religious books	47.4	1	11.5	1
Tea/coffeewares	29.5	5	77.0	5
Chocolatewares	0		0	
Sugarwares	6.4	1	8.2	1
Beds	32.1	1	83.6	1

Table 9.4 Asset distribution among the parent and former-orphan households

	Males	Females	Total
Parents – number	341	367	708
% with no assets household assets	13.8%	21.5%	17.8%
mean	314.9 guilders	244.5 guilders	280.1 guilders
median	80.6 guilders	60.1 guilders	68.5 guilders
Former orphans			
– number	55	93	148
% with no assets household assets	3.6%	2.2%	2.7%
mean	119.7 guilders	165.7 guilders	148.7 guilders
median	52.5 guilders	69.8 guilders	62.9 guilders

Note: Assets are computed as the total value of all household possessions, including any shop goods and stores of foodstuffs or firewood as appropriate, with the value of real property, financial assets and outstanding credits owed to the estate of the deceased added on. The mean and median values for this table have been calculated using only those households which had fully enumerated inventories. If the households recorded *per memorie*, that is without a valuation, had been included in the calculation and assigned a total asset value of zero guilders, the parental households would show somewhat lower measures of central tendency than the former-orphan households.

Notes

* The author gratefully acknowledges the stimulating commentary and suggestions of conference participants from the symposium 'Domestic and Institutional Interiors in Early Modern Europe' held at the V&A in November 2004, as well as the detailed comments and editorial assistance of the conference organizers, Sandra Cavallo and Silvia Evangelisti.

1 See Thera Wijsenbeek-Olthuis, *Achter de Gevels* (Hilversum: Verloren, 1987), 282, for a discussion of this phenomenon in Delft. Daniel Roche has made similar observations for Paris in his book, *The People of Paris: An Essay in Popular Culture in the 18th Century* (Berkeley CA: University of California Press, 1987) as has Lorna Weatherill for England in 'The Meaning of Consumer Behaviour in Late Seventeenth- and Early Eighteenth-Century England', in *Consumption and the World of Goods*, ed. John Brewer and Roy Porter (London: Routledge, 1993), 206–27.

2 Colin Jones has made a compelling argument that the commercialization of medical services, particularly as manifested in medical advertising, was an important component of the development of a bourgeois (and consumer-oriented) culture in eighteenth-century France. See his 'The Great Chain of Buying: Medical Advertisement, the Bourgeois Public Sphere, and the Origins of the French Revolution', *American Historical Review*, 101/1 (1996), 13–40.

3 See Anne E.C. McCants, 'Meeting Needs and Suppressing Desires', *Journal of Interdisciplinary History*, 26/2 (1996), 191–207.

4 Erving Goffman, *Asylums* (New Brunswick NJ: Aldine, 1961), 11.

5 The inventory documents themselves include information on the family members still alive at the time of household dissolution: that is, names and ages of living children and names of any surviving spouses; a full listing with description, location and valuation of all household possessions; an enumeration of all outstanding debts to be paid and credits to be reclaimed, and often the names of debtors and creditors; the pawnshop tickets left unredeemed at the time of death; and the residential location of the household. It should also be noted that these inventories were drawn up by the professional full-time bookkeepers of the Orphanage. Evidence internal to the documents themselves suggest that the quality of bookkeeper inspection to ferret out deceit on the part of surviving household members was very high. A number of the inventories contain later emendations of household goods, credits, and even debts, which were only discovered upon subsequent investigation. Such additions were most often found at another location than the residence of the deceased.

6 It may not appear on first consideration that 22 out of 148 possible cases represent a remarkable linkage rate. However, when we take into consideration the often substantial time lag between the original arrival of a child in the Orphanage (that is, at the moment of their parents' death), and their own death many years later, the linkage of even 15 per cent of orphan deaths within the 42 years covered by the data is quite good. Not surprisingly, most of these links have been secured among those former orphans who died late in the sample period and/or who died younger than average. The earliest inventory of a former orphan that can be linked to the inventory of the natal household was recorded in September 1754, a full 14 years after the start of the sample period. Furthermore, the mean age at death of the linked orphans is 26.1 years (median = 26) versus a mean age at death of 42.9 years (median = 39.5) for the

former orphans who could not be linked. Thus, as the data entry work continues forward in time adding inventories from the last two decades of the eighteenth century and the first decade of the nineteenth, the overall linkage rate should increase considerably and the average age at death of linked former orphans should rise towards the whole group mean (currently at 38.6 years with a median of 35).

7 For mortality statistics for the Burgerweeshuis, see Anne E.C. McCants, *Civic Charity in a Golden Age* (Urbana IL: University of Illinois Press, 1997), 46–58.

8 R. Meischke, *De Monumenten van Geschiedenis en Kunst: Amsterdam Burgerweeshuis* (Amsterdam: Stadsuitgeverij, 1975), 61.

9 S. Groenveld et al., *Wezen en Boefjes* (Hilversum: Verloren, 1997), 158.

10 I make this argument in multiple ways throughout McCants, *Civic Charity*.

Bibliography

Printed Primary Sources

Albertini, Francesco, *Opusculum de mirabilibus novae et veteris urbis Romae* (Rome, 1510).

Ardia, Antonio, *Tromba catechista: cioè spiegazione della dottrina cristiana* (Naples, 1713).

Bartoli, Cosimo, *L'Architettura di Leonbatista Alberti, tradotta in lingua Fiorentina da Cosimo Bartoli* (Florence: Torrentino, 1550).

Bellori, Giovanni Pietro, *Le vite de' pittori, scultori, ed architetti modern* (Rome: Mascardi, 1672).

de Bie, Cornelis, *Het Gulden Cabinet vande edele vry schilder Const* (Antwerp: Ian Meysens, 1661).

Biringuccio, Vannocchio, *La pirotecnia* (Venice: Fiori, 1540).

Boase, Charles W., *Registrum Collegii Exoniensis* (Oxford: Oxford Historical Society, 1894), cviii.

Branco da Silva, Elsa Maria (ed.), *O Catecismo Pequeno de D. Diogo Ortiz Bispo de Viseu* (Lisboa: Colibri, 2001).

Brodrick, George C., *Memorials of Merton College* (Oxford: Clarendon Press, 1885).

Burchard, Johann, *Johannis Burckardi liber notarum: ab anno MCCCCLXXXIII usque ad annum MDVI*, in *Rerum Italicarum Scriptores, XXXII*, ed. Enrico Celani (Città di Castello: Tipi della Casa editrice S. Lipi, 1907–42).

Cadioli, Giovanni, *Descrizione delle pitture, sculture, ed architetture che si osservano nella città di Mantova, e ne' suoi contorni* (Mantua: A. Pazzoni, 1763).

Castiglione (Castilio), Baldassar, *Il libro del cortegiano* (Milan: Garzanti, 2003).

_____ , *The Book of the Courtier*, by Sir Thomas Hoby (1561) as edited by Walter Raleigh, for David Nutt, Publisher, London, 1900 (transcribed by Risa S. Bear at the University of Oregon during the summer of 1997), © 1997 The University of Oregon (<http://www.uoregon.edu/~rbear/courtier/courtier.html>).

_____ , *Il libro del cortegiano*, ed. B. Maier (Turin: Einaudi, 1950).

_____ , *Il libro del cortegiano*, 1st edn (Venice: nelle case d'Aldo e d'Andrea d'Asolo, 1528).

Cats, Jacob, *Houwelick* (Middelburg: J.P. van de Venne, 1625).

Celano, Carlo, *Notizie del bello dell'antico e del curioso della Città di Napoli*, ed. Giovanni Battista Chiarini (Naples: Agostino de Pascale, 1858).

Conciliium Tridentum, IX, ed. Stephan Ehses (Freiburg: Herder, 1924).

Council of Trent, *The Canons and Decrees of the Sacred and Oecumenical Council of Trent*, ed. and trans. J. Waterworth (London: Dolman, 1848); available through Hanover Historical Texts Project at <http://history.hanover.edu/texts/trent.html>.

Crónica do Felicissimo Rei D. Manuel composta por Damião de Góis. Nova edição conforme a de 1566, 4 vols (Coimbra: Universidade, 1949).

D'Arco, Carlo, *Delle arti e degli artefici di Mantova*, 2 vols (Mantua: G. Agazzi, 1857–59); anastatic repr. Bologna: A. Forni, 1975.

Decretum de reformatione monialium, see *Conciliium Tridentum*.

Documentary Sources for the Arts and Humanities, Medici Archive Project database at <http://documents.medici.org/>.

Donesmondi, Ippolito, *Dell'istoria ecclesiastica di Mantova*, 2 vols (Mantua: Aurelio & Lodovico Osanna, 1613–16); anastatic repr. Bologna: A. Forni, 1977.

Freire, Anselmo Braamcamp, 'Inventário da infanta D. Beatriz 1507', *Arquivo Historico Português*, 9 (1914), 64–110.

_____ , 'Inventário da casa de D. João III em 1534', *Archivo Historico Portuguez*, VIII (1910), 261–80 and 367–90.

_____ , 'Inventário da Guarda-Roupa de D. Manuel I', *Archivo Historico Portuguez*, II (1904), 381–417.

Frei de Beja, António, *Traducção da Epistola de S. João Chrysostomo* (Lisbon: Germão Galharde, 1522).

Gemma, Fulgenzio, *Ritratto della Serenissima Principessa Caterina di Toscana Duchessa di Mantova e di Monferrato, poi Governatrice di Siena* (Siena, 1630); edn consulted: Florence: B. Paperini, 1737.

Guarini, Tiberio, *Breve naratione e vera historia della fondatione del nobillitissimo monasterio di S. Orsola*, Biblioteca Comunale di Mantova (MS 1088), cc. 31v–32.

Huelsen, Christian, *Il Libro di Giuliano da Sangallo, Codice Vaticano Barberiniano Latino 4424 riprodotto in fototipia* (Modena: Biblioteca Apostolica Vaticana, 1984).

_____ , *Il Libro di Giuliano da Sangallo, Codice Vaticano Barberiniano Latino 4424 riprodotto in fototipia*, 2 vols (Leipzig: O. Harrassowitz, 1910).

La Insalata. Cronaca Mantovana dal 1561 al 1602, ed. Daniela Ferrari and Cesare Mozzarelli (Mantua: G. Arcari, 1992).

Intra, Giovanni Battista, *Il Monastero di Santa Orsola in Mantova* (Mantua: L. Rossi, 1902; first publ. in *Archivio Storico Lombardo*, 3rd ser., XXII, 4 (1895).

Marchese, Domenico Maria, *Vita della Ven. Serva di Dio Suor Maria Villani dell'Ordine de' Predicatori, fondatrice del monastero di S. Maria del Divino Amore di Napoli* (Naples: 1674).

Opera di M. Bartolomeo Scappi, cuoco secreto di Papa Pio Qvinto …; con il discorso funerale, che fu fatta nelle essequie di Papa Paolo III; Con le figure che fanno bisogno nella cucina & alli reverendissimi nel conclaue (Venice: 1598).

Ortiz, D. Diogo, *Catecismo pequeño da doctrina e instruiçam que os xpãos ham de creer e obrar pera conseguir a benaventurança eterna* (Lisbon: Valentim Fernandes e João Pedro de Cremona, 1504).

Registrum Annalium Collegii Mertonensis, ed. John M. Fletcher (Oxford: Clarendon Press for the Oxford Historical Society, 1974).

Resende, Garcia de, *Breve Memorial dos pecados e cousas que pertencem ha confissam hordenado por Garçia de Resende fidalguo da casa delRei nosso senhor*, ed. Joaquim de Oliveira Bragança (Lisbon: Gráfica de Coimbra, 1980).

——— , *Crónica de D. João II e Miscelânea* (Lisbon: Imprensa Nacional, 1973) [1533].

Sangiorgi, Fert, *Documenti urbinati. Inventari del Palazzo Ducale (1582–1631)* (Urbino: Accademia Raffaello, Arti Grafiche Editoriali, 1976).

Segarizzi, Arnaldo, *Relazioni degli Ambasciatori Veneti al Senato*, 3 vols (Bari: G. Laterza & Figli, 1912–16).

Statutes of the Colleges of Oxford, 3 vols (Oxford: J.H. Parker, 1853), vol. 2.

Il Taccuino Senese di Giuliano da San Gallo: 50 facsimili di disegni d'architettura, scultura ed arte applicata, pubblicati da Rodolfo Falb (Siena: Stab. Fotolit. del Cav. L. Marzocchi, 1899).

'Testamento de D. Diogo de Sousa com os documentos da publicação e execução do mesmo', in *O Mecenato de D. Diogo de Sousa Arcebispo de Braga (1505–1532). Urbanismo e Arquitectura*, ed. Rui Maurício (Leiria: Magno, 2000), vol. 2, 305–480.

Valiero, Agostino, *La Istituzione d'Ogni Stato lodevole delle donne Cristiane* (Padua: Giuseppe Comino, 1744).

——— , *Modo di vivere proposto alle Vergini che si chiamano Dimesse ovvero che vivono nelle lor case con voto … di perpetua castità* (Padua: Giuseppe Comino, 1744).

Vasari, Giorgio, *Le vite de piu eccellenti scultori e architettori nelle redazioni del 1550 e 1568*, ed. Rossana Bettarini (Florence: Sansoni, 1976), vol. IV.

Vasi, Giuseppe, *Delle Magnificenze di Roma antica e moderna, Libro VIII* (Rome: Niccolò & Marco Pagliarini, 1758).

I vestigi dell'antichità di Roma raccolti et ritratti in perspettiva con ogni diligentia da Stefano Dv Perac Parisino (Rome: Lorenzo della Vaccheria, 1575 and 1600).

Wagenaar, Jan, *Amsterdam in Zyne Opkomst*, 2 vols (Amsterdam: Isaak Tirion, 1765).

Secondary Sources

Adamson, John S.A. (ed.), *The Princely Courts of Europe, Ritual, Politics and Culture under the Ancien Régime 1500–1750*, 2nd edn (London: Cassell, 2000).

Ackerman, James S., *The Cortile del Belvedere* (Città del Vaticano: Biblioteca Apostolica Vaticana, 1954).

Ago, Renata, 'Collezioni di quadri e collezioni di libri a Roma tra XVI e XVIII secolo', *Quaderni Storici*, 3 (1997), 663–83.

Ainsworth, Maryan, '"A la façon grèce": The Encounter of Northern Renaissance Artists with Byzantine Icons', in Evans (ed.) (2004).

Ajmar, Marta, 'Introduction' to 'Special Issues: Approaches to Renaissance Consumption', *Journal of Design History*, 15 (2002), 207–209.

Ajmar-Wollheim, Marta, and Flora Dennis (eds), *At Home in Renaissance Italy* (London: V&A Publications, 2006).

Algeri, Giuliana, and Daniela Ferrari (eds), *Quadri, libri e carte dell'Ospedale di Mantova: sei secoli di arte e storia* (Mantua: Tre Lune, 2002).

Appadurai, Arjun (ed.), *The Social Life of Things: Commodities in Cultural Perspective* (Cambridge: Cambridge University Press, 1986).

Arscott, Caroline, and Katie Scott (eds), *Manifestations of Venus: Art and Sexuality* (Manchester: Manchester University Press, 2000).

Askew, Pamela, 'Lucrina Fetti', in *Women Artists 1550–1950* (exh. cat.), ed. Ann Sutherland Harris and Linda Nochlin (New York, 1976).

Atti del convegno di studio, VII centenario del 1 conclave (1268–1271) (Viterbo: Azienda autonoma di cura, soggiorno e turismo di Viterbo, 1975).

Aynsley, Jeremy, Charlotte Grant and Harriet McKay (eds), *Imagined Interiors: Representing the Domestic Interior Since the Renaissance* (London: V&A Publications, 2006).

Baernstein, P. Renée,'Vita pubblica, vita familiare e memoria storica nel monastero di San Paolo a Milano', in Pomata and Zarri (eds) (2005).

_____ , *A Convent Tale: A Century of Sisterhood in Spanish Milan* (New York and London: Routledge, 2002).

_____ , 'In Widow's Habit: Women between Convent and Family in Sixteenth-Century Milan', *Sixteenth Century Journal*, 25/4 (1994), 787–807.

Banner, Lisa A., 'Private Rooms in the Monastic Architecture of Habsburg Spain', in Spicer and Hamilton (eds) (2006).

Bartoli Langeli, Attilio, and Glauco Sanga (eds), *Scrittura e figura. Studi di antropologia della scrittura in memoria di Giorgio Raimondo Cardona*, special issue of *La Ricerca Folklorica*, vol. 31 (1996).

Bartoli Langeli, Attilio et al., *La città e la parola scritta*, ed. G. Pugliese Carratelli (Milan: Credito italiano, Garzanti, Scheiwiller, 1997).

Batini, Giorgio, *L'Italia sui muri* (Firenze: Bonechi, 1968).

Baudrillard, Jean, 'The System of Collecting', in Elsner and Cardinal (eds) (1994).

Baumgartner, Frederic J. (ed.), *Behind Locked Doors, A History of the Papal Elections* (New York: Palgrave Macmillan, 2003).

_____ , 'Conclaves During the Renaissance', in Baumgartner (2003).

_____ , 'Election of the College of Cardinals, 1059–1274', in Baumgartner (2003).

_____ , 'Sfumata!', in Baumgartner (2003).

Bazzotti, Ugo, 'Margherita Gonzaga e il convento di Sant'Orsola', in Safarik (1996).

Beijerman-Schols, Janna, 'Platenatlas. Een Keuze uit de Drie Atlassen', in Beijerman-Schols et al. (2000).

_____ et al., *Geschiedenis in Beeld* (Zwolle: Waanders Uitgevers, 2000).

Belting, Hans, *Likeness and Presence: A History of the Image before the Era of Art* (Chicago IL: Chicago University Press, 1994).

Benevolo, Leonardo, and Paolo Boninsegna, *Urbino* (Rome-Bari: Laterza, 2000) (1st edn 1896).

Benhabib, Seyla, and Drucilla Cornell (eds), *Feminism as Critique* (Minneapolis MN: University of Minnesota Press, 1988).

Benjamin, Andrew, *Architectural Philosophy* (London and New Brunswick NJ: Athlone Press, 2000).

Bennett, Tony, and John Frow (eds), *The Sage Handbook of Cultural Analysis* (Los Angeles and London: Sage, 2008).

Bertini, Giuseppe, 'The Marriage of Alessandro Farnese and D. Maria of Portugal in 1565: Court Life in Lisbon and Parma', in Lowe (ed.) (2000).

Bethencourt, Francisco, and Diogo Ramada Curto (eds), *Portuguese Oceanic Expansion, 1415 to 1822* (Cambridge: Cambridge University Press, 2007).

Bhabha, Homi, *The Location of Culture* (London: Routledge, 1994).

Blunt, Anthony, *Neapolitan Baroque and Rococo Architecture* (London: Zwemmer, 1975).

Boccadamo, Giulia, 'Una riforma impossibile? I papi e i primi tentativi di riforma dei monasteri femminili di Napoli nel "500"', *Campania Sacra*, 21 (1990), 86–122.

Boesch Gajano, Sofia, and Lucetta Scaraffia (eds), *Luoghi sacri e spazi della santità* (Turin: Rosemberg & Sellier, 1990).

Bologna, Corrado, 'L'invenzione dell'interiorità: spazio della parola, spazio del silenzio: monachesimo, cavalleria, poesia cortese', in Boesch Gajano and Scaraffia (eds) (1990).

Bonvini Mazzanti, Marinella, *Battista Sforza Montefeltro. Una 'principessa' nel Rinascimento italiano* (Urbino: Quattroventi, 1993).

Borettaz, Omar, *I graffiti nel castello di Issogne in Valle d'Aosta* (Ivrea: Priuli & Verlucca, 1995).

Bornstein, Daniel, 'Women and Religion in Late Medieval Italy', in Bornstein and Rusconi (eds) (1996).

_____ , and Roberto Rusconi (eds), *Women and Religion in Medieval and Renaissance Italy* (Chicago IL: Chicago University Press, 1996).

Borsi, Franco, *Bramante* (Milan: Electa Editrice, 1989).

_____ , *Giovanni Antonio Dosio. Roma Antica e i disegni di architettura agli Uffizi* (Rome: Officina Edizioni, 1976).

Borsi, Stefano, *Giuliano da Sangallo. I disegni di architettura e dell' antico* (Rome: Officina Edizioni, 1985).

Bosi, Kathryn, 'Leone Martosa and *Martel d'amore*: a *balletto della duchessa* Discovered', *Ricercare*, 17 (2005), 5–69.

Bossy, John, *Christianity in the West, 1400–1700* (Oxford: Oxford University Press, 1985).

Bottaro, Silvia, Anna Dagnino and Giovanna Rotondi Terminiello (eds), *Sisto IV e Giulio II, mecenati e promotori di cultura: atti del convegno internazionale di studi, Savona, 1985* (Savona: Coop Tipografi, 1989).

Bourdieu, Pierre, 'What Makes a Social Class?', *Berkeley Journal of Sociology*, 32 (1987), 1–18.

——, *Outline of a Theory of Practice*, trans. Richard Nice (London and New York: Cambridge University Press, 1986).

——, *Distinction: A Social Critique of the Judgment of Taste* (Cambridge MA: Harvard University Press, 1984).

Boureau, Alain, 'L'imene e l'ulivo. La verginità femminile nel discorso della chiesa nel XIII secolo', *Quaderni storici*, 75/3 (1990), 791–803.

Brenninkmeyer de Rooij, Beatrijs, *Roots of Seventeenth-Century Flower Painting* (Leiden: Primavera Press, 1996).

Brewer, John, and Roy Porter (eds), *Consumption and the World of Goods* (London: Routledge, 1993).

Bruschi, Arnaldo, *Bramante* (London: Thames & Hudson, 1973).

——, *Bramante architetto* (Bari: Editori Laterza, 1969).

Bucherie, Luc, 'Graffiti de prisonniers anglais au château de Tarascon (Bouches-du-Rhône): l'exemple du H.M.S. sloop of war Zephir (1778)', *Archeologia postmedievale*, 10 (2006), 205–16.

——, 'Graffiti et histoire des mentalités. Genèse d'une recherche', *Antropologia Alpina*, Annual Report, 2 (1990–91), 41–64.

——, 'Mise en scène des pouvoirs dans les graffiti anciens (XV–XVIIe siècles)', *Gazette des Beaux-Arts*, CIII, 1 (1984), 1–10.

Buescu, Ana Isabel, *Catarina de Austria. Infanta de Tordesilhas, Rainha de Portugal* (Lisbon: Esfera dos Livros, 2007).

Bugge, John, *Virginitas. An Essay in the History of a Medieval Ideal* (The Hague: Martinus Nijhoff, 1975).

Butler, Judith, 'Variations on Sex and Gender', in Benhabib and Cornell (1988).

Cabibbo, Sara, 'La santità femminile dinastica', in Scaraffia and Zarri (eds) (1994).

——, and Marilena Modica, 'Identità religiosa e identità di genere: scritture di famiglie nella Sicilia del Seicento', *Quaderni storici*, 83 (1993), 415–42.

Calvi, Gilia (ed.), *Barocco al femminile* (Bari: Laterza, 1993).

Canali, Luca, and Guglielmo Cavallo, *Graffiti latini. Scrivere sui muri a Roma antica* (Milan: Bompiani, 1991).

Cancellieri, Francesco, *Storia de' solenni possessi de' sommi pontefici detti anticamente processi o processioni dopo la loro coronazione dalla Basilica Vaticana alla Lateranense*, dedicata alla santita' di n.s. Pio VII. P.O.M. (Rome: Presso Lvigi Lazzarini Stampatore della R.C.A., 1802).

Carita, Helder, *Lisboa Manuelina e a formação de modelos urbanísticos na Epoca Moderna (1495–1521)* (Lisbon: Livros Horizonte, 1999).

Carneiro de Sousa, Ivo, *A Rainha D. Leonor (1458–1525). Poder, misericórdia, religiosidade e espiritualidade no Portugal do Renascimento* (Lisbon: Fundação Calouste Gulbenkian, 2002).

Castillo Gómez, Antonio, *Entre la pluma y la pared. Una historia social de la escritura en los Siglo de Oro* (Madrid: Akal, 2006).

Cavallo, Sandra, 'Family Obligations and Inequalities in Access to Care (Northern Italy, 17th–18th Centuries)', in Horden and Smith (eds) (1998).

_____ , and Isabelle Chabot, 'Introduzione' to *Oggetti, Genesis*, V/1 (2006), 7–22.

_____ , and David Gentilcore (eds), *Spaces, Objects and Identities in Early Modern Italian Medicine, Renaissance Studies*, 21/4 (2007), 522–50.

Ceccarelli, Luciano, *'Non mai'. Le 'imprese' araldiche dei Duchi di Urbino, gesta e vicende familiari tratte dalla corrispondenza privata*, ed. Giovanni Murano (Urbino: Accademia Raffaello, 2002).

Centro de Estudios Historicos, *La mujer en el arte espanol: VIII jornadas de arte* (Madrid: Alpuerto, 1997).

Cepeda, Isabel Villares, 'Os livros da Rainha D. Leonor, segundo o códice 11352 da Biblioteca Nacional', *Revista da Biblioteca Nacional*, 2nd series, 2/2 (1987), 51–81.

Cerboni Baiardi, Giorgio, Giorgio Chittolini and Pietro Floriani (eds), *Federico di Montefeltro. Lo stato, le arti, la cultura* (Rome: Bulzoni, 1986).

de Certeau, Michel, *The Mystic Fable. Vol. I: The Sixteenth and Seventeenth Centuries*, trans. Michael B. Smith (Chicago IL and London: University of Chicago Press, 1982).

Chambers, David S., 'Papal Conclaves and the Prophetic Mystery in the Sistine Chapel', *Journal of the Warburg and Courtauld Institutes*, 41 (1978), 322–6.

_____ , 'The Economic Predicament of Renaissance Cardinals', in *Studies in Medieval and Renaissance History*, 3 (1966), 291.

_____ , and Jane Martineau (eds), *Splendours of the Gonzaga* (Cinisello Balsamo: Pizzi, 1981).

Chartier, Roger (ed.), *A History of Private Life. Passions of the Renaissance* (Cambridge MA: Harvard University Press, 1989).

Chittolini, Giorgio, and Giovanni Miccoli (eds), *Storia d'Italia. Annali 9. La Chiesa e il potere politico dal medioevo all'età contemporanea* (Turin: Einaudi, 1986).

Christian, William A., Jr., *Local Religion in Sixteenth-Century Spain* (Princeton NJ: Princeton University Press, 1981).

Christensen, Carl, 'Art', in Hillerbrand (ed.) (1996).

_____ , *Art and the Reformation in Germany* (Athens OH: Ohio University Press, 1979).

Ciociola, Claudio (ed.), *Visibile parlare: le scriture esposte nei volgari italiani dal Medioevo al Rinascimento* (Naples: Edizioni Scientifiche Italiane, 1997).

Clifford, Helen, *A Treasured Inheritance: 600 Years of Oxford College Silver* (Oxford: Ashmolean Museum, 2004).

Clough, Cecil H., 'La "familia" del duca Guidubaldo da Montefeltro e il *Cortegiano*', in Muzzarelli (1988).

_____ , *The Duchy of Urbino in the Renaissance* (London: Variorum Reprints, 1981).

Colombo, Antonio, *Il Monastero e la Chiesa di S. Maria la Sapienza* (Trani, 1901).

Colomina, Beatriz (ed.), *Sexuality and Space* (Princeton NJ: Princeton Architectural Press, 1992).

Cooper, Alix, 'Homes and Households', in Park and Daston (eds) (2006).

Cooper, Nicholas, *Houses of the Gentry, 1480–1680* (New Haven CT and London: Yale University Press, 1999).

Cortelazzo, Manlio, and Paolo Zolli, *Dizionario etimologico della lingua italiana* (Bologna: Zanichelli, 1979–88).

Costa, João Paulo Oliveira e, *D. Manuel I, 1469–1521: um príncipe do renascimento* (Lisbon: Círculo de Leitores, 2005).

Coster, William, and Andrew Spicer (eds), *Sacred Space in Early Modern Europe* (Cambridge: Cambridge University Press, 2005).

Colvin, Howard, *The Canterbury Quadrangle: St John's College Oxford* (Oxford: Oxford University Press, 1988).

Couvrer, Walter, 'Daniël Seghers inventaris van door hem geschilderde bloemstukken', *Gentse Bijdragen tot de Kunstgeschiedenis en de Oudheidkunde*, 20 (1967), 87–158.

di Crollalanza, Giovanni Battista, *Dizionario storico-blasonico delle famiglie nobili e notabili italiane estinte e fiorenti* (Bologna: Forni, n.d.; orig. publ. Pisa, 1886–90).

Crowley, John, *The Invention of Comfort* (Baltimore MD: Johns Hopkins University Press, 2001).

Curtis, Mark H., *Oxford and Cambridge in Transition, 1558–1642* (Oxford: Clarendon Press, 1959).

Dacome, Lucia, 'Women, Wax and Anatomy in the "Century of Things"', in *Spaces, Objects and Identities in Early Modern Italian Medicine*, ed. Sandra Cavallo and David Gentilcore, *Renaissance Studies*, 21/4 (2007), 522–70.

Dal Poggetto, Paolo, *La Galleria Nazionale delle Marche e le altre Collezioni nel Palazzo Ducale di Urbino* (Urbino and Rome: Novamusa del Montefeltro e Istituto Poligrafico dello Stato, 2003).

―――― , 'La Galleria Nazionale delle Marche nel Palazzo Ducale: Collezioni fruizioni allestimenti', in Polichetti (ed.) (1985).

―――― , and Benedetta Montevecchi (eds), *Gli ultimi Della Rovere: il crepuscolo del Ducato di Urbino* (Urbino: Quattroventi, 2000).

Daston, Lorraine, and Katherine Park, *Wonders and the Order of Nature* (New York: Zone Books, 1998).

Davidson, John Norman Kelly, *The Oxford Dictionary of Popes* (Oxford and New York: Oxford University Press, 1986).

Davies, Clifford S.L., 'A Woman in the Public Sphere: Dorothy Wadham and the Foundation of Wadham College, Oxford', *English Historical Review*, 118/478 (2003), 883–911.

De Fine Licht, Kjeld, *The Rotunda in Rome, a Study of Hadrian's Pantheon* (Copenhagen: Gyldendal, 1968).

Deleuze, Gilles, and Félix Guattari, *A Thousand Plateaus: Capitalism and Schizophrenia*, trans. Brian Massumi (London: Athlone Press, 1988).

De Mare, Heidi, 'The Domestic Boundary as Ritual Area in Seventeenth-Century Holland', in De Mare and Vos (eds) (1993).

_____ and Anna Vos (eds), *Urban Ritual in Italy and the Netherlands* (Assen: Van Gorcum, 1993).

Dennistoun, James, *Memoires of the Dukes of Urbino, Illustrating the Arms, Arts, and Literature of Italy from 1440 to 1630* (London: Longman, Brown, Green and Longmans, 1851).

Denucé, Jean, *Brieven en documenten betreffend Jan Brueghel I en II*. Bronnen voor de geschiedenis van de Vlaamsche Kunst I (Antwerp: De Sikkel, 1934).

_____ , *De Antwerpsche 'Konstkamers': Inventarissen van kunstverzamelingen te Antwerpen in de zestiende en zeventiende eeuw*. Bronnen voor de geschiedenis van de Vlaamsche kunst II (Amsterdam: De Spieghel, 1932).

_____ , *Exportation d'oeuvres d'art au 17e siècle à Anvers: La Firme Forchoudt* (Antwerp: de Sikkel, 1931).

Derrida, Jacques, 'Architecture Where the Desire May Live', in Leach (ed.) (1997).

Dias, Pedro, *Arte Indo-Portuguesa* (Coimbra: Almedina, 2004).

Diefendorf, Barbara B., *From Penitence to Charity: Pious Women and the Catholic Reformation in Paris* (Oxford: Oxford University Press, 2004).

Dinan, Susan E., *Women and Poor Relief in Seventeenth-Century France: The Early History of the Daughters of Charity* (Aldershot and Burlington VT: Ashgate, 2006).

Dirks, Nicholas, *Castes of Mind* (Princeton NJ: Princeton University Press, 2003).

Distelberger, Rudolf, '"Quanta Rariora Tanta Meliora", The Fascination of the Foreign in Nature and Art', in Trnek and Vassallo e Silva (2001).

Dizionario Biografico degli Italiani (Rome: Istituto della Enciclopedia Italiana, 1979).

Duhamel, Leopold, *Une Visite à Notre Dame de Doms d'Avignon. Guide de l'étranger dans ce monument, avec un plan inédit et trois gravures* (Avignon: J. Roumanille, 1890).

Dunn, Marilyn R., 'Spaces Shaped for Spiritual Perfection: Convent Architecture and Nuns in Early Modern Rome', in Hills (ed.) (2003).

_____ , 'Spiritual Philanthropists: Women as Convent Patrons in Seicento Rome', in Lawrence (ed.) (1997).

_____ , 'Nuns as Patrons: The Decorations of S. Marta at the Collegio Romano', *Art Bulletin*, 70/3 (1988), 451–77.

Durante, Stephanie-Suzanne et al., *Peter Paul Rubens. A Touch of Brilliance* (Munich: Prestel, 2003).

Durning, Louise, 'Woman on Top: Lady Margaret Beaufort's Buildings at Christ's College Cambridge', in Durning and Wrigley (eds) (2000).

_____ (ed.), *Queen Elizabeth's Book of Oxford* (Oxford: Bodleian Library Publications, 2006).

_____ , and Richard Wrigley (eds), *Gender and Architecture* (Chichester: Wiley, 2000).

Duverger, Erik, *Antwerpse Kunstinventarissen uit de zeventiende eeuw* (Brussels: Koninklijke Academie voor Wetenschappen, Letteren Schone Kunsten van Belgie, 1984–), 13 vols.

Eco, Umberto, 'Graffiti di San Giovanni in Monte', in *San Giovanni in Monte. Convento e carcere: tracce e testimonianze* (Bologna: Bologna University Press, 1995).

Egger, Hermann, *Carlo Madernas Projekt für den Vorplatz von San Pietro in Vaticano* (Leipzig: Poeschel & Trepte, 1928).

Ehrle, Franz, and Hermann Egger, *Die Conclavepläne beiträge zu ihre Entwicklungsgeschichte* (Vatican City: Biblioteca Apostolica Vaticana, 1933).

Eiche, Sabine (ed.), *Ordine et officij de casa de lo illustrissimo signor duca de Urbino* (Urbino: Accademia Raffaello, 1999).

_____ , 'Behind the Scenes of the Court', in Eiche (ed.) (1999).

Ekkart, Rudolf, E.O., 'Ein Leidse Loterijkaart uit de Zestiende Eeuw', *Leids Jaarboekje* 66 (1974).

Elsner, John, and Roger Cardinal (eds), *The Cultures of Collecting* (London: Reaktion Books, 1994).

Ensaios II, 2nd edn (Lisbon: Sá da Costa, 1978).

Ermini, Giuseppe, *Ordini et offitji alla corte del Serenissimo Signor Duca di Urbino* (Urbino: Regia Accademia Raffaello, Società Tipografica Editrice Urbinate, 1932).

Ertz, Klaus, *Jan Brueghel der Ältere* (Cologne: Dumont, 1979).

Esch, Arnold, *Economia, cultura materiale ed arte nella Roma del Rinascimento: studi sui registri doganali romani, 1445–1485* (Rome: Roma nel Rinascimento, 2007).

Evangelisti, Silvia, 'Rooms to Share: Convent Cells and Social Relations in Early Modern Italy', in Harris and Roper (eds) (2006).

_____ , 'Monastic Poverty and Material Culture in Early Modern Italian Convents', *The Historical Journal*, 47/1 (2004), 1–20.

_____ , 'Moral Virtues and Personal Goods: The Double Representation of Female Monastic Identity', in Hufton (ed.) (1996).

_____ , '"Farne quello che pare e piace …": l'uso e la trasmissione delle celle nel monastero di Santa Giulia di Brescia (1597–1688)', *Quaderni storici*, 30 (1995), 85–110.

_____ , 'Angelica Baitelli, la storica', in Calvi (ed.) (1993).

Evans, Helen C. (ed.), *Byzantium. Faith and Power (1261–1557)* (New York and New Haven CT: Metropolitan Museum of Art and Yale University Press, 2004).

Fabri, Felix, *Evagatorium*, available at <http://chass.colostate-pueblo.edu/history/seminar/fabri.htm>.

Fairchilds, Cissie, 'Consumption in Early Modern Europe: A Review Article', *Comparative Studies in Society and History*, 35 (1993), 850–58.

Fernández, Henry Dietrich, 'Avignon to Rome, The Making of Cardinal Giuliano della Rovere as Patron of Architecture', in Verstegen (ed.) (2007).

_____ , 'The Patrimony of St. Peter: The Papal Court at Rome', in Adamson (ed.) (2000).

_____ , and Barbara Shapiro, 'Il Palazzo Vaticano al tempo di Raffaello. La Scala di Bramante e Raffaello nei Palazzi Vaticani, stato attuale', in Pietrangeli and Mancinelli (eds) (1984).

Findlen, Paula, *Possessing Nature. Museums, Collecting, and Scientific Culture in Early Modern Italy* (Berkeley CA: University of California Press, 1994).

Fiore, Francesco Paolo, 'La fabbrica quattrocentesca del Palazzo della Rovere in Savona', in Bottaro, Dagnino and Rotondi Terminiello (eds) (1989).

Fiorio, Maria Teresa, *Le chiese di Milano* (Milan: Credito Artigiano, c. 1985).

Filipczak, Zirka Zaremba, *Picturing Art in Antwerp 1550–1700* (Princeton NJ: Princeton University Press, 1987).

Fleming, Juliet, *Graffiti and the Writing Arts of Early Modern England* (London: Reaktion, 2001).

Fock, C. Willemijn, 'Semblance or Reality? The Domestic Interior in Seventeenth-Century Dutch Painting', in Westermann (2001).

Fontebuoni, Luisa, 'Destinazioni d'uso dal sec. XV al XX', in Polichetti (1985).

Fortini-Brown, Patricia, *Private Lives in Renaissance Venice. Art, Architecture and the Family* (New Haven CT and London: Yale University Press, 2004).

Fortunati, Vera, and Claudio Leonardi (eds), *Pregare con le immagini: il breviario di Caterina Vigri* (Florence: SISMEL Edizioni del Galluzzo, 2004).

Foster, Marc R., 'Domestic Devotions and Family Piety in German Catholicism', in Foster and Kaplan (eds) (2005).

_____ , and Benjamin J. Kaplan (eds), *Piety and Family in Early Modern Europe. Essays in Honour of Steven Ozment* (Aldershot and Burlington VT: Ashgate, 2005).

Foucault, Michel, *Discipline and Punish: The Birth of the Prison*, trans. Alan Sheridan (Harmondsworth: Penguin, 1977).

Freedberg, David, 'The Origins and Rise of the Flemish Madonnas in Flower Garlands: Decoration and Devotion', *Münchner Jahrbuch der bildenden Kunst*, 32 (1981), 115–50.

Frommel, Christoph Luitpold, *Architettura alla corte papale nel rinascimento* (Milan: Mondadori Electa S.p.A., 2003).

_____ , 'I palazzi di Raffaello: come si abitava e viveva nella Roma del primo Cinquecento', in Frommel (2003).

_____ , 'La cappella Paolina di Antonio da Sangallo. Un contributo alla storia edilizia del palazzo Vaticano', in Frommel (2003).

_____ , 'I tre progetti bramanteschi per il Cortile del Belvedere', in Winner, Andreae and Pietrangeli (1998).

_____ , 'Il Palazzo della Cancelleria', in Valtieri (1989).

_____ , 'Il Palazzo Vaticano sotto Giulio II e Leone X. Strutture e funzioni', in Pietrangeli and Mancinelli (eds) (1984).

_____ , 'Lavori architettonici di Raffaello in Vaticano', in Frommel, Ray and Tafuri (1984).

_____ , *Der Palazzo Venezia in Rom* (Opladen: Westdeutscher Verlag, 1982).

_____ , 'Antonio da Sangallos Cappella Paolina. Ein Beitrag zur Baugeschichte des Vatikanischen Palastes', *Zeitschrift für Kunstgeschichte*, 27 (1964), 1–42.

_____ , Stefano Ray and Manfredo Tafuri (eds), *Raffaello Architetto* (Milan: Electa Editrice, 1984).

Frutaz, Amato Pietro, *Il Torrione di Niccolò V in Vaticano* (Vatican City: Tipografia Poliglotta Vaticana, 1956).

Galasso, Giuseppe, and Adriana Valerio (eds), *Donne e religione a Napoli, secoli XVI–XVIII* (Milan: Franco Angeli, 2001).

Gatto, Ludovico, 'Il conclave di Viterbo nella storia delle elezioni pontificie del "200"', in *Atti del convegno di studio* (1975).

Gaze, Delia (ed.), *Dictionary of Women Artists*, 2 vols (London: Fitzroy Dearborn, 1997).

Geary, Patrick, 'Sacred Commodities: The Circulation of Medieval Relics', in Appadurai (ed.) (1986).

Geraci, Giovanni, 'Ricerche sul proskynema', *Aegyptus*, 51/1 (1971), 3–211.

Gilchrist, Roberta, *Gender and Archaeology: Contesting the Past* (London: Routledge, 1999).

_____ , *Gender and Material Culture: The Archaeology of Religious Women* (London and New York: Routledge, 1994).

Gimeno Blay, Francisco M., and Maria Luz Mandingorra Llavata (eds), *Los muros tienen la palabra: materiales para una historia de los graffiti* (Valencia: Departamento de historia de la antiguedad y de la cultura escrita, 1997).

Girard, Joseph, *Evocation du vieille Avignon* (Paris: Les Editions de Minuit, 1958).

Gladen, Cynthia, 'Suor Lucrina Fetti: pittrice in una corte monastica seicentesca', in Pomata and Zarri (eds) (2005).

Glanville, Philippa, *Silver in Tudor and Early Stuart England* (London: Victoria and Albert Museum, 1990).

Godinho, Vitorino Magalhães, 'Finanças públicas e estrutura do estado', in *Ensaios II* (1978).

Goffman, Erving, *Asylums* (New Brunswick NJ: Aldine, 1961).

Goldthwaite, Richard A., *Wealth and the Demand for Art in Italy, 1300–1600* (Baltimore MD: Johns Hopkins University Press, 1995).

Gottschalk, Karin, 'Does Property have a Gender? Household Goods and Conceptions of Law and Justice in Late Medieval and Early Modern Saxony', *The Medieval History Journal*, 8 (2005), 7–24.

Grassi, Maria Giustina, 'Spigolature d'archivio sull'attività didattica e artistica del pittore Giovanni Cadioli (1710–1767)', *Atti e Memorie dell'Accademia Nazionale Virgiliana*, n.s. 65 (1997).

Greco, Gaetano, 'Monasteri femminili e patriziato a Pisa (1530–1630)', in *Città italiane del '500 tra riforma e controriforma* (Lucca: Maria Pacini Fazzi, 1988), 313–39.

Green, Vivian H.H., *The Commonwealth of Lincoln College, 1427–1977* (Oxford: Oxford University Press, 1979).

Grieco, Allen J., 'Conviviality in a Renaissance Court: The *Ordine et Officij* and the Court of Urbino', in Eiche (ed.) (1999).

Groenveld, S., et al., *Wezen en Boefjes* (Hilversum: Verloren, 1997).

Grundmann, Herbert, *Religious Movements in the Middle Ages: The Historical Links between Heresy, the Mendicant Orders, and the Women's Religious Movement in the Twelfth and Thirteenth Century, with the Historical Foundations of German Mysticism* (Notre Dame IN: University of Notre Dame Press, 1995).

dos Guimarães Sá, Isabel, 'Ecclesiastical Structures and Religious Action', in Bethencourt and Ramada Curto (eds) (2007).

_____ , 'Catholic Charity in Perspective: The Social Life of Devotion in Portugal and its Empire (1450–1700)', *e-Journal of Portuguese History*, 4 (2004).

_____ , ' "Fui em tempo de cobiça": sociedade e valores no Portugal manuelino através de Gil Vicente', *Revista de Guimarães*, 112 (2002), 57–82.

Hairs, Marie-Louise, *The Flemish Flower Painters in the Seventeenth Century* (Brussels: Lefebvre & Gillet, 1985).

Halsema-Kubes, Wilhelmina, 'Hendrick de Keyser', in Turner (ed.) (1996).

Hamburgher, Jeffrey F., *The Visual and the Visionary: Art and Female Spirituality in Late Medieval Germany* (New York: Zone Books, 1998).

_____ , and Susan Marti, *Crown and Veil: Female Monasticism from the Fifth to the Fifteenth Centuries* (New York: Columbia University Press, 2008).

Hamling, Tara, and Richard L. Williams (eds), *Art Re-Formed: Re-Assessing the Impact of the Reformation on the Visual Arts* (Newcastle: Cambridge Scholars, 2007).

_____ , 'The Appreciation of Religious Images in Plasterwork in the Protestant Domestic Interior', in Hamling and Williams (2007).

Haneveld, G.T., *Oude Medische Gebouwen van Nederland* (Amsterdam: R. Meesters, 1976).

Harris, Ruth, and Lyndal Roper (eds), *The Art of Surviving: Gender and History in Europe, 1450–2000. Supplement of Past and Present* (Oxford: Oxford University Press, 2006).

Hart, Marjolein t', 'The Glorious City: Monumentalism and Public Space in Seventeenth-Century Amsterdam', in O'Brien et al. (eds) (2001).

Heal, Felicity, *Hospitality in Early Modern England* (Oxford: Oxford University Press, 1990).

Held, Julius S., 'Artis Pictoriae Amator. An Antwerp Art Patron and His Collection', in Lowenthal, Rosand and Walsh, Jr. (eds) (1982).

Henderson, John, *The Renaissance Hospital: Healing the Body and Healing the Soul* (New Haven CT: Yale University Press, 2006).

Highfield, John R.L., and Geoffrey H. Martin, *A History of Merton College, Oxford* (Oxford: Oxford University Press, 1977).

Hill, Christopher, *Society and Puritanism in Pre-Revolutionary England* (London: Secker & Warburg, 1966).

_____ , 'The Spiritualization of the Household', in Hill (1966)

Hillerbrand, Hans J. (ed.), *The Oxford Encyclopedia of the Reformation*, vol. 1 (Oxford: Oxford University Press, 1996).

Hills, Helen, 'Too Much Propaganda', *Oxford Art Journal*, 29/3 (2006), 446–55.

_____ , *Invisible City: The Architecture of Devotion in Seventeenth-Century Neapolitan Convents* (Oxford: Oxford University Press, 2004).

_____ (ed.), *Architecture and the Politics of Gender in Early Modern Europe* (Aldershot and Burlington VT: Ashgate, 2003).

_____ , 'Iconography and Ideology: Aristocracy, Immaculacy and Virginity in Seventeenth-Century Palermo', *Oxford Art Journal*, 22/1 (1999), 16–31.

Höfler, Janez, *Der Palazzo Ducale in Urbino unter den Montefeltro (1376–1508). Neue Forschungen zur Bau- und Ausstattungsgeschichte* (Regensburg: Schnell & Steiner, 2004).

Hollingsworth, Mary, *The Cardinal's Hat. Money, Ambition, and Everyday Life in the Court of a Borgia Prince* (London: Profile Books, 2004).

Horden, Peregrine, and Richard M. Smith (eds), *The Locus of Care: Families, Communities, Institutions* (London: Routledge, 1998).

Howe, Eunice D., 'The Architecture of Institutionalism: Women's Space in Renaissance Hospitals', in Hills (ed.) (2003).

Hsia, Ronald Po-Chia, *Social Discipline in the Reformation: Central Europe, 1550–1750* (London: Routledge, 1989).

Hufton, Olwen (ed.), *Women in the Religious Life* (Florence: European University Institute, 1996).

Hughes, Diane Owen, 'Representing the Family: Portraits and Purposes in Early Modern Italy', in Rabb and Brown (eds) (1988).

Huisman, Anneke, and Johan Koppenol, *Daer compt de Loterij met Trommels en Trompetten. Loterijen in de Nederlanden tot 1726* (Hilversum: Verloren, 1991).

Impey, Oliver, and Arthur MacGregor (eds), *The Origins of Museums: The Cabinet of Curiosities in Sixteenth- and Seventeenth-Century Europe* (Oxford: Oxford University Press, 1985).

Israel, Jonathan, *The Dutch Republic. Its Rise, Greatness and Fall, 1477–1806* (Oxford: Clarendon Press, 1995).

Jäggi, Carola, 'Eastern Choir or Western Gallery?: The Problem of the Place of the Nuns' Choir in Königsfelden and Other Early Mendicant Nunneries', *Gesta*, 40/1 (2001), 79–93.

Jardine, Lisa, *Worldly Goods: A New History of the Renaissance* (London: Papermac, 1997).

Jarrard, Alice, *Architecture as Performance in Seventeenth-Century Europe: Court Ritual in Modena, Rome, and Paris* (Cambridge: Cambridge University Press, 2003).

Jetter, Dieter, *Grundzüge der Hospitallgeschichte* (Darmstadt: Wissenschaftliche Buchgesellschaft, 1973).

Johnson, Geraldine A., and Sara F. Matthews-Grieco (eds), *Picturing Women in Renaissance and Baroque Italy* (Cambridge: Cambridge University Press, 1997).

Jones, Colin, 'The Great Chain of Buying: Medical Advertisement, the Bourgeois Public Sphere, and the Origins of the French Revolution', *American Historical Review*, 101/1 (1996), 13–40.

Jones, Pamela, *Federico Borromeo and the Ambrosiana. Art Patronage and Reform in Seventeenth-Century Milan* (Cambridge: Cambridge University Press, 1993).

Jordan, Annemarie, 'Portuguese Royal Collecting after 1521: The Choice between Flanders and Italy', in Lowe (ed.) (2000).

Kasl, Ronda (ed.), *Giovanni Bellini and the Art of Devotion* (Indianapolis IN: Indianapolis Museum of Art, 2004).

_____ , 'Holy Households: Art and Devotion in Renaissance Venice', in Kasl (ed.) (2004).

Kaufmann, Thomas DaCosta, 'From Treasury to Museum: The Collections of the Austrian Habsburgs', in Elsner and Cardinal (eds) (1994).

Kenseth, Joy (ed.), *The Age of the Marvelous* (Hanover NH: Hood Museum of Art and University of Chicago Press, 1991).

Kent, Dale, *Cosimo de' Medici and the Florentine Renaissance, the Patron's Oeuvre* (New Haven CT and London: Yale University Press, 2000).

Kieckens, Fr., SJ, 'Daniël Seghers, de la Compagnie de Jésus, peintre de fleurs: sa vie et son oeuvre, 1590–1661', *Bulletin de l'Academie d'Archeologie de Belgique* (1884).

Koerner, Joseph L., *The Reformation of the Image* (Chicago IL: University of Chicago Press, 2004).

Komaneck, Michael K. (ed.), *Copper as Canvas: Two Centuries of Masterpiece Paintings on Copper, 1575–1775* (New York: Oxford University Press, 1999).

Koslow, Susan, *Frans Snyders* (Antwerp: Fonds Mercator, 1995).

Kraack, Detlev, *Monumentale Zeugnisse der spätmittelalterlichen Adelsreise: Inschriften und Graffiti des 14.–16. Jahrhunderts* (Göttingen: Vandenhoeck & Ruprecht, 1997).

_____ , and Peter Lingens, *Bibliographie zu Historischen Graffiti zwischen Antike und Moderne* (Krems: Medium Aevum Quotidianum, 2001).

Kubler, George, *Building the Escorial* (Princeton NJ: Princeton University Press, 1982).

Labande, Léon-Honoré, 'Le début du Cardinal Julien de la Rovère', in *Annuaire de la Société de Amis du Palais des Papes et des Monuments d'Avignon* (1926).

_____ , *Le Palais des Papes et les monuments d'Avignon au XIVe siècle*, 2 vols (Aix/Marseilles: F. Detaille, Editeur, 1925).

Lanzinger, Margareth, and Raffaella Sarti (eds), *Nubili e celibi tra scelta e costrizione (secoli XVI–XX)* (Udine: Forum, 2006).

Larner, John, 'Introduction', in Eiche (ed.) (1999).

La Sizeranne, Robert de, *Federico di Montefeltro capitano, principe, mecenate (1422–1482)*, transl. by Carmine Zeppieri (Urbino: Argalia, 1972; orig. publ. as *Le verteux condottiere: Federigo de Montefeltro duc d'Urbino: 1422–1482*, Paris: Hachette, 1927).

Laven, Mary, *Virgins of Venice: Enclosed Lives and Broken Vows in the Renaissance Convent* (London: Penguin, 2002).

Law, John Easton, 'The *Ordine er officij*: Aspects of Context and Content', in Eiche (ed.) (1999).

Lawrence, Cynthia (ed.), *Women and Art in Early Modern Europe: Patrons, Collectors, and Connoisseurs* (University Park PA: Pennsylvania State University Press, 1997).

Lazure, Guy, 'Possessing the Sacred: Monarchy and Identity in Philip II's Relic Collection at the Escorial', *Renaissance Quarterly*, 60 (2007), 58–93.

Lazzari, Alfonso, *Le Ultime tre Duchesse di Ferrara e la corte estense a' tempi di Torquato Tasso* (Florence: Ufficio della Rassegna Nazionale, 1913).

Leach, Neil (ed.), *Rethinking Architecture: A Reader in Cultural Theory* (London and New York: Routledge, 1997).

Lebrun, François, 'The Two Reformations: Communal Devotion and Personal Piety,' in Chartier (ed.) (1989).

Lehfeldt, Elizabeth A., *Religious Women in Golden Age Spain: The Permeable Cloister* (Aldershot and Burlington VT: Ashgate, 2005).

_____ , 'Spatial Discipline and its Limits: Nuns and the Built Environment in Early Modern Spain', in Hills (ed.) (2003).

Leonard, Amy, *Nails in the Wall: Catholic Nuns in Reformation Germany* (Chicago IL: University of Chicago Press, 2005).

Leonardi, Claudi (ed.), *Caterina Vigri: la santa e la città. atti del convegno, Bologna, 13–15 novembre 2002)* (Florence: SISMEL Edizioni del Galluzzo, 2004).

Lobel, Mary D., and Herbert E. Salter (eds), *The Victoria History of the County of Oxford*, vol. 3, *The University of Oxford* (London: Oxford University Press for the University of London Institute of Historical Research, 1954).

L'Occaso, Stefano, 'Margherita Gonzaga d'Este: pitture tra Mantova e Ferrara intorno al 1600', *Atti e Memorie dell'Accademia Nazionale Virgiliana*, n.s. 73 (2005), 81–126.

_____ , 'Santa Croce in Corte e la devozione dei Gonzaga alla Vera Croce', in Trevisani and L'Occaso (eds) (2005).

_____ , 'Per la storia di una collezione', in Algeri and Ferrari (eds) (2002).

Logan, Oliver, 'Counter-Reformatory Theories of Upbringing in Italy', in Wood (1994).

Lombroso, Cesare, *Palinsesti del carcere* (Turin: Bocca, 1888).

Loughman, John, and John Michael Montias, *Public and Private Spaces* (Zwolle: Waanders, 2000).

Lowe, Kate J.P., *Nuns' Chronicles and Convent Culture in Renaissance and Counter-Reformation Italy* (Cambridge and New York: Cambridge University Press, 2003).

_____ (ed.), *Cultural Links between Portugal and Italy in the Renaissance* (Oxford: Oxford University Press, 2000).

_____ , 'Rainha D. Lenor of Portugal's Patronage in Renaissance Florence and Cultural Exchange', in Lowe (ed.) (2000).

Lowenthal, Anne W., David Rosand and John Walsh, Jr. (eds), *Rubens and His Circle* (Princeton NJ: Princeton University Press, 1982).

McCants, Anne E.C., *Civic Charity in a Golden Age: Orphan Care in Early Modern Amsterdam* (Urbana IL: University of Illinois Press, 1997).

_____ , 'Meeting Needs and Suppressing Desires', *Journal of Interdisciplinary History*, 26/2 (1996), 191–207.

McConica, James (ed.), *The History of the University of Oxford: vol. 3. The Collegiate University* (Oxford: Clarendon Press, 1986).

_____ , 'The Collegiate Society,' in McConica (ed.) (1986).

_____ , 'The Rise of the Undergraduate College', in McConica (ed.) (1986).

_____ , 'Scholars and Commoners in Renaissance Oxford', in Stone (ed.) (1974).

MacDonald, Deanna, 'Collecting a New World: The Ethnographic Collections of Margaret of Austria', *Sixteenth Century Journal*, 33/3 (2002), 649–63.

Machado, Maria de Fátima, *O Central e o Local. A Vereação do Porto de D. Manuel a D. João III* (Porto: Afrontamento, 2003).

McIver, Katherine A., *Women, Art and Architecture in Northern Italy 1520–80* (Aldershot and Burlington VT: Ashgate, 2005).

Magnani, Lauro, 'Temporary Architecture and Public Decoration: The Development of Images', in Mulryne, Watanabe-O'Kelly and Shewring (eds) (2004).

Magnuson, Torgil, *Studies in Roman Quattrocento Architecture* (Stockholm: Almqvist & Wiksell, 1958).

Mallett, Michael E., *The Borgias. The Rise and Fall of a Renaissance Dynasty* (Chicago IL: Academy Chicago Publishers, 1987).

Manetti, Giannozzo, *Vita di Nicolò V*, edited trans. in Italian by Anna Modigliani, pref. Massimo Miglio (Rome: Roma nel Rinascimento, 1999).

Mannoni, Tiziano, Diego Moreno and Maurizio Rossi (eds), *Pietra, scrittura e figura in età postmedievale nelle Alpi e nelle regioni circostanti*, special issue of *Archeologia postmedievale*, 10 (2006).

Marcocchi, Massimo, *La riforma dei monasteri femminili a Cremona. Gli atti inediti della visita del vescovo Cesare Speciano (1599–1606)* (Cremona: Athenaeum Cremonense, 1956).

Marques, António Henrique R. de Oliveira, and João José Dias Alves, 'As finanças e a moeda', in Serrão and Marques (eds) (1998).

_____ and _____ , 'As realidades culturais', in Serrão and Marques (eds) (1998).

Marques, João Martins da Silva, 'Armas e Tapeçarias Reais num inventário de 1505', in *Congresso do Mundo Português* (Lisbon: 1940), vol. V, t. III, 557–605.

Mattox, Philip, 'Domestic Sacral Space in the Florentine Renaissance Palace', *Renaissance Studies*, 20/5 (2006), 658–73.

Medioli, Francesca, 'Reti famigliari. La matrilinearità nei monasteri femminili fiorentini del Seicento: il caso di Santa Verdiana', in Lanzinger and Sarti (eds) (2006).

_____ , 'La Clausura delle monache nell'amministrazione della Congregazione Romana sopra i Regolari', in Zarri (ed.) (1997).

Meischke, R., 'Het Amsterdamse Fabrieksambt van 1595–1625', *Bulletin von Koninlijke Nederlandse Oudheidkundige*, 93 (1994), 100–124.

_____ , *De Monumenten van Geschiedenis en Kunst: Amsterdam Burgerweeshuis* (Amsterdam: Stadsuitgeverij, 1975).

Miele, Michele, 'Monache e monasteri del Cinque-Seicento tra riforme imposte e nuove esperienze', in Galasso and Valerio (eds) (2001).

Miglio, Luisa, 'Graffi di storia', in Ciociola (ed.) (1997).

Millon, Henry A. (ed.), *Studies in Italian Art and Architecture, 15th through 18th Centuries* (Cambridge MA and London: MIT Press, 1980).

Miretti, Monica, *Sul viale del tramonto*, n.d., available online at: <www.uniurb.it/storia/edocs/ducato_di_urbino.pdf>.

Molinari, Franco, 'Visite pastorali de monasteri femminili di Piacenza nel sec. XVI, in *Il Concilio di Trento e la riforma tridentina. Atti del convegno Storico internazionale (Trento 2–6 settembre 1963)* (Rome-Freiburg: Herder, 1965), 679–731.

Monducci, Elio, *Il Correggio: la vita e le opere nelle fonti documentarie* (Cinisello Balsamo: Silvana, 2004).

Morse, Margaret A., 'Creating Sacred Space: The Religious Visual Culture of the Renaissance Venetian *Casa*', *Renaissance Studies*, 21/2 (2007), 151–84.

Morselli, Raffaella, *Le Collezioni Gonzaga: l'elenco dei beni del 1626–1627* (Cinisello Balsamo: Silvana, 2000).

—— (ed.), *Gonzaga. La Celeste Galeria: Le Raccolte* (exh. cat.) (Milan, 2002).

Muller, Jeffrey, 'Private Collections in the Spanish Netherlands: Ownership and Display of Paintings in Domestic Interiors', in Sutton (ed.) (1993).

Muller, Sheila, *Charity in the Dutch Republic* (Ann Arbor MI: University of Michigan Press, 1985).

Mulryne, J.R, Helen Watanabe-O'Kelly and Margaret Shewring (eds), *Europa Triumphans: Court and Civic Festivals in Early Modern Europe* (Aldershot and Burlington VT: Ashgate, 2004).

Murphy, Caroline P., *The Pope's Daughter* (London: Faber & Faber, 2004).

Muzzarelli, Cesare (ed.), *'Familia' del principe e famiglia aristocratica* (Rome: Bulzoni, 1988).

Natali, Antonio (ed.), *Federico Barocci. Il miracolo della Madonna della gatta* (Cinisello Balsamo: Silvana, Amici degli Uffizi, 2003).

Negro, Emilio, and Nicosetta Roio, *Francesco Francia e la sua Scuola* (Modena: Artioli, 1998).

Nelson, Jonathan (ed.), *Plautilla Nelli (1524–1588): The Painter-Prioress of Renaissance Florence* (Florence: Syracuse University Press, 2008).

Neurdenburg, Elisabeth, *Hendrik de Keyser* (Amsterdam: Scheltma & Holkema, 1930).

Newman, John, 'The Architectural Setting', in Tyacke (ed.) (1997).

—— , 'The Physical Setting: New Building and Adaptation', in McConica (ed.) (1986).

Northoff, Thomas, *Graffiti. Die Sprache an den Wänden* (Vienna: Löcker, 2005).

Novi Chavarria, Elisa, *Monache e gentildonne: un labile confine. Poteri politici e identità religiosa nei monasteri napoletani secoli XVI–XVII* (Milan: Franco Angeli, 2001).

Nuechterlein, Jeanne, 'The Domesticity of Sacred Space in the Fifteenth-Century Netherlands', in Spicer and Hamilton (eds) (2006).

O'Brien, Patrick, et al. (eds), *Urban Achievement in Early Modern Europe* (Cambridge: Cambridge University Press, 2001).

Olival, Fernanda, 'Structural Changes within the Sixteenth-Century Portuguese Military Orders', *e-Journal of Portuguese History*, 2/2 (2004).

Olsen, Harald, *Urbino* (Copenhagen: Bogtrykkeriet Hafnia, 1971).

Ozzòla, Leandro, *La Galleria Di Mantova. Palazzo Ducale* (Cremona: Tip. Ed. Pizzorni, 1949).

Padley, Kenneth, 'Revising Early Modern Exeter', *Exeter College Register* (2000), 38–45.

Palumbo Fossati, Isabella, 'La casa veneziana', in Toscano and Valcanover (eds) (2004).

_____ , 'L'interno della casa dell'artigiano e dell'artista nella Venezia del Cinquecento', *Studi Veneziani*, 8 (1982), 109–53.

Pane, Roberto, *Il Monastero di S. Gregorio Armeno* (Naples: Arte Tipografica, 1957).

Park, Katharine, and Lorraine Daston (eds), *The Cambridge History of Science, Volume 3: Early Modern Science* (Cambridge: Cambridge University Press, 2006).

Parshall, Peter, '*Imago Contrafacta*: Images and Facts in the Northern Renaissance', *Art History*, 4 (December 1993), 554–79.

Pastor, Ludwig, *The History of the Popes from the Close of the Middle Ages: Drawn from the Secret Archives of the Vatican and Other Original Sources* (St. Louis MO: B. Herder, 1898).

Pastore, Giuse, 'La chiesa di Sant'Orsola e l'eremo delle grotte,' *Quaderni di San Lorenzo*, 4 (2006), 5–20.

_____ , 'Testimonianze di monasteri nella città di Mantova', in *Francescanesimo in Lombardia: Storia e Arte* (Milan: Silvana, 1983), 475–7.

Patetta, Luciano, 'L'Età di Carlo e Federico Borromeo e gli sviluppi delle chiese "doppie" conventuali nella diocesi di Milano', in Spagnesi (ed.) (1989).

_____ , 'La Tipologia delle chiese doppie dal Medioevo alla Controriforma', in *Storia e Tipologia: cinque saggi sull'architettura dela passato* (Milan: Clup, 1989), 11–71.

Pearson, Andrea, *Envisioning Gender in Burgundian Devotional Art, 1350–1530* (Aldershot and Burlington VT: Ashgate, 2005).

Peetoom, Lenie, and Letty van der Hoek, *Door Gangen en Poorten naar de Hofjes van Haarlem* (Leiden: Stichting Uitgeverij Barabinsk, 2001).

Periti, Giancarla, 'Correggio, Prati, e l'*Ecce Homo*: nuovi intrecci intorno a problemi di devozione nella Parma rinascimentale', in Vecchi and Periti (eds) (2005).

Peruzzi, Paolo, 'Lavorare a corte: "Ordine et officij". Domestici, familiari, cortigiani e funzionari al servizio del duca d'Urbino', in Cerboni Baiardi, Chittolini and Floriani (eds) (1986).

Peters, Francis E., *The Monotheists, Jews, Christians and Muslims in Conflict and Competition* (Princeton NJ: Princeton University Press, 2003).

Petrucci, Armando, *La scrittura. Ideologia e rappresentazione* (Turin: Einaudi, 1986).

Pevsner, Nikolaus, *A History of Building Types* (London: Thames & Hudson, 1979).

_____ , 'Hospitals', in Pevsner (1979).

Pietrangeli, Carlo (ed.), *The Sistine Chapel, the Art, the History, and the Restoration* (New York: Harmony Books, 1986).

_____ and Fabrizio Mancinelli (eds), *Raffaello in Vaticano* (Milan: Gruppo Editoriale Electa, 1984).

Pitrè, Giuseppe, *Del Sant'Uffizio di Palermo e di un carcere di esso* (Roma: Seli, Soc. Ed. del Libro Italiano, 1940).

_____ and Leonardo Sciascia, *Urla senza suono. Graffiti e disegni dei prigionieri dell'Inquisizione* (Palermo: Sellerio, 1999).

Polichetti, Maria Luisa, *Il Palazzo di Federico da Montefeltro* (Urbino: Quattroventi, 1985).

_____ , 'Nuovi elementi per la storia del palazzo: restauri e ricerche', in Polichetti (ed.) (1985).

Polman, Mariette, *Het Frans Halsmuseum* (Haarlem: Vrieseborch, 1990).

Pomata, Gianna, and Gabriella Zarri (eds), *I monasteri femminili come centri di cultura fra Rinascimento e barocco* (Rome: Edizioni di Storia e Letteratura, 2005).

Pomian, Krzysztof, *Collectors and Curiosities. Paris and Venice, 1500–1800* (Cambridge: Polity, 1990).

Porter, Stephen, 'University and Society', in Tyacke (ed.) (1997).

Prodi, Paolo (ed.), *Disciplina dell'anima, disciplina del corpo e disciplina della società tra Medioevo ed età moderna* (Bologna: Il Mulino, 1994).

Prosperi, Adriano, 'Un muro di parole. Graffiti nelle carceri bolognesi', in *America e Apocalisse e altri saggi* (Pisa-Rome: Istituti editoriali poligrafici internazionali, 1999).

Pucci, Italo, 'I graffiti del *Palazzo del Principe* Andrea Doria in Genova', *Archeologia postmedievale*, 10 (2006), 141–54.

Quaderni storici, Special Issue 3 (2001).

Quint Platt, Arlene, *Cardinal Federico as Patron and Critic of the Arts and his 'Musaeum' of 1625* (New York: Garland, 1986).

Rabb, Theodore K., and Jonathan Brown (eds), *The Evidence of Art: Images and Meaning in History* (Cambridge: Cambridge University Press, 1988).

Radke, Gary M., *Viterbo. Profile of a Thirteenth-Century Papal Palace* (Cambridge: Cambridge University Press, 1996).

Randolph, Adrian, 'Regarding Women in Sacred Space', in Johnson and Matthews-Grieco (eds) (1997).

Rapley, Elizabeth, *The Dévotes: Women and Church in Seventeenth-Century France* (Montreal: McGill-Queen's University Press, 1990).

de Reume, Auguste Joseph, *Les Vierges Miraculeuses de la Belgique* (Brussels, 1856).

Ricketts, Annabel, with Claire Gapper and Caroline Knight, 'Designing for Protestant Worship: The Private Chapels of the Cecil Family', in Spicer and Hamilton (eds) (2006).

Robels, Hella, *Frans Snyders: Stilleben- und Tiermaler, 1579–1657* (Munich: Deutscher Kunstverlag, 1989).

Roche, Daniel, *The People of Paris: An Essay in Popular Culture in the Eighteenth Century* (Berkeley CA: University of California Press, 1987).

Rocher, Yves (ed.), *L'art du XVIIme siècle dans les Carmels de France* (exh. cat.) (Paris: Musée du Petit Palais, 1982).

Rodella, Giovanni (ed.), *I Dipinti della Galleria Nuova* (Mantua: Tre Lune Edizioni, 2002).

Russell, Elizabeth, 'The Influx of Commoners into the University of Oxford before 1581: An Optical Illusion?', *English Historical Review*, 92/365 (1977), 721–45.

Russo, Carla, *I monasteri femminili di clausura a Napoli nel secolo XVII* (Naples: Arte Tipografica, 1970).

Safarik, Eduard, *Domenico Fetti, 1588/89–1623* (exh. cat.) (Milan: Electa, 1996).

———, *Fetti* (Milan: Electa, 1990).

Safley, Thomas M., *Children of the Labouring Poor: Expectation and Experience Among the Orphans of Early Modern Augsburg* (Leiden and Boston MA: Brill, 2005).

———, *Charity and Economy in the Orphanages of Early Modern Augsburg* (Boston MA: Humanities Press, 1997).

Salgado, Abílio José, and Salgado, Anastácia Mestrinho, *O Espírito das Misericórdias nos Testamentos de D. Leonor e de Outras Mulheres da Casa de Avis* (Lisbon: Ed. da Comissão para os Quinhentos Anos das Misericórdias Portuguesas, 1999).

Salvalai, Raffaella, 'Margherita Gonzaga d'Este e Giuseppina Bonaparte: vicende di un Collezionismo Minore,' *Civiltà mantovana*, 3rd ser., 116 (2003).

Sánchez, Magdalena S., *The Empress, the Queen, and the Nun: Women and Power at the Court of Philip III of Spain* (Baltimore MD: Johns Hopkins University Press, 1998).

Sander, C.A.L., 'Het Dolhuys of Dolhuis Ande Vesten of de Kloveniersburgwal', *Maanblad amstelodamum* 45 (1958), 29–40.

San Maurizio in Mantova. Due secoli di vita religiosa e di cultura artistica (exh. cat.) (Brescia: Grafo, 1982).

Sanz, Ana Garcia, and Leticia Sánchez Hernandez, 'Iconografia de monjas, santas y beatas en los monasterios reales espanoles', in Centro de Estudios Historicos (1997).

Sarti, Raffaella, 'Graffitari d'*antan*. A proposito dello scrivere sui muri in prospettiva storica', *Polis*, 21 (2007), 399–428.

———, *Europe at Home. Family and Material Culture, 1500–1800*, trans. by Allan Cameron (New Haven CT and London: Yale University Press, 2002; orig. edn *Vita di casa. Abitare, mangiare, vestire nell'Europa moderna*, Rome-Bari: Laterza, 1999).

Savage, Mike, 'Culture, Class, and Classification', in Bennett and Frow (eds) (2008).

Scaraffia, Lucetta, and Gabriella Zarri (eds), *Donne e Fede: Santità e vita religiosa in Italia* (Rome: Laterza, 1994).

Schama, Simon, *The Embarrassment of Riches* (New York: Knopf, 1987).

Schofield, Richard, and Grazioso Sironi, 'Bramante and the Problem of Santa Maria presso San Satiro', *Annali di Architettura*, 12 (2000), 17–57.

Sciascia, Leonardo, *Graffiti e disegni dei prigionieri dell'Inquisizione* (Palermo: Sellerio, 1977).

Sebastiani, Lucia, 'Cronaca e agiografia nei monastery femminili', in *Raccolte di vite di santi dal XIII al XVIII secolo: strutture, messaggi, fruizioni* (Brindisi: Fasano, 1990), 159–68.

Segal, Sam, with Liesbeth Helmus, *Jan Davidsz. de Heem en zijn kring* (Braunschweig: Herzog Anton Ulrich Museum, 1991).

Senos, Nuno, 'A Coroa e a Igreja na Lisboa de Quinhentos', *Lusitania Sacra*, 2nd ser., XV (2003), 97–117.

_____ , *O Paço da Ribeira 1501–1581* (Lisbon: Editorial Notícias, 2002).

Serrão, Joel, and António Henrique R. de Oliveira Marques (eds), *Nova História de Portugal* (Lisbon: Presença, 1998).

Shaw, Christine, *Julius II, the Warrior Pope* (Oxford and Cambridge MA: Blackwell, 1993).

Shearman, John, 'The Fresco Decoration of Sixtus IV', in Pietrangeli (ed.) (1986).

_____ , 'The Vatican Stanze: Functions and Decorations', *Proceedings of the British Academy*, 57 (1971), 369–424.

Siegl, Norbert, *Kulturphänomen Graffiti* (Vienna: Institut für Graffiti-Forschung, 2007), and online at <www.graffitieuropa.org/kultur1>.

Silva, Isabel L. Morgado de Sousa e, 'A Ordem de Cristo (1417–1521)', *Militarium Ordinum Analecta*, 6 (2002), 5–42.

Skeggs, Beverley, *Formations of Class and Gender* (London: Sage, 1997).

Smith, Christine, and Joseph O'Connor, *Building the Kingdom: Giannozzo Manetti on the Material and Spiritual Edifice* (Tempe AZ and Turnhout, Belgium: Arizona Center for Medieval and Renaissance Studies and Brepols, 2006).

Smith, Pamela H., *The Body of the Artisan. Art and Experience in the Scientific Revolution* (Chicago IL: Chicago University Press, 2004).

Solfaroli Camillocci, Daniela, 'L'obbedienza femminile tra virtù domestiche e disciplina monastica', in Scaraffia and Zarri (eds) (1994).

Spagnesi, Gianfranco (ed.), *L'architettura a Roma e in Italia (1580–1621), Atti del 23o Congresso di storia dell' architettura* (Rome: Centro di Studi per la Storia dell'architettura, 1989).

Sperling, Jutta G., *Convents and the Body Politic in Late Renaissance Venice* (Chicago IL: University of Chicago Press, 1999).

Speth-Holterhoff, S., *Les peintres flamands de cabinets d'amateurs au XVIIe siècle* (Brussels: Elsevier, 1957).

Spicer, Andrew, and Sarah Hamilton (eds), *Defining the Holy: Sacred Space in Medieval and Early Modern Europe* (Aldershot and Burlington VT: Ashgate, 2006).

Spierenburg, Pieter, *The Broken Spell* (New Brunswick NJ: Rutgers University Press, 1991).

Sterrit, Laurence Lux, *Redefining Female Religious Life: French Ursulines and English Ladies in Seventeenth-Century Catholicism* (Aldershot and Burlington VT: Ashgate, 2005).

Stevenson, Christine, *Medicine and Magnificence: British Hospital and Asylum Architecture, 1660–1815* (New Haven CT: Yale University Press, 2000).

Stevenson, William H., and Herbert E. Salter, *The Early History of St John's College* (Oxford: The Clarendon Press for the Oxford Historical Society, 1939).

Stoichita, Victor, *The Self-Aware Image* (Cambridge: Cambridge University Press, 1997).

Stone, Lawrence (ed.), *The University in Society*, 2 vols, *vol. 1, Oxford and Cambridge from the 14th to the Early 19th Century* (Princeton NJ and London: Princeton University Press, 1974).

_____ , 'The Size and Composition of the Oxford Student Body 1580–1909', in Stone (ed.) (1974).

Stramigioli Ciacchi, Carlo, 'Araldica ecclesiastica. La Legazione di Urbino-Pesaro. Pontefici, Governatori, Cardinali Legati, Presidenti, Delegati apostolici e Vicelegati', *Frammenti*, 5 (2000), 149–239.

Strasser, Ulrike, *State of Virginity: Gender, Religion and Politics in an Early Modern Catholic State* (Ann Arbor MI: University of Michigan Press, 2004).

Strazzullo, Franco, *Edilizia e Urbanistica a Napoli dal '500 al '700* (Naples: Arte Tipografica, 1995).

Strocchia, Sharon, 'Sisters in Spirit: The Nuns of Sant'Ambrogio and their Consorority in Early Sixteenth-Century Florence', *Sixteenth Century Journal*, 33/3 (2002), 735–67.

Styles, John, and Amanda Vickery (eds), *Gender,Taste and Material Culture in Britain and North America 1700–1830* (New Haven CT: Yale University Press, 2006).

_____ and _____ , 'Introduction', in Styles and Vickery (eds) (2006).

Sutton, Peter C. (ed.), *The Age of Rubens* (Boston MA: Museum of Fine Arts, 1993).

Swan, Claudia, *Art, Science and Witchcraft in Early Modern Holland: Jacques de Gheyn II (1565–1629)* (Cambridge: Cambridge University Press, 2005).

Terpstra, Nicholas, *Abandoned Children of the Italian Renaissance: Orphan Care in Florence and Bologna* (Baltimore MD: Johns Hopkins University Press, 2005).

Thofner, Margit, '"Spirito, acqua e sangue". Gli arredi delle chiese luterane (XVI–XVII secolo)', *Quaderni storici*, 123/3 (2006), 519–48.

Thomas, Anabel, *Art and Piety in the Female Religious Communities of Renaissance Italy: Iconography, Space and Religious Woman's Perspective* (Cambridge: Cambridge University Press, 2003).

Thompson, John D., and Grace Goldin, *The Hospital: A Social and Architectural History* (New Haven CT: Yale University Press, 1975).

Thornton, Peter, *Form and Decoration. Innovation in the Decorative Arts 1470–1870* (New York: Abrams, 1998).

Torres Sánchez, Concha, *La clausura imposibile. Conventualismo femenino y espansión contrarreformista* (Madrid: Asociación Cultural Al-Mudaya, 2000).

Toscano, Gennaro and Francesco Valcanover (eds), *Da Bellini a Veronese: temi di arte veneta* (Venice: Istituto Veneto di scienze lettere ed arti, 2004).

Trevisani, Filippo and Stefano L'Occaso (eds), *Rubens. Eleonora de' Medici Gonzaga e l'oratorio sopra Santa Croce: pittura devota a corte* (exh. cat.) (Milan: Electa, 2005).

Trnek, Helmut, '*Exotica* in the *Kunskammers* of the Habsburgs, their Inventories and Collections', in Trnek and Vassallo e Silva (eds) (2001).

_____ and Nuno Vassallo e Silva (eds), *Exotica. The Portuguese Discoveries and the Renaissance Kunstkammer* (exh. cat.) (Lisbon: Calouste Gulbenkian, 2001).

Troncarelli, Fabio, 'I muri parlano', in Attilio Bartoli Langeli et al., *La città e la parola scritta*, ed. Giovanni Pugliese Carratelli (Milan: Credito italiano, Garzanti, Scheiwiller, 1997), 457–64.

Turner, Jane (ed.), *Dictionary of Art* (London: Macmillan, 1996).

Tyacke, Nicholas (ed.), *The History of the University of Oxford, vol. 4. Seventeenth-Century Oxford* (Oxford: Clarendon Press, 1997).

Ullman, Walter, *A Short History of the Papacy in the Middle Ages* (London: Methuen, 1972).

Valazzi, Maria Rosaria, 'Le arti "roveresche" e il tramonto del ducato di Urbino. Federico Barocci e Francesco Maria della Rovere', in Natali (ed.) (2003).

Valtieri, Simonetta (ed.), *Il Palazzo dal Rinascimento a Oggi, in Italia nel regno di Napoli in Calabria storia e attualità* (Rome: Gangemi, 1989).

van der Ploeg, Peter, and Carola Vermeeren (eds), *Princely Patrons. The Collection of Frederick Henry of Orange and Amalia of Solms in The Hague* (Zwolle: Waanders Publishers, 1997).

van der Stighelen, Katlijne, 'Productiviteit en samenwerking in het Antwerpse kunstenaarsmilieu, 1620–1640', *Gemeentekrediet: Driemaandelijks Tijdschrift van het Gemeentekrediet van België*, 172 (1990–92), 5–15.

Vassallo e Silva, Nuno, 'Precious Objects and Marvels: The Goa–Lisbon Trade', in Trnek and Vassallo e Silva (eds) (2001).

Vauchez, André, *The Laity in the Middle Ages: Religious Beliefs and Devotional Practices* (Notre Dame IN: Notre Dame University Press, 1993).

de Vecchi, Pierluigi, and Giancarla Periti (eds), *Marche ed Emilia: l'Identità Visiva della 'Periferia'. Studi Sulla Cultura e sulla Pratica dell'arte nel Rinascimento* (Bergamo: Bolis, 2005).

Verstegen, Ian (ed.), *Patronage and Dynasty. The Rise of the della Rovere in Renaissance Italy*, *Sixteenth-Century Essays and Studies* 77 (Kirksville MO: Truman State University Press, 2007).

Visceglia, Maria Antonietta, 'Linee per uno studio unitario dei testamenti e dei contratti matrimoniali dell'aristocrazia feudale napoletana tra fine Quattrocento e Settecento', *Mélange de l'Ecole française de Rome*, 95 (1983), 393–470.

Viterbo, Sousa, *A Livraria Real especialmente no Reinado de D. Manuel. Memória apresentada à Academia Real das Sciencias de Lisboa* (Lisbon: Typographia da Academia, 1901).

Waddy, Patricia, *Seventeenth-Century Roman Palaces: Use and Art of the Plan* (Cambridge MA: MIT Press, 1990).

Walker, Claire, *Gender and Politics in Early Modern Europe: English Convents in France and the Low Countries* (London: Palgrave Macmillan, 2003.

Weatherill, Lorna, 'The Meaning of Consumer Behavior in Late Seventeenth- and Early Eighteenth-Century England', in Brewer and Porter (eds) (1993).

Weaver, Elissa, *Convent Theater in Early Modern Italy: Spiritual Fun and Learning for Women* (Cambridge: Cambridge University Press, 2002).

Webb, Diane, *Privacy and Solitude in the Middle Ages* (London and New York: Hambledon Continuum, 2006).

_____ , 'Domestic Space and Devotion in the Middle Ages', in Spicer and Hamilton (eds), (2006).

Weber, Alison, *Teresa of Avila and the Rhetoric of Femininity* (Princeton NJ: Princeton University Press, 1990).

Weddle, Saundra, 'Woman's Place in the Family and the Convent', *Journal of Architectural Education*, 55/2 (2001), 64–72.

Weil-Garris, Kathleen, and John D'Amico, 'The Renaissance Cardinal's Ideal Palace: A Chapter from Cortesi's *De Cardinalatu*', in Millon (ed.) (1980).

Westermann, Mariet, *Art and Home. Dutch Interiors in the Age of Rembrandt* (Zwolle: Waanders, 2001).

Wigley, Mark, 'Untitled: The Housing of Gender', in Colomina (ed.) (1992).

Wijsenbeek-Olthuis, Thera, *Achter de Gevels* (Hilversum: Verloren, 1987).

Wilkinson-Zerner, Catherine, *Juan de Herrera, Architect to Philip II of Spain* (New Haven CT and London: Yale University Press, 1993).

Williams, Penny, 'State, Church and University 1558–1603,' in McConica (ed.) (1986).

Willis, Robert, and John Willis Clark, *The Architectural History of the University of Cambridge, and of the Colleges of Cambridge and Eton*, 4 vols (Cambridge, 1866), vol. 3, part III.

Winkelmes, Mary-Ann, 'Taking Part: Benedictine Nuns as Patrons of Art and Architecture', in Johnson and Matthews-Grieco (eds) (1997).

Winner, Matthias, Bernard Andreae and Carlo Pietrangeli (eds), *Il Cortile delle statue der Statuenhof des Belvedere im Vatikan* (Mainz am Rhein: Verlag Philipp von Zabern, 1998).

Wittkower, Rudolf, and Margot Wittkower, *Born under Saturn: The Character and Conduct of Artists: A Documental History from the Antiquity to the French Revolution* (London: Weidenfeld & Nicolson, 1963).

Wolff Metternich, Franz Graf, *Die Erbauung der Peterskirche zu Rom im 16. Jahrhundert*, vol. I, 1 (Vienna and Munich: Verlag Anton Schroll & Co., 1972).

Wood, Diana (ed.), *The Church and Childhood*, 31 (Oxford: Published for Ecclesiastical History Society by Blackwell, 1994).

Wood, Jeryldene, *Women, Art and Spirituality: The Poor Clares of Early Modern Italy* (Cambridge: Cambridge University Press, 1996).

Woodall, Joanna, 'Drawing in Colour,' in Durante et al. (2003).

_____ , 'Wtewael's *Perseus and Andromeda*: Looking for Love in Early Seventeenth-Century Dutch Painting', in Arscott and Scott (eds) (2000).

Woollett, Anne T., and Ariane van Suchtelen, *Rubens and Brueghel: A Working Friendship* (Los Angeles and The Hague: J. Paul Getty Museum and Royal Picture Gallery Mauritshuis, 2006).

Zampetti, Pietro, and Rodolfo Battistini, 'Federico da Montefeltro e il Palazzo Ducale', in Polichetti (ed.) (1985).

Zarri, Gabriella (ed.), *Recinti: donne, clausura matrimonio nella prima età moderna* (Bologna: Il Mulino, 2000).

_____ (ed.), *Il monachesimo femminile in Italia dall'alto medioevo al secolo XVII a confronto con l'oggi* (Verona: Il Segno dei Gabrielli editori, 1997).

_____ (ed.), *Donna, disciplina, creanza cristiana dal XV al XVII secolo: studi e testi a stampa* (Rome: Edizioni di Storia e Letteratura, 1996).

_____ , 'Monasteri femminili e città (secoli XV–XVIII)', in Chittolini and Miccoli (eds) (1986).

Zemon Davis, Natalie, *The Gift in Sixteenth-Century France* (Madison WI: University of Wisconsin Press, 2000).

Zerbi Fanna, Myriam, 'Fetti, Lucrina', in Gaze (ed.) (1997).

_____ , 'Lucrina Fetti Pittrice', *Civiltà mantovana*, 23–26 (1989), 35–53.

Dissertations

Anderson, Caroline, 'The Material Culture of Domestic Religion in Early Modern Florence, c. 1480–1650' (PhD diss., University of York, 2008).

Carlton Humble, Susannah, 'From Royal Household to Royal Court: A Comparison of the Development of the Courts of Henry VII of England and D. Manuel of Portugal' (PhD diss., Johns Hopkins University, 2003).

Coope, Clare, 'Federico Borromeo's *Musaeum*' (MA thesis, Courtauld Institute of Art, 1977).

Fernández, Henry Dietrich, 'Bramante's Architectural Legacy in the Vatican Palace: A Study in Papal Routes' (PhD diss., University of Cambridge, 2003).

Gladen, Cynthia, 'A Painter, a Duchess, and the Monastero di Sant'Orsola: Case Studies of Women's Monastic Lives in Mantua, 1599–1651' (PhD diss., University of Minnesota, 2003).

Jordan, Annemarie, 'The Development of Catherine of Austria's Collection in the Queen's Household: Its Character and Cost', 2 vols (PhD diss., Brown University, 1994).

_____ , 'Portuguese Royal Collections (1505–1580): A Bibliographic and Documentary Survey' (MA thesis, George Washington University, 1985).

Knöll, Stefanie, 'Commemoration and Academic "Self-Fashioning": Funerary Monuments to Professors at Oxford, Tübingen, and Leiden, 1580–1700' (DPhil. diss., University of Sussex, 2001).

Taynter Brown, Deborah, 'Cardinal Giuliano Della Rovere, Patron of Architecture, 1471–1503' (MPhil. diss., University of London, Courtauld Institute of Art, 1988).

Voelker, Evelyn Carole, 'Charles Borromeo's *Instructiones fabricae et supellectilis ecclesiasticae*, 1577. A Translation with Commentary and Analysis' (PhD diss., Syracuse University, 1977; University Microfilms, Ann Arbor MI, 1977).

Index

(References to illustrations are in italic)